Published with the assistance of the Getty Foundation.

The publisher gratefully acknowledges the generous contribution to this book provided by the Art Endowment Fund of the University of California Press Foundation, which is supported by a major gift from the Ahmanson Foundation.

Modernism and the Feminine Voice

Modernism and the Feminine Voice

O'Keeffe and the Women of the Stieglitz Circle

Kathleen Pyne

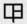

University of California Press

Berkeley | Los Angeles | London

Georgia O'Keeffe Museum | Santa Fe

High Museum of Art | Atlanta

This book serves as the companion to the exhibition *Georgia O'Keeffe and the Women of the Stieglitz Circle*, organized by the Georgia O'Keeffe Museum and the High Museum of Art:

Georgia O'Keeffe Museum, Santa Fe
September 21, 2007–January 13, 2008

High Museum of Art, Atlanta
February 9–May 4, 2008

San Diego Museum of Art
May 24–September 28, 2008

University of California Press, one of the most distinguished university presses in the United States, enriches lives around the world by advancing scholarship in the humanities, social sciences, and natural sciences. Its activities are supported by the UC Press Foundation and by philanthropic contributions from individuals and institutions. For more information, visit www.ucpress.edu.

University of California Press
Berkeley and Los Angeles, California

University of California Press, Ltd.
London, England

Library of Congress Cataloging-in-Publication Data
Pyne, Kathleen A.
 Modernism and the feminine voice : O'Keeffe and the women of the Stieglitz circle / Kathleen Pyne.
 p. cm.
 Companion book to an exhibition that will open at the Georgia O'Keeffe Museum in Santa Fe, New Mexico, in fall 2007.
 Includes bibliographical references and index.
 ISBN-13: 978-0-520-24189-3 (cloth : alk. paper)
 ISBN-13: 978-0-520-24190-9 (pbk. : alk. paper)
 1. Modernism (Art)— United States. 2. Women artists— United States. 3. Stieglitz, Alfred, 1864–1946—Art patronage.
4. O'Keeffe, Georgia, 1887–1986. I. O'Keeffe, Georgia, 1887– 1986. II. Title.
N6512.5.M63P96 2007
704'.042097309041—dc22 2005034482

Manufactured in Canada

16 15 14 13 12 11 10 09 08 07
10 9 8 7 6 5 4 3 2 1

The paper used in this publication meets the minimum requirements of ANSI/NISO Z39.48–1992 (R 1997) (*Permanence of Paper*).

Contents

For my sister,

Nanette Marie Pyne

Illustrations

Directors' Foreword

The Georgia O'Keeffe Museum and the High Museum of Art are honored to have collaborated on the presentation of *Georgia O'Keeffe and the Women of the Stieglitz Circle*. The exhibition derives from this important book by Kathleen Pyne, *Modernism and the Feminine Voice: O'Keeffe and the Women of the Stieglitz Circle*. Professor Pyne completed aspects of her study in 2001 as a scholar-in-residence at the Georgia O'Keeffe Museum Research Center, Santa Fe. She subsequently served as guest curator for this exhibition in collaboration with Barbara Buhler Lynes, Curator, Georgia O'Keeffe Museum, and Sylvia Yount, Margaret and Terry Stent Curator of American Art, High Museum of Art. We wish to thank them all for their vital efforts in realizing the exhibition. We also want to acknowledge the assistance of Kaaren Boullosa, Heather Hole, and Judy Chiba Smith of the O'Keeffe Museum and that of Nicole Smith, Marjorie Harvey, Amy Simon, Akela Reason, and Laurie Carter of the High Museum. Following its presentation in Santa Fe, the exhibition will travel to the High, in Atlanta, and then to the San Diego Art Museum. We are grateful to our colleagues in San Diego—particularly Derrick R. Cartwright, the Maruja Baldwin Director, and D. Scott Atkinson, Chief Curator and Curator of American Art—for their participation in the tour. They join with us in thanking the many private and public lenders who were willing to share their treasured works of art with a wider public. The exhibition has been made possible by the generous support of the National Endowment for the Arts as part of the American Masterpieces: Three Centuries of Artistic Genius initiative. Additional funding has come from the National Council of the Georgia O'Keeffe Museum and The Burnett Foundation.

This groundbreaking exhibition, with its companion scholarly publication, repositions O'Keeffe—the iconic woman artist of twentieth-century modernism—in the fresh context of artistic predecessors in the circle of her dealer and husband, Alfred Stieglitz. It features approximately ninety paintings, drawings, and photographs by Georgia O'Keeffe, Pamela Colman Smith, Katharine Nash Rhoades, Georgia Engelhard, Gertrude Käsebier, Anne Brigman, and Alfred Stieglitz. This unprecedented look at O'Keeffe—one of the most popular of all American artists—in the company of her lesser-known female contemporaries offers

viewers a new perspective that raises significant questions about the relationships between femininity, creativity, and modern life. We are excited to introduce our audiences to a group of influential women modernists who preceded and helped ensure O'Keeffe's success. Indeed, it is with great enthusiasm that we present this insightful project, which we believe will contribute to a broader understanding of and appreciation for the work of each individual artist as well as the development of modernism in early twentieth-century America.

George G. King
Director, Georgia O'Keeffe Museum

Michael E. Shapiro
Nancy and Holcombe T. Green, Jr. Director,
High Museum of Art

Acknowledgments

The process of writing this book has been an enormous pleasure, from beginning to end. The solitary work that produces exhilarating discoveries in the archives in this case was followed by immensely satisfying debates with my colleagues in the field of American modernism about the role of women and gender in modern art. I particularly enjoyed the collegiality of Marcia Brennan, Michael Leja, Barbara Buhler Lynes, and Alex Nemerov, all of whose readings of the manuscript helped me to refine my thesis. I am especially grateful to Barbara Lynes, who shared with me her vast knowledge of Georgia O'Keeffe and American modernism. Nick Clark, Anne Hammond, Paul Johnson, Denise Massa, Melinda Boyd Parsons, Nanette Pyne, Carol Robinson, Mike Weaver, Terri Weismann, Sophie White, and Sylvia Yount also gave me valuable suggestions for various parts of the project. A scholarship from the Georgia O'Keeffe Museum Research Center provided substantial resources for the research and writing of the book, as did grants from the Institute for Scholarship in the Liberal Arts, College of Arts and Letters, and the Graduate School at the University of Notre Dame.

Both Barbara Lynes and Sylvia Yount have my undying gratitude for the care they have given to every stage of our collaboration on the exhibition "Georgia O'Keeffe and the Women of the Stieglitz Circle," which is based on this book. Heather Hole deserves special acknowledgment for her organizational work on the exhibition, and Akela Reason also helped to translate this project into an exhibition. For their support of the exhibition, I thank George King, Director of the Georgia O'Keeffe Museum; Michael Shapiro, Director of the High Museum of Art; and Derrick Cartwright, Director of the San Diego Museum of Art.

At the University of California Press I am indebted to Stephanie Fay for her guidance in the project and her hard work in taking the book through the publication process. Sigi Nacson assisted her admirably in this task. Elizabeth Magnus, who copyedited the book, provided many fine suggestions for improving the writing.

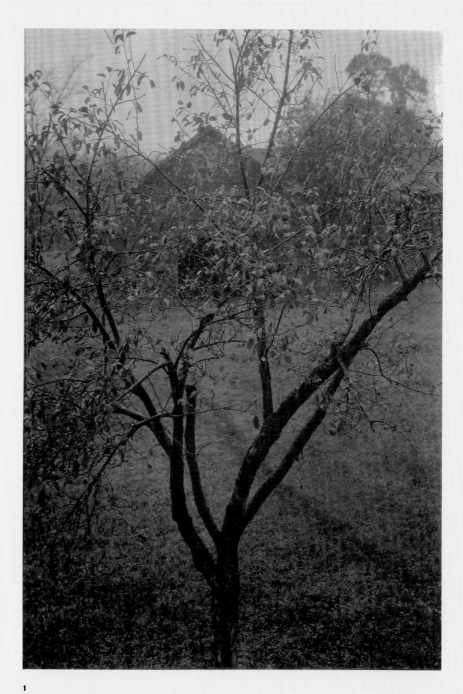

1

Alfred Stieglitz, *Plum Tree, Lake George*, 1920,
palladium print, $9^5/_{16} \times 7^1/_{16}$ in.

Introduction

That—what you see—is not an apple tree nor raindrops nor a barn [Fig. 1]. It is shapes in relationship, the imagination playing within the surface. Perhaps the raindrops are tears. And perhaps that dark entrance that seems to you mysterious is the womb, the place whence we came and where we desire when we are tired and unhappy to return, the womb of our mother, where we are quiet and without responsibility and protected. That is what men desire, and thinking and feeling and working in my own way I have discovered this for myself.

ALFRED STIEGLITZ, conversation with Herbert Seligmann, February 22, 1926

In the early decades of the twentieth century, there existed a group of extraordinary women who developed individual voices through their affiliation and conflicts with the Stieglitz circle, a circle that defined artistic modernism in New York City until 1930. Yet in the annals of modernism the memory of these women has been eclipsed by the presence of Georgia O'Keeffe, positioned as the one woman, the iconic figure, who made transparent the entire program of Stieglitz's modernism. Until recently, histories of American modernism have rigorously followed Stieglitz's lead in framing O'Keeffe as a lone woman surrounded by Stieglitz's men. The shining white image of O'Keeffe (Fig. 2), as Stieglitz transformed her into the iconic natural body celebrated in his modernism, has been rendered time and again as the climax of modernism in New York in the 1920s.[1] Her arrival on the scene and her romantic coupling with Stieglitz were essential to his own image as a heroic bohemian.

The women artists who preceded O'Keeffe in Stieglitz's modernist circle—the photographers and painters Gertrude Käsebier, Pamela Colman Smith, Anne Brigman, and Katharine Nash Rhoades—each contributed to the identity of the

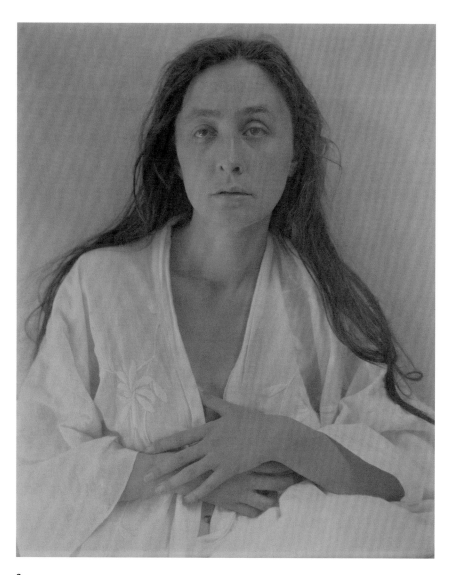

2
Alfred Stieglitz, *Georgia O'Keeffe,* 1918, palladium print, 9⅛ × 7⅜ in.

woman modernist. In a large sense, they collectively "made" the image O'Keeffe later took on. Their creativity in defining the woman modernist through their lives and their individual photographs and paintings is an essential but overlooked chapter in the history of modernism in New York. Their stories, as I tell them in this book, profoundly revise Stieglitz's narrative of the making of the woman modernist as she became embodied in the person and imagery of O'Keeffe. That Stieglitz fashioned O'Keeffe's image from her predecessors' self-images reveals O'Keeffe's "natural" unitary womanly essence as fractured and contrived. Further, she was not the only modernist woman artist worthy of our contemplation; rather, she stands as one among several who deserve recognition as pioneers of American modernism. O'Keeffe's fame as the lone woman of the Stieglitz circle reflects on Stieglitz's success in canonizing her, but it is also the result of her own phenomenally long productivity and record of experimentation and her ability to take over and orchestrate her own myth after Stieglitz's death.

The problem each of these women confronted in becoming an artist was the same: how to become a modernist. While in the nineteenth century the feminine had been placed outside modernity in a separate, premodern domain, in the early years of the twentieth century women had to negotiate their way out of that enclosure into modernity, to make space for themselves there as producers, not just as consumers or public women of a demimonde. To be a modernist and a woman meant to imagine oneself outside the conventions of domesticity, to know the essential self, the whole self—body and soul. In 1914 this modernist identity required the artist to disclose both the spiritual and erotic energies hidden in the depths of the artist's unconscious. To be a modernist in Greenwich Village and in the Stieglitz circle meant not simply to be in touch with this erotic life of the unconscious but also to "bare" one's essential self willingly to the world, displaying the signs of this life force in the visual energies of the work of art.

For women in modernism, baring oneself meant exposing the experience and sexual difference that marked woman's unconscious self according to the medical community and scholars of human sexuality—who would become known as sexologists. To be a modernist in the Stieglitz circle necessitated, first of all, an awareness of erotic life, which in turn could animate the formal rhythms of the

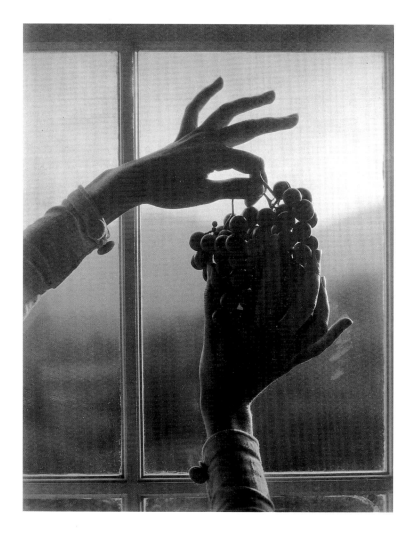

3

Alfred Stieglitz,
*Georgia O'Keeffe–
Hands and Grapes,*
1921, gelatin silver
print, 9 1/16 × 7 1/8 in.

work of art. Stieglitz's modernist catechism was built on a belief in life's penetration into art. Following this logic, I have therefore considered the lives and works of these women modernists as they themselves perceived them—as reciprocal parts of a seamless whole. To turn away from the life of the artist and regard the work merely in terms of its intertextual relationships and formal strategies—its pure form—is to lose sight of what the modernists regarded as an essential dimension of their writings and images: the self in the image. For the modernist, textual innovation marked, not simply a formal freedom of the image, but a personal trans-

formation and finally a disruption of the old order.[2] It was the social rituals of New York bohemians as much as their literary and artistic works that identified them as members of a cultural vanguard. Village radicals also associated modernism with the problem of woman. Modernist parables, for example, inevitably have at their center a woman who goes in search of her "true self." In real life too, women transgressing their stable domestic boundaries violated the old social code. This cultural shift led some modernist men to sympathize with feminists and identify themselves and their own creative processes with a repressed subterranean consciousness, regarded as feminine, primitive, and libidinally charged, as a means of subverting the previous regime.[3]

As Stieglitz's meditation in the epigraph to this introduction suggests, the new patriarchs of modernism found it difficult, if not impossible, to forget the maternal home.[4] Sinclair Lewis's play *Hobohemia* (ca. 1918) satirized cultural radicals like Hutchins Hapgood and Stieglitz who continued to be nurtured by feminine domesticity even as they rejected it. In Lewis's play a leader of Village politics is discovered to be secretly maintaining a bourgeois establishment in suburban New Jersey.[5] For many male modernists, such as Stieglitz, Randolph Bourne, and Van Wyck Brooks, the fall away from home into modernity coincided with a desire to return to that premodern space.[6] Especially during their first and most serene years together, Stieglitz and O'Keeffe explored the trope of a return to the original primitive paradise in which they would be exempt from the guilt of knowledge (Fig. 3). This paradise could be evoked in picturing a lover's hand holding the fruits of paradise, which promised a return to that wholeness of being. Stieglitz achieved a return to the maternal space in the eroticized terms of his modernism most satisfactorily for himself in his portrait of O'Keeffe as his woman-child, a fantasy figure who possessed the capacity to release him to the renewal promised in erotic play.

To a large extent, this book is focused on the interplay between Stieglitz and the women artists he mentored—in particular, Käsebier, Smith, Brigman, Rhoades, and O'Keeffe. Stieglitz has deservingly been praised for making a space within modernism for women. I trace here how he formed that space and how these

women artists helped to conceptualize it. My study also gives these women back their voices and takes seriously their resistances, for the moments when these women felt their autonomy imperiled by the limits of that space reveal the dissonance in modernism's glittering vision of the future. If at times in my account the women speak more than Stieglitz, they do so partly because of an asymmetry in the extant archival materials and partly because of my conviction that Stieglitz has already aired his views in his own vehicles of publicity and in the works of an army of biographers, scribes, and critics.

In many ways Stieglitz's project to find a "woman in art" was locked into his own sense of his identity as a man.[7] His strategies—in creating himself as a modernist—were founded in the oppositional gestures that early on drove his relationship to his family. Stieglitz set up arguments that allowed him to invent himself as he wished to be seen—as a visionary who had transcended the rules of bourgeois materialism and bourgeois masculinity and femininity. Oppositional rhetoric as a modernist mode was certainly not original to Stieglitz but already functioned as the logic of Greenwich Village's radical culture. Stieglitz, however, recognized and seized the opportunities such rhetoric held for modernist art.

During the first two decades of the century, modernists in New York manufactured themselves through constantly shifting terms as time and again they turned against old paradigms, scrambling to re-create themselves triumphantly as purveyors of the new. Striving to master the politics of modernism, Stieglitz crafted a rhetoric that drew heavily on the writings of Walt Whitman, Edward Carpenter, Henri Bergson, Havelock Ellis, Sigmund Freud, and later D. H. Lawrence. Through his engagement with the sexologists and the women artists he mentored, a phantom figure of the woman-child took shape in his mind. The woman-child, as Stieglitz envisioned her in O'Keeffe, however, was a complex creation. This woman was possessed of an adult sexuality, yet energized by innocence. While she was "clean," as Stieglitz liked to say, of the guilt and secretiveness of bourgeois femininity, she clearly recuperated other norms of feminine sexuality, especially woman's given purity and childlikeness. For the modernist intellectual elite were *of* the bourgeoisie. To critique their own class, the elite exiled and distanced themselves from their origins, but the terms of their revolt still belonged to those origins.[8] With the com-

plicity of the woman who agreed to take on the role of the woman-child, Stieglitz after 1918 restructured his critique of his middle-class roots around that feminine ideological figure.

Stieglitz's search for "woman in art"—as a pure, essential feminine vision—led him to several women before culminating in his finding and production of O'Keeffe as *the* woman. Although Stieglitz included a number of women in the Photo-Secession and exhibited the works of even more over the long span of his gallery activity, my study focuses on the women artists who contributed to Stieglitz's phantom of the woman modernist. So this book does not comprise a complete history of the women of the Stieglitz circle, nor is it concerned to relate complete biographies of the principal players. Rather, in *Modernism and the Feminine Voice* I trace the evolution of an idea. Because that idea culminated in the public presentation of O'Keeffe as the woman-child, my narrative reconstructs the path of Stieglitz's trajectory toward that historical moment. O'Keeffe takes shape here, however, as much more than the sum of her female antecedents.

All these early modernist women sought to define the identity of the modern woman in their artworks. In chapter 1, Gertrude Käsebier's photography reveals the baseline from which the feminine paradigm in modernism developed. Stieglitz and Käsebier's public connected her with the modern woman who was progressive, educated, and above all maternal. But Käsebier's evolution in her photography led to the undoing of that maternal paradigm as the modern woman's identity. From 1900 to 1910, Käsebier's decade, critics perceived the progress of women in art to be slow, if not retarded. In their eyes Käsebier was a conundrum: If mastery and genius were still masculine prerogatives, how could a woman produce the masterly images that came out of her darkroom? What was the role of sex and gender in her process of artistic creation? The critics were ambivalent about the role of Käsebier's femininity in her art, as was Stieglitz. But Stieglitz later put this ambivalence to work in constructing O'Keeffe as an artist who could claim universal vision, encompassing both masculine potency and feminine purity. Already as powerful as that of her male colleagues, Käsebier's work was nonetheless regarded as different. For, given its feminine subjectivity, it spoke with greater authority of the maternal home—a theme at the core of the early Photo-Secession.

Pamela Colman Smith's drawings, supposedly dictated by her mystical inner voice, offered Stieglitz a tentative break from the feminine paradigm of creativity as maternal nurture that Käsebier's images suggested. In Smith we encounter for the first time in New York's modernism the exhibition of feminine subjectivity as mystical, childlike, and primitive, by Smith's own mechanisms.

Chapter 2 examines the process by which the feminine in modernism was detached from the maternal paradigm. It follows the photography of the Californian Anne Brigman as an episode in which the woman artist released herself from the demands of bourgeois maternity to engage fully with another form of productivity: self-definition. Brigman's photographs of nudes focused primarily on her own body and produced the notion of the woman modernist's work as an act of feminine self-embodiment. In the 1910s, this aperçu became fundamental to Stieglitz's presentation of his modernists' works of art, whether produced by men or women artists. Anne Brigman's nudes resonate with the conception of modern dance as an externalizing of the inner self, and these associations helped create a sympathetic reception for her photographs as self-dramatizations of a struggle of her soul. The image of the dancer dancing her art endowed Stieglitz with a means of visualizing the artist embodied in the work of art. This tactic proved especially successful for his presentation of O'Keeffe in the early 1920s. Two of Stieglitz's key intellectual mentors, Henri Bergson and Havelock Ellis, regarded the dance as the exemplary art form—one in which the whole individual, body and spirit, moved mystically in rhythmic unity with the life force.[9] Such rhapsodic writing on dance, especially that devoted to the modern dance of Isadora Duncan, glorified the body's beauty. Duncan was already a legend when she danced in New York (in 1908 and after). For the modernists Duncan's myth, woven from her life and her art, projected her as the very image of modern woman. Stieglitz knew Duncan's dance well, and he traded on the discourse that surrounded it to legitimate his modernists, such as Matisse and Rodin, in whose works the female nude predominated. By speaking of the movement of the body as the movement of the soul, Stieglitz represented sexuality as the mystical origin of art. It was a ploy that impressed Stieglitz strongly, and he recirculated it in photographs that orchestrated O'Keeffe's dancing body in front of her abstract drawings to suggest their embodiment of her

story. O'Keeffe herself had already been moved by the dynamic bodies of Russian dancers, as Léon Bakst visualized them in drawings that celebrated the sensuous spiralings of body, form, and motif. Most important, Bakst's designs offered O'Keeffe a lexicon of abstract motifs for externalizing her own emotional life, which she believed she could not articulate in words. After Brigman, the artist's body and soul had to be perceived dancing in the formal rhythms of the image. Examining the works of Käsebier, Smith, Brigman, and O'Keeffe in relation to each other, we become aware of the extent to which Stieglitz learned his central strategies in creating a feminine voice of modernism from these early women associates.

Stieglitz thought his ideal woman had appeared in the person of Katharine Nash Rhoades, a young artist infatuated with modernist art and philosophy when he met her in 1911. She refused, however, to move with Stieglitz's teleology of the feminine, denying his demands to "crystallize" herself according to his Freudian scenario, which stipulated that the artist create out of the unconscious. As Rhoades and Stieglitz together studied the first English translations of Freud's "dream work," they came to believe that only from the erotic life of the unconscious could the "vital" work of art be born. Rhoades, however, confronted with the ravages of free love on women who drifted from one affair to another, declined to sacrifice her autonomy and stability to experience the erotic life and thus release the mind's hidden power. Her refusal to "develop" into Stieglitz's woman-child was also a denial of bourgeois productivity in which pain is borne to create either art or children—the choices also given her in Stieglitz's scenario for the woman artist he wished her to be. Why exchange one constraining existence for another equally circumscribed, she reasoned. In the end Rhoades chose to live in meditative solitude, a spiritual existence that went against the assertion of self, against modernist self-performance. When Rhoades rejected the woman-child model, Stieglitz's scheme went awry. He had misrecognized himself in her. We must wonder why Stieglitz persisted in his attempts to remake Rhoades in this image. Her denial of him, and his willingness to suffer her refusal so many times over, suggest that she brought to life for him another phantom that had obsessed him since his youth—not the white apparition of the woman-child but a distant cousin—a tall, smooth-haired lady in black with a pale complexion. This dark lady had haunted him ever

since her first visits to his childhood home; every time she returned, she triggered in him a resurgent feeling of loss and mourning.[10] Resurrecting Rhoades as the dark lady in the story of Stieglitz's modernism not only vexes the neatness of Stieglitz's successful drive toward the woman-child; it also subverts his mythic discovery of O'Keeffe as he wished to present her, as a natural, self-generated woman-child. In my history of Rhoades, however, it becomes clear that Stieglitz fully fashioned this persona for O'Keeffe after first failing to realize its creation in O'Keeffe's predecessor. Remarkably, even after his successful presentation of O'Keeffe as the woman-child in the early 1920s, Stieglitz continued to hold Rhoades up as an object lesson, portraying her to friends as O'Keeffe's unrepentant, unfulfilled twin who cast O'Keeffe's success into bolder relief.

Stieglitz's investment in O'Keeffe's iconic stature made certain that all other women artists were eclipsed by her presence, for as a woman alone among men O'Keeffe as icon had the greatest power to represent his modernist ideology. The stories of Käsebier, Smith, Brigman, and Rhoades, as I tell them here, reveal their contribution to the feminine space in modernism as O'Keeffe would inhabit it. *Modernism and the Feminine Voice* puts O'Keeffe back into circulation among these women artists—and even in touch with that other feminine icon of New York modernism, Edna St. Vincent Millay—to illuminate her function as icon. Like Millay, O'Keeffe organized "the contradictory symbolic life of the [modernist] subculture" and represented "the dangers and promises of modernity" to the subculture and the world outside Greenwich Village.[11] As we examine here the Villagers' paradigmatic linkage of modern love with modern creativity, the romantic myth of Stieglitz and O'Keeffe as the iconic modernist couple comes into focus as one of many such myths that had its birth in the heroic bohemianism of that cultural moment.

Chapter 4 investigates Stieglitz's making of O'Keeffe into the woman-child but also O'Keeffe's response to this charge—how she took on the role—and her own imagining of herself as a woman-child—that is, as a woman artist who drew her vision from the intuitive resources of her inner child self. Modernism was a culture directed toward acts of individual transformation. In Stieglitz's adaptation of modernist paradigms, the image of the artist had to testify to a utopian transformation of the self. As an example to the unreformed bourgeois viewer, the modernist work

of art had to manifest the enlightened artist's psyche. Stieglitz deployed art criticism and portrait photography as his central strategies to establish his artists' visibility in the field of modernism. The performing self was given a central position in modernist culture, which relied on publicly circulating images and identities. Self-presentation and self-dramatization, especially in the work of art, loomed large in the thematics of Stieglitz's modernism. Stieglitz praised O'Keeffe's success, in her early drawings, in projecting emotional states both personal to her and universal. Her drawings were "living" for him because he could see her in them, as well as part of himself. [12]

Stieglitz, the master impresario, put his artist-actors on center stage at his 291 gallery and later at the American Place. No sooner had Gertrude Käsebier severed her link to Stieglitz in 1911–12 than Stieglitz turned to her métier of portrait photography as a means of creating a stable of personae for his artists. In his prose and through his lens, his artists emerged as children, primitives, and neurotics—modernism's new mythic types who lived outside the constricted mental terrain of the bourgeoisie. Although he had primarily taken portraits of family members previous to 1910, he now discovered photography's power to animate his artists as larger-than-life presences. While Käsebier traded on her skill for her living, Stieglitz profited from the cultural capital that came to him and his artists from the celebrity that floated upon these images. [13]

In making O'Keeffe visible as a modernist, Stieglitz presented her in the persona of the woman-child. To recognize the presence of this phantom in their relationship clarifies the conditions of their collaboration. [14] Many scholars have described O'Keeffe's ambivalence about Stieglitz's creation of her public image through his portraits of her and his critical machinery. [15] In her letters and her art, O'Keeffe's responses to Stieglitz's erotic readings of her and her images vacillate between disagreement and silence and at times even acceptance. My research discovers her passivity and silence in the face of these interpretations—her reluctance to confront her mentor—as her characteristic modes of conflict resolution: most often, she simply escaped into compensatory psychological spaces. During her childhood these intensely private spaces had enabled her earliest creativity. To reassert her control over her conflicted adult world, she continued this pattern of es-

cape into solitude, making art there as a form of reasserting herself. In the silence of her private world she made an ordered universe with herself at its center and her voice and her will as its ordering principles. As Barbara Lynes has made clear, O'Keeffe worked hard on her public image, to counter Stieglitz's machinations, by portraying herself to journalists as a hardworking professional artist concerned above all with pure artistic (that is, formal) issues. In this way she deflected Stieglitz's insistence on her public baring of her private self and protected her sense of herself as an intuitive, nonverbal, impetuous child, which she exhibited only to intimates.

In contrast to previous views of O'Keeffe's self-identity as either a strong, hardworking professional or a strong, erotically charged woman, this book poses a new theory of her secret self-identity, which was indebted to Stieglitz's gendered notions of the feminine voice as intuitive and childlike, yet resistant to his eroticizing. O'Keeffe accepted the child identity for herself as a woman artist but gave this conceit an interpretation very different from Stieglitz's. My view of O'Keeffe is based on a crucial but overlooked body of her work produced in 1917 and on other clues she provided in confidential statements to friends. At the time when Stieglitz began to mentor her, she demonstrated her sympathy with children, whom she had recently taught in Texas, as well as with his child model for the modernist artist. She rejected, however, his idea of a woman-child whose creativity was founded in her sexual generativity. According to her own testimony, the formative moment for her self-image as an artist occurred in her childhood play in nature, making a dollhouse: it was at this time that she learned how to re-create the world in the form of the miniature, according to her own will. Thus this book sets out for the first time the ways in which the woman-child shaped Stieglitz's image of O'Keeffe, but it also reveals a new picture of O'Keeffe's private identification with the child's vision that was implicated in her way of looking at the world as well as in the very structures of her images throughout the 1920s.

This privileging of the image of the artist as child was not particular to O'Keeffe and Stieglitz but was forged in the modernist rhetoric of youth that demanded the restoration of a paradise lost. For the modernists, only the recovery of the child within the adult self could produce the utopian dream. Through the practices of

depth psychology modernists became convinced that each adult producer must locate the inner child, for it was this child self that liberated the individual from the shackles of culture to return to the flow of playful creativity. In nineteenth-century European literature the child is rendered as a feminine figure of desire, a surrogate for the lost child self of the male creator. Stieglitz's search for the woman-child was likewise directed toward a figure of seductive innocence who would redeem adult sexuality as innocent play. After first focusing on the paradise of the child in photographs of his daughter, Katherine, Stieglitz realized his object in O'Keeffe as his ideal woman-child. To his friend Seligmann in the 1920s he admitted that the aim of his quest was to find his own child self still existing within the imaginary feminine space—"the womb of our mother, where we are quiet and without responsibility and protected." In such an image of a nostalgic utopia, longing is directed toward a return to unitary reality, here a maternal paradise. But as Susan Stewart observes, in "longing for an impossibly pure context of lived experience at a place of origin, nostalgia wears a distinctly utopian face, a face that turns toward a future-past. . . . The realization of re-union imagined by the nostalgic is a narrative utopia that works only by virtue of its partiality, its lack of fixity and closure: nostalgia is the desire for desire."[16] Such was the function of the woman-child in modernism, at once to incorporate that lack and to fill it.

4
Gertrude Käsebier, *Blessed Art Thou among Women,*
1903 (negative, 1899), photogravure, $9^5/_{16} \times 5^9/_{16}$ in.

The Photo-Secession
and the Death of the Mother
Gertrude Käsebier and Pamela Colman Smith

Stieglitz's search to discover a "woman in art" was locked into his masculine self-identity and driven by changing paradigms of gender in early-twentieth-century New York. As his first voice of feminine creativity, Gertrude Käsebier, in her images and in her person, represented the late-nineteenth-century paradigm of progressive femininity. Roughly of the same intellectual generation (she was born in 1852, he in 1864), Käsebier and Stieglitz were shaped by the social practices of late-nineteenth-century progressive femininity and masculinity. Käsebier was the prototype of a series of women artists whose art for Stieglitz successively embodied the symbolic world he wished to bring into being.

By the 1910s, however, modernists—including Stieglitz—would come to regard this symbolic world of the progressives as requiring purification, cleansing of its inbred puritanism, if artists such as those of the Stieglitz circle were to be able to refashion themselves in the guise of more virile masculine creators. Their attacks on that puritanism were displaced onto the bourgeois Anglo-American matriarch, whom they figured as its representative.[1] This chapter charts the struggle of New York's turn-of-the-century photographers over that older feminine paradigm, encoded in Whistler's Symbolist veiling—a feminized syntax of disembodiment invested in the sign of the Mother. Käsebier's images (Fig. 4) seemed to crystallize the pictorialist vision of progressive middle-class values of the 1890s, an era that for the modernists was dominated by the matriarch of genteel culture—who was also represented in the person of Käsebier herself (Fig. 5). Undeniably, Edward Steichen and Clarence White were equally responsible for the aesthetic vision of pictorialism. But since Käsebier's public identity as a bourgeois matriarch was

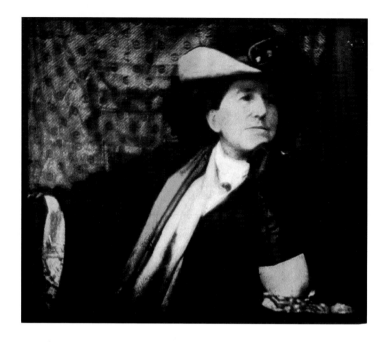

5
Edward J. Steichen,
Gertrude Käsebier,
1907, autochrome print.

intertwined with her role as an artificer of photographs that glamorized a feminine world, the artist and her feminine world became indivisibly wedded. She thus presented a singular target wherein the vision of an imprisoning domesticity and the maker of that vision could be efficiently sighted and destroyed in one blow, as Stieglitz and his colleagues moved on to a modernism invested in a disruptive formal order and a freer sexuality.

By the time Stieglitz met her, however, Käsebier was already a double-faced figure who could not be wholly contained within the matrix of feminine domesticity, even though she would for a time represent its voice. Her photographs that seemed to give definitive shape to the world of mothers and children were deceptive: these images could not encompass the entire domain of bourgeois Anglo-American women, for that world was changing rapidly. By 1906–10, in fact, both Stieglitz and Käsebier would openly display their dissatisfaction with this world and its rules of conduct. An anecdote related by Sam Lifshey, the professional photographer from whom she sought technical training at about this time, underscores the point. Lifshey told how Käsebier first appeared one day on his studio doorstep

in Greenpoint, Brooklyn. She was strange looking, he remembered, and wore a "bedraggled wet hat and a man's raincoat." Lifshey, who thought she had come to beg, turned her away. Two days later she astonished him by returning with a portfolio of photographs so beautiful that he thought they were prints after paintings. He therefore agreed to take her on as an apprentice in photographic printing techniques. Accompanying her home one day to help her reorganize her own darkroom, he was again surprised to encounter an imposing domestic establishment complete with servants, children, and a husband who complained to Lifshey how embarrassed he was to have a working wife.[2]

Lifshey's story renders Käsebier as an ambivalent figure. Standing at the threshold of a new age that opened up the world to American women, she was unable in her life and her work to break entirely free of the older feminine paradigm. Stieglitz, in contrast, would eventually escape the maternal culture Käsebier represented to him and adopt a new feminine figure as the symbolic representation of his modernism—that of the liberated daughter, who would ultimately be personified in Georgia O'Keeffe. O'Keeffe never met Käsebier, but O'Keeffe's image as a woman artist in the early 1920s was profoundly formed in relation to the world represented in Käsebier's photographs, sometimes as a figure who ameliorated that older world's perceived repressiveness, its lack of comfort, even as she fulfilled its utopian promises. Stieglitz left Käsebier behind in 1911–12, but he took with him an iconic imagery and technique of representing femininity that he would employ in shaping the image of O'Keeffe a decade later.

Käsebier's problematic relationship with Stieglitz mirrors Stieglitz's relation with his own bourgeois identity, which existed symbiotically with the major project of his first two decades of professional activity—the Photo-Secession. In rebuffing Käsebier, he cast off his old identity to redefine the Photo-Secession in the new terms of modernism. Projecting Käsebier as the emblematic figure of a stagnant, even corrupt, feminized pictorialist aesthetic, Stieglitz attacked her through his editorship of *Camera Work*. Discarding pictorialism allowed Stieglitz to move on to a modernist rhetoric of "straight" photography and a new moral universe championed by Manhattan's modernists as more truthful in social and sexual relations. The white, "clean" imagery that for Stieglitz summoned this utopian dream

of modernism—a world rid of the detritus and sham conventions of the past—was represented most clearly in the figure he fashioned of O'Keeffe as woman-child. But its roots are found in Käsebier's photographic world, in which young women and children inhabit a light-suffused, middle-class paradise.

Photo-Secessionist Aesthetics: Matrilineal Descent

Stieglitz's photographic program originated in the organizational structure of the camera clubs that flourished throughout the United States and England in the 1890s. The clubs provided a focus for the activities of amateurs who wished to distance their productions from those of commercial photographers. These amateur photographers, in fact, were at the fore of the debate concerning the potential of the photograph to approach the aesthetic quality of a painting. No one was more adamant in this mission to view the photograph as a work of art than Alfred Stieglitz, who in 1896 took over the leadership of the New York Camera Club, which was modeled after the elite photographic society the Linked Ring in London. Formed out of an amalgamation of two smaller clubs, the Camera Club began to publish a journal, *Camera Notes*, in July 1897. Under Stieglitz's editorial direction, the journal became a powerful organ for proselytizing for what would be termed the pictorialist aesthetic in photography and for elevating certain of the club's members to star status.[3] Gertrude Käsebier and Clarence White were two photographers whom Stieglitz discovered at their spectacular showings of prints at the Philadelphia Salon of 1898. Their work was informed by the imagery of leading Aestheticist painters: White's by William Merritt Chase, Thomas Dewing, and Whistler; Käsebier's by Whistler, Chase, and Arthur Wesley Dow. Stieglitz published both photographers in *Camera Notes* and succeeded in having them elected to the Linked Ring in 1900. That year Stieglitz met the third major pictorialist he would support when Edward Steichen stopped in New York on his way to Europe to introduce himself to Stieglitz. Steichen had begun working in gum bichromate printing two years earlier and had just won recognition at the Philadelphia and Chicago pho-

tographic salons. In the next few years the two men became close collaborators in conceptualizing the Photo-Secession and propagating its ideals through its journal and its Little Galleries at 291–293 Fifth Avenue. Other central members of the group were Frank Eugene, Joseph Keiley, Dallet Fuguet, and later Alvin Langdon Coburn and Eva Watson-Schutze.

If, as Christian Peterson asserts, there developed an aesthetic homogeneity among Stieglitz's Photo-Secessionists,[4] the sources of their characteristic veiling practices are located in the Symbolist imagery of the poet Maurice Maeterlinck and the painter James McNeill Whistler. In contrast to the stereotype of photography as a medium invested in mimicry of nature and indexical graphic detail, the Photo-Secessionists preferred an ideal, weightless vision of the world, achieved by muted middle tones that obscured the world as it is in a dream of the world as it should be. In the 1890s Stieglitz had used the language of science and scientific research on photography to bolster the medium's intellectual legitimacy. As Geraldine W. Kiefer has shown, however, toward the end of the decade Stieglitz shifted the viewpoint of *Camera Notes* to a more emphatic Aestheticist argument for photography that was still supported by empirical research.[5] Although he came out for "straight" photography in 1898 as a way of invigorating pictorialism, Stieglitz continued to vacillate on pictorialist practices of manipulation of the negative, an operation that his colleagues performed on the thick black painterly surfaces achieved in gum printing. Moreover, in the 1890s Stieglitz had promoted platinum printing, with its fine gradation of grays, as the ideal medium for obtaining rich tonal photographs, and he asserted that the veiled image was the sign of good photography.[6] Maeterlinck's verses, in which Steichen and Stieglitz in these years were deeply immersed, conjured up just such a veiled world, where human characters walked about as if in a dream, searching to make contact with their essential selves.[7]

In the pages of *Camera Work*, in fact, the names of Whistler and Maeterlinck were constantly invoked as the highest standard of achievement in art. In 1906 *Camera Work* published a statement, which Steichen had persuaded Maeterlinck to write, urging readers to think of photography as the art form of the future. At the historical moment when depth psychology was first being articulated in the United States and Europe, Stieglitz's house critics advanced the Symbolist aesthetics of

silence and musicality associated with Whistler and Maeterlinck to privilege an imagery of the "unsayable"—an imagery that evoked the "blurring process" of the unconscious, of "mystery." Modern painters, Sadakichi Hartmann wrote in *Camera Work* in 1904, "are aware that mystery dredges deeper than any other emotional suggestion; that it represents to our mind an everlasting enigma which no human thought can solve. The music of mystery . . . drags up 'abysmal bottom-growths' from our soul sea. It is the endeavor to perpetuate particular moments of human happiness, vague currents of the 'unsounded sea' which at rare intervals lash our feeling into exquisite activity. And to realize this is indisputably one of the most deserving and ambitious tasks a modern artist can set himself."[8]

In his nocturnes of the 1870s and 1880s, Whistler had established the visual idiom of mystifying and veiling nature that the pictorialists now adopted. Transforming London and Amsterdam into dreamworlds, his nocturnes offered ready visual counterparts to the disembodied soulscapes of Maeterlinck's drama that fascinated Stieglitz and Steichen at this time. As Charles Caffin explained, in "the tonality of a nocturne [one finds] . . . the nearest thing that painting presents to the tonality of a photograph." Specifically, it was in Whistler's "penumbra, between the clear visibility of things and their total extinction in darkness, when the concreteness of appearances becomes merged in half-realized, half-baffled vision, that spirit seems to disengage itself from matter and envelope it with a mystery of soul-suggestion."[9] Whistler's low tonalities, with their emphasis on the grays, and his rhythmic devices of mirroring and repetition formed the basis of Steichen's early landscapes (Figs. 6 and 7). Steichen's "moonlight" compositions, in both oil and photographic media, for example, rely on veiling for their twilit, introspective mood, while his splitting the composition in two suggests the Symbolist thematics of correspondence, of an unseen spiritual world in nature that corresponds to the seen, physical world. The aesthetic strategies of Symbolist art lead the viewer to realize this hidden reality, which is essentially one with the soul of the viewer.

In 1889 Whistler's small private works in oil, pastel, watercolor, etching, and lithography had been installed at Wunderlich's in New York in an exhibition few young or established artists would have missed. And in 1893 Whistler's larger works, his portraits and nocturnes as well as the smaller works on paper, domi-

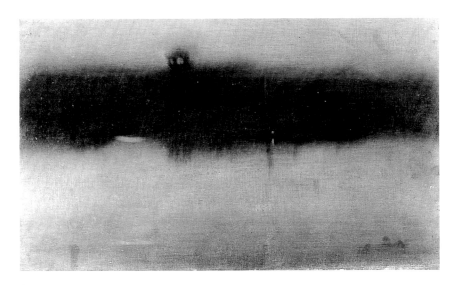

6

James McNeill Whistler, *Nocturne: Grey and Silver,* 1873, oil on canvas, 12¼ × 20⅜ in.

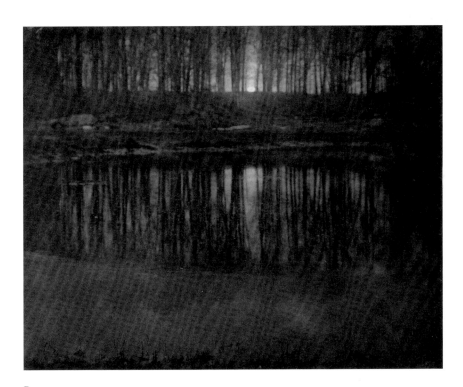

7

Edward Steichen, *Moonlight: The Pond,* 1906, photogravure, 6⅜ × 8 in.

nated the display of American art at the World's Columbian Exposition in Chicago, as they did at other international exhibitions of the 1890s, especially those mounted by Secessionist and Symbolist organizations in Munich, Brussels, and Vienna.[10] Just as important, the Photo-Secessionists had learned their techniques of photographic composition from Arthur Dow, a seminal codifier of Whistlerian aesthetics who taught at Pratt (1895–99) and then at the Teachers College at Columbia (1903–10). Dow based his system on Whistler's work and Japanese art (also the basis of Whistler's aesthetics), which he had studied while serving as assistant curator of Japanese art at the Museum of Fine Arts in Boston. The prints Stieglitz selected for publication in *Camera Notes* show how keenly Dow had impressed on the pictorialists the value of shaping the view by framing and cropping the object so that the space moved up or across the surface in an interesting way to harmonize with the movement of the form. Often the movement was long and vertical, mimicking the format of a Japanese scroll, or lateral, suggesting the horizontal movement of a scroll or a screen, sometimes even divided into three parts. An asymmetrical balance of positive and negative space was also valued, often with the negative or empty space in the foreground and the horizon line pushed up high toward the top of the composition. This emphasis on framing, the making of an interesting picture through the photographer's conscious placement of the object within the space of the frame, seemed to lend Dow's instructions a special utility for those photographers striving to transform their craft into high art.

Dow's system was broadly taken up by pictorialists not only in New York but throughout the country, a development that was made possible by the publication of his system of design in the textbook *Composition* (1899). Käsebier was one of those who actually studied with Dow at Pratt, from 1893 to 1896. The pervasiveness of Japanese-style compositions and Whistlerian veiling, however, is abundantly evident in the pictorialist work Stieglitz chose to publish in *Camera Notes* during his editorship. He maintained this worship of Whistler throughout the run of *Camera Work*. In fact, issues without critical reference to Whistler or his art are rarities. In 1903 *Camera Work* urged pictorialists to work as Whistler would if he had found himself holding a camera.[11] In short, to position the photograph as art, there was no better strategy immediately available to Stieglitz and the pictorialists than

8
James McNeill Whistler,
*Symphony in White,
No. 2: The Little White
Girl,* 1864, oil on canvas,
$30\frac{1}{8} \times 20\frac{1}{8}$ in.

that of aligning their images with Whistler's vision. Whistler's name stood above all others for values of rarification and abstraction in art, an aesthetics advanced by cognoscenti dedicated to the expression of the soul in art. To be in the camp of Whistler meant standing against the vulgar, commercial side of middle-class art that depended on mechanical imitation; it meant refuting the understanding of the photograph as imitative, a naturalist rhetoric that had traditionally obstructed its recognition as art.[12]

Whistler's imagery also provided the Photo-Secessionists, from Clarence White to Käsebier to Stieglitz himself, with the trope of the "white girl" (Fig. 8), the spiritualist table rapper and crystal ball gazer, the occulted female body—a body that was divested of its sexuality, chastened, and invested with the powers of the mys-

tic. Circulated by the early-nineteenth-century Protestants reforming a traditional typology of women as Eves and temptresses, this paradigm generated an Anglo-American practice of modeling the middle-class woman as an "angel of the house"—that is, as a woman whose sexuality is redeemed through motherhood or effaced and repressed in favor of bodiless purity. The power of such feminine bodilessness, represented in Whistler's "white girls" of the 1860s and his veiled female figures of the 1870s, as a model for bourgeois order is evidenced in the host of "white girls" that followed in the paintings of The Ten, who were the dominant force in American art at the turn of the century, and in the photographs of the Photo-Secessionists.

Yet while these images portray a feminine sexuality that is mystified and hidden, they do acknowledge feminine sexuality and the viewer's fascination with it. *Symphony in White, No. 2* is a case in point: the chaste white body of the female figure is thrust forward toward the viewer, the past life of that body suggested only in her dreaming eye. Her masklike face in the mirror was seized by both Whistler and his friend the poet Algernon Swinburne as an opportunity to speak a hidden desire that they ascribed to woman, displacing the viewer's desire into the feminine body and the feminine voice. Swinburne wrote verses for the picture in the form of an interior monologue describing feminine desire, and Whistler pasted them onto the frame. With Whistler's approval, Swinburne ventriloquized the voice of the "white girl," and in his poem it is as if we hear her consciousness emerging from deep in the psyche, floating through time and space, carried along a stream of desire, loss, and melancholy. At the same time, the image of this woman, clothed in pure white, staring into a glass as she communes with the "higher" world of art (signaled in the rarified blue and white jar on the mantle), conjures up the contemporary practice of spiritualist divination and trances, which were induced by looking into mirrors or crystals—a practice that Whistler, his mistresses, and others of the Anglo-American intelligentsia adopted in the 1860s and 1870s.[13]

This feminized economy of picture making is paradoxically shot through with desire that is denied because it is wrapped in and effaced by the language of spiritualism. Stieglitz's house critics for both his journals, especially Charles Caffin and Sadakichi Hartmann, devoted much of their careers to championing this fem-

inized aesthetic in the works of Whistler and his followers (Figs. 9 and 10).[14] In the first decade of the twentieth century they now reengaged these tropes to legitimate the Photo-Secessionists' aspirations to raise photography to the status of fine art. For example, Hartmann, in his essay "On the Elongation of Form" for Stieglitz's *Camera Work*, laid out this lesson for photographers: that the Whistlerian practice of dematerializing form endowed images with a higher, more evolved, more spiritual quality. Through comparing Dewing's female figures (Fig. 11), the Graces of Botticelli's *Primavera*, and the women of the ukiyo-e masters, Hartmann asserted the elongated body to be a universal sign of evolutionary status and the elegant female body in particular as evidence of civilization.[15]

In the early *Camera Work* circle, however, the poetics of whiteness and the nocturne's technique of disembodiment were often joined in an imagery of a weightless waterworld. Photographs such as George Seeley's *White Landscape*, for example, offered the dreamworld of a garden filled with sylphlike mothers and daughters (Fig. 12). Placed alongside the critical writing in *Camera Work*, such images encouraged the reader to use Whistlerian blurred and vague forms to produce mysterious "sound-impressions." In Hartmann's lecture on mystery (*Camera Work*, 1904), he not only feminized the technique of blurring but also associated the aesthetic experience of blurring with a return to the mother. The creative artist should cull such effects from the depths of the mind, he suggested, to fashion a language that "dredges deeper" and arrives at the "everlasting enigma which no human thought can solve." As in Seeley's *White Landscape*, Hartmann's use of oceanic metaphors embeds his imagery in a preoedipal, prelinguistic motherworld of the deep psyche. As we have seen, he imagines such a landscape where "[t]he music of mystery . . . drags up 'abysmal bottom-growths' from our soul-sea. It is the endeavor to perpetuate particular moments of human happiness, vague currents of the 'unsounded sea' which at rare intervals lash our feeling into exquisite activity."[16] The experience of art, as he would have it, takes us to the forgotten mother-place hidden deep in the psyche's past, dragging up "abysmal bottom-growths." It miraculously restores us, Hartmann says, to a lost *jouissance*, an indescribable joy and pain in which feeling is lashed into "exquisite activity," at the impossible moment of remerging with the primal watery world that psychoanalysis associates with the

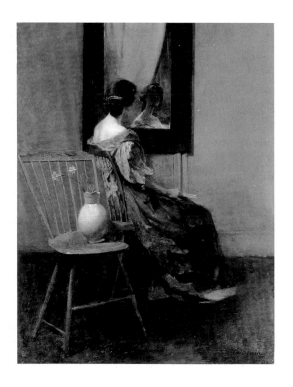

9
Thomas W. Dewing,
The Mirror, 1907, oil on
wood panel, 20 × 15¾ in.

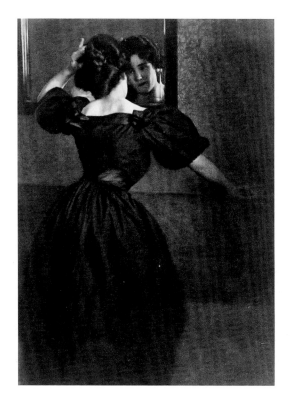

10
Heinrich Kuehn,
Girl with the Mirror,
1906, photogravure.

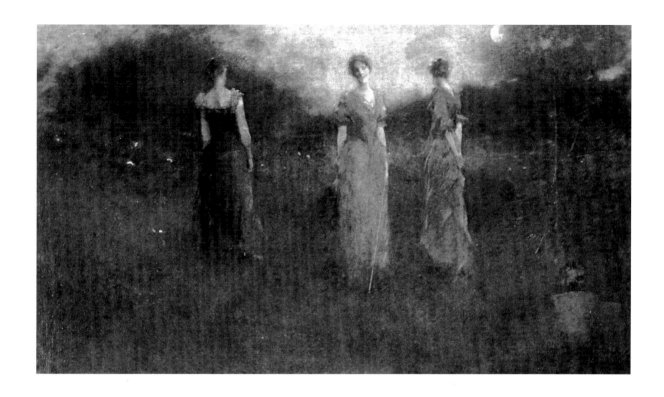

11
Thomas W. Dewing,
In the Garden, ca. 1894,
oil on canvas.

12
George H. Seeley,
The White Landscape,
1907, photogravure.

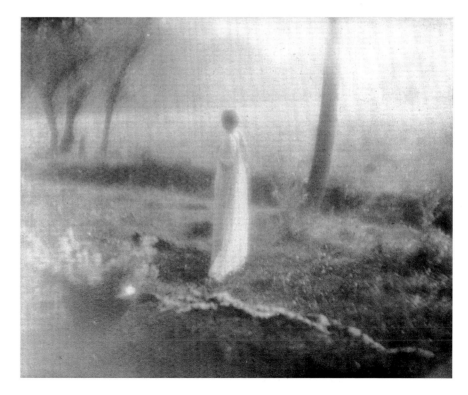

feminine in the unconscious.[17] Blending concepts such as duration and the unconscious with spiritualist metaphors, he struggles here to visualize an impossible maternal space—impossible because it has no form and cannot be articulated other than as darkness—in which great art is born and nurtured.

The feminist theorist Julia Kristeva has attempted to recuperate the psychoanalytic formulation of the preoedipal as a mother-space, so that in the unconscious the early experience of the mother remains formative in the life of the individual. This experience of the mother as a oneness with the self reemerges in adult life as a longing to recapture that moment of extreme happiness.[18] But since the age of Jean-Jacques Rousseau, social theorists have been articulating the place of the feminine in social life through the figure of the archaic mother, as the literary scholar Rita Felski has explained; beginning with Hegel, this myth of the feminine has been central to literary, anthropological, and historical narratives of civilization's development. In this scheme, Felski writes, "the maternal body is seen to embody a fullness of presence, a phantasmic image of originary harmony that is contrasted to the adult consciousness of alienation and lack." For the theorists of depth psychology in Freud's circle, such notions of life as a falling away from harmony supported the idea that individual growth began with a phase preceding the acquisition of language, acculturation, and memory and that this preverbal psychic state was dominated by the figure of an archaic mother. The ruling concept in this cultural discourse was the dictum that ontology recapitulates phylogeny: the development of the individual recapitulates the development of human beings as a species. Thus woman was equated both with the nature of the child and with nature itself—that is, with a primitive, premodern world of pleasure that existed outside of history and civilization, while man was identified with the painful processes of self-division and alienation from and existential loss of the original maternal paradise, a condition deemed necessary to the creation of civilization and modernity.[19] Elaborating on the Freudian narrative of masculine lack and maternal plenitude, Susan Stewart has enlarged our understanding of this cultural bifurcation by noting modernity's nostalgia in its fixation on "a return to the utopia of biology and symbol united within the walled city of the maternal."[20]

As we have seen, Stieglitz's house critics argued for photography as high art,

staking their claims on photography's investment in this essential structure of nostalgia, since for them true art resonated with this gap between life's (masculine) pain and the longing for (feminine) origins. Using the same Symbolist language of mystery and sexuality, Benjamin de Casseres in *Camera Work* (1910) asserted that the most profound art is born out of disequilibrium and passion, but only if that passion cannot be satiated. "Music mirrors the ideal rapture one seeks and which forever flies, and in flying draws the soul with it, transforming it to its own majestic, immeasurable proportions, teasing it, swelling it, with a desire never to be satisfied. Sexual love is the rapture one may satisfy, and a rapture satisfied is a rapture dead. We live by things we do not possess and are slain by the things we do possess." Thus "Music infinitizes the soul of the strong man, while woman enfeebles and finitizes."[21] He seemed to agree with Hartmann that it was much better to keep pursuing the half-remembered, disembodied pleasure of the feminine than to experience the actual pleasure of the female body; desire needed to be kept alive as a condition of the creation of art. Rather than satisfy desire and put closure to the mystery, it was necessary to sustain the nostalgia and chase after the lost *jouissance* of that feminized space called childhood bliss, repetitively figured in the imaginary, narcissistic "white girls" of the pictorialists White, Käsebier, and Steichen.

Exemplifying these practices of veiling, disembodiment, and sublimation as signs of a higher form of art, Stieglitz chose to publish the work of Gertrude Käsebier as the female figurehead of the Photo-Secession. The product of a woman's experience, Käsebier's work represented the Photo-Secession's feminized language firsthand. Because it could not be divorced from her gendered and sexual identity, her photography literally stood for pictorialism's difference and was impressed with all that the feminine signified in the 1890s—refinement and civilization. Stieglitz thus deployed her femaleness and her femininity to legitimate the Photo-Secession's image and represent an elite cadre of highly evolved and progressive artists. When Stieglitz's interest in the field of modern art changed, however, Käsebier, whose key images projected the symbolic order of genteel, late-nineteenth-century Anglo-America, would be deemed an impediment to the emergence of a more virile and vital modernism. By 1910 Stieglitz rejected the sublimation de-

manded by the musical, elusive, feminized work of art, turning instead to the erotic gratification evoked in masculine modernist images, especially those offering the female nude. He would eventually present the nude's ideal form as O'Keeffe's body, as a figure that for him preserved the innocence of childhood while promising the bliss of adult sexuality. But before he could release himself into modernism, Stieglitz carried out a ritual cleansing of photography by purging the mother—the figure of photography's symptomatic feminization—from the field of modern art. By divesting pictorialism of its premier status in the field of photography and discarding it, he freed himself to make his identity anew as a hard-bitten modernist.

Käsebier: The Feminine Voice of Pictorialism

The first women artists Stieglitz supported represented themselves in the terms of progressive femininity. By hyphenating her maiden name with her married name, the Photo-Secessionist Eva Watson-Schutze projected her desires to achieve a professional career and to maintain a traditional marriage, in which she followed her professor husband to his new appointment in Chicago. While Stieglitz included several women in the membership of the Photo-Secession, it was Gertrude Käsebier whom he put into place as the feminine face of his new photography. Her eminence in the field had already been established before the founding of his camera club. Stieglitz acknowledged her primacy to the goals of the Photo-Secession when he devoted the first issue of the Photo-Secessionists' journal, *Camera Work*, to her, over the pleas of Steichen to award it to him because, he told Steichen, Käsebier was "the pioneer."[22] In fame and achievement, she eclipsed her female colleagues and perfected several strategic themes that were taken up by both male and female Photo-Secessionists. Her imagery capitalized on the feminine as a function of motherhood—the selfless, maternal body—and a type of bodiless woman without children, a dematerialized link to the occult energies of nature. Käsebier showed the pictorialists how to stage the female figure to incorporate the new middle-class typologies of woman as an agent of social progress and, at the same time contradicting such rationalism, as a muse and a force of mystery. The type

looked back to Whistler's mystifying spiritualists and forward to the college-educated and professional women who were called the new women in the 1890s.

If Käsebier's early fame helped make the Photo-Secession visible in the field of photography, Stieglitz was also important to her career, as he was to those of all his photographers: his journals and his 291 galleries were paramount in the shaping and promotion of their work. The prestige associated with the Photo-Secession emanated from the elitism of the group, which set itself up as discriminating and distinct from the crowd of photographers jumping on the pictorialist bandwagon.[23] In becoming *the* figurehead of the Photo-Secession, Käsebier amplified her reputation as the leading "artistic portrait photographer" in the country, which Stieglitz had pronounced her in 1899.[24] She had become well known for her images of femininity in the two years before she met Stieglitz. As Barbara Michaels has commented, even non–New Yorkers knew Käsebier's photographs from their publication in magazines such as *Everybody's*, *The World's Work*, and *Ladies' Home Journal*.[25] The successful reception of her work by art critics and the middle-class reading public suggests that her thematics responded to the turn-of-the-century agendas that forecast comfortable avenues for reinventing middle-class women's roles.

Käsebier was of the generation that spearheaded the movement for women's suffrage in the 1880s and 1890s. Although Käsebier was never a suffragist, she was a product of the feminine culture that made the push for women's equality conceivable. The "new woman," in the words of the historian Carroll Smith-Rosenberg, was a "revolutionary demographic and political phenomenon." Although Käsebier chose to marry, she shared the new woman's aspirations to higher education, professional competence, economic autonomy, and social reforms.[26] Born Gertrude Stanton in Des Moines in 1852, Käsebier spent four years of her childhood in the mining town of Leadville, Colorado, before she and her family moved to Brooklyn in 1864. Of a solid middle-class, Methodist family, she attended the Moravian Seminary for Women in Bethlehem, Pennsylvania, a prominent secondary school for women, from 1868 to 1870.[27] The culture that flourished in such institutions in these years allowed women a freedom of expression verbally and physically. Out of this freedom women developed friendships characterized by

affectionate and supportive relations that often led them after college to continue living in separatist havens, where they felt exempt from the demands of patriarchy. Confronted with this female world that flourished during the last quarter of the nineteenth century, the sexologists exerted increasing pressures to end its separatist practices, which they labeled perversions. Even so, a large number of college women, primarily from affluent middle-class homes, rejected the traditional family and the feminine model of their mothers' domestic lives. They refused marriage altogether and devoted their lives to alternative, single-sex familial institutions that promoted social reform and especially women's autonomy.[28]

Käsebier was not among those more radical college women, although her later career shows that she often contemplated the more liberal goals of feminists. She married Eduard K. Käsebier in 1874 and raised their three children at their farmhouse in Durham, New Jersey, while Eduard built a prosperous shellac business. In 1889 the Käsebiers moved to Brooklyn so that Gertrude could continue her education at the Pratt Art Institute.[29] At thirty-seven, with her children grown to more independent ages, she set on a course of training that would lead to images underwritten by Pratt's progressive feminine culture. The modern women of Käsebier's work would be nurturing and creative. Käsebier's feminine imagery was important for Stieglitz's evolving typology of woman in modernism; in fact, nothing contributed as much to his later presentation of O'Keeffe as Käsebier's paradise of mother and child orchestrated in the thematics of whiteness.

The Women's Culture of Pratt

Founded only two years before Käsebier's enrollment in the college, Pratt was dedicated to educating men and women in home economics, teaching, fine arts, engineering, and the industrial arts. Art academies established in the United States during the late nineteenth century—especially Pratt—encouraged women students to take up "less ambitious forms of art" and directed them away from aspirations in the fine arts toward careers in industrial arts, crafts, and teacher education.[30] Pratt built its progressive philosophy on the belief that raising the aesthetic qual-

ity of the designed environment could reform the social environment. Those be-
hind this agenda, who took the bourgeois order of their own lives as the model of
a better world, focused their utopian dreams on educating children by sensitizing
them to the wonders of art and nature. Pratt's curriculum and pedagogy were driven
by Friederich Froebel's philosophy of child education, which emphasized the cen-
trality of the mother's role in the early shaping of the child's learning experience
and ultimate development. Froebel's ideas were taught in Pratt's teacher training
and kindergarten classes and permeated the institute's classroom discussions and
publications.[31] Froebel wanted women to educate themselves in "the science of
motherhood," which he believed was natural to women. Drawing on a metaphor
of gardening in naming the learning space of early childhood a "kindergarten,"
he called on mothers to guide their children into a natural development with a sys-
tem of games, music, and play—a regimen that exercised imagination and intel-
lect. Pratt's monthly journal termed this feminine vocation a "spiritual mother-
hood" that would "lift woman up to the side of man, his equal, but with her own
sphere of work. . . . [I]t will . . . settle the vexed question of woman's rights and
woman's intellectual equality with man."[32] In teacher education it was widely as-
sumed that women provided a natural, nurturing presence for children in the class-
room and that the aesthetic education students received from these maternal teach-
ers would lead them to constructive social values. For Käsebier and her colleagues,
it was a given that the higher principles taught by Pratt's aesthetic culture would
inevitably produce a more aesthetic and moral home environment.

Although there was no instruction in photography at Pratt, from the 1880s on-
ward photography was considered an appropriate craft for middle-class women,
as were skills in the decorative and industrial arts. Photography could be practiced
in the home, the reasoning went, and as such would not take women away from
domestic duties. Portrait photography that focused on recording children and their
growth was deemed fundamental to the rituals of the home and mothering, while
at the same time women were regarded as having intuitive, sympathetic natures
that made them well suited to working with children and adult sitters. The cam-
era clubs allowed women to acquire expertise in photography through lectures,
publications, and classes for women.[33]

In contrast to the many women photographers who remained single, Käsebier attached herself to the structure of the traditional family, identifying her portrait practice with the practice of mothering to the point of making the mother and child dyad her signature image. She also made good on the promise of her seminary education by entering the still largely masculine preserve of the marketplace, a move that was considered problematic for women. Pratt was designed to channel women into the professional world and offered a support system for those entering the applied and industrial arts and teaching. Encouraging women to mimic the business principles of men, the school journal dismissed the notion that a woman who knew sound business practices would be regarded as "unfeminine." Pratt counseled its women students that "'business is business,' and there appears to be no more necessity for distinction of sex in commercial transactions than there is need for consideration of party in municipal affairs." Thus no woman entering the marketplace needed to fear losing her femininity.[34]

In the field of photography in the 1890s, the rule was separate but equal status for men and women. Women were welcomed into the camera clubs but were herded into a separate sphere of space and activity, including darkrooms separate from those for men. Suspicion of women, the fear that their entry into the field would devalue the practice of photography, was still rife. It can be heard in the complaints of such prominent photographers as F. Holland Day, who in 1897 publicly expressed his fear that the great number of women entering photography—a field that required no formal academic training—would feminize the profession and handicap the pictorialists' bid to raise photography to the status of a fine art.[35] But this was before he knew a woman photographer whose work possessed the strength of Käsebier's. Within a few years of his complaint, she would become Day's close colleague.

Käsebier's first successful photographs engaged the pictorialist aspiration to make photographic images that approached the poetry of painted images. At Pratt, Käsebier had studied painting (1889–93, 1894–96) and, since photography was not taught there, then put together a postgraduate course for herself in that medium. After getting advice from a German chemist on a trip to Europe in 1894, she served an apprenticeship to a Brooklyn photographer in 1897. Her early portraits of chil-

dren, typically printed on textured paper in warm shades of brown, such as *Portrait of a Boy* and *Portrait Study* (both done in 1897), have the rich, tonal look of old-master portraits. From the first she composed with her characteristic simplification, tightly focusing in on the face and the sheen of velvet, which glow in the surrounding darkness. Käsebier's ability to capture the childishness of children in straightforward compositions—for example, in the way a wide-eyed boy bites his lip and a girl in her velvet costume playacts as a serious adult—so impressed Stieglitz and his colleagues in the camera clubs of New York and elsewhere that her rise in the field of art photography was meteoric. No sooner had she taken up the camera than she was featured in prestigious exhibitions, one after another: at the Boston Camera Club (1896), the Philadelphia Photographic Society (1898), and the Boston Arts and Crafts Society (1899).[36] In 1897 Käsebier opened her first studio on East Thirtieth Street just off Fifth Avenue, and in the summer of 1899 she was at Newport photographing the wives and daughters of the East Coast elite.

Signature Images: Maternal Origins

Käsebier's art was a product of the progressivist environment, which confirmed woman's essential role as maternal but also accommodated her desire to achieve some economic independence through operating outside the home in a world previously reserved for men. From 1897 to 1910 her photography found a widespread audience, which marveled at her signature image—a modern mother whose maternal creativity is expressed in an aesthetic of whiteness.

Her breakthrough to this image came in 1897 in *Adoration* (Fig. 13, also called *The Vision*), obviously modeled on Mary Cassatt's paintings. Abandoning her dark old-master palette, Käsebier adopted a blonde tonality that would become a favored device of engaging a feminizing vision. Compressing the maternal group in the shallow space formed by the few feet between the curtain and the camera lens, Käsebier massed the figures into a compact white hieroglyph against a white background, the child's head and torso thrusting upward spontaneously from the mother's body. Seated in profile, the mother's body forms a diaphanously draped

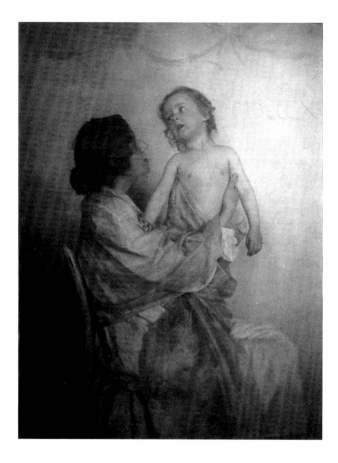

base from which the child's body launches upward to life, his head arching over toward hers, while she responds with an adoring gaze. Their bodies are both differentiated and locked in symbiosis. Käsebier undoubtedly captured a spontaneous movement when the child pushed off from the mother, restlessly moving against her embrace during a long sitting. Capitalizing on the ambivalence of the gestures, she produced an image that speaks to the complexities of bonding and individuation.

By posing the mother's body seated and in profile to the viewer, Käsebier deliberately recalled the ur-maternal figure of "Whistler's Mother." But the mood and color of Käsebier's mother have metamorphosed from a funereal black to the white of purity and birth. Whiteness, which resonates from the effect of the blonde tones

of mother and child placed against the white backdrop, is key to Käsebier's reinvention of the maternal trope. This luminosity as the sign of the feminine draws upon Whistler's other archetypal feminine principle of his "white girls," but in Käsebier's works the erotic energy of the female is transformed from the self-regarding gaze of the "white girl" or the interiority of Whistler's mother into the mother's complete investment in the child. In Käsebier's imaginary, woman—no longer a narcissist lost in the labyrinth of her own unconscious—has now awakened to the proper and morally responsible feminine role, according to the discourse of gender that crystallized in Freud's pronouncements on feminine sexuality.[37]

Adoration was printed in *Camera Notes* in July 1899 as a halftone engraving, along with another mother-and-child composition from the same sitting. The negative was cropped to produce an emphatic vertical composition and manipulated with erasures to produce the effect of light hovering over the child's head. Significantly, it was this image that helped secure Käsebier's first public success in Philadelphia, and it undoubtedly attracted Stieglitz, who served as a juror for that salon. Within a year's time Käsebier's connection with the image of maternity was solidified when in the July 1900 issue of *Camera Notes* Stieglitz published two new works in this genre from her darkroom: *Blessed Art Thou among Women* (Fig. 4) and *The Manger* (Fig. 14) are probably still her best-known works. He would publish them again in the first issue of *Camera Work* in 1903. In both compositions Käsebier played again on the feminine as whiteness, the selfless maternal figure whose physical body is ambivalently rendered. With her body nearly effaced by its luminous draping, we are uncertain whether she is flesh or spirit or some combination of both. In both works, the white figure turns her face away from the viewer to assume the role of the universal mother. Such overtones are reinforced through Christological references in each photograph—in one, the setting of the stable and reference to the manger, and in the other, the cropped image of the Annunciation hovering over the mother and child on the rear wall.[38]

The vertical framing of *Blessed Art Thou among Women* ensures a connection between the scene taking place in the present and its biblical antecedent in the vertical frame on the wall. A comparison of an intermediate negative at the George Eastman House with the prints Käsebier made from it show that she cropped the

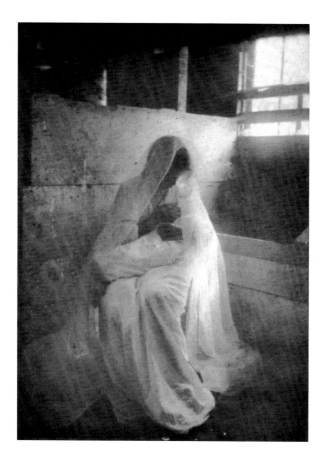

14

Gertrude Käsebier,
The Manger, 1903
(negative, 1899),
photogravure, 8 ³⁄₈ ×
5 ⁷⁄₈ in.

negative on both sides to produce this exaggerated verticality, which is reinforced
by the white door frame. In the formalist terms of pictorialist critics who followed
Whistler, the image is a "study in white," composed primarily of light forms that
contrast with the dark form of the daughter, poised to move from the whiteness
of the space behind her into the shadows of the space before her. The cropping
emphasizes the figures pausing in the threshold, so the picture is very much about
the moment of passage from one state of being, phase of life, or knowledge to
another. The title's invocation of the Angel Gabriel's words to the Virgin, "Hail,
Mary, full of grace, the Lord is with thee; blessed art thou among women," regis-
ters the burden of woman—here shaped in the form of a nascent woman—to sub-
mit to motherhood and bear the next generation. The mother—an angel of the

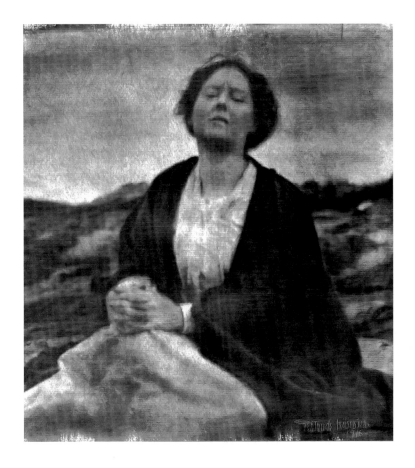

15

Gertrude Käsebier,
*The Heritage of
Motherhood,* 1916
(negative, 1904),
gum bichromate
print, 10⅝ × 9¾ in.

household—passes on this burden to her daughter and the next generation of women. With one hand on the door frame so that her body is aligned with its strength, she directs her daughter forward into the future of her prescribed feminine role; the other arm encircles and stays the young girl's shoulder with what one contemporary critic described as "the utmost reach of tender maternity, the affection that is of renunciation and self-control."[39]

Käsebier's *Heritage of Motherhood* (Fig. 15) of a few years later was received as her completion of the narrative of motherhood. It focuses again on the mother of *Blessed Art Thou among Women,* Käsebier's friend Agnes Rand Lee, an author of children's books. Käsebier composed it in 1904 after the death of Lee's daughter, Peggy, the little girl who had been poised to step out into the world in the earlier image. The

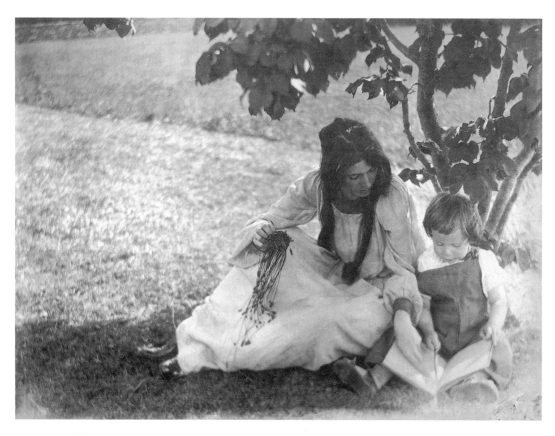

16

Gertrude Käsebier, *The Picture-Book,* 1903, platinum print, 9⅝ × 13 in.

maternal figure now wears a dark shroud over her once luminous body. She is approached from below so that her body looms up above the viewer, her head thrown back in an expression of grief. The arms held close to the body and hands clasped tightly together signal the self closed off from the world, the mother's life now consumed in suffering, which is externalized in the darkness and barrenness of the landscape all around her. A Madonna in lamentation, this "ghost" of the previous image of "radiant motherhood" was out of place in the contemporary discourse of motherhood as a progressive middle-class institution.[40] More prevalent in Käsebier's photography are the Froebelian pictures of the maternal role as one that educated and guided the sensibilities of the growing child: for example, *The*

Picture-Book (Fig. 16) of 1903. In this image of a light-filled landscape, a mother, weaving a basket, helps her child to master artistic expression as she guides him in drawing directly from nature. Her loose white gown, like the robes in the other two white images, universalizes the maternal relationship, avoiding any historical specificity. These flowing, informal gowns worn by Käsebier's mothers are based on the reform style fashioned by Whistler and revised by the English Aesthetes such as the illustrator Walter Crane, who published an essay on "artistic dress" in 1894.[41] This dress, which frees the body and reveals its natural lines, functions like a uniform of progressive womanhood in Käsebier's pictorial world. In a topos of innocence and learning, it is a costume fitted to the mother's role in Käsebier's garden for children.

These maternal images are carried by large spaces of radiant, subtly gradated blonde tones that were possible in platinum printing. Käsebier exploited their luminescence as much as possible by printing on Japanese tissue papers.[42] The sheer material delicacy of the papers and the fragility of the image registering elusively on the paper betray Käsebier's training in the *craft* of photography. This self-conscious aestheticism—a perfectionism in making the material object a thing of beauty—was crucial to the pictorialists' (and to Stieglitz's) notion of art. Her study with Arthur Wesley Dow during her last year at Pratt (1895–96) also handsomely paid off in her ability to compose according to the Japanese design principles Dow taught. Käsebier's use of marginal space, her arrangement of figures in compelling relations of asymmetrical balance within an eloquent void, became her compositional strength. The off-center placement of the figures in *The Picture-Book*, for example, allows the whiteness of the light to fill the space and establish the heightened mood, the transcendence of the moment, as in the other two white maternity pictures. Her representation of maternal femininity as whiteness is striking even in pictures otherwise pervaded by the darker terms of masculine sobriety. This tendency can be seen in Käsebier's portrait of the Clarence H. White family (Fig. 17), made during a visit to their Ohio home in 1902. Here the three males cluster together in the lower half of the composition, while the mother in white rises above her husband, their two bodies together composing the vertical axis of the picture, as if they were complementary halves of the same whole. His head is

illuminated, his consciousness connected with the whiteness of her draped body,
while her head is thrown into shadow. With her hand placed on the door frame in
a manner reminiscent of the maternal figure in *Blessed Art Thou*, she towers over
the group like a guardian angel, while they seem unconscious of her presence
among them.

Stieglitz's sense of the accomplishment of these images is registered in his re-
peated publication of them in *Camera Notes* and *Camera Work*.[43] That he helped to
fix her identity as a photographer of maternity is clear in his selection of *The Man-
ger* and *Blessed Art Thou* as her signature works among other prints in the Photo-
Secession's retrospective display of 1910 at the Albright Art Gallery's International
Exhibition of Pictorial Photography. Moreover, he chose Käsebier to photograph

19

Mary Cassatt, *Peasant Mother and Child,* ca. 1894, drypoint on ivory paper, 11 ½ × 9 ⅜ in.

his own wife and daughter, Emmeline and Katherine (Kitty) Stieglitz, in 1899–1900, surely knowing that Käsebier would render them through her lens of maternal whiteness, as she did indeed arrange them as elegant white forms against a white drapery (Fig. 18). While the figures and poses recapitulate those of her *Adoration,* the white bodies and dark heads massed together at the center of the picture space explicitly recall Cassatt's compositions (Fig. 19). Käsebier had internalized Cassatt's repertoire of poses and the techniques of defining white forms on a white sheet of paper, which Käsebier would have learned from Cassatt's etchings exhibited at Durand-Ruel's New York gallery in 1895.[44] She indicated her identification with Cassatt in her own photographic self-portrait, executed in the same period, 1899–1900 (Fig. 20), and published by Stieglitz in *Camera Notes* in April 1900.

In the manner of Cassatt's etchings, only Käsebier's head and hands are fully re-
alized in the self-portrait, while her body is left unfinished, sketched on the neg-
ative in a manner to resemble the etcher's strokes of the burin.

Taking Cassatt as a starting point, then, Käsebier treated the forms in her pho-
tographs according to a hierarchy in which hands and heads command the most
attention, while whitened bodies register secondarily and sometimes not at all. This
tends to be true as well in her best portraits of men, F. Holland Day, for example,
where head and hands provide focal points of glowing light in a composition oth-
erwise totally dark. That hands were her key to the story of the individual self was
suggested in the notes of one critic who on a 1903 visit to her studio reported ob-
serving a series of images of hands as character studies, mounted on half a dozen

21
Alfred Stieglitz,
Kitty–Flower Pot, 1904,
platinum print, 9 1/2 × 7 5/8 in.

large sheets of paper.[45] Stieglitz visited her studio at about the same time and could not have missed this experimental work. Nearly two decades later, a substantial number of Stieglitz's portraits of O'Keeffe similarly would substitute expressive hands for the face as a part that can stand for the whole to register the essence of personality. During this early period of the Photo-Secession, however, Stieglitz too appropriated Käsebier's thematics of whiteness in rendering the feminine paradigm of the child, especially in his portraits of his daughter, Kitty (Fig. 21). Stieglitz gave one of the most famous of these portraits a humorous, even cynical, gloss by placing his "white girl" before a painted figure on the wall behind—that of a butcher's wife, who suggests the loss of childish innocence in the inevitable growth to womanhood.

Phantasmic Femininity:
Whiteness and Ambivalence

In the critical reception of Käsebier's photographs, her femininity and, as important, her own maternity proved to be crucial interpretive guideposts. That a woman's sexuality and experience imprinted her photographic world with an essential difference was a given in the response to her photography. Much of the earliest writing on her images, especially essays by her women colleagues Frances Benjamin Johnston and Eva Watson-Schutze, wrestles with this issue of how Käsebier projected her femininity in her work. Charles Caffin, writing in 1901 in the same language he used to champion the work of Whistler and his American acolytes, followed Stieglitz's agenda in framing Käsebier as a "straight" photographer with a fine poetic instinct. In 1899 Käsebier's teacher Arthur Dow had similarly seen her work as evidence that "straight" photographs could achieve the status of a work of art. Johnston and Watson-Schutze saw her photographs as justifying the medium as a fine art but also linked her achievement to her experience as a mother.[46] Soon, a chorus of reviewers adopted the example of Joseph Keiley, Stieglitz's trusted associate, who had written in *Camera Notes* (1899) of the naturalness of Käsebier's portraits as somehow intrinsically related to her own feminine ability to make contact with the sitter's essence. A studio assistant later confirmed these perceptions of her "wonderful magnetism and compelling personality" with sitters. In the debut issue of *Camera Work* (1903), which featured her as the standard-bearer of the Photo-Secession, Caffin expanded on this perception of her work, writing of her sympathy with the sitter and her magnetic influence, which were important to her ability to relax her sitters into revealing themselves to her camera. Stieglitz's editorial in that issue reinforced Käsebier's "genius" in terms of feminine virtues—intuition, sympathy, and patience—and often this same perception, that her femininity inflected her work, was rephrased as an emotional expressiveness.[47]

What is more surprising in the reception of Käsebier's images, however, is the grappling to come to terms with the force of her compositions—their simplicity and directness—in relation to her femininity. This problem arises from the tradi-

tional claim that composition, that is, *disegno,* is an intellectual act and therefore a masculine preserve. That such assumptions led to perplexity in view of Käsebier's strengths can be observed in the responses of Stieglitz and his house critics. In 1899 Stieglitz himself had commented that the "strength of her prints never betrays the woman." Clearly, her identity as a woman artist, as well as the voice appropriate to a woman's artwork, was at issue in the Stieglitz circle's first attempts to place Käsebier's work within its nexus. The challenge was to articulate her photography as a revelation of middle-class femininity and as a form of high art: that is, art that did not show the obvious weaknesses of the feminine character. Käsebier's images had to be free, then, of what was deemed woman's tendency toward excess, manifested in her perceived inability to abide in a course of masculine reason. Sadakichi Hartmann, for one, was dismayed by the weakness he perceived in the self-conscious aestheticism of her earliest portraits, even as he puzzled over her mastery. Such aestheticized photographic images he found to be no longer properly "photographic" in the sense of the truth-telling capability of the camera. A better term for her work, he decided, was "hermaphroditic" in that it feminized the masculine capacity of the photograph to speak the truth. That the same could be said for other pictorialists—Day, White, Steichen, and Coburn—was the basis of Stieglitz's later condemnation of the group aesthetic. Thus his rhetoric of the "straight" photograph proved highly effective as an oppositional strategy through which he could divorce himself from their enterprise. Caffin, in his 1903 essay for *Camera Work,* similarly perceived a duality of gender in Käsebier's photographs, finding them "masculine in breadth" and rich in mass, yet also feminized in their delicacy, intricacy, and subtlety—at once "full and organ-like and vibrating like a flute." The following year Keiley picked up on Caffin's conceit of mutability by offering a portrait of Käsebier that blurred boundaries of age and gender, describing her as highly professional in her training, childlike in nature, an untiring, unfeminine worker, careless of her self-image—hands stained with chemicals, hair streaked with gray like the grandmother she was—yet possessed of a youthful energy—highly emotional, nervous, quick-witted, imaginative, and original. To account for her success and her status as the woman photographer Stieglitz had selected as the equal of the men in his circle, Käsebier had to be understood as

22

Gertrude Käsebier, *Auguste Rodin,*
1905, platinum print, 12⅞ × 9¹³⁄₁₆ in.

23 ▶

Gertrude Käsebier, *The Sketch,* 1903,
platinum print, 6⅛ × 8¼ in.

somehow transcending the limitations of her sex, though her photography was
received as the voice of femininity of that cultural moment.[48]

In this respect, Käsebier's images of the artist as a feminine or feminized voice
illuminate her own sense of her art as gendered. In her portraits of artistic figures
such as Auguste Rodin (Fig. 22) and the illustrator Beatrice Baxter Ruyl (Fig. 23),
Käsebier used themes of purity and whiteness to convey the artist's spiritual vi-
sion. When she photographed Rodin in his studio in 1906, Käsebier asked him to
mask his dark business suit with a white studio robe. As he stood among the plas-
ter models, the reflected light of the surroundings bathed him in a soft radiance,
dematerializing his body. Only his massive head and hands were allowed the sem-
blance of flesh and blood. This white, spiritualized Rodin engaged and revised Stei-

chen's earlier image of the master as a brooding presence who inhabited a sublime darkness. Käsebier's portrait presents Rodin as a simple, childlike peasant, as he was often described, perhaps strategically so by his supporters to counter a sensationalized press that painted him as a hedonist who glorified the animal sensuality of the human body.[49]

In *The Sketch* Beatrice Ruyl, who had also posed for the maternal figure of *The Picture-Book*, portrays natural woman as an artistic voice, her hair tumbling down over her shoulders, like a child's, her figure uncorseted, in the loose, reform-style gown of Käsebier's women. Significantly, Käsebier shows her wearing Native American jewelry.[50] Gazing out at nature for her inspiration, the woman artist is thus linked with the primitive through the symbolic artifacts she wears. In Ruyl's

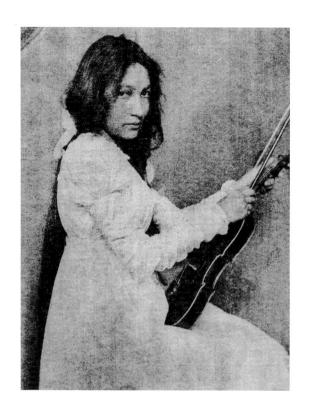

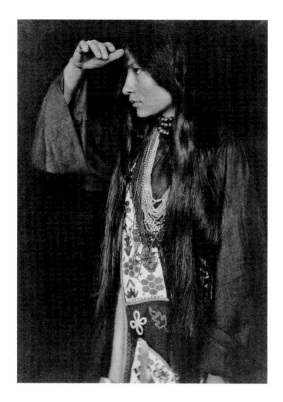

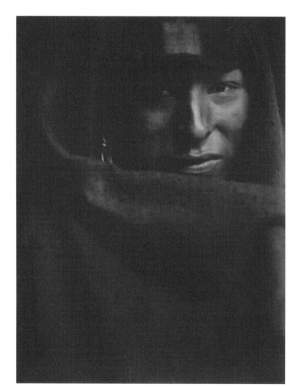

24

(Above, left) Gertrude Käsebier,
Zitkala-Sa, 1898, platinum print,
$7\frac{1}{4} \times 5\frac{1}{8}$ in.

25

(Above) Gertrude Käsebier, *Zitkala-Sa,* 1898, platinum print, $6\frac{5}{16} \times 4\frac{1}{2}$
in.

26

(Left) Gertrude Käsebier, *The Red Man,* 1900, gelatin silver print,
$13\frac{7}{8} \times 10\frac{3}{4}$ in.

whiteness and childlike appearance Käsebier signals to the viewer her status—as a pure, authentic feminine voice. She is nature looking outward to her mirror image in the world; listening to her inner voice, which she hears reflected all around her, she is able to transcribe that voice directly onto the blank page before her.

Another portrait of a "white girl" in Aesthetic dress amplifies Käsebier's equation of the pure, primitive voice with the feminine voice. The Sioux writer Zitkala-Sa (Red Bird), who also took the name Gertrude Simmons (Bonnin), was an accomplished violinist who had studied at the New England Conservatory of Music, then returned to her Dakota reservation and later campaigned for Indian rights.[51] Käsebier photographed her as both an assimilated, white figure and a dark and decorated Indian body (Figs. 24 and 25). The doubling of her persona suggests two sides of the same being: printed in platinum and blurred into immateriality, the "white" Zitkala-Sa remains impenetrable, remote from the viewer; in the other photograph, her dark body is pushed toward the picture plane and displayed tangibly to the viewer in fine platinum resolution. But even as a "white girl," Zitkala-Sa betrays a wariness that is the price of acculturated whiteness.

Zitkala-Sa, as a mystery figure, is related to Käsebier's attempt to visualize the essential primitive: *The Red Man* (Fig. 26), a photograph Stieglitz printed in *Camera Work* in 1903 as the finest achievement in Käsebier's Indian series. The prints were made famous as a group when they were published in *Everybody's Magazine* (January 1901). Käsebier worked on these noncommissioned portraits in her Fifth Avenue studio from 1898 to 1901, after she befriended a group of Sioux Indians from Buffalo Bill's Wild West Show. Käsebier undoubtedly met Zitkala-Sa through the same Wild West Show group during the time Zitkala-Sa was living in Boston. Most of these portraits exhibit the Sioux in their full ritual dress of beaded clothing, headdresses, and jewelry.[52] Within this context, *The Red Man* is unique, as the figure is reduced to all-face, in a single simplified form. To produce the true Indian she sought, Käsebier peeled off layers of artifacts to get to a visual image that corresponded to a memory from her childhood in Colorado. The compositional structure she arrived at recalls that of her dark presentation of Zitkala-Sa as Indian. Although Zitkala-Sa's body is swathed in beads and embroidered cloths, both her face and that of the "Red Man" are encircled, hers by her hair and hand, his by

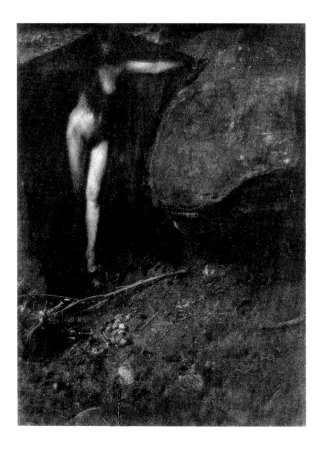

27

Gertrude Käsebier,
The Bat, 1904 (negative,
1902), platinum print,
$8^{1}/_{16} \times 5^{15}/_{16}$ in.

his blanket. Käsebier has lighted the faces so that they shine out from the dark-
ness surrounding them, as if to say that they are gentle children who now require
the protection of those who have transformed them into mere spectacle and mass
entertainment.

Käsebier's images of Zitkala-Sa, then, enfold the two conceptions of woman as
nature, the dark and light sides of the primitive: a childlike, feminine or feminized
being and a dark, mysterious, unknowable creature. The darker side of woman as
primitive nature that was suppressed in or distinct from feminine whiteness
emerges in another group of photographs she made in this period. One of them,
The Bat (Fig. 27), Stieglitz held back from printing in *Camera Work*, perhaps because
he felt it was too difficult to reproduce accurately the blurred tones of this plat-
inum print. There was also some question about White's collaboration in the mak-

ing of the photograph. The negative was made during Käsebier's visit to the White family in Ohio in the summer of 1902, when Jane White posed nude for the picture.[53]

Stieglitz found the image interesting enough to keep in his private collection of Käsebier's work and included it (as hers) in several exhibitions he arranged for the Photo-Secession. With its affinity to Symbolist illustrations of the femme fatale, *The Bat* was an image that would easily find a European audience, so he exhibited the print in England (1902) and twice in Germany (1903 and 1904).[54] Picturing woman as a nocturnal creature emerging from a sinister space in the earth, her body and arms outspread under a flowing, capelike veil of hair (which is drawn on the negative), Käsebier elicits an animal, predatory, erotic side of woman's nature. As a type, this woman seems to have been formed in a universe similar to the purgatory of ensnaring female figures Rodin was incorporating into the fabric of his ongoing monumental project, *The Gates of Hell*. Acknowledging this kinship, Käsebier sent a print of the image as a gift to Rodin in Paris, where it remains in the Musée Rodin.

The erotic dream of the femme fatale had living counterparts in the New York celebrities who fashioned themselves after this figure. Since they traded on the public display of their private lives, the photographer was integral to the process of making them into public commodities. So they came to Käsebier to be alluringly posed and shot. In at least two portrait commissions Käsebier fulfilled the aspiration of such women. One was the showgirl Evelyn Nesbit (Fig. 28), who was brought to Käsebier by Nesbit's patron, Stanford White. The other was the society figure and trophy wife of Philip Lydig, Rita de Acosta (Fig. 29). In Nesbit's image Käsebier reimagines the "white girl," from a dematerialized woman of middle-class nurture to a corrupted innocent embodying red-blooded nature. Dressed in a white empire gown that reveals her lithe adolescent body, Nesbit is perched on a table to lean forward into the viewer's space, permitting us to imagine her smooth, tangible neck, shoulders, and arms. Her bee-stung lips are offered to—and almost pushed into—the viewer's face. In the convention of the Salon virgin, the small porcelain vessel Nesbit holds stands for the untouched womb. But as Nesbit's pitcher tips toward the viewer, almost enough to permit a view down its throat, we

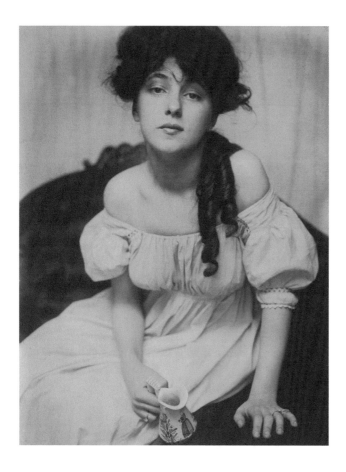

28

Gertrude Käsebier,
*Portrait–Miss N (Evelyn
Nesbit),* ca. 1901–1902,
platinum print, 8 × 6 in.

are teased with a glimpse of her not-so-recondite sexuality. This too was a print Stieglitz published as *Portrait of Miss N.* in the first issue of *Camera Work* devoted to Käsebier in 1903. Later he avidly followed the trial against Nesbit's husband, Harry Thaw, for the murder of White in 1906.[55]

Mrs. Lydig in her portrait presents the flip side of *Miss N.*, the seductive, worldly feminine body literally rotated around so that the back side, an expanse of luxuriant flesh (albeit discretely shadowed), is offered for the viewer's delectation. A woman of means known for her lively personality and her taste in fashion, Lydig is recognizable here not only in the display of her back by virtue of her habitually low-cut evening gown but also in the distinctive lines of her facial profile. Käsebier has struck her identity in the visual terms in which Lydig presented herself as

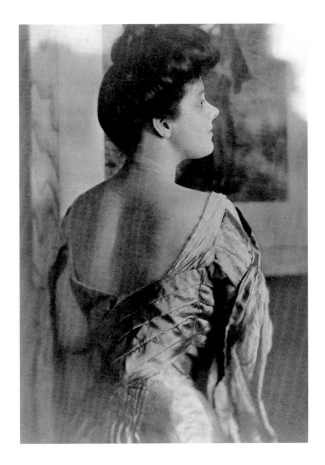

29
Gertrude Käsebier,
Portrait–Mrs. Philip Lydig,
photogravure, 1905.

a spectacle in her box at the Metropolitan Opera. She was glimpsed by the suitors who visited her there and by those in the audience below as a figure who freely displayed her "miraculous back bare almost to the waist, . . . half-turned to the crowd."[56]

Where There Is So Much Smoke . . .

If Käsebier's signature work was deeply invested in the progressive ideal of femininity as a pure domestic space where innocent children were nurtured by principles of beauty and truth, her clientele ranged beyond this domestic femininity

and into another, darker, world—the nocturnal life of New York. The portraits of Mrs. Lydig and Evelyn Nesbit exploited the terms of public display that drove that domain's sexual economy. By the time Käsebier photographed Mrs. Lydig, however, her own world had come to resemble the conflicted, modern space of the urban streets near her Fifth Avenue studio more than the white domestic haven of her signature photographs. By 1905 her practice as an artistic photographer in the commercial marketplace produced such tension between her and Stieglitz, as well as between her and her domineering husband, that she fell ill with "mental strain." In response, she left the country during the summer months for a cruise around the Mediterranean with Frances Benjamin Johnston and a stay in Paris, where she met Rodin.[57] While her husband disapproved of her portrait business—her success exposed his own inadequacy as family provider—Stieglitz was opposed to artists, both men and women, working for money. Käsebier, however, was one of a number of middle-class women who realized that they could use their artistic training to satisfy their economic needs. Candace Wheeler, a leader of the Aesthetic movement in the arts and crafts, lauded the trend in which newly trained women, formerly mere consumers, were now becoming producers in the economy of household and industrial design.[58] The same was true of commercial photography, a field in which the ranks comprised both men and women.

Stieglitz and many of the leading pictorialists, however, could afford to form their artistic identities around an antilucre principle. Because they came from wealthy families and did not have to work for a living, they had the luxury of setting themselves apart as an elite group, in contrast to the common crowd, by talking of money as if it contaminated their pure works of the spirit. As is well known, Stieglitz depended on his wife's fortune until that ran out and then on the largesse of his family until O'Keeffe became a moneymaker in the 1920s. Oblivious to the meaning of economic need, he set his modernists apart from commercial photographers, drawing in broad strokes their supposed conflict: the modernists upholding a purity and freedom untarnished by the profit motive and the middle-class producers enslaved to vulgarity and hackneyed convention. The aura granted to pictorialist works emanated from their status as unique, handmade objects rather than photographs mechanically turned out in large quantities. This, ironically,

endowed the pictorialists' works, unbesmirched by the taint of money, with a distinction that translated into higher prices, while Stieglitz's own *haut bourgeois* formation permitted him to disavow the economic terms of the Photo-Secession enterprise. As Ulrich Keller has pointed out, the imaginary boundaries Stieglitz created around his elite group, based on a dichotomy between spirit and money, had a political utility: they created for the Photo-Secession a mission that could be stated in the terms of rejecting tradition and corruption.[59]

In a further irony the Photo-Secessionists were implicated in the photographic modes of their time and the market because they shared a widely popular aesthetic that was based on the Japanese principles of design taught by Dow and registered as a distinct feature of high art in Whistler's work. Stieglitz's disavowal of the market allowed him to situate his projects, *Camera Work* and the 291 galleries, in an ambiguous public/private space. Hating museums and commercial galleries, he invited the public into 291 to look at the art; but after inviting them in he would ridicule their responses or require the more appreciative viewers to prove their worthiness before being allowed to purchase the works, which were both for sale and not for sale, depending on his mood. He eventually used anticommercial rhetoric to rid himself of colleagues who wanted to control their own work and the income from it; the alternative of ceding control to Stieglitz meant he sold only a few of their photographs and dribbled back to them a miniscule income. Käsebier, like Steichen and White, needed the income to establish her economic independence, especially when she had to confront her husband's physical decline. Since she was the first of Stieglitz's colleagues to assert this need for money, her willingness to place her work in the commercial sphere was for Stieglitz a double violation: as an artist and as a woman who violated the norms of pure femininity that were based on segregation of women away from the marketplace.[60]

Käsebier's discontent with her personal identity as a wife and her public identity as an artist of domestic space reverberates in her playful print *Where There Is So Much Smoke, There Is Always a Little Fire* (Fig. 30). Here she showed herself (at left) with her assistants gathered around a table, engaged in the late afternoon studio ritual of smoking and drinking tea. The practice of smoking in the feminine space of Käsebier's studio distinguishes her and her assistant, Harriet Hibbard, as

modern women who are here free from the middle-class femininity that channels women into the role of genteel nurturers. Instead, they aggressively mug as the women they are: women who have adopted masculine habits and incorporated themselves into the masculine commercial world represented in the space of the portrait studio. The print responds to the self-portrait of Käsebier's friend Frances Benjamin Johnston (Fig. 31), which also lampoons the threat that the working woman (here, as commercial photographer) will evolve into a mannish woman. In the title Käsebier satirizes the idea that this unconventional behavior threatened the old social order and could result in the masculinization of women and the overthrow of the old feminine model.

That Käsebier by 1906 had forged a different identity for herself, at least one with which she was more at ease, is indicated in her portrait of an artist and friend Rose O'Neill (Fig. 32), in which Käsebier tries out a new image for the woman artist. In fact, a second print of O'Neill smoking a cigarette links her with Käsebier's studio group smoking in the photograph of the previous year, suggesting the way this image reflected Käsebier's own self-identity at this point. An earlier Käsebier photograph, *Real Motherhood* (1898), visible in the background, functions as Käsebier's signature but also measures the distance between the old identity and the new, freer feminine figure represented in O'Neill. O'Neill's body language is casual, her hair and clothing loose and free, her smock recalling the colorful em-

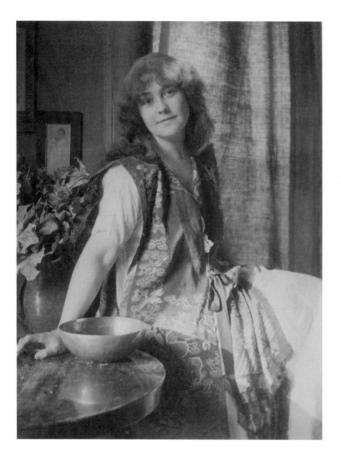

32
Gertrude Käsebier,
Rose O'Neill, ca. 1907,
platinum print, 8 × 6 in.

broidered Chinese clothing that Käsebier wore every day in the studio. The disposition of O'Neill's body across the picture plane, close to the viewer, as well as her cocked head and coquettish gaze outward, echoes Nesbit's earlier position. Such an attitude of bodily awareness is most appropriate to this woman, who originated the Kewpie doll.[61] But she is neither the bad girl forced to depend on sexual favors for her well-being nor the woman in the background print who is inseparable from reproductive responsibilities and middle-class motherhood. In O'Neill, Käsebier confronts the viewer with the figure of the new woman, creative and independent, aware of the potential of her body and mind. The truth was that Käsebier, the foremost image maker of femininity as a spiritual whiteness, personally engaged in other social behaviors gendered masculine: she often wore "mannish

attire," adopting a man's Chinese jacket and a black cape and refusing a corset; she preferred men's company to women's; she exhibited hardworking, even selfish behavior that centered her life on her career rather than her domestic responsibility, embarrassing her husband and making her family resent her art; she was bold, tactless, outspoken, dynamic, and honest, with the "frank stare of a child."[62] This new woman artist, then, could be, like Käsebier herself, a study in contradictions, neither one thing nor the other but an agent free to make her own image as she negotiated the terrain of modernism in New York.

The Woman Artist as the Mystical Voice

While Kasebier's photographs were included in the Photo-Secessionist exhibitions at 291, the first one-person exhibition Stieglitz accorded to a woman was the 1907 show of watercolor and ink drawings by Pamela Colman Smith. Smith was a woman of mysterious origins, who to contemporaries seemed part Asian or part African or of some indeterminate "mixed blood." Much of her fascination for Stieglitz depended on this image of strangeness she created for herself. Her identity as an authentic primitive and childlike voice that spoke the truth of the inner self against the restrictions of cultural convention was crucial to Stieglitz's strategy of redirecting his modernist agenda away from the pictorialists and in so doing reinventing it as a modernism that lay solely within his control.

The truth is that Smith was born in London, England, in 1878, to American parents from Brooklyn, New York. Her father was an auditor for the West India Improvement Company, and he moved the family frequently to locales in England, Jamaica, and New York. While a teenager Smith studied with Arthur Dow at the Pratt Institute (1893–97), where she met Gertrude Käsebier and was regarded as a child wonder. She would carry this identity with her for the rest of her life and ally it with a feeling for the exotic that she acquired during the periods she spent in Jamaica with her father (probably in the early 1890s, and briefly in 1896 and 1898). There she used her time to perform her toy theater for a kindergarten, engaging in the quintessential woman's role in favor at Pratt.[63]

In the late 1890s Smith had operated a multifaceted publishing business in New York, successfully selling her own illustrated cards, music sheets, and Shakespeare prints; she illustrated a huge number of children's books and stories as well, among them a volume of Jamaican folktales of her own telling. Smith's productions were also sold by the New York dealer William Macbeth from 1897 to 1902. But after a rejection of a major publishing project in 1899 she returned to London and in 1901 began to channel her energies into theatrical designs for the Lyceum Company. Smith was integrated into the theatrical family of Ellen Terry and Henry Irving and worked for them as a set designer. The Symbolist poet William Butler Yeats introduced Smith into the secret society of the Golden Dawn, a cult that practiced mystical rituals and encouraged spiritual refinement of the self, based on contemporary spiritualist beliefs. In a manner similar to theosophical practice, the Golden Dawn revived Egyptian rituals overlaid with Hindu and cabalistic ideas. Initiates were to advance through stages of spiritual evolution toward complete enlightenment through the scholarly study of ancient religious texts. An experienced set designer from her work for Terry's troupe, Smith was responsible for costumes and the staging of several of the cult's rituals. Her most lasting contribution to this occult world was a deck of Tarot cards that she began working on as early as 1906 and completed for publication in 1909.[64] The imagery of the works she exhibited at Stieglitz's 291 gallery in her three displays there from 1907 to 1909 is intertwined with the occult world of the Golden Dawn and the narrative structure of the cards.

In the watercolors she showed at 291, Smith appears as an androgynous sorceress, a prophetess who seeks and finds the cosmic, heroic voice in nature—for example, in *Beethoven Sonata No. 11—Self-Portrait* (Fig. 33). The image encapsulates the narrative structure of the Tarot, in which a medium seeks and finds a vision of the future as she assembles the Tarot cards in a specific order and reads them as a revelation of a spiritual reality, present and future. In her symmetrical, iconic *Sketch for a Glass* (Fig. 34), we see the end of this journey. The same seer now triumphantly faces the sun, standing on a cloudy parapet. Turning her back on the past, which is figured as a death, the seeker is reborn into a state of spiritual enlightenment, indicated in the yods, the dewlike drops of the spirit, and the stars raining down all around.

33

Pamela Colman Smith,
Beethoven Sonata No. 11–
Self-Portrait, 1907, watercolor
on paper board, 15⅛ × 11 in.

34

Pamela Colman Smith,
Sketch for a Glass, 1908,
watercolor and ink on paper,
14⅛ × 9 in.

35
Pamela Colman Smith,
The Blue Cat (Schumann's "Carnivale"), 1907, water-
color with pencil on paper
board, 10 5/8 × 13 3/4 in.

36
Pamela Colman Smith,
Sea Creatures, 1907,
watercolor on paper,
13 3/16 × 11 3/8 in.

Many of Smith's landscapes with figures suggest the pitfalls along the way to enlightenment, relating psychological states in which humans struggle helplessly against emotions of jealousy, longing, and melancholy. In these, the sinister aspect of nature is feminized, as in *The Blue Cat (Schumann's "Carnivale")* (Fig. 35), where a sphinxlike creature menacingly dominates the landscape. Passion and desire will soon lead the lovers, at left, to the dark side of human nature. They will soon join the souls who are trapped in the cavern of grapevines hidden under the sphinx's gigantic body. Existence is condemned to the condition of obliterating consciousness in wine. Smith's *Sea Creatures* (Fig. 36), another watercolor of 1907 that Stieglitz kept in his own collection, plays out traditional notions of woman's identity as nature: here the female body is visualized as part of the almost hidden but ceaseless flow of cosmic rhythms, suggesting the erotic lure of woman's mysterious, fluid sexuality for the men who approach in the boats at the horizon.

Writing to Stieglitz, Smith presented herself as a visionary, claiming, in the popular language of spiritualism, that her images originated in the "subconscious energies" of her mind and were liberated by music. Clearly, Dow's teachings from her days at Pratt were at work here, encouraging a synesthetic manner of composition and connecting her work to Whistler's aesthetics. With its emphasis on flattened forms bounded by strong contours, Smith's art was also heavily indebted to the style and imagery of Kate Greenaway, Walter Crane, William Blake, and Japanese printmakers such as Hokusai.[65] Her rhythmic use of line, which secured effects of surprise and spontaneity, convinced Stieglitz and others of the authenticity of Smith's vision, even though in hindsight it appears more like an art nouveau convention. In Smith's landscapes, such as *Beethoven Sonata No. 11—Self-Portrait*, her musically mobile line differentiates the heroic from the merely human, yet establishes a kinship for the two. In *Sea Creatures* the rocking, curling line makes the sea nymphs one with the feminine medium of the water. This device, which identifies the feminine with the mysterious and even lethal in nature, pervades Smith's illustrations as a leitmotif. At times, as in *The Blue Cat*, Smith's line blends trees, earth, and mountains so that the landscape surrounding the lovers encloses them in the fluid, watery world of subconscious desire.

Smith's world of desire and longing engaged an antimodern thematic that was

at the heart of symbolist modernism. Her simplified, free rhythmic style was as striking in New York in 1907 as her self-presentation. The images she claimed were generated automatically from her subconscious mind as she sketched to music were probably made from abstract scribbles on sheets of white paper that she later clarified into the coherent figural watercolor drawings she exhibited. Smith wrote to Stieglitz in late 1907 that she had four sketchbooks of music drawings done at concerts with ink and a brush that were getting "bolder and more definite than those of a year ago." "I find the more I do, the more I see!" she stated a few months later. In one recent week alone, she related, she had completed ninety-four drawings, "almost all of them useable ones," suggesting that she continued to work these automatic scribblings into more finished products. The list of drawings she had just completed in December 1907 and sent to Stieglitz in New York, from her apartment in London, enumerates thirteen watercolors, each of which was given a title corresponding to the piece of music that inspired it: *Symphony no. 5 in C* by Beethoven, *Spring Song* by Grieg, and *Overture, "Manfred,"* by Schumann, for example.[66] To Stieglitz she related that her images were not attempts to illustrate music as music, "But just what I see when I hear music. Thoughts loosened and set free by the spell of sound. . . . When I take a brush in hand and the music begins, it is like unlocking the door into a beautiful country."[67] Thus her drawings are not about the intrinsically musical language of line; rather, they use one ethereal medium to summon up its hidden visual correlative—to reveal a spirit world hidden to the eye.

Smith's fantastical, dreamlike art appeared in New York when Freud's essay on dreams had not yet appeared in English translation, but the intelligentsia of Greenwich Village were already fascinated by cultural artifacts they regarded as direct manifestations of the psyche. Smith's actual appearance in the gallery completed the image of the artist as a mystic. Stieglitz must have been startled by her first appearance at 291 as a small, dark figure, seeming "scarcely more than a girl," her head wrapped in bright scarves and feathers to complement a brightly colored costume that would have recalled gypsy or West Indian attire; his description resembles her self-fashioning in a photograph of about 1912 (Fig. 37). This exotic Smith is in complete contrast to the more conventionally feminine Smith, styled

after a Pre-Raphaelite stunner, who appears in an earlier photograph by Käsebier (Fig. 38). Stieglitz's first presentation of Smith's seventy-two works in 1907 drew an uptown crowd of New York's elite families, among them the Vanderbilts and the Whitneys, who purchased a large number of the drawings, thus displaying their eagerness to associate themselves with the cultural capital of Smith's spiritualism. The most theatrical of Smith's appearances at 291 was at her last exhibition there in March 1909, when she stood in the gallery, reciting West Indian nursery tales and chanting ballads by W. B. Yeats in a voice described as lilting and rhythmic, a perfect aural equivalent for the lyricism of the watercolors.[68]

In the spiritualist language common to early-twentieth-century psychological discourse, the house critics for 291 framed Smith's illustrations as modern penetrations into the deepest psychic reality. James Huneker, writing for the *New York Sun* in 1907, commented on the "startling" and bizarre morbidity of the work and paid her the compliment of suggesting that she was the appropriate artist to translate Maeterlinck—in the *Camera Work* circle, a huge accolade.[69] Writing in *Camera Work* in 1909, Benjamin de Casseres approached the drawings as direct utterances from the spirit world, accessed through the subconscious: "These wonderful little drawings are not merely art; they are poems, ideas, life-values, and cosmic values that have long gestated within the subconscious world of their creator—a wizard's world of intoxicating evocations—here and now accouched on their vibrating colored beds, to mystify and awe the mind of some few beholders; to project their souls from off this little Springboard of Time into the stupendous unbegotten thing we name the Infinite."

According to de Casseres, Smith was able to strip away the veil to reveal the infinite in nature, which at times appeared as a nightmare world, precisely because of her "simplicity." "The minds of the greatest visionaries are infantile," he asserted, "and here Miss Smith approaches Blake and Beardsley." In fact, her images were

> so simple that fat practical brains will either see in them nothing or lunacy. All simplicity is madness because it is nearer unity. . . . The world is so completely and irretrievably lost in the concrete, it has so carefully moulded of the secondary and incidental characteristics of creation a world within a world, that a poet, such as Pamela

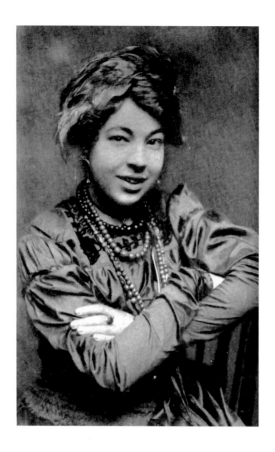

37
Unknown photographer,
*Portrait of Pamela Colman
Smith,* ca. 1912.

38
Gertrude Käsebier, *Pamela
Colman Smith,* ca. 1899.

Colman Smith, who speaks directly of things as they are perceived by the mind not yet overlaid by the painted illusions of sight and not affected by the deadly automatism of routine, is believed to have a touch of insanity. All absolute simplicity startles, is eccentric and bears about it the mark of other-worldness, when in reality it is merely the reservation of the virginal, first-day mind in the bogs of matter, the perception of unity and fundamental things through the blinding fogs of this multiplied absurdity called practical life.[70]

Although de Casseres, in describing Smith's strangeness, invoked the similarities between the vision of the child and the lunatic, he stopped just short of actually calling her a child. Comparisons of Smith to a child were a constant in the writing on her: her art was characterized as "childlike" in its expression of the "hidden life" within, a quality these critics granted to the work of great artists. The *Craftsman* in 1912, for example, repeated that Smith as an intuitive artist possessed "second sight" and a childlike sincerity. The fact was that she self-consciously played on her identity as an artist whose life was totally immersed in the fantasy life of children: she specialized in children's literature, children's illustrations, and children's theater. Her adoption of the nickname "Pixie" set her image as a child, and she capitalized on the playful aspects of her creativity. Contemporary writing on Smith often featured her work with miniature theaters that resembled dollhouses in photographs accompanying the reviews of her watercolor drawings.[71] Alphaeus Cole's 1906 portrait of Smith even shows her seated on the floor playing with the toylike figures for one of her miniature sets. Her strange appearance mystified acquaintances as to her origins and her age, and contemporaries consistently resorted to the metaphor of the child and the primitive to explain her vision and personality—a practice that Smith encouraged. If Stieglitz himself never referred to Smith as a child, de Casseres's delineation of her as possessed of an "infantile . . . simplicity" and even a childlike near-lunacy remained a touchstone for the image of the modernist artist, one that would be recirculated in the Stieglitz group after 1912 with increasing frequency up to and through Stieglitz's discovery and forming of O'Keeffe in the image of the woman-child.

Earlier, Käsebier had played with a similar type of spiritualist imagery in equating her creative process with the divining process of the spiritualist medium. Crit-

ics frequently commented on her uncanny powers with her sitters, her intuitive nature that allowed her to penetrate their character and manipulate them. The most striking example of Kasebier's identification of the feminine voice with the mystical is *The Magic Crystal* (Fig. 39), in which the figure again offers the bodiless femininity that predominated in her images of "white girls" and mothers with children—here taken all the way to its logical conclusion. During her 1905 trip to Paris she presented this print to Robert Demachy, another early member of the Photo-Secession. He described the woman in white bending over the sphere as hypnotized by her vision and swaying with a near-dizziness. Demachy found the technical inventiveness and achievement of the print remarkably successful, particularly as it dematerialized the form and conveyed the weirdly fluid psychic state that unified figure and surroundings. Not simply the attribute of the spiritualist, the crystal in this image is the feminine body, its transparency responding to the phantasmal body of woman, which has the power to give life, even if its sexuality in this scenario is hidden, left a mystery. If the woman's divining power resides in her intuitive link with the occult energies of nature, that link is registered in her vaporous self, which is on a continuum with the ether all around her.[72]

Demachy made clear that the image reflected Käsebier's own sense of her artistic process, relating his interview with Käsebier at length in an appreciation of her work he published the year following her visit to him. In explaining to Demachy just how she was able to capture the inner character of each of her sitters, Käsebier described a process in which she had learned both to translate color and form into tone and rhythmic line and to "penetrate the soul of my model." The hands, in particular, she found "the key to their character." "I know how to discover sweethearts," she claimed. "I feel myself in communion with the mother in the adoration of her child; I find out what has happened to the old man and the ambition of the young man; I understand the silent gaze, the seeker of indulgence, of the ugly woman." Using the language of spiritualism, she explained that each sitter gave out "particular vibrations." Demachy responded that this last phrase conveyed Käsebier's "special character" and allowed us to "understand her as a mystic, almost a clairvoyant, carrying out the movements of her art with the conviction and the solemnity of a priest." Käsebier held that her method was spontaneous and

39

Gertrude Käsebier,
The Magic Crystal,
ca. 1904, platinum
print, 9½ × 7½ in.

direct rather than calculated and that she did not know how she would picture her models until she saw them reflected on the lens glass. The interchange of energies between model and photographer in each portrait session was exhausting for both, but it was this charged interchange—"the psychological factor," she stated—"that composed the life of the portrait," communicating an unarticulated subtext that gave the portrait its interest.[73]

Again, to Demachy and others, she presented herself as ignorant of real technique, although she wished to be viewed as a photographer who produced perfect

negatives "that . . . don't have to be retouched or modified." Demachy confirmed that her method was intuitive—without words and speech—like that practiced by certain painters. "Mme. Käsebier is right," he concluded, "when she affirms that to imagine a living image requires emissions of emotional vibrations in the air, at the moment of its conception."[74] Käsebier's belief in her own psychic powers and in her photography as a product of these powers is supported by the testimony of Käsebier's studio assistant, Adele Miller, who recalled the photographer's pride in recounting the visions produced by her trance states.[75]

If Käsebier and Smith had in common this feminine paradigm of the woman artist as a mystical voice, however, their visions produced very different worlds. Smith's universe was the nocturnal dreamworld of the soul, freed from the pettiness and material burdens of domesticity and the marketplace. She took her viewers to an imaginative landscape outside the boundaries of modernity. It was a place where they could renew their sense of an essential, inner life that disavowed modernity as reality, and it hinted at a loss of reason to fear, lust, and maniacal depths and heights in the space of a strange inner darkness. Käsebier's signature images, in contrast, celebrated the small, familiar intimacies of bourgeois domesticity as woman's true reality. Her middle-class world believed in the progressive dimension of modernity even as it placed women on the borders in a pure domain of their own. As we have seen, however, her world was also broad enough to include in its scope the feminine figures that evoke the economy of sexual desire: for example, in the Nesbit portrait or in Käsebier's experiment with the nude of the Symbolist purgatory. Smith's audience was a mixture of an uptown elite and Village bohemia, both seeking what her occult art could provide: the mark of distinction that suggested that the individual lived a rich inner life.

Stieglitz profited from the theatricality of Pamela Colman Smith's presence at 291, but as a long-term strategy that would help to maintain his cutting edge in modernism an association with her was not viable. Smith had sold her works for years at Macbeth's New York gallery before Stieglitz got hold of her to make her a celebrity with a fashionable set and transform the 291 galleries, which he clearly thought were losing energy under the tired banner of pictorialism. By 1909–10 her novelty had worn off, and Stieglitz had begun to develop a new group of modernists

through which he would advance an ever more sensational program of modernism. Smith could not be integrated with the likes of Rodin, Matisse, Cézanne, Picasso, Marsden Hartley, John Marin, Max Weber, and Marius de Zayas. Her persona, predicated on the strange, the excessive, the exotic, could not be assimilated to the likeness of this group, especially those who formed the men's club of 291 and presented themselves in the public guise—via Stieglitz's camera—of middle-class intellectuals. Smith was out of step in that she did not identify herself with monumental statements in the more permanent media of oils, bronze, or stone, as would Stieglitz's male modernists. Moreover, while her images recycled certain anxieties about the dark powers of feminine sexuality that were commonplace in the works of male Symbolists, her female figures were often androgynous. Even when they appeared as nudes, they were not revealing enough about feminine sexuality because they were not focused enough on the female form for its own sake— that is, in isolation from Symbolist narratives of desire. We need only consider Stieglitz's exhibition schedule for 1908–12 to understand how important the statement of the female nude was to Stieglitz's espousal of a liberated modernism, as Sarah Greenough has recently noted.[76]

Living in London after her 291 exhibitions, Smith could not sustain herself on her income as an artist. Her correspondence with Stieglitz, in fact, is almost entirely given over to financial concerns and pleas for reimbursement for drawings sold, rather than any exploration of mutual spiritual concerns that might be imagined as uniting their interests in the mysteries of art and the soul. Smith converted to Roman Catholicism in 1911 and gave her services to the woman suffrage movement through her poster designs. She worked for the Red Cross during World War I, again contributing poster designs and toys she made herself for children's aid. After the war she faded away from the sight of the art world, living on the Cornwall coast, where she rented part of her home (which included a chapel) as a vacation retreat for priests and where she died in 1951.[77]

During the years Stieglitz showed Smith's images at 291, he cooled his relations with Käsebier. Recognized as the grande dame of the Photo-Secessionists, Käsebier was emphatically out of place in the new scenario at 291. Moreover, it was Käsebier who bore the brunt of Stieglitz's first public attack against the Photo-

Secession. In late 1907, tiring, he said, of the egotism of the photographers, he had allowed the house critic Charles Caffin to satirize Käsebier in *Camera Work*. After a final publication of Käsebier's photographs in *Camera Work* in 1905 and her last major exhibition at 291 in 1906, Stieglitz became ever more disenchanted with the middle-class gender relations epitomized in her photographs and her very person. As a stout hausfrau whom the Photo-Secessionists called "Granny," Käsebier embodied the sexual ethos he wanted to leave behind. In this way she also represented his wife, Emmeline, with whom he had maintained a troubled relationship since the birth of their daughter, Katherine, in 1895. Käsebier found the tensions with both Stieglitz and the men who staffed his operations unbearable. After the Photo-Secession's 1910 retrospective in Buffalo, Stieglitz, through a critical piece in *Camera Work* written by Keiley, launched a final public attack on Käsebier as a technically indifferent and impulsive photographer whose work constituted an "inner blind groping to express the protean self within—that finer, bigger self that cannot always find voice."[78] Keiley here addressed Käsebier's same photographs he had praised earlier for their technical finesse. These included many of her best-known works (among them, *Blessed Art Thou among Women, The Manger, The Bat, The Red Man,* and *Rodin*). His language was a thinly veiled indictment of a hysterical feminine vision that did not know its true self. In contrast, just five years later Stieglitz would identify in the vision of O'Keeffe a fully developed sexuality as the essence of the feminine self. To sever his ties with Käsebier and White after the Buffalo retrospective, Stieglitz once again accused them of commercialism; he had complained increasingly since 1907 that the Photo-Secessionists were devolving into stagnant producers. Given that Stieglitz enjoyed a private income from his own and his wife's inheritances and did not rely on sales of his photographs for his living, his complaint of commercialism against his colleagues can hardly be taken seriously, especially in light of the fact that Käsebier was already one of the most successful commercial portrait photographers in New York City when Stieglitz met her, embraced her work, and invited her into his elite circle.[79] Käsebier finally resigned from the Photo-Secession in 1912 and continued her professional activity and exhibitions through a new organization, the Pictorial Photographers of America, headed by Clarence White.[80]

In Smith Stieglitz located the feminine as mystic, child, and primitive. In Käse-
bier he found a mystifying woman whose pictorial world represented ideas of fem-
ininity against which his modernism would found itself. But that modernism
sought, not to discard these feminine paradigms, but to reinvent them and re-
cuperate their displaced sexuality in the image of the child—in her whiteness.
Over woman's child persona Stieglitz would place a mystifying, dark façade that
allowed him the power to possess and reveal the child concealed in the woman.
All these multiple aspects of the feminine he would disclose in the miraculous
image of O'Keeffe.

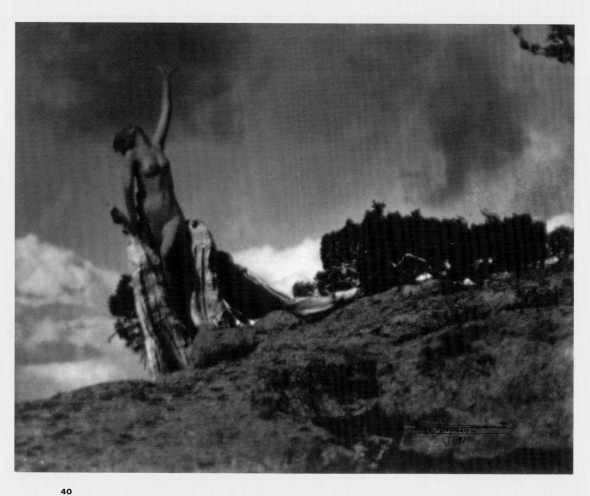

40

Anne Brigman, *Soul of the Blasted Pine,* 1907
(negative, 1906), platinum print, $7\frac{1}{2} \times 9\frac{9}{16}$ in.

The Speaking Body
and the Feminine Voice
Anne Brigman

Just as Stieglitz had replaced Käsebier with Smith as the woman artist at the forefront of 291, he came to replace Smith with yet another woman artist, this time one who did not hold back from examining the nude female body. By the time of Smith's last exhibition at 291 in 1909, he had discovered Anne Brigman, a photographer from the far West (Oakland, California). She offered Stieglitz the opportunity to consider the nature of woman's sexuality from a woman's perspective. At the moment when the female body dominated the visual space of 291, her photographic nudes figured the complex of ideas and practices that over the next five years Stieglitz would define as his modernism.

Brigman was one of the last two initiates into the Photo-Secession group that he would support after setting the group in place with the inauguration of *Camera Work*. The other was Alvin Langdon Coburn. What Coburn had to offer the Photo-Secession was technical prowess in any number of photographic printing techniques and a haunting poetic imagery he had learned from studying Whistler and Japanese art.[1] He seemed to best the members of the group at their own game. Brigman, however, expanded its rules in a way that Stieglitz could only have imagined before seeing her work. While his male confreres engaged the female nude as a formal vehicle of universal human mood, in Brigman's hands the nude related the struggle of the modern woman giving birth to herself. In her images woman is freed from the maternal paradigm and thus the burden of conventional middle-class domesticity. Since Brigman was interested in woman alone, without children, she narrowed her vision to the female body as the focus of feminine identity.

Brigman always located the female body in the landscape, framing feminine

identity in traditional terms as harnessed to nature. Yet, posed like a dancer, her typical female body, as in *Soul of the Blasted Pine* (Fig. 40), is choreographed into an ambivalent relationship with its surroundings; the viewer is hard-pressed to know if the woman's body struggles against nature—its own nature—or is in harmony with the natural, given woman's definition as a figure of the premodern. The story that Brigman told Stieglitz and interviewers about her own images encapsulates the feminist issues of the prewar period. It focuses on woman's quest to free herself from the restrictions of her place in a social order predicated on assumptions about woman's nature and about the body itself. What makes her photographs so compelling is the way they relish what she sees as the female body's natural musicality, yet paradoxically her female body at times seems to struggle against this inner harmony. So Brigman's story, though it tells of one particular woman's struggle, suggests the problems of a whole class of women. Although she appropriated from her male colleagues the vocabulary of the female nude that made up her images, her female form, with its limbs and torso swaying this way and that, was received as a voice emanating from a woman's hidden psyche. Stieglitz was thoroughly taken with the way in which Brigman made the female body speak of woman's universal nature and modern predicament—from a woman's point of view. The genre of the nude had traditionally been practiced by men artists, so what startled Stieglitz and his collaborators was the way in which Brigman made it tell her personal story of becoming a modern woman and, by implication, the saga of middle-class women with intellectual aspirations—in other words, those women of Stieglitz's own milieu in whom he was increasingly interested as his marriage continued its decline.

This idea in Brigman's work—that woman's creative voice would speak through her body—coincided with Stieglitz's own reading of the new "scientific" authorities on woman's sexuality, now referred to as the sexologists, primarily Havelock Ellis, Edward Carpenter, and Sigmund Freud. In 1910 modernist creativity was beginning to revolve around a dramatization of the self, a plumbing of the depths of the unconscious for the origins of creativity. It was at this very moment that Stieglitz began his portrait project to capture the psychological essence of each of his male modernist colleagues. Since the unconscious, according to the sexologists,

was marked by gender and sexuality, Brigman demonstrated for Stieglitz exactly how women artists could represent themselves in modernism—uniquely as women. By visualizing the deep self as resonating through the body, and thereby making the body an expressive voice, she opened up the space for women in modernism that would later be more fully, even notoriously, shaped by O'Keeffe.

Becoming Anne Brigman

One of Brigman's earliest public self-presentations (Fig. 41) makes clear that the identity of the creative feminine voice she desired for herself was that of a seer.

Here her pose, gazing into a crystal ball, recalls Käsebier's self-identity in *The Magic Crystal* of the preceding year—the same identity that supported Smith's entire production of occult illustrations. This portrait predates Brigman's discovery of her signature female nude. But already the conceit of woman as intuitively one with the spiritual forces of nature is in place. At this point, it is the expressive potential of the female body that Brigman is about to discover.

Brigman claimed that her childhood experience shaped her into the artist she was to become. Born Anne Nott in Hawaii in 1869, and raised there by her missionary family, she related her creative development to the impressions of the "primitive"—primitive idols and the paradisiacal landscape.[2] Such a story was already a stock item in the narratives modernist artists told about their rootedness in primitive origins. Paralleling Smith's refashioning of herself as an exotic after her stays in Jamaica, Brigman assigned a large importance to island flora and fauna in forming her artistic sensibility as one that was always in touch with the senses and the body. That landscape was still vivid to her at eighty years of age, as she remembered it:

> Mango trees, tall and ample in their glossy foliage, hung in season with huge jewel-like clusters of yellow, pendulous fruit, red-cheeked at the stem-end . . . the golden globes of the guava and the heavy abundance of the banana and papaya and in their season of blossoming, magenta bouganvillia, scarlet pociana regia and the orange trumpets of the bignonia, flamed against a tropic sky caraveled with lazy trade-wind clouds against whose white glory, frigate-birds and the exotic crests of the up-sweeping cocoanut trees swayed to wind-meles as old as Time.
>
> From the misty peaks above the Nuuanu Valley, clothed in their gray-green forests of koa and kukui, to the smooth, white crescent beach that was Waikiki in those innocent days, was even in the era of horse-back and the carriage but a few miles . . . so that odors and sounds were closely related to my young senses . . . with a difference . . . the difference of the smell of warm, forest loam and the haunting perfume of fern jungles and maile and wild ginger floating on the air . . . to the sweet, strange, salty redolence of iridescent sea-weeds when the tide is out.[3]

Here Brigman relived her experience of the island as a mysterious and sensuous moment in which sound, smell, movement, and color all merged. She recalled her

childhood on the island as wild and free, describing herself then as a "young savage." Brigman tried to preserve the child and the primitive in her adult identity, and she was characterized in the same terms by family members in later interviews.[4] As we will see in the following chapter, the endurance of this child self into adulthood became a familiar refrain in Stieglitz's talk about his artists—both men and women—from about 1911 to 1912, when Stieglitz and his house critics routinely employed this rhetoric to claim the purity of the artist's vision.

After Brigman's family relocated to Northern California when she was sixteen, she married Martin Brigman, a sea captain, in 1894. They separated in 1910, when Brigman began living alone in a small studio behind the large house in Oakland she had shared during the past decade with her husband, her mother, and her sisters. Brigman made the vine-covered cottage her private sanctuary, devoted to the "life beautiful" according to the Arts and Crafts philosophy of William Morris and Elbert Hubbard. The Oakland circle of artists and poets to which she belonged was one of many such turn-of-the-century groups that attempted to integrate the arts in theatrical productions and pageants and to perfect life in stylized environments. Following the lead of the perfected art object, life was to be structured, theatrically and ritually, around heightened moments of beauty. Brigman acted in the group's theatrical productions, wrote poetry, and, like Käsebier, took up the camera after turning away from painting.[5] After she solicited Stieglitz's attentions in 1903 for her newly begun photographic work, primarily landscapes and portraits, he made her an associate member of the Photo-Secession. The Arts and Crafts aesthetic of *Camera Work* immediately appealed to her belief in the religion of Art, as did the organization of the Photo-Secession as an elect group of artists fighting the good fight to elevate photography to a higher plane of achievement.

Membership in the elite of New York photographers—the most distinguished and progressive camera club in the country—gave Brigman preeminent status in the California artistic community, undoubtedly supporting her already strong individuality. Her credo of the divine self (in Hubbard's terms) made it possible for her to pursue the highly unconventional existence of a solitary woman artist. Her sense of herself as Stieglitz's kindred spirit, as one who had to struggle against the base motives of the masses, emerges from a letter to Stieglitz early in their

42

Anne Brigman, *Self-Portrait(?) in the Studio,* ca. 1910, gelatin silver print.

friendship in 1903: "I'm a stumbler yet, but my soul is afire with enthusiasm. Elbert Hubbard says truly, 'Your own will come to you if you hold the thought firmly—and hustle.'" Stieglitz's recognition of Brigman as a member of his elite granted her permission to fly in the face of domesticity and devote herself entirely to her art in the rarefied space of her studio, a place conditioned by a few, select objects (Fig. 42). In important ways Brigman's childless life contradicted the norms of progressive femininity so amply objectified in Käsebier's imagery; she even defied the advice of the most radical marriage reformers, such as Ellen Key, who condoned divorce but still thought maternity the natural state of every woman.[6]

Brigman's work spans a range of subjects, but because Stieglitz controlled its public presentation she became known solely for her compositions of nudes in landscapes. In San Francisco salons and galleries she exhibited portraits, landscapes, and figure studies, some of which illustrated literary works, such as William Ernest Henley's poem "Captain, Oh, My Captain." For *Camera Work* and

exhibitions in New York and in other venues of the Photo-Secessionists, this broader range was eliminated, so that her nude studies were left to stand for her photographic vision. In Stieglitz's view these images were fresh and in some way original to her. They distinguished her, in his eyes, as "one of the very few photographers who have done any individual work."[7] He cast Brigman's female nude as part of the drama in which women were laying claim to social spaces occupied by men. In that framework, Brigman was extending the language of the nude developed by the Photo-Secessionists Frank Eugene, Robert Demachy, and Edward Steichen, whose photographs were published in *Camera Work* from 1903 to 1910. Brigman's project transformed the nude to fit her narrative of modern woman.

It was Demachy's *Struggle* (Fig. 43), published in *Camera Work* in 1904, that was Brigman's epiphany in realizing how the nude could incorporate her personal voice. Immediately after receiving that issue, she wrote to Stieglitz, telling him that the Demachy image had jolted and awakened her to the possibility of the form. The interpretation she supplied for the print was all her own: the body, even in the extremities of hand and knee, expressed the crux of the woman's character. "That 'Struggle' is wonderful," she wrote. "One hand and knee show how bravely her will is fighting against the odds—but every curve shows how ill prepared sensitive, high born woman is capable of struggling."[8] Here Brigman, the budding photographer, makes the picture respond to her own story, just recently begun, of a woman in early middle age, as she later said, taking up an artistic medium and attempting to make it her own, to reveal herself.[9] The shock was not only one of self-recognition but also one of recognizing the violent manipulation of the negative as a new means of expression, as in Demachy's painted striations that create the whorling vortex around his struggling nude.

Brigman's *Via Dolorosa* (Fig. 44) reveals how Demachy's nude stayed with her, how she internalized its story, by introducing her own body into the High Sierra landscape that she made her own imaginary universe. The creative leap of projecting her inner life into the form of the nude occurred in the summer of 1906, when she and her friends took a hiking trip into the mountains. In the wake of the earthquake that devastated San Francisco that spring, they were seeking quiet and calm, a therapeutic relief from shattered nerves. Eating and sleeping under the open

sky, Brigman awakened once after a thunderstorm, with the light still weirdly il-
luminating the forms of the craggy landscape, and suddenly "saw things" in the
trees and rocks there.[10] "One day during the gathering of a thunder storm," she
later recounted, "when the air was hot and still and a strange yellow light was over
everything, something happened almost too deep for me to be able to relate. New
dimensions revealed themselves in the visualization of the human form as part of

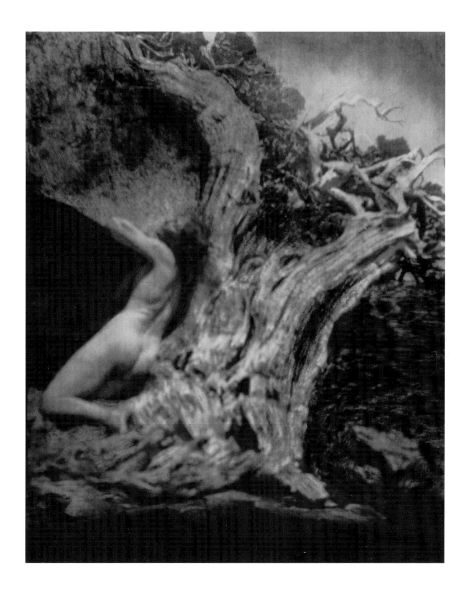

tree and rock rhythms and I turned full force to the medium at hand and the beloved Thing gave to me a power and abandon that I could not have had otherwise." At another time, recalling the same formative moment, she elaborated: "Here stored consciousness began its work . . . not only with the splendor of the strange trees, but a sense of visualization developed in amazing ways in which the human figure suggested itself as part of their [the trees'] motive . . . even before the camera was

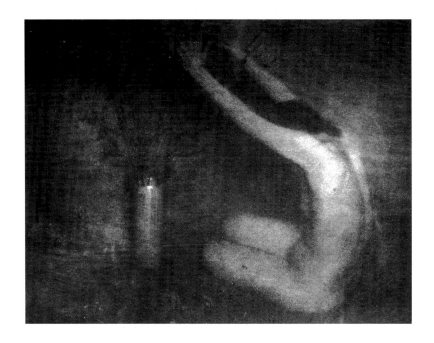

45

Edward J. Steichen,
Dawn Flowers
(negative, 1901),
photogravure, 1903.

brought to bear upon the revelation . . . (*The Dying Cedar* . . .) being an early experience."[11] (See Fig. 58.)

Brigman also realized that she was indebted for these new "flashes of visualization" to her discussions on this camping trip with a young woman friend who was studying sculpture and "brimming with interpretive ideas of earth and sky and winds." She knew too that her schooling in design in San Francisco during this period—her study of "dynamic symmetry"—also contributed to a new capacity to think visually, as each new fantastic rock formation, juniper, or tamarack pine "shaped by the winds of the centuries" allowed her to see "wings and flames and torso-like forms, unbelievably beautiful in their rhythms."[12] In the play of analyzing the strange landscape of the Sierra, Brigman brought her own order to this bizarre topography. Out of its chaos of wild forms she could fashion a fantasy life.

The nudes of the Photo-Secessionists were clearly on her mind. The precedents for Brigman's nudes include not only Demachy's but also White and Käsebier's collaboration, *The Bat*. Although Brigman probably never saw Käsebier's image of the female body as a predatory, nocturnal animal, *The Bat* resembles several of Brig-

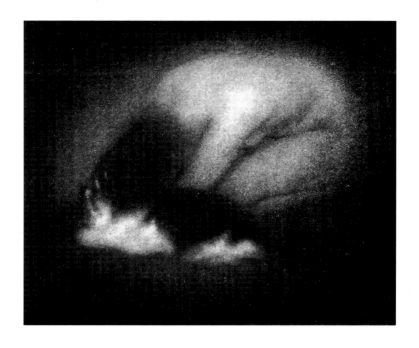

46

Edward J. Steichen,
Nude with Cat, 1903
(negative, 1901),
halftone reproduction,
$4\frac{1}{4} \times 5\frac{1}{4}$ in.

man's nudes—for example, *Echo* and *The Cleft in the Rock* (Fig. 64)—except that Brigman's images lack such sinister elements. More directly related are Edward Steichen's nudes, *Dolor* and *Dawn Flowers* (Fig. 45), which were published among others in the second issue of *Camera Work* in 1903. Given how closely Brigman studied each issue of Stieglitz's journal, we can be sure that she tutored herself in Steichen's nudes, grasping how he treated the female form as a muted language of the feminine psyche by picturing the glowing torso, barely discernible in a womblike darkness. Maurice Maeterlinck, the beloved poet of Steichen and other Photo-Secessionists, wrote of this feminine interiority as a mystery to man: it issued from the other side of a "primeval gate," as he put it, and was heard only as a "bewildering whisper that doubtless waited on the birth of things, . . . when speech was yet hushed." For in Maeterlinck's vision, "women are, indeed, the veiled sisters of all the great things we do not see. . . . Theirs are still the divine emotions of the first days; and the sources of their being lie, deeper far than ours, in all that was illimitable."[13] This mystification of woman is completed in a third study by Steichen, *Nude with Cat* (Fig. 46), published in that same issue. Now folded into herself, her

47

Auguste Rodin, *Standing Nude with Draperies,* ca. 1900–1905, watercolor and graphite on ivory wove paper, 17½ × 12½ in.

48

Auguste Rodin, *Sunset,* ca. 1900–1905, watercolor and graphite, with smudging, on cream wove paper, 12¹⁵⁄₁₆ × 19¾ in.

form corresponds perfectly to her animal alter ego, revealing nothing and with-holding her secret sexuality, her essential self, from man.[14]

At the same time that Stieglitz chose to bring Brigman forward to the public, he showcased the work of Rodin, Cézanne, and Matisse at 291.[15] For Stieglitz, relating her nudes to those of these modernists was as appropriate as comparing her with her colleagues in photography. Steichen's photographic nudes, prompted principally by his friendship with Rodin beginning in 1901, played off Rodin's drawings of the female figure, which were displayed at the 1900 Paris Exposition Universelle and in the capitals of Europe almost every year after the exposition. Rodin's drawings finally came to New York in 1908 and 1910 because of Steichen's efforts. As simplified calligraphic forms enlivened by bold splashes of watercolor, two of Rodin's dancers (Figs. 47 and 48) are typical of those Stieglitz and Steichen chose to feature at 291. Stieglitz held back, however, from showing Rodin's more explicit nudes, which probe the female body, exposing a more graphic female sexuality, although these drawings were circulated in Rodin's European exhibitions. Stieglitz, in fact, owned two of these pencil drawings (now in the collection of the Metropolitan Museum of Art, New York), which presented the viewer with the figure from the waist down, her legs spread, her hand placed on her genitals.[16] In contrast, Steichen's nudes circle more politely around feminine sexuality; they deny the body as body, only to eroticize it by veiling the form as spirit or mood.

Camera Work's defense of Rodin clarifies why the nude required a justification and why Steichen and Brigman allegorized their nudes, pointing the viewer to an idea rather than to the body's beauty. After first shocking the prudish American public with Rodin's 1908 exhibition, Stieglitz took a different tack in the 1910 showing and attempted to tone down the controversy by deflecting the discussion to the drawings' formal economies and beauties.[17] In the 1911 issue of *Camera Work* devoted to the Rodin drawings, Benjamin de Casseres continued this defense. He passionately exalted Rodin's "paganism" as "the perception of the mystery of surfaces; the delirious delight of touch; the transports of joy bred of the melodies of motion; the worship of Venus for the sake of her divine body, that body that is a love-canticle of mystic lines and shadows. . . . The adventure of the mind in matter . . . the divinizing of the sensual and the materializing of the sensuous." Thus attempting

to mystify Rodin's eroticism, de Casseres wandered restlessly through a number of strategies to establish the rightness of Rodin's worship of the female body; predominant among them, again, was the attempt to picture Rodin as an innocent child who looked at the universe with wonder and "childish delight."[18] At stake in Stieglitz's promotion of the nude at 291, whether in Brigman's photographs or in the works of European artists, was his entire modernist program, in which the body's freedom and desires were made to stand for the social freedoms of the individual.

Mothers and Daughters:
Hysteria and Feminine Vision

From the variety of photographs Brigman delivered to Stieglitz, he tailored her image into a figure who was politically useful to him in the contested terrain of modernist Manhattan. In the eyes of Hutchins Hapgood and other cultural radicals, modernism in New York was set in motion by women and revolved around issues of woman's rights and sexuality.[19] It was critical, then, that Stieglitz be able to give his modernism a feminine face to show his alignment with that cultural moment—that break with the past. Selecting only her female nudes for exhibition and publication, Stieglitz made sure that her art solidly contributed to the modernist assault he was launching against middle-class values of materialism and propriety. He encouraged the critics to see Brigman as one who had "studied Cézanne . . . 'on her knees,'"[20] although this assessment had no real validity in her development. To her peers at 291, however, her images clearly looked as if they belonged with those of the "big men," as Stieglitz liked to say, the European modernists he promoted. He had begun grooming Brigman in 1907 for a solo exhibition at 291 that was continually delayed, never to materialize, as Stieglitz constantly redefined his modernism.[21] He exhibited her photographs consistently at Photo-Secession exhibitions from 1904 to 1910 and published her work three times in *Camera Work*, in 1909, 1912, and 1913. With the debut of her photographs in *Camera Work*, the house critic Nilsen Laurvik, giving Stieglitz's official view, set Brigman on a pedestal as

one of the few photographers who "counted," as Stieglitz would later say of her. In the context of 291's running program of Rodin's and Matisse's nudes, Brigman's art was presented as of a piece with theirs. So *Camera Work* admired her as an original and powerful voice whose speech belonged to an elemental, premodern order and was invested with the sublime of nature, its crescendos of mystery, beauty, terror.[22]

These Stieglitz-endorsed accolades made Brigman the new feminine face of the Photo-Secession. She replaced Käsebier in her perch at the top. In a review of the group's work shown in 1909 at the National Arts Club in New York, Laurvik castigated Käsebier for her prints, which looked "tentative in treatment" and "slurred over." If now Käsebier's works had a veiled, aestheticized effect, not conforming to the "straightforward" quality of Stieglitz's, this soft focus had formerly been lauded as a hallmark of Photo-Secession photography. Brigman, meanwhile, was praised as an original who had made a "personal and highly imaginative contribution" that attracted both photographers and the public.[23] Two years later, in the critical essay Stieglitz published as the Photo-Secession's obituary, his close colleague Joseph Keiley found Käsebier inept and disoriented, as we have seen in chapter 1. Juxtaposed with Brigman's female bodies that suggested the sureness of a "true" feminine voice, Käsebier's dematerialized world appeared as an "inner blind groping to express the protean self within—that finer, bigger self that cannot always find voice." That is, hers was a hysterical feminine vision, one that could not find its true self in the female body. In prose that prefigures the Stieglitz-directed reception of O'Keeffe's early work, Brigman's photographs were said to penetrate "the very soul of nature and her entire collection is rhythmic with poetry of nature, its bigness, its grandeur, its mystery."[24]

In reality, Stieglitz's gesture against Käsebier was aimed at a philosophy of life and art that he passionately wished to abandon: she was the matriarch of a movement that had enshrined a late-nineteenth-century worldview. During the years 1908–12, when he began showing European modernism at 291, Stieglitz abandoned his support for the members of the Photo-Secession, damning them as intellectually stagnant and commercialized and eventually even becoming hostile to his former collaborator Steichen. In this respect, the Photo-Secessionist homages

to the figure of the mother as the controlling source of the photographer's vision are indeed striking, as photographers either represented themselves in portraits with their own mothers (for example, Clarence White and Alvin Langdon Coburn) or focused their photography on the maternal world of domesticity. Following Whistler and the spiritualist vision of his art and the world—itself shaped by his mother's religious aspirations—the Photo-Secessionists conceived their images within the terms of matriarchal culture of the 1890s, which refused to grant status to human sexuality as a civilizing and creative force. For Stieglitz and his modernists, the rub with Käsebier lay in the symbolic world of her images, in which the feminine body was either effaced into the ether or claimed by childbearing. But it also had to do with Käsebier herself, who in her person embodied the domineering, full, matronly figure that for the moderns stood for Anglo-American middle-class values, especially that of sexual repression. Hers was the body type that modernism would emphatically reject and replace with the streamlined, adolescent, almost androgynous figure of the flapper—an infantilized body liberated from the constraining effects of corsetry and middle-class demands for reproduction, which the Gibson Girl readily served. Charles Gibson's cartoon *Thirty Years of Progress* (Fig. 49) satirized the change in feminine paradigms, which in his view could not possibly be regarded as evolutionary progress. If in the 1890s that progress was embodied in the shape of the female figure—specifically, here in the Gibson Girl—then the social history of the nation, its rise and fall, could be represented as the history of the female sex.[25] The next historical epoch, in Gibson's eyes, has inverted the former narrative of evolution to champion a movement of devolution—of regression, symptomatically represented in the figure of a child-woman. These images illuminate how the modern debate over feminine sexuality was really a debate about social order and the power of one group or another to control that order.[26] The female body functioned as a symbolic arena, an object each faction bent to testify to its own "natural" vision.

In the panorama of modernist New York Stieglitz's visibility circa 1910 depended on a politics of sexual relations. His modernism was one of many efforts to commit matricide, to possess the figure of desire—the daughter. Adopting modernist sexual collaborations and partnerships with modernist men, modernist daughters

49

Charles Dana Gibson,
Thirty Years of Progress,
1926.

fully rebelled against their mothers to place themselves higher in the sphere of cultural power. For Stieglitz, this symbolic gesture demanded a modern art founded on qualities that were "big," "straightforward," "honest," "virile." A more rigid masculinity was enlisted to purge the masculine self of the mother whom modernists now deemed ornamental, deceptive about female sexuality, and repressive of male sexuality. But a complete break from the past was not successful: even though modernist men staked their own identity *against* the matriarchal culture of the 1890s, they also owed to that same culture their defense of modernism as a higher, purer, more spiritual form of art and experience.[27] So it was the transcendent experience of Rodin's and Matisse's dancing nudes (Fig. 50) that was emphasized in the pages of *Camera Work*—that is, their qualifications for the status

50

Henri Matisse, *The Joy of Life (Le bonheur de vivre),*
1905–6, oil on canvas, 69⅛ × 94⅞ in.

of high art. The figure of the dancer or the nude allowed Stieglitz to relate the
source of art and creativity directly to sexual experience and the life of the body.
Now, as Stieglitz positioned himself as a leader of radicalism in New York, he pre-
sented experimental modernism as a guide to social and sexual liberation.

"Wonderful, Terrible": Modernist New York and Modernist Sexuality

If we examine Brigman's role in this intergenerational drama, we see that her life
and her autobiographical nudes put her squarely between the two generations.
Chronologically, she was Stieglitz's contemporary; she was born in 1869, Stieg-
litz in 1864. By the time she took up photography and went to New York in 1910 to

work among Stieglitz and his companions, Brigman was middle-aged and unwilling to convert fully to their more liberal views of sexuality. Her confrontation with Stieglitz over this issue measures the distance between their versions of modernism, a distance that can be assessed in their differing agendas for the female nude. During these years when the new field of sexology was legitimating the religion of free love in the Village, Stieglitz was moving in parallel motion in promoting a modernist art that boldly flaunted its eroticism. He undoubtedly agreed with the feminist politics of Floyd Dell and Max Eastman that the intellectual and sexual liberation of woman would also set man free. Brigman, however, dramatized a different feminist politics that rejected the utopia of free love.

It is difficult to develop an exact chronology of Stieglitz's exploration of female sexuality. His biographers make clear that from his youth he was obsessed with sex. In the first decade of the twentieth century, however, a science of sexuality supplanted his earlier interest in erotica. Even before Freud's essays appeared in English, the writings of sexologists Edward Carpenter and Havelock Ellis saturated the discourse of Village bohemia. Sexology encompassed a range of positions—from the middle-of-the-road, and therefore more popular, marriage handbooks of Margaret Sanger to the more Whitmanesque pronouncements of Carpenter, who championed homosexuality and androgyny. In particular, Stieglitz was an inveterate reader of Krafft-Ebing's *Psychopathia Sexualis* (1886), Ellis's *Studies in the Psychology of Sex* (1897–1910), and, later, Freud's works.[28] Ellis, who was as influential a sexologist as Freud, created the picture of a natural feminine sexuality that needed to be expressed within the confines of heterosexual marriage. Insisting on gender as biologically determined, Ellis wrote of masculinity and femininity as complementary and polar—a relationship that produced woman as all body and man as all mind. He declared that "in a certain sense . . . [women's] brains are in their wombs"—a sentiment that Stieglitz would later famously echo. In a more liberal spirit, however, the sexologists permitted middle-class women an erotic life that was modest, healthy, and passive but also responsive. Such a "natural" sexuality, they reasoned, benefited from regular expression, in contrast to earlier views that stigmatized women's sexual feelings (except for purposes of procreation) as signs of race, class, and/or moral deficiency. So, through reading Carpenter and

Ellis, women acquired a language in which they could begin to conceive and articulate their own desire.[29]

Most important for aspiring modernists, Carpenter and Ellis linked the creative energy of the artist to the sexual drive. In fact, for the sexologists the erotic life provided the very source of that energy. This revelation underwrote Stieglitz's aesthetics as he turned to the nude as a religion of the body. That science now supported the sexual life as promoting health and happiness gave Stieglitz and Village intellectuals permission to act out aggressively in public a number of erotic practices. For Stieglitz, this meant exhibiting Rodin, Matisse, Picasso, and Cézanne (all shown at 291 from 1908 to 1914), who were understood to picture woman's sexuality as the site of liberation and paradise. He could feel vindicated in abandoning Photo-Secession photography with its Whistlerian strategies of erotic sublimation.

In October 1911 Stieglitz purchased all six volumes of Ellis's *Studies in the Psychology of Sex*, stating to the publisher his particular interest in reading Ellis on sexual modesty in women.[30] This acquisition took place not long after Brigman's extended stay in New York in 1910, a time when she regularly met at 291 with the painters, photographers, and critics who collaborated daily on the gallery's projects. Arriving in mid-February, she had come to look firsthand at the new modernist art and to see how the (promised) exhibition of her work would fit into the program at 291. Brigman had also come to take her place in the elite group of photographers she had joined, the Photo-Secession. But while she was eager to feel herself their peer, she also knew she lacked their technical accomplishment, and she hoped to learn the platinum printing process Stieglitz had been urging her to use since 1906.[31] In April, a mere seven weeks after her arrival, Brigman retreated to a farm in Norwich, Connecticut, indicating the extent to which she felt herself mismatched to Stieglitz's modernism. Her experience of 291 had resulted, she said, in an "overdose of Matisse, Rodin, Hartley, Steichen and all the rest including the Independents." The shock of modernism Brigman registered is echoed in the discomfort expressed by others who had been reared in Whistlerian veiling. Steichen, for one, had a similar response to the Armory Show in 1913. After seeing the show, he returned to his garden world at Voulangis and simply chose not

to put himself through the philosophical transformation modernism required. Becoming a modernist did not mean simply taking up a new style, he told Stieglitz; it meant committing oneself to a revolutionary worldview.[32] As Brigman put it, moving into modernism was "like stepping to a new planet with almost absolute change of food and air." "It has all been very wonderful to me," Brigman assured Stieglitz, "it is a part of the chaos I am passing through." She would return when she was a "little steadier." But she vowed that she would never like "gyrating ladies or Maurers or most Marins or some of those wonderful, terrible de Zayases, Rodins, and Lautrecs."[33] Before returning to California, in October 1910, she spent some time in July at Fire Island, Maine, trying to learn different photographic processes at Clarence White's school there and defending herself and Stieglitz, who was now at odds with White.[34]

In the following years, the brutality of modernist New York softened for Brigman as she remembered 291 through the haze of nostalgia. Not only was she proud of having been part of an important cultural movement, but she claimed New York had transformed her after all. A year later she told Stieglitz that now "there is a vital current in my consciousness running swift and steady that I did not have before. It *was* there. I woke to it." Stieglitz assured her that it had been good for the men of 291 to have a woman among them; she assured him that she revered their camaraderie and the "wonderful terrible city."[35] But passing through the crucible of modernism brought Brigman to a personal crisis, which culminated in her decision to separate from her sea captain husband of seventeen years. She was ready now to live her life in a more unified and honest way, she said, rather than split herself between a domestic relationship she no longer believed in and the life of art she lived without her husband. As she recovered her stability, Brigman schooled herself in the possibilities open to women who were willing to consider freer, more progressive ways of organizing their lives, reading Ellen Key, the Swedish writer on marriage reform, who was popular among Village radicals.[36]

As Brigman reflected on her marriage, she was finally able to vocalize her response to Stieglitz's sexual liberalism, resentfully recalling the raw discussions of sexuality she had been subject to at 291: "You made me ashamed, deep down," she wrote to Stieglitz, "when you talked of those photographs of the Pompeiian friezes

Weber had. I'm pretty clean and unafraid, but they staggered me." She urged Stieglitz to read Carpenter's essay "Love as an Art" (in his book *The Drama of Love and Death*) to learn a higher way of thinking about human sexuality. Writing on the physical act of love, Carpenter employed the same terms of transcendence that Stieglitz reserved for the highest forms of art and experience—as the vitalizing and regenerating force of life—and he lectured that the act of love could not achieve its potential as an effective evolutionary force in individual growth unless it included the entire "complex of human relations—physical, mental, emotion, spiritual, and so forth." Physical love alone lacked the transformative and liberating, even creative force that took over when the physical union engaged an inner or psychic union between a man and a woman.[37]

Brigman's purpose was to use Carpenter to rebuke Stieglitz, to sting him back in kind for the embarrassment and shock she had clearly suffered in the presence of her male colleagues. "When you read this chapter," she told him, "you will know why I quivered and fought against those wonderful terrible french chalk things by De Zayas." Elaborating on her disapproval of these erotic cartoons, she went on: "They are wonderful conceptions of the hideous misuse of our divine powers and holy temples. You've tasted deep of pain, of utter weariness, of hatred of sham. You'll understand it. Your own words are in the very heart of it. 'Purity is a fundamental in all that is worthwhile.' That is a fine thing to think and to say, Comrade—it doesn't mean to be anemic—it means exactly what it means."[38]

Clearly uncomfortable with the eroticism that was revitalizing 291 in these years, Brigman used the nude for a different agenda, one shaped by the dilemmas and opportunities facing modern women in the first decade of the new century. Stieglitz supported Brigman's interpretation of her own nudes, telling a reporter for *Vanity Fair* in 1916 that her work expressed her own life.[39] Rodin's and Matisse's female nudes for Stieglitz implied quite a different scenario—that of the free sexual life of the enlightened age to come. But he did not forget Brigman's upbraiding of what she saw as his schoolboy voyeurism. Her insistence that sexuality must incorporate purity, as she quoted Stieglitz back to himself, came again into play when he later possessed the power to shape the image of the new modernist woman. In Stieglitz's hands, the image of the woman-child would be both pure

and erotic. She would be a daughter who delivered herself over to the father to be formed in his image.

The Dancer, the Speaking Body, and the Modern Woman

Brigman's photographs of the female nude, published and exhibited by Stieglitz from 1906 to 1912, were essential to his concept of how a feminine vision could project woman's experience of modern life. Her nudes showed him how a woman's art could uncover the hidden truths of feminine sexuality as natural. To revive and celebrate an aspect of the human condition that in the bourgeois world was repressed in the unconscious would prove the central problem of Stieglitz's modernism. At a time when psychoanalysis was describing a hidden primitive self as a constituent of the modern psyche, Stieglitz developed a similar narrative in shaping Brigman's career. His house critics took advantage of Brigman's outsider origins, that she was a strange Californian—a woman from another world— juxtaposing her with the more conventional East Coast representatives of femininity published in *Camera Work.* The men at 291 found in her nudes, set in the wildest of landscapes, glimpses into nature's mystery that only a woman could offer—a woman who had dared to live intimately with the primitive, as her photographs testified.

What Brigman was concerned with in photographs such as *Finis* (Fig. 51) and *Soul of the Blasted Pine* (see Fig. 40) was woman's psyche as it could be evoked through a lexicon of natural forms: the female body choreographed to harmonize with rhythmic movements of trees and rock formations. In some images, the female figures perform mystical rituals; in others, they are made to mimic the dramatic movement of twisted pines and junipers. In 1909 Laurvik, speaking for Stieglitz, had found something elemental and primitive—wholly original to Brigman—in her style and regarded her work as "the most personal and highly imaginative contribution to pictorial photography that has appeared in some time." And at the 1910 Buffalo exhibition that punctuated the end of the pictorialist phase of the Photo-

Secession, Coburn and others judged her one of the eight stars of the field of photography.[40] To understand what made Brigman's nudes appear so exceptional within this ubiquitous genre, we can compare her images with those of the Photo-Secessionist Alice Boughton, published in the same 1909 issue of *Camera Work* as Brigman's. Boughton's girl with a bubble (Fig. 52) makes us realize how Brigman has wrenched the female nude out of the tropes of Arcadian sweetness and light to complicate the figure's relation to her surroundings. Brigman's settings for the nude are themselves highly unorthodox—the craggy, ravaged, shattered forms of the sublime rather than the smooth harmonies of the beautiful or the Arcadian reverie. In her narrative nature is not the garden; it does not tell the tale of the civilizing process accomplished by human exertions. Instead, it seems to continue a violence that has already deformed rocks and trees and in which the human figure now participates. Brigman enhanced the tension in her landscapes through the calculated torsion of a smooth, classical female body. These manip-

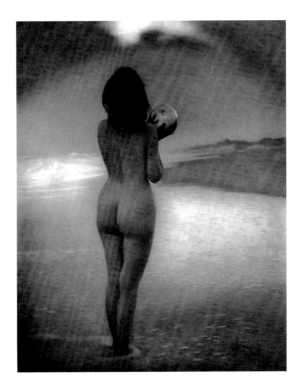

ulations of the nude she explained in terms of her personal history allegorized as
the struggle of modern woman.

Coinciding with Stieglitz's promotion of Brigman's nudes was the modernists'
celebration of Isadora Duncan's dance in New York, also as an embodiment of the
modern woman. Brigman produced her first photographs of the female nude in
1905–6. Duncan, who brought her new form of modern dance to the New York stage
in mid-1908, was probably not Brigman's inspiration. The Photo-Secessionists'
presentation of the female form to theatricalize the feminine psyche, however,
owed much to their fascination with the dancer in whom they could freely study
the female body. From the 1890s on, the stages of Europe and New York were
crowded with sensational dancers, some even hypnotized to perform their sub-
liminal selves when released by music of the orchestra. Among these new artists,
Ruth St. Denis, Loie Fuller, and Isadora Duncan would explore the idea of mod-
ern dance as an externalizing of the inner self.[41]

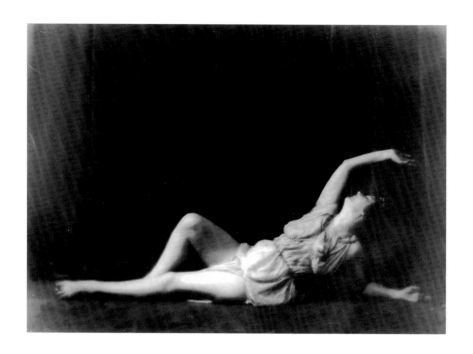

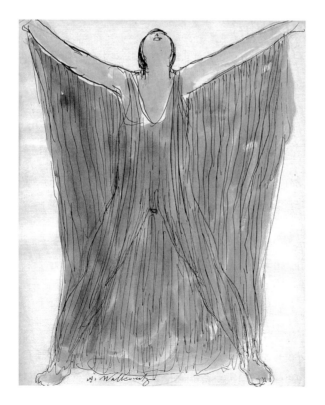

53

Arnold Genthe, *Isadora Duncan (in a Pose from Unfinished Symphony, Symphony No. 7 of Schubert),* 1916, gelatin silver print, 4¾ × 7⅛ in.

54

Abraham Walkowitz, *Isadora Duncan Dancing,* 1910, ink and watercolor on paper, 10 × 8 in.

More than any other, Duncan (Fig. 53) personified "emancipated woman" in the radical freedom of her dance.[42] The response to Duncan's dancing in New York in 1908–9 paralleled the contemporaneous sense of Brigman's woman as projecting a psychic state or mood that corresponded to a larger universal rhythm. Both made the nude their medium, casting it as an elemental body against a cosmic backdrop, so that it demanded to be interpreted as larger than itself—as standing for a collective, universal experience. Duncan appeared on stage seemingly nude. Her costume, a diaphanous silk tunic, with a slit skirt exposing and freeing her legs, was considered scandalously indecent and improper, an affront to balletic convention. The simple full-length blue curtains that were her only stage set alluded to the infinity of sea and sky.[43]

In what she called the "dance of the future," Duncan presented herself as the universal, timeless woman. Having seen her perform in New York in 1911, the artist John Sloan felt that the image she produced stood for "all womanhood"; she was, he stated, "as big as the mother of the race."[44] No longer repressed by civilization, this modern woman's body was now freed to discover a new, sensuous, "natural" relation with the world, akin to that of the Greeks—"the natural society" after whose art she had formed her dance. The irony of this image was that, while Duncan represented herself as a "pure" universal woman, she assigned a premodern consciousness to women, drawing the same picture as that offered by social theorists, anthropologists, and other nineteenth-century intellectuals who regarded women as existing in a psychic terrain outside history.[45] Moreover, her sense of herself as "modern woman" was still mediated by late-nineteenth-century appeals to mind: Duncan promoted her dance as "the highest intelligence—in the freest body."[46] She convinced her vast audience of admirers to look past her personal hedonism, to see her dance as a disembodied abstract principle of beauty.

To demonstrate this notion of the fluid body as a free mind, Duncan developed a technique of creating an undulating line through her extremities, her flowing bodily rhythm suggesting a spontaneous projection of musical mood. The abundant accolades in response to her performances record the success of these effects. Summing up the consensus of critics, Stieglitz's friend Abraham Walkowitz put it simply: "Her body was music" (Fig. 54). Walkowitz's estimated five thou-

sand drawings of her dancing, from 1908 and after, translate her rhythms into flowing line to illustrate the impression of her body as "pure music."[47] The *Boston Transcript*, reviewing her performance in November 1908, wrote that she gave the impression "of disembodied and idealized sensuousness," of a body moving by "steadily and delicately undulating . . . in endless flow. . . . Her dancing is as intangible, as unmaterial, as fluid as are sound and light." If there was such a category as "absolute music," then Duncan's art was "absolute dancing." After watching her performance to Beethoven's Seventh Symphony, Charles Caffin in *Camera Work* echoed her Boston reception, seeing the dancer as "a presence, distilled from the corporeality of things . . . [that] floated in." "The personality of the woman," he wrote, "was lost in the impersonality of her art. The figure became a symbol of the abstract conception of rhythm and melody. The spirit of rhythm and melody by some miracle seemed to have been made visible."[48]

Duncan's movement was thus perceived to flow from her inner state, so that her body seemed merely the vehicle for expressing the unconscious. Stieglitz would later employ Duncan's projection of essential femininity in his image of O'Keeffe as *the* woman artist, similarly insisting that her female sensuality was nonetheless pure. Both Duncan and her critics, in contrast, denied any erotic appeal in her dance, possibly in part to separate her dance from the scandal of her private life, in which she practiced free love.[49]

For the male modernists in the Stieglitz circle, it is difficult to overestimate Duncan's impact on their idea of modern feminine sexuality. Walkowitz and Rodin were just two of the artists Stieglitz exhibited between 1908 and 1912 who were fascinated with Duncan's body as a form that spoke of woman's beauty and mystery. When she danced in New York during these years, she became acquainted with many of the most important figures in modernist circles. In fact, Edward Steichen, Stieglitz's closest associate in building the modernist program at 291 in these years, was Duncan's close friend. In 1909 she reportedly danced at Steichen's villa garden in Voulangis, France, and possibly became his lover.[50] That same year Stieglitz's colleagues compared her new "primitive" form of dancing to the "primitive, elemental feeling" of Matisse's art. The relationship of her dance to painting, the way in which a woman's body, like Matisse's painted forms, could be composed to

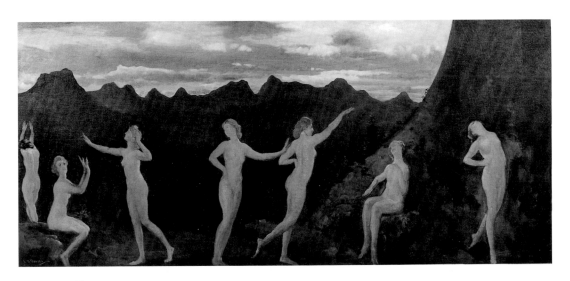

55

Arthur B. Davies, *Crescendo,* 1910, oil on canvas, 18 × 40 in.

express the modernity of life, was important to Stieglitz then and for years after as he continued to argue the point.[51]

Certainly, the relationship between dance, the female nude, and modernist art formed the basis of painting for Arthur B. Davies, organizer of the Armory Show. Stieglitz, who bought a Kandinsky painting from that landmark exhibition, also acquired there one of Davies's pastels, a drawing showing Davies's mistress, the dancer Edna Potter, reading in bed in a state of semiundress. Davies's paintings of the female nude dancing through the landscape are reminiscent of Brigman's images, although they engage the nude's harmony with an Arcadian landscape. Davies was familiar with Duncan's dance: his *Crescendo* (Fig. 55), painted the year of Duncan's triumphal New York debut and purchased by Gertrude Vanderbilt Whitney the following year, presents a number of slender nudes whose outstretched limbs undulate sinuously across the canvas to harmonize with the rising and falling line of mountains in the background. In that same year George Hearn acquired Davies's *A Measure of Dreams* (1908) and gave it almost immediately afterward to the collection of the Metropolitan Museum of Art. The sale of Davies's nudes for large amounts of money beginning in 1909, as in the case of Whitney's and Hearn's pur-

chases, points to the currency of the modern dance for New York's elites. More-over, Hearn's sleepwalking nude and its companion image of dreaming women, *Sleep Lies Perfect in Them* (1908), underscored once again the still common as-sumption in modernism that the instinctual life of the female body was seamlessly connected to the instinctual life of nature.[52]

The focus on the female body in modernist New York as the dancer or as the nude in painting and photography indicates how these imaginary figures circu-lated as emblems of a new social force. Modernist men in New York perceived fem-inine sexuality as the motivating energy behind modernism, as the new woman liberated herself—and men along with her—from the old constraints of civiliza-tion. As Duncan remarked of herself, she danced, not in a nudity of the primitive, but in a "new nakedness" in which body and mind were one. The female body, in short, was read as the source of the civilization to come. Significantly, among Dun-can's New York audience the sense was growing that woman now needed to dance her own role—the "purest expression" of herself in the scenario of modern life—in order to free herself, as Duncan said, from the enslavement of old sexual cate-gories, rejecting all traditional, eroticized roles, whether of wife or courtesan.[53]

"Woman Unafraid": The Woman in the Nude

Reminiscing about these heady years of personal and social transformation, Amer-ican modernists penned autobiographies in which a core self evolved over time, to free itself from its internal repression and realize its full expressive potential. This set narrative served especially well to relate the changes in women's social roles.[54] Anne Brigman gave her female nudes this same autobiographical trajec-tory of a flight away from repression toward evolution of consciousness. To Stieg-litz and contemporary interviewers, Brigman told her story of making the photo-graphs in the wild landscape of the Sierra, posing herself and her sister for these works. Emphasizing that it was her own body, or her sister's, in her photographs was her way of claiming her images as her own story of metamorphosis. The ex-perience of making the photographs at the site, Brigman said, produced a kind of

exhilaration, a psychic liberation. Her model of creativity was one in which the resources of the deep self were mined, and in this way her idea of photography agreed with Stieglitz's notion of aesthetic experience as personal liberation.

The snapshots of herself Brigman sent Stieglitz during these years (Fig. 56) mirror the attitudes of her nudes (Fig. 57), as if to authenticate her women posed in the wild as disclosures of her own interior landscape. The female body functions as a feminine voice that speaks for Brigman and, by analogy, relates the story of other women who were questioning woman's conventional domestic role, a role premised on a feminine nature assumed to be inherent in the female body.

As we have seen, Brigman wrote to Stieglitz of how struck she had been with the way Demachy had made the nude of *Struggle* convey its own story, the way the movements of the form "show how bravely her will is fighting against the odds— but every line and curve show how ill prepared sensitive high born woman is capable of struggling."[55] It is evident that she was recognizing herself in the image as a sensitive, highly educated, and highly aspiring woman. It took Brigman at least two years to transform Demachy's figure into a stand-in for herself, and in the interval she kept producing the standardized portraits and ideal figures that recall the Photo-Secessionists' women in white.[56] We might say that her second formative moment came during her hiking trip through the High Sierra in the summer of 1906, when, studying the oddities of the rock and tree formations, she suddenly "saw things." What Brigman recognized in these forms was, again, herself, her emotional landscape, so that wedding the natural landscape to her body offered a way of explaining herself.

In a memoir she described the discovery that resulted in her best-known images, *The Dying Cedar* (Fig. 58) and *Soul of the Blasted Pine* (see Fig. 40):

> All trees are beautiful or strange but not all are pictorial. I learned how and where to look for trees by the trend of the prevailing wind and the contour of the storm-swept glacial wastes . . . and then I found glorious ones without any of these apparent indications . . . each find, an ecstatic experience of breathless wonder . . . some times from a distance, some times in a turn in a rocky ledge . . . and my heart missed a beat.
>
> Into these tree and rock forms the sensitive yet hardy feminine figure took its place with sculptural fitness.[57]

56

Anne Brigman, *Self-Portrait–On the Beach,* ca. 1909–10, gelatin silver print.

57

Anne Brigman, *Dawn,* 1909, gelatin silver print, 5¼ × 10¼ in.

58

Anne Brigman, *The Dying Cedar,* 1908 (negative, 1906),

toned gelatin silver print, $9\,^{3}/_{8} \times 6\,^{3}/_{8}$ in.

59

Anne Brigman, *Self-Portrait with Sister and Guide in the High Sierra,* ca. 1912, gelatin silver print.

The "sensitive yet hardy feminine figure"—whoever the model—is a surrogate for Brigman. Her women companions on the trip (Fig. 59) resemble Brigman in physical appearance, so that at times it is difficult to tell whether the nude model is Brigman, her sister, or her friend—and their responses to the spectacle of nature there are also her responses. The artist is thus always both inside the frame of the image and outside it, as subject and object.

In this meditation on her weeks spent in the wild, Brigman relates how experiences of pain and beauty, evoked in her photographs from these trips, led to her personal growth.

Who can experience such days and not grow into new dimensions of body and thought, selfless and unafraid.

They were wonderful days of hard going, of happy freedom, of comradeship, of endurances through hail and rain and bone-chilling aftermaths . . . and then into summer weather of sunny glory and bird songs and wild flowers and the magnificent, twisted trees.[58]

She seemed to think of these experiences as preparing her for her separation from her husband after she returned from New York. This event created a dividing line in her reflection on her own life and her photography, and it proved to be a watershed in her willingness to personalize her narrative of her images, whereas she had earlier assigned them universal emotions.[59] After a complete breakdown in 1911, she went back to her therapeutic hikes in the mountains in the summer of 1912. Thereafter she spoke of her photographs to Stieglitz in a manner recalling her description of her breakdown and recovery: evoking one of her summer studies reminiscent of *Soul of the Blasted Pine*, she wrote, "It treats the passionate struggle of the evolving consciousness—the fight for clean, strong freedom of body and soul—which are one."[60] Faced with rumors that she was about to divorce her husband, Brigman came out in public the following year with her story of personal crisis and liberation. In an interview with a reporter for the *San Francisco Call*, she now linked the crisis of her marriage to her photographs and to the larger fight for woman's social freedom:

Fear is the great chain which binds women and prevents their development, and fear is the one apparently big thing which has no real foundation in life. Cast fear out of the lives of women and they can and will take their place in the scheme of mankind and in the plan of the universe as the absolute equal of man.

Women are, and always have been afraid, and ordinarily they do not know what they are afraid of. They fear lest some of the little things of their domestic drudgery will go wrong and lead to some little inconvenience. They are afraid of their families when they are present and when they are absent. They fear to make changes and that is why they do not change, and why they do not develop. Intrinsically, women are the exact equals of men, and men of women, but women are afraid and men are not. Part of the cure of fear in women is making changes. A man gets changes by going down town to his daily work, but a stay at home woman does not and she suffers and grows afraid of things being different than what they are, or what she thinks they are.

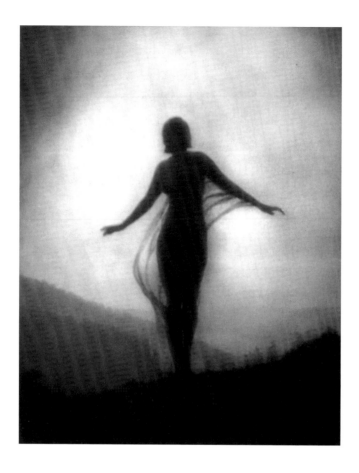

60
Anne Brigman, *The Breeze,*
1918 (negative, ca. 1910),
gelatin silver print, 9 ¾ × 7 ¾ in.

Recounting her own free, unconventional relation to the landscape, Brigman made her new feminist interpretation of her nudes explicit: "My pictures tell of my freedom of soul, of my emancipation from fear."[61]

Brigman's confessional mode and her retrofitting of her entire production within its scope prompted Stieglitz in 1916 to follow suit and explain, for an article on Brigman in *Vanity Fair*, her early images of feminine struggle in the light of the personal troubles she had kept secret for many years.[62] *Via Dolorosa* (see Fig. 44), a photograph made at the time of her lingering postseparation crisis, features a nude who is clearly Brigman clinging to a rocky cliff, her body twisted into a tortured configuration that echoes the tree to her right. *Finis* (see Fig. 51), another photograph she made during this period, evokes resignation to the finality of a phase

of life. These images fit easily in her new narrative of psychic struggle. Other images from about the same time, such as *The Breeze* (Fig. 60) and *Dawn* (see Fig. 57), with their female bodies arranged balletically to float vertically or horizontally at the heights of a mountainous bluff, register Brigman's euphoric moments in the wild. In both prints the reciprocity of woman's body to nature suggests a feminine nature in harmony with itself.

Brigman told Stieglitz that the essays of Ellen Key had helped her get through her crisis.[63] Key's book *Love and Marriage*, published in New York in 1911 and reprinted four times in that same year,[64] was a favorite of intellectuals and thousands of middle-class women. According to Floyd Dell, Key's broad appeal lay in the fact that her feminism was at once radical and conservative: she recognized the need for freedom yet held up the "spiritual ideal of monogamy"—the love of one man and one woman—as the highest social and spiritual ideal. The "spiritual magic of sex," Key said, was the "finest achievement of the human race" and should serve as a "central guiding principle of social and economic evolution." Key spurned the legal obligations of marriage and instead promoted the right of women to motherhood, regardless of their marital status; the right to a passionate love that was both spiritual and physical; and the right of soul mates to full unity in a "trial marriage." While her preservation of monogamy seemed tame to a radical such as Dell, he acknowledged that her liberalizing of marriage salvaged the "truest human values" while offering the changes for which middle-class women hungered.[65] This vision of human sexuality, and specifically feminine sexuality, would have appealed to Brigman as she strove to recuperate the female body both in her personal regimen of exercise and in her imagery of that body as natural. As her correspondence with Stieglitz discloses, Brigman's embrace of the body, far from being hedonistic, required an aesthetic distancing, a spiritualizing gloss. As in Duncan's dance, the movements of Brigman's women staged an interior landscape of soul and intelligence.

The strength and virility of woman's body were important to Brigman's sense of her social freedom—a condition that she obtained and expressed through her relationship to nature. In a photographic self-portrait accompanying her essay on this very subject, "The Glory of the Open," she poses with hand on hip and bobbed

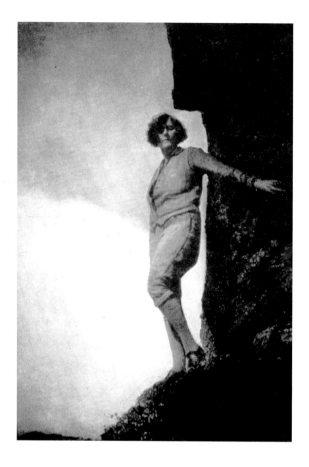

hair (Fig. 61). Dressed in knickerbockers and hiking shoes, she stands assertively on a cliff overlooking a vast distance. Brigman followed this image with her meditations on verses from Walt Whitman's *Leaves of Grass* and Edward Carpenter's poem cycle *Towards Democracy* as a means of reflecting on the meaning of her nudes. These volumes, which Brigman carried with her on her trips, constantly supported her belief in the divine relation of the human body to nature. In the lines of the Whitman verse she selected, the body is released into the boundless air and shares in nature's freedom and transcendence. In those from Carpenter, the nude is pictured in nature as an object of contemplation—the human body as aesthetic object juxtaposed with the aesthetic forms of nature to elicit their likeness in their divine perfection.[66]

The poems set up two positions for the body in nature, as a contained, aesthetic object and as part of the boundless expanse that is the world. This dichotomy between the self as circumscribed or free comprises the alternating conceits through which Brigman saw her nudes acting out woman's dilemma. To function as struggling or liberated figures, she made her female bodies merge with the forms of fantastically twisted and distorted trees and brutal boulders. The wild landscape of the Sierra supplied the requisite natural forms in a way that the garden world that she had readily at hand outside her Oakland studio could not have. Brigman's setting—a sublime mountainous world of disorder and chaos—envelops the human figure, so that the nude is swept into movements that parallel those of natural forms, rhymings that evoke struggle (the twisted tree) or musical harmony (the undulating lines of mountains and rocks). She wanted the viewer to sense an experience of the individual body in relation to nature's dynamism and formlessness, which overwhelm the human with their cosmic immensity.[67] Brigman's nudes at times are so wedded to their counterparts in nature that at first glance they are difficult to see. Yet the female form does not merge completely with nature; it does not transcend its own limits. It mimics nature to join with it but retains a separate identity. *Soul of the Blasted Pine* projects this ambivalence. The female body is strongly delineated at its contours; is the woman therefore meant to be breaking away from nature (that is, defying her own feminine nature)? Or is her body, as it merges with the tree, meant to be perceived as harmonizing with a free, wild nature as to resist the restricting world of human culture beyond? Both meanings are plausible in the context of the artist's avowed feminist framework for her photographs.

For Brigman's landscape—although wild—is, however, a product of culture. Her study of Japanese design yields in each photograph a sense of spatial proportion, balance, and control. These are qualities that compose the experience of the world as a miniature—the closed world of the cultural and the interior space of the domestic, in contrast to the big, undifferentiated space of the gigantic, which is awash in a field of unintelligible forms. So, while Brigman means to address woman's quarrel with what is culturally deemed her "nature," she still relishes the beauty of the nude and what she implies to be its natural musicality in the order of nature. In this respect, her female body is also profoundly cultural; its aestheti-

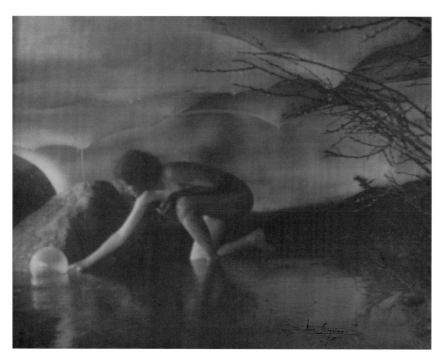

62

Anne Brigman, *The Bubble,* 1910, gelatin silver print, $9^{7}/_{16} \times 7^{1}/_{2}$ in.

cizing renders it as still life. Even in its twisting exertion, this nude is undistorted by the psychic trauma it supposedly externalizes. It remains the ideal of the dancer's body, classical and static.[68] Brigman thus projects her body as a paradox: she treats it as a transcendent aesthetic form and hence as a cultural object that obeys the traditional norms of femininity; but as a hieroglyph conditioned by extreme states of joy or pain, her nude also engages her desire to contest those social norms.

Ultimately, the distance between the viewer and Brigman's small female figure shapes the experience of her landscape as a miniature. As viewers, we are not positioned inside the body displayed there, to experience its plight of struggling against gigantic forces. We are placed outside the body, at a considerable remove from the nude, watching it perform its dance. It is through the mechanism of distancing—with its consequent idealizing and miniaturizing of the form—that the body becomes doll-like and endearing, enabling desire and opening itself to the control of others.[69]

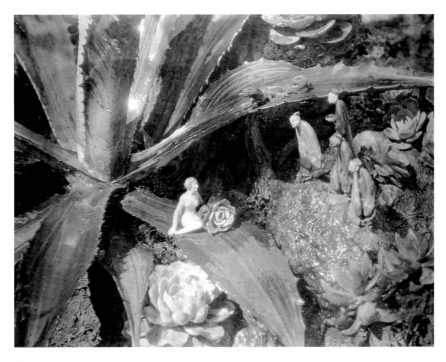

63

Anne Brigman, *Aloe with China Nude with Sages,* after 1915?,
recent print from original nitrocellulose film negative.

Perhaps Brigman later realized the resemblance of her nudes to the imprison-
ing world of the dollhouse. When she seldom traveled to the mountains to pro-
duce her landscapes, she created a number of humorous parodies in her studio.
These miniature tableaux feature a porcelain female nude, reminiscent of her own
figure in *The Brook* and *The Bubble* (Fig. 62), now sitting on the leaf of an aloe plant,
greeting four porcelain Chinese sages (Fig. 63). The figures offer a retrospective
fantasy on her own career as her ideal but vulnerable body is confronted by these
little patriarchs in a playful manner that approaches the surreal. One of these par-
odies is titled *Susanna,* suggesting the biblical story of Susanna ogled and falsely
accused by lecherous elders; here Brigman represents herself, typically, as her own
object and subject. But now into what was her private space intrude the critical gazes
of the wizened sages—whom, we can only think, she imagined as proxies for her
controlling mentor, Stieglitz, and his colleagues at 291.

Struggling for Technique, Controlling Identity

Stieglitz was one of a number of male modernists who acted as male feminists. To Brigman, he was the guardian of her career—hovering between paternal nurturance and control. To grasp the complicated relationship of Brigman and Stieglitz, it is productive to consider his role in shaping her career and technical growth. A self-taught photographer, Brigman had to work hard to master her medium. Her images, staged at the site, were generated from small, 4 x 5 negatives that were subsequently reworked through an elaborate sequence of internegatives and interpositives, both printed on sheets of film, before the final printing on bromide papers. At times, she eliminated unwanted details, scraping out with a stylus to make the landscape more abstract. At other moments, she painted on these intermediate positive and negative images on film, adding striations to develop rhythmic draperies and white pigmented clouds, reinforcing the distortion of form, or enhancing the sense of obscurity and brooding mood. But she never used a composite process—that is, from multiple printings of two or more negatives—as some critics charged.[70] Stieglitz felt compelled to defend her from accusations of "artistic monkeying with the plates" in his premier presentation of her work. He explained that her technique was to enlarge and refine the negatives but that the negatives were not the products of a "studio fitted up with papier-maché trees and painted backgrounds."[71] At one point Brigman expressed her appreciation that Stieglitz had never condemned her method of manipulation: "You have never said a word, yea or nay, about my free use of pencil and graver, but you know that I am after an 'illusive thought' and not a method." Her method was defensible, she said, "as long as . . . my ideal predominates."[72]

The truth was, however, that Stieglitz was never happy with Brigman's technique, and in 1906–7, when he was grooming her for her solo exhibition at 291, he pushed her to work in the platinum process, the favored printing medium of the Photo-Secession. Presumably, Stieglitz wanted her to move away from the dark, murky shadows of her bromide prints toward platinum's delicate luminosities and subtle intermediate tones, which were fundamental to the collective identity of the Photo-Secession. Even after she had learned the platinum process in New York in

1910, Stieglitz wondered whether the time Brigman had spent "putting in acquiring technique is worthwhile." Although her technique had advanced, he admitted that her new prints were "no finer than some of the old bromides." At one point while she was at 291 and could compare her images directly with those of the other Photo-Secessionists, she forced Stieglitz to assess her photographs with brutal frankness. "The *way* you did them was *rotten*," he acknowledged, "but they were a new note—they were worth while." Brigman consoled herself with the thought that although she could not "attain the velvet and pearl texture of a Steichen, or White, or Eugene," Stieglitz still gave her the ultimate compliment: "You are yourself," he told her, asserting a claim for her that he would continue to uphold until his death, that she was one of the few originals in the field of photography. "As I have written to you so often," he assured her, "I consider you one of the very few photographers who have done any individual work."[73] Such a statement, coming in 1914, when Stieglitz had no use for the Photo-Secession, was high praise indeed.

There is no question that Stieglitz put Brigman on the map of modernism in New York. With her consent he had shaped her artistic identity, so that she was known exclusively for her landscapes with nudes, even though she had explored a broader range of genres. By posing herself for many of her nudes, Brigman underscored the highly personal content of these images, letting her body speak for her. Stieglitz presented her as a feminist photographer who had seized the language of Cézanne for her own purposes. Even after he finished promoting the Photo-Secession, Stieglitz continued to act as Brigman's agent in New York, representing her in negotiations to publish her work.[74] And while she only too happily gave him a large measure of control over the selection, interpretation, exhibition, publication, and sales of her photographs, she tensely negotiated with him over their titles and his interpretation of them when he printed her negatives as photogravures for *Camera Work*. Too often he allowed others to change her titles, or he changed them himself if he felt they were too literary.[75] She was also anxious about the printing of her *Soul of the Blasted Pine* in *Camera Work*, telling Stieglitz to keep the "features indistinct" and blur them into soft forms as she did.[76]

Yet Brigman always agreed with Stieglitz's assessment of her work, no matter how harsh, and she accepted his decision to make her nudes alone represent her

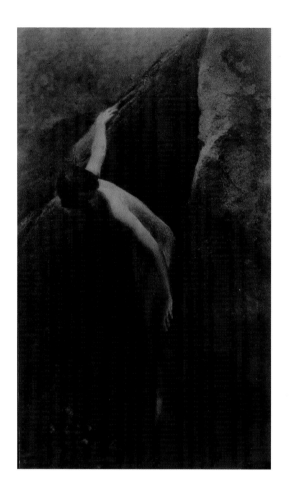

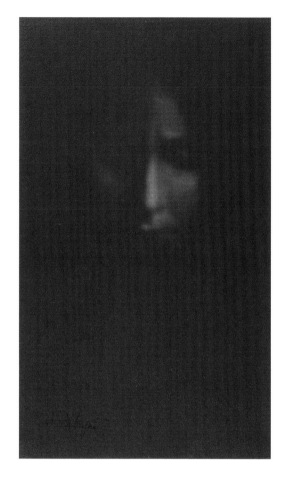

artistic identity, even though this meant that as early as 1908 she felt pressured to repeat herself in her compositions.[77] While her landscapes were interpreted as offering an image of woman freeing herself from the past, there was also another, suppressed side of Brigman's work that was darker and more resigned in mood. In *The Cleft in the Rock* (Fig. 64), for example, the female figure emerges from a dark space in the earth, suggesting that this mysterious, V-like fold in the earth's surface is her natural home, a shadowy abyss that, for Brigman's Photo-Secessionist colleagues, would elicit the strange space of woman's psyche. This idea of woman's essential self as deeply engaged in nature's darkness takes its cues from the Symbolist motifs circulated in Photo-Secessionist works such as Käsebier's *The Bat* of

64

(Opposite, left) Anne Brigman,
The Cleft in the Rock, 1905,
gelatin silver print, 9⅝ × 5¾ in.

65

(Opposite, right) Anne Brigman,
*Minor, the Pain of All the
World,* ca. 1906–10, bromoil
print, 9¹⁄₁₆ × 5¼ in.

66

Anne Brigman, *Sphinx,* 1927,
gelatin silver print, 9⅝ × 7⅝ in.

1902. Brigman continued to cultivate this darkness for her artistic identity in self-portraits such as *Minor, the Pain of All the World* (Fig. 65). The veiled androgynous face registers a suffering that Käsebier attached to motherhood. Brigman, however, now attaches this pain to the essential saga of woman, regardless of her status in bourgeois culture. In *Sphinx* (Fig. 66), another self-portrait, Brigman juxtaposes a life mask of her own face with a small head of a Buddha, as if the suffering has led to an evolution to a more enlightened state of being—one that is distant, impersonal, and unknowable for other human beings. Possibly Stieglitz recognized an occult dimension in these portrait heads, since Brigman's theosophical and New Thought beliefs can be implicated here.[78] But even if these dark images of woman

incorporating pain and strangeness at her core were not exhibited or published by Stieglitz, they still left their legacy in his ultimate conception of woman as unfathomable and shape-shifting, the portrait of his universal woman, Georgia O'Keeffe.

Brigman's Legacy

Stieglitz's praise of Brigman's work in 1914 also sounded her epitaph in modernism. He made it clear that her moment in the field of photography was over, as was the Photo-Secession's. Since his first sight of Brigman's nudes in 1906, when they appeared to him as fresh and original statements of the feminine self, the sexual politics of modernism in New York had changed. The utility of a personal alliance with a woman artist who could reveal her femininity in the new eroticized terms of modernism in 1914 had become apparent to Stieglitz. In the 1910s, however, Brigman continued to repeat her earlier compositions. *Sanctuary*, for example, which she made in the Grand Canyon, restaged her earlier works such as *Incantation* of 1905, and on a trip to the Sierra in 1926 she revised *Soul of the Blasted Pine* into *Invictus*.

Her impact on the generation of California photographers who followed her is not in doubt, however. Women such as Imogen Cunningham and Louise Dahl-Wolfe began their careers imitating her nudes—"doing Anne Brigman." By appropriating the female nude she gave these women a way of owning their vision, as they photographed themselves nude, or of owning desire, as in Cunningham's photographs of her husband as a nude in the landscape. Brigman's nudes provided men and women photographers with a way to represent their relation to vision, as both object and subject, since the photographer is present both inside and outside the frame. The patriarch of California photographers, William Dassonville, was playing on Brigman's nudes when he posed fellow photographer Don Oliver on a rocky outcropping, stripped to the waist and sandwiched between his tripod and a splintered but massive tree trunk (Fig. 67).[79] Here Dassonville twists Brigman's landscape of contorted and beaten natural forms to rework her terrain into the

67

William Dassonville,
*Don Oliver Photographing
the Sierra Nevadas,* 1939.

terms of a muscular, masculine photography. The presence of the camera here, as it is aligned with Oliver's body, makes explicit what was implicit in Brigman's nudes as psychological self-portraits, that the photographer's own subjectivity is the object of vision.

Giving up her nudes in the 1920s and 1930s, Brigman was led by younger California photographers such as Cunningham to produce a group of studies focused on botanical forms and sand erosions on southern California beaches, framed as she had composed her female bodies—as simplified, rhythmic arrangements across the surface of the picture. She had always spoken of her pantheist beliefs when talking about her landscapes, emphasizing her sense of herself as a primitive and free soul. But now her intensifying spiritualism directed her production of cloud images, similar to Stieglitz's *Songs of the Sky.* None of these later works received the kind of public exposure her photographs had been given when she was under Stieglitz's wing.

During World War I, Stieglitz had turned his efforts to creating an American modernism that could stand up to the European art he had been showing at 291.

Vital to this effort was his search for a woman artist who could dramatize and reveal her inner life in a form that would mirror the efforts of his male modernists as they explored with a new directness the unconscious mind as the source of creative and sexual energy. Brigman was not this new woman who could embrace and reveal her sexuality. Faced with Stieglitz's interest in erotic art in 1910 and after, she balked at such frank expressions, requiring a spiritualizing gloss for the life of the body, just as she balked at the fracturing idioms of modernism, whether in Hartley's and Marin's abstractions or in Duchamp's ironic view of human sexuality.[80] The story of Brigman's relation to Stieglitz lay in the turn-of-the-century struggle of the "new woman," the feminist who rejected patriarchy and the demands of heterosexual marriage, to assert control over her own life and career. Brigman and Stieglitz belonged to the same generation, yet Stieglitz would remake himself to conform to the image of the modernist sons and daughters who through sexuality would reform the repressive ways of the older generation. The Photo-Secessionists, including Brigman, could not follow him there. For companions in search of an erotic modernist utopia, Stieglitz would have to find younger men and women—generationally, his sons and daughters.

Anne Brigman's images of the free, natural female body were crucial to Stieglitz's evolving conception of a feminine voice that would articulate the hidden life of modern woman—the secret truths to be revealed in baring her sexuality. Personally, Brigman projected the new ideal of the modernist who fearlessly lived each day as an adventure. Her exploits camping with other women in the wilds of the High Sierra, unprotected by any man, confronted Stieglitz with a living example of the vitalist philosophy that he was turning to as the rationale for his modernism. No other member of Stieglitz's circle even began to approach Brigman's break with the past in the latitude she permitted herself to move outside the codes of femininity. Here was a modern woman unafraid to be alone, stripping herself of the frivolities and conventions that defined the bourgeois world of domesticity to face the extremities of nature—heat, cold, storms, and a basic diet of nuts, berries, and fish. The snapshots of herself that she sent Stieglitz from these adventures helped him to visualize a woman in the new terms of vitalism: hiking to the highest peaks, reinvigorating her already strong and athletic body, drinking in the transcendent

experience of cold, clear mountain air and water. Equally daring for that moment was Brigman's act of leaving her husband and, in that move, her public rejection of the domestic order for a life devoted to her self-fulfillment. This was a move that Stieglitz, himself desperately unhappy in his own marital relations, desired to make, though he could not bring himself to do it for another ten years.

Nonetheless, Brigman's life, and her photographs as allegories of her life, taught Stieglitz much about the body's regenerating power that would become a central thematic in his modernism. To the best of his ability, he imitated her return to primitive experience in the Sierra during his own period of crisis at Lake George in 1914–15. He wrote to Brigman of the "tremendous reality" of his solitary midnight swims and the "glorious rest" as he enjoyed the out of doors.[81] Alone at the family's summer home, free to enter a fantasy life, Stieglitz began to feel alive again in allowing himself pleasurable sensations of nature acting on the body.

Stieglitz had given Brigman a place in the history of photography. Because he edited and shaped her work for publication and exhibition, promoting only her nudes, Brigman's legacy to the women modernists after her was contained in that group of images. What separated Brigman from Stieglitz, however, was her refusal to go beyond the problem of sexuality as it had been framed by the first generation of feminists. In Stieglitz's eyes, Brigman's work could not transcend its origins in a late-nineteenth-century worldview: her photographs responded to a feminist vision that recuperated the body but saved it for a female separatism. Brigman's nude was a sign of woman's quest for political power rather than the new "quest for sexual pleasure." Both men and women modernists of the 1920s rejected this separatist female world for the emergent modernist landscape supporting the libidinal feminine psyche—a typology predicated on free heterosexual relations that respected the demands of modernist patriarchy. Like Charlotte Perkins Gilman, Brigman addressed the liberation of restless women as an economic and political question rather than as the issue of free love that consumed the New York modernists of the 1910s and 1920s.[82]

From Brigman, however, Stieglitz learned the major strategy he would use in presenting his modernists as authentic voices of the universal male or female self, for in Stieglitz's modernism the authentic voice was explicitly gendered, as we will

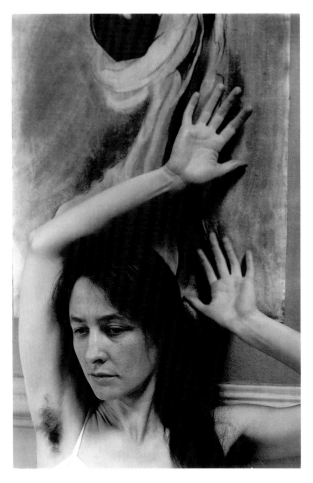

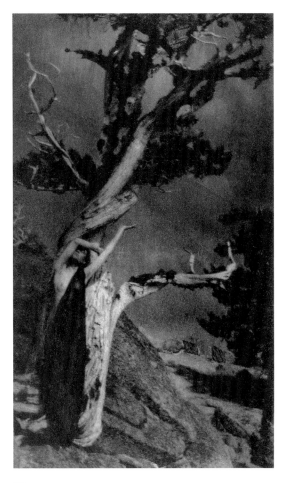

68
Alfred Stieglitz, *Georgia O'Keeffe*, 1918, gelatin silver print, 9¼ × 6¹/₁₆ in.

69
Anne Brigman, *The Dying Cedar*, 1908 (negative, 1906), toned gelatin silver print, 9³/₈ × 6³/₈ in.

see. Brigman taught him not only that the artist could represent the self as literally present in the work, rather than just standing behind the work as an imaginative mind, and that the body was key to visualizing and liberating a repressed inner voice—the central struggle of being modern. Stieglitz could see his own story in Brigman's marital woes, and her photographs of herself baring her body as a baring of her soul set the stage for what Stieglitz would promote as the paradigmatic act of modernist self-revelation.

Most important, her photographs taught Stieglitz how to stage O'Keeffe's body as speaking its secret, inner life a few years later when he created his iconic woman modernist. In early 1918, after closing 291, Stieglitz told Brigman that in his tiny room below the old gallery he was enjoying himself, sifting through his collection of her photographs. "I'm so glad to have them," he wrote. "They are a real pleasure. And I have been showing them too to people."[83] A few months later, he was photographing O'Keeffe, arranging her bare arms twisting through space to recall Brigman's new woman (Figs. 68 and 69, *The Dying Cedar*, 1906). Here Stieglitz had O'Keeffe perform the "natural woman" to authenticate her works as utterances from her unconscious self—that is, her body. Although in his image of O'Keeffe Stieglitz reworked Brigman's feminine identity, stripping it of its grand Romantic antecedents, it was nonetheless Brigman who had tutored Stieglitz in how to orchestrate the female body to make it evoke an imagined feminine sexuality. In 1919 he wrote Brigman again of his photographic sessions with O'Keeffe, tacitly admitting that he was reinventing Brigman's nudes twisting through space like trees: "Clean cut sharp heartfelt mentally digested bits of universality in the shape of Woman—head—torso—feet—hands—Even some trees too—just human trees—new ideas all."[84]

In contrast to Stieglitz's portrait of O'Keeffe, the artist as an eroticized body, Brigman had remained ambivalent about the myth of the feminine as a body, attempting to own it as an idea while distancing herself from its actual corporeal existence. Stieglitz, however, would conceptualize O'Keeffe as the woman modernist who created out of her unconscious body. This fantasy figure illustrating the regenerative powers of feminine sexuality had to be theorized and visualized to explain the promise of O'Keeffe. Such was the work of the woman-child, a phantom that Stieglitz in 1914 imagined would lead him back to his own child-self.

70

Edward Steichen, *Katharine Nash Rhoades,* ca. 1912–14, platinum print.

The Feminine Voice
and the Woman-Child
Katharine Nash Rhoades and Georgia O'Keeffe

"When the world began to change, the restlessness of women was the main cause of the development called Greenwich Village, which existed not only in New York, but all over the country."[1] So recalled the cultural radical Hutchins Hapgood of the force that begat the subculture of New York's modernism. Whereas the Village in the 1890s had fostered a genteel literary and artistic culture, in the second decade of the twentieth century it was transformed into a social space that supported a more adventurous life outside the norms of middle-class propriety, a place where artists and writers could adopt alternative identities and women could explore a new sexuality with each other or with men. As we have seen, Brigman did not flourish in New York, away from the West Coast terrain where she was free to write her own modernist narrative rather than adopt Stieglitz's. She was not interested in experiencing a new sexuality, at least of the kind that permeated the talk at 291. Her Oakland studio home was the halfway house of a feminism that allowed her to develop as a professional and work in the public arena. But that vine-covered cottage did not admit lovers, and Brigman employed her strong exercised body in her art as an abstract form that related the struggle of her soul.

The year after Brigman's confrontation with the new sexuality at 291, a younger woman whom Stieglitz would attempt to fashion into his ideal woman modernist over the next five years appeared at the gallery. Her name was Katharine Nash Rhoades. A tall, elegant, well-bred New Yorker, on the surface she personified the assertive physicality and restless intelligence of the new woman. Among the many striking photographs of her are two made by Steichen, probably in the summer of 1912 when she visited his villa at Voulangis outside Paris (Figs. 70 and 71).

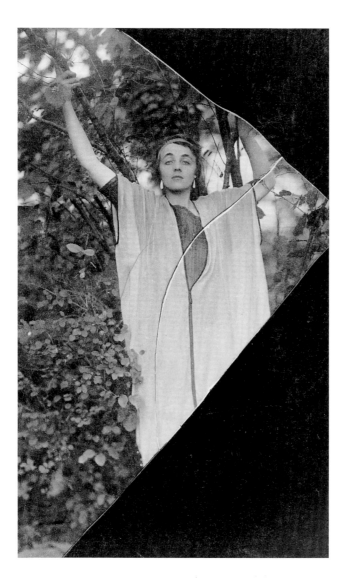

These images encompass the conventions of woman as nature and woman as culture. In the picture of Rhoades dressed in summer white in Steichen's garden paradise, she looks modestly down, away from her observer's gaze, gently caressing heavy stalks of amaranthus to her breast with long elegant fingers that resemble O'Keeffe's.[2] Her dark hair and brows and strong facial structure also prefigure O'Keeffe's stark beauty; yet Rhoades has a softer look that is due not only to her

rounder face but here also to Steichen's diffusion lens. Such effects are completely absent in the other image, in which she confronts us with a directness that is startling and towers over us as she reaches up to align her body with the tree behind her. Dressed here in Grecian-style Fortuny robes, similar to those in which Isadora Duncan draped her body to dramatize her dance as that of the universal, natural woman, Rhoades is resolutely a creation of culture, with kohled eyes and ear pendants of large ivory calla lilies that were her jewels of choice. Always the fashionable beauty, she is costumed as a model for the large decorative murals on which Steichen was laboring. Rhoades appears regal, her arrogant gaze forming a protective mask to distance the viewer from her. To Steichen, she was clearly a dream woman. Given the fraught relationship she would develop with Stieglitz, she uncannily suggests a Daphne who chose to become a tree rather than give in to male desire.

Stieglitz preserved the print, made from a broken glass negative, in his papers, along with Rhoades's letters to him. Who knows how the plate was broken into the sharp V-shape, when or why it happened. It is tempting to view the violence done to this image as symptomatic of the course of Stieglitz's friendship with Rhoades that would itself fracture in 1916 with the entrance of O'Keeffe. This chapter tells the story of Stieglitz's creation of his phantom, the woman-child, through his encounter with Rhoades. It was in the imaginary form of the woman-child that he would shape O'Keeffe, the artist who would finally complete his plan for modernism in America.

The Feminine Voice at Modernism's Core

Stieglitz's Little Galleries of the Photo-Secession at 291 Fifth Avenue had to present art that engaged the new theories of feminine sexuality at the heart of modernist debates if 291 was to remain at the center of the modernist revolution. So the sensuous body was now put on display there as the voice of the soul speaking in the work of art. Meanwhile, in the pages of *Camera Work* Stieglitz's critics stepped gingerly around these nudes to avoid charges of hedonism, defending this modernism

in the late-nineteenth-century language of transcendence—of the experience of the body as spiritual.

Stieglitz supported his modernist art with a rationale founded in sexological science and spiritualist philosophies, enlisting the writings of Wassily Kandinsky and Henri Bergson, both of whom were published in *Camera Work* in 1911 and 1912.[3] Stieglitz would purchase Kandinsky's painting *Garden of Love (Improvisation 27)* (1912) from the Armory Show in 1913 and try to arrange an exhibition of his work at 291. Kandinsky's book *Concerning the Spiritual in Art* (1911), instructing the artist to meditate in the creative act in order to reach a higher plane of consciousness, was adopted as words to live by in the Stieglitz circle.[4] Inspired by his study of theosophy, Kandinsky's idea of meditating to reach the unconscious self supported Stieglitz's evolving belief that creativity was locked into the unconscious life of the body. Most important, Kandinsky's apocalyptic tone linked the new abstract art to the coming of a new age of enlightenment. This understanding of art as a sign of a social revolution was integral to Stieglitz's sense of his own personal messianic mission and his faith in the new art as a liberation of life.

Like other radicals and progressives, Stieglitz selectively read the books supporting the new mind-body-creativity dynamic. Key among these sources for New York radicals were the sexologists' writings, as we have already seen, along with Bergson's popular account of mystical consciousness, *Creative Evolution* (1907). Following the *Camera Work* publication of his essays, Bergson, who was "the rage in intellectual America," lectured at Columbia University in February 1913, when his book had reached the status of a best-seller.[5] His vitalist philosophy, like Kandinsky's, focused on the unconscious mind as the source of creativity. In Bergson's universe, spirit and matter interpenetrated one another to compose the creative force—the élan vital. Unconscious life is always evolving and expresses itself through the medium of matter. The sensation of living Bergson called an experience of duration, which, as the historian Tom Quirk explains, is "felt from within, and implicated in the real in an immanent world of ceaseless becoming." Thus "rigid forms," such as symbols, numbers, or language have no power to convey reality because they "reify what is in its very nature a flowing"—that is, a duration. "If we are to seek the real, then, as it lives in us and is perceived as change, we must

by an effort of intellectual 'sympathy,' or intuition, immerse ourselves in this flux." In the passages from *Laughter* that Stieglitz excerpted in *Camera Work*, Bergson praised artists who through intuitive procedures embodied the spirit in a living, material form.[6]

In these years it was important for artists and intellectuals who wished to be recognized as members of the new modernist elite to demonstrate their intuitive access to the unconscious mind. Both Kandinsky's and Bergson's publications preceded the first English translation of Freud's essays on the unconscious. For this reason, they corrupted the first American reading of Freud with their sense of the unconscious as a mystical dimension of the self. Freud's lectures in 1909 at Clark University in Worcester, Massachusetts, and their publication soon after made available his ideas, not to lay readers, but primarily to professional psychologists, who then began to debate his theory linking sexual repression with neurosis. Freud had denounced the repression of sexuality, which he said led to neurotic symptoms and suffering, especially in women of the "cultured classes." *The Interpretation of Dreams*, translated into English in 1913, finally opened his theories to an educated lay audience. Until the beginning of his "real popularity" in America with the publication of *The Basic Writings* in 1938, the essay on dreams was responsible for the popular understanding of Freud's psychology in England and the United States.[7] American modernists, however, read Freud through Bergson's mystifying language of the unconscious, which collapsed the élan vital into the libido and promoted confusion about the functioning of dreams, memory, and the unconscious. The historian Nathan Hale recounts, "The enthusiasm for Bergson swept together several currents: Freud and abnormal psychology; a sanction for radical change in morals and society; a benediction for instinct and intuition. It was not hard to identify an overthrow of unhealthy repressions with Bergsonian liberation," even though Freud's dark vision of the unconscious was far removed from Bergson's utopian view of human evolution. The American adoption of psychoanalysis was thus optimistic and superficial, and it allowed radicals and progressives to legitimate their programs under the authority of "science."[8]

Further complicating Freud's American reception was the way in which Americans learned of his ideas through the writings of Havelock Ellis, who enjoyed a

preeminence in the field of sexology from 1890 to 1910. Ellis had liberally incorporated Freud's insights into the six volumes of his *Studies in the Psychology of Sex* (1896–1911), and through correspondence engaged Freud in a debate on whether the production of sexuality was essentially biological or environmental. Ellis based his views on his knowledge of history, anthropology, and biology and, like Freud, worked through case studies. Taking the nonjudgmental stance of the naturalist, he catalogued the varieties of human sexuality. His comparisons of the sexual morality of "civilized" and "primitive" cultures, as well as the mating customs of animals, established the relativity of human practices specific to each culture. Moreover, Ellis systematically repudiated "nearly every tenet of 'civilized' morality and nineteenth-century sexual hygiene."[9] Castigating Americans for their puritanical attitudes, he regarded human sexuality as a "powerful force which suffused and enhanced the whole of life." In this respect he worked, as Freud did, "to widen the acceptable definitions of sexuality."[10]

As we have seen, Stieglitz was highly attuned to Ellis's research, in 1911 ordering the first of several sets of Ellis's *Studies* and indicating his enthusiasm for reading about "modesty in women."[11] Ellis saw women in their sexual natures as grossly misunderstood—as far from frigid, but without experience and knowledge of their inherent sexual feelings.[12] Rejecting promiscuity as a norm, however, he set up the new ideal of a "naturally" monogamous union between two experienced individuals—a man and a woman—who satisfied each other in sexual pleasure. Ellis sanctioned a trial union of partners outside marriage and considered both children and marriage peripheral to the function of sexuality as a joy that enriched life. In Ellis's writings, then, sexuality is liberated from reproduction and encouraged as a pleasure for its own sake. But this was a faulty introduction to Freud. Like Bergson, Ellis believed in the goodness of human nature and the mystical harmony of life. He misinterpreted Freud's research as an advance of society toward a better and freer state, mirroring his own romanticism. The full extent of Ellis's misunderstanding is conveyed in his characterization of Freud's work as a "poetry of psychic processes which lie in the deepest and most mysterious recesses of the soul."[13]

While the belief that a liberated sexuality would launch a spiritual revolution per-

vaded Ellis's work on sex, it stood also at the core of the writings of Edward Carpenter, the British socialist whose visionary poetry and prose galvanized the feminist and socialist radicals of Greenwich Village before World War I. This sense of an imminent age of enlightenment is common to the philosophies that fed Stieglitz's modernism—of Kandinsky, Bergson, Ellis, and Carpenter. For Kandinsky and Bergson, plumbing the depths of mystical consciousness held out the way to a greater oneness and harmony with the universe; for Ellis and Carpenter, the way to paradise took the form of a spiritual liberation through sexuality. Desperately awaiting a new gospel of the body, the men and women of the Village devoured the writings of Ellis and Carpenter, searching for a new morality of life to replace the bourgeois codes of capitalism they were rejecting. To give just one example, Carpenter's classic, *Love's Coming of Age* (first published in 1896), had gone through eleven editions by the end of World War I. Promising the body as "the root of the soul," his first major volume of verse, *Towards Democracy* (1881–82), appealed precisely in its condemnation of bourgeois existence as a "prison life of custom without one touch of nature."[14]

Love's Coming of Age continued this critique in a series of essays that examined sexual relations, especially women's place in the social order. Significantly, the book had its first American publication in 1911 in New York by Stieglitz's good friend Mitchell Kennerley, the owner of the Anderson Galleries, where, after the demise of 291, Stieglitz would move his artistic enterprise and show his photographic portraits of O'Keeffe. We can be relatively certain that Stieglitz obtained a copy of Carpenter's revolutionary volume from Kennerley at this time because Kennerley and Stieglitz began to exchange publications in 1912.[15] In *Love's Coming of Age* the enslaved middle-class woman stands as a symptom of the disease that Carpenter names "civilization." Not only did this tract call to women to rebel against the capitalist order and become free, but it also invented Carpenter's ultimate evolutionary goal for men and women: to transform them into "intermediate" types—that is, into a third sex that would freely constitute itself of feminine and masculine attributes. Carpenter's model of androgyny aimed to create liberalized social roles that would permit women to do men's work in professional, public arenas and men to do some of women's work in the private, domestic space of

the home. Sexual liberation and the rejection of the dead, capitalist order are inseparable, and both depend on woman's central place in this spiritual and social revolution.[16] Carpenter's analysis of social malaise and his proposed cure seduced Village radicals, as it must have Stieglitz, who railed time and again against what he called the death blows of capitalism to the soul and its puritanical restraints against sexuality.

Opposing middle-class materialism, the Stieglitz circle and Village bohemia fashioned their identity as a new elite of awakened creators who were in tune with a mystical core self. Carpenter's vision of a mystic wholeness—of self and world, the sexual body and the spirit, human culture and nature—was essential to the utopian subtext Stieglitz developed as the narrative for his American modernists, especially John Marin, Arthur Dove, and O'Keeffe.[17] The modernism of the Stieglitz circle was deeply grounded in an antimodernism that Stieglitz nurtured by his immersion in the mystic Whitman, the theosophist Helena Blavatsky, the Swami Vivekananda, Claude Bragdon, William James, Bergson, and Kandinsky, among others.[18] After the war, this optimism of wholeness and evolutionary consciousness was simply impossible to maintain. When the disenchanted mood of European modernism intruded, Freud's and Ellis's scientism replaced Carpenter's romantic socialism in the study of sex, and Duchamp brought a new irony and cynicism—a new philosophy—to the arena of art.[19]

Carpenter exalted the sexual act as the means of liberating creative energies—an idea Stieglitz drew upon in promoting the aesthetic experience of modernism as a surrogate for the catharsis of sexuality. But the aesthetic experience he offered at 291 primarily represented the experience of life and art from the perspectives of modernist men when the sexologists emphasized that women's sexuality and thus their experience of the world were essentially different from men's. Since modernism in New York revolved around the issues of women's liberation and feminine sexuality, Stieglitz needed to complete his picture of the modernist utopia with a woman artist who would speak of her sexuality. Her work would be marked by her difference but would also be commensurate with that of his men. Brigman and the younger women artists who joined the circle at 291 about 1912 raised the question of how a woman's sexuality might reveal itself a visual idiom all its own—a

language that registered an essential femininity. Where was that courageous woman who would dare to be modern, to allow her core self to speak? What were the marks of that femininity?

As we shall see, Stieglitz would heed the sexologists' description of woman's essential nature as more like a child's than a man's. At 291, which he called his laboratory, and in its organ *Camera Work*, Stieglitz as a scientist of culture experimented with the new theories that located the source of creativity in the unconscious mind and connected it there with sexual energy. For reformers such as Ellis and Ellen Key, this new model of sex as a creative force depended on the companionate love relationship of two social and intellectual equals. It would no longer do for men to go to prostitutes or mistresses for their sexual pleasure. That was the corrupt practice of the Victorian fathers. Rather, the sexologists were speaking of the vitality an erotic friendship gave to creative partners. That modernists regarded sex as "more 'spiritual' than the spirit itself"[20] made the sexually intimate couple the rule in the Village. Radical men welcomed the reform of marriage and love relationships, but to change sexual relations between men and women it was imperative to heighten awareness of women's innate sexuality and encourage their self-expression and uninhibitedness. It is safe to say that, for cultural radicals such as Stieglitz, helping woman locate her essential nature and free her libido was the key to male vitality. Modernist women partners to radical writers, journalists, and politicos were emerging in numbers in the Village in the early 1910s, prompting Stieglitz to find his version of them—the woman artist who would ensure the integrity of his modernist program.[21]

Since a bohemian personal life was now regarded as a badge of one's modernism, Brigman could not be the feminine equivalent to the male modernists Stieglitz was grooming in these years—Max Weber, Abraham Walkowitz, Marsden Hartley, and Dove. But two young aspiring painters who appeared at 291 for the first time soon after Brigman's residency there presented new possibilities. Marion Beckett and Katharine Rhoades became part of Stieglitz's circle at 291 in 1911 (Fig. 72 shows Beckett's own portrait of Rhoades). They were fresh from a long sojourn in Paris, the center of European modernism, and both were eager to begin working with the new aesthetics in their painting. As Stieglitz's friendship

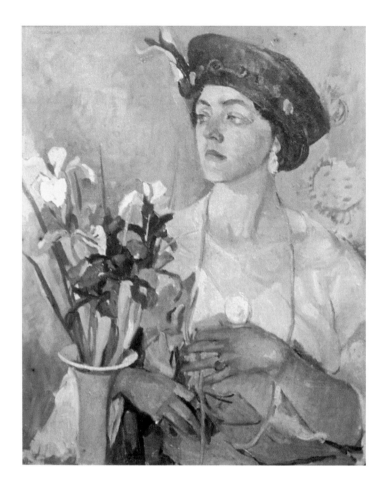

72

Marion Beckett,
*Katharine Nash
Rhoades,* ca. 1915,
oil on canvas.

with Rhoades developed, he found the opportunity to create the figure of the woman modernist in her true guise, as woman-child.

The First Modernist Daughter:
Katharine Rhoades

The story of Stieglitz and Rhoades uncovers Stieglitz's first attempt to find the feminine vision that would reveal woman's secret life; it is an essential chapter in the birth of his iconic woman modernist. Stieglitz's woman-child was another of those

phantasmal feminine figures in which the modernist subculture made its fears and utopian desires comprehensible to itself and to the larger world. At the same time, Rhoades's story relates the dilemma that a large number of middle-class and elite women confronted when they tried to find a place for themselves as producers of modernity, outside the prescribed roles for women as consumers of modernity. That dilemma turned on the double bind of bourgeois sexuality: while the sexual drive was now deemed the source of creative energy, for women artists, pursuing an active sexuality, at least outside marriage, meant placing themselves in opposition to feminine conventions of modesty and domesticity that the sexologists still required of women—and that even bohemian women felt compelled to measure themselves against. Women artists and writers who took up the life of free love romanticized by the modernists risked "the degradation of public sexual exposure," as the critic Nina Miller notes. These women had to negotiate the stigma of a private life lived in public in order to reinvent themselves in terms of the modernist dictum that the creative temperament was of necessity highly erotic.[22] When Stieglitz, for example, insisted that Rhoades become his lover and publicly bare her erotic life, she defended herself precisely in terms of her unwillingness to suffer the consequences of the double bind. She also despaired at her inability to remake herself into the conflicted personality that Stieglitz had fancied her when he demanded that she expose her childhood trauma in her art as the mark of her modernism.

Rhoades was the daughter of Elizabeth Nash (1856–1919) and Lyman Rhoades Sr. (1847–1907), a wealthy New York banker and clubman from an old Anglo–New England family. Educated at Brearley, she was tutored privately in art as a young woman. After her father's sudden death in 1907, she spent a year in Paris, studying old masters and familiarizing herself with European modernism. On her return to New York in early 1911, she followed the trail of modernist art to Stieglitz, who was forty-eight to her twenty-seven. Over the next five years their friendship progressed into intimacy through her visits to 291, his visits to her studio not far away, and their intense periods of letter writing when she vacationed at her friend Marion Beckett's house in Williamstown, Massachusetts, or at her family's houses in Sharon, Connecticut. Rhoades's letters to Stieglitz record the intensifying

friendship, the struggle to make it something more, and finally its breakdown. Because she destroyed Stieglitz's letters to her shortly before her death in 1965, it is Rhoades's voice that tells of both her struggle to preserve Stieglitz's support and his struggle to make her into the modernist woman-child. His voice is present implicitly in her letters, steering their discussion, insisting that the friendship be physically consummated as part of her development into the woman-child, while she tried to make Stieglitz into an affectionate father figure who mentored her intellectual and emotional evolution.[23]

Rhoades had met Stieglitz briefly in December 1905, when she went to sit for her portrait by Steichen, who was living in the rooms in back of the 291 galleries. Several years later she and Beckett traveled to Europe with Rhoades's Brearley schoolmate, the aspiring sculptor Malvina Hoffman. Making their way from Italy to Paris, they connected there with Rodin, probably through an introduction from Steichen or Agnes Ernst Meyer, and then spent much time at the village of Voulangis outside the city. Steichen had set up an idyllic existence at the cottage and garden he called L'Oiseau bleu. Rhoades and Beckett joined the festivities there along with another young painter, Arthur Carles, and his new wife, the actress Mercedes de Cordoba. In early 1912 Stieglitz would mount an exhibition of Carles's painting, which experimented with the post-Impressionism of Cézanne. When Rhoades returned from her study in France, she kept abreast of the modernist art she had come to admire and emulate in her work by visiting 291.[24] Her mother, in February 1911, purchased a painting by Carles from Stieglitz, a transaction that gave Rhoades another reason to make herself known to Stieglitz, in addition to her devotion to French modernism and the philosophy of Henri Bergson.[25]

Vision

The bond that grew between Rhoades and Stieglitz in 1911 and 1912 was first established through their commitment to Bergson's teachings. Publishing excerpts from *Creative Evolution* and *Laughter* in *Camera Work* in those years, Stieglitz was setting up Bergson's vitalism as the new philosophy by which artists should live and

work. Rhoades attended Bergson's lecture at Columbia University in New York in 1913. In the passages Stieglitz had edited for emphasis in *Camera Work*, Bergson had written of intuition as a technique that could break down the barrier of space between the artist and the model and between the viewer and the work of art—between human consciousness and the vital currents of life that are hidden from us by the veil of external nature. Intuition leads "to the very inwardness of life," Bergson had stated; by establishing a "sympathetic communication . . . between us and the rest of the living, by the expansion of our consciousness which it brings about, it introduces us into life's own domain, which is reciprocal interpenetration, endlessly continued creation." If we entered into "immediate communion with things and with ourselves . . . our soul would continually vibrate in perfect accord with nature." We would "hear the strains of our inner life's unbroken melody," the élan vital, which was veiled from us. There were some artists with this special capacity, however, who could "perceive all things in their native purity." The highest forms of art could reveal this essence of nature through a kind of musical speech—a rhythmic, dancelike manipulation of color and form that responded to the "rhythm of life." Such an art was a "more direct vision of reality . . . [a] purity of perception." Thus did Bergson—as presented by Stieglitz—urge artists to give forms to the "necessities of life," its "inward states."[26]

Even before Bergson's publication in *Camera Work*, Rhoades needed little tutoring from Stieglitz to speak Bergson's language, only his encouragement. That she echoed and reaffirmed Stieglitz's new vision of life must have been exciting to him. Her first several letters to him are full of praise for his endeavors in promoting modern art as "big," "vital," "definite," and the "real in life"—terms that Stieglitz used to characterize modernist art as cathartic psychic experience that would transform the dead, puritanical, sham lives of middle-class Americans. Rhoades, for example, reiterated back to Stieglitz her sense of *Camera Work* as "so vital and so definite," a coming age of enlightenment, and a new year that would be "full of the unconscious and of the intangible which alone make life pure and clear, in this chaotic town!"[27] Over the next several years, Rhoades and Stieglitz played a private game of imagining this new world according to their standards of "fineness" and "Vision" (always capitalized) that was "direct, clear, true" to an inner reality. Ap-

propriating Bergson's soul-speech allowed them to form an intimacy, an elect so-
ciety of two who, in contrast to the unenlightened, possessed Bergson's "creative
force." For Rhoades, Stieglitz was Bergson's exemplary artist; looking up to him,
she told him that he should realize "just how deeply you have given to . . . [many]
the desire to have a truer vision and to be more completely alive in the finenesses
of living. . . . It is a wonderful thing when a man has the creative force developed
so purely that even when he is not consciously working toward the creation of
something, some expression, he nevertheless is able to creatively give one to an-
other the incentive for those others to create."[28]

Looking at himself reflected in Rhoades's eyes, Stieglitz could feel his own im-
portance as a mover and shaker, pushing America into a new cultural epoch. As
for her, her link to Stieglitz made her feel "more alive than ever," as if she were en-

tering a "greater consciousness." The romance of modernism as revolution—a threshold to another world—comes through in her sense of the moment as a pulsing of life in the flow of duration, and it suggests how well fitted that language was to the image of modernism as youth—specifically here, her youth: "And it's worthwhile being alive just to feel the inner pulse and to sense as clearly as our vision may permit the great significance of today—In its passing."[29] Hers is a heightened sense of experience, as if they are living through a great event, at a time when the world is being shaped anew. Rhoades, writing to Stieglitz in 1914 from Beckett's home in the Massachusetts countryside, at a moment when the friendship was deepening, sent a snapshot of herself looking like a young girl (Fig. 73). Accompanying this image, she offered a picture of herself as an artist on the cusp of inner illumination, watching the moon, electrified by the beauty of the summer night, or rolling like a child in a field of grass. Pure, clear vision is a metaphor central to her experience, as is the expansion of consciousness in the silence and boundless space of nature. Closing a letter to Stieglitz in September 1914, Rhoades uses their private language of self-recognition:

> May the Great Dawn when it comes, come so sweetly that you shall not
> recognize it, and shall only sense the necessity for a Greater!
> These things in life which are greatest "have no beginning," "justified
> by Life and by the inner need,"
> They come.
> But to you, who have Vision,
> Your Dawns will be as sky space,
> Crystal clear.
> Greater and Greater,
> and always the need for a finer,
> purer comprehension.
> But it's nice to be Alive!
> To confront today and to *touch it*,
> Singing.[30]

She adopts the singing voice that for Whitman and Carpenter appeared at the mystical moment when self transcended its boundaries to merge with the universe. In

74
Edward Steichen,
Alfred Stieglitz, 1909–10,
platinum print, $11^5/_8 \times 9^1/_2$ in.

its ecstatic mood and exalted language, the letter is fairly typical of the cultlike pro-
nouncements that Stieglitz encouraged in the elect circle of those who acted as his
disciples. At 291 it was essential that artists conceive their images in this language
of the soul, for it was read as a sign of personal evolution. With Stieglitz's assis-
tance, Paul Rosenfeld later wrote of 291 that "in this place nothing but that final
self, that utter, inner design of the soul was revered."[31]

Rhoades in late 1914 closed her daily letters to Stieglitz with "I greet the day—
singing!"—in effect, playing to and invoking Stieglitz's sense of himself as a new
Whitman (Fig. 74). In this model of the poetic voice, the artist sings of the essen-
tial self who is one with the world, and it is as a singing voice that Stieglitz was
also described by his most faithful hagiographer, Rosenfeld, in 1924.[32] Stieglitz's

photographs *Songs of the Sky*, which evolved from images dedicated to Rhoades in 1923, in fact, recirculate this sense of the transcendence gained in the skyward gaze that focuses on nothing but the heavens. For Stieglitz, such "Vision," however, meant more than the making of beautiful objects, as he had told Agnes Ernst in 1908. The investment in modernism extended beyond acts of language and imagination. The artist's whole being and identity had to stand behind the work of art and be embedded in it to ensure the authenticity, the "livingness," of modernist expression. The artist of "Vision" had to act out the freedom that entailed a complete re-visioning and perfecting of life itself. [33] As Rhoades wrote to Stieglitz of her summer days and nights in the New England countryside, she was convincing him that she was living that dream as she danced in the moonlight or stood motionless in the soft grass, losing herself in the infinite space around her. Picturing herself for Stieglitz as the Bergsonian artist, Rhoades spoke of feeling beautiful on a moonlit October night, "bathed in a sort of living electric atmosphere" until her "whole body became entirely alert . . . and filled with a current of sensitiveness pulsating." This performance of the student for her mentor, however, was only one of the ways in which the two of them bonded as soul mates. Another was the new depth psychology, which allowed them to explore a partnership of self-knowledge as they pursued a Freudian notion of art as a psychotherapeutic form—one that was nurtured by childhood traumas. Stieglitz and Rhoades now plunged into a relentless and punishing round of self-analysis.

Giving

Turning to Bergson, then to Freud, Stieglitz sought an evolution of consciousness, looking first to expand its perimeters in experiences of joy and then plumbing its depths, losing the self, only to find pain at its origins. Rhoades had an impressive command of Western literature and philosophy. If she reflected back to Stieglitz his sense of himself as a visionary artist and leader, he catered to her sense of herself as a poetic voice with insight into the unseen world. In keeping with this feminine identity (already favored by Käsebier and Smith), he would send her the first

English translation of Kandinsky's book, a number of psychotherapeutic pamphlets, and, later, works by Nietzsche, George Moore, and Romain Rolland. In 1914, however, the friendship took a new turn when Stieglitz sent Rhoades a volume of Ellis's *Psychology of Sex* and began to tutor her in sexology, pressuring her to "develop." As they were reading Freud's *Interpretation of Dreams*, Stieglitz prodded Rhoades to remember her early relationship with her father and analyze her feelings for her father through her dreams. While Stieglitz was still politely addressing her in his letters as "Miss Rhoades," it must have been titillating for him to be allowed a glimpse into the most private events of her life. Rhoades willingly encouraged his desire to know her in this way and flattered Stieglitz, noting his gift of prophetic "Vision."[34] Coming to 291 had given her a new "Faith," she said, and a new form of "speech" with which to master life.

One of Rhoades's earliest attempts to demonstrate her mastery of Freudian theory is her account of a dream structured as a conversion experience, a moment when she recognized Stieglitz as a soul mate. The imagery of this dream suggests the ambiguous space of a Symbolist painting—a landscape by Edvard Munch or Arthur B. Davies, in which a man and a woman wander through a fog seeking a lover—a spiritual twin—and self-fulfillment. In Rhoades's vision, she and Stieglitz walked through an amorphous landscape that was the 291 gallery. Out of the void, she heard Stieglitz's voice calling to her, while a "brilliant blue—and struggling" energy, a heavy, "terrific force," swirled above her head "at tremendous speed in absolute silence." As the Matisse sculptures in the gallery began moving, Rhoades realized that the force above her was Stieglitz's mind, "battling with itself and everything around it." Suddenly, the Matisse figures were illuminated in brilliant colors, all motion ceased, and the room turned white and silent, "until a voice above my head said 'I have found.'"[35]

The narrative of the dream as a conversion experience relates the tensions Rhoades faced in deciding to enter into a secret friendship with Stieglitz. Her refusal to comply with the high bourgeois feminine role expected of her greatly irritated her domineering mother. Rather than marry a suitably wealthy and socially prominent man and bear his children, she wanted to live the life of an artist, like Stieglitz, independent of the marketplace. Both Rhoades and Stieglitz had incomes

provided by their families. (Stieglitz's wife provided most of his living expenses until they separated in 1918.) Rhoades's "I have found" reference to Stieglitz was also significant because she was searching for a father figure who would guide her through the complexities of modernist Manhattan and help her to become a new kind of professional—a woman artist. While her father was alive, Rhoades was caught in the middle of her parents' hostile marriage; she preferred her father's warm, gregarious company over her mother's controlling and possessive ways. Rhoades alone in her family had been caring for her father at the time he died during a rest cure in South Carolina in 1907.[36] Made by her father into her mother's surrogate, Rhoades was clearly finding it difficult to recover from these emotional scars. For example, at about this time she began to be drawn to older, married, and thus unavailable men. At the same time, her desire to escape from home, to live the life of art, bound her through guilt to her mother, who held Rhoades close to her.

In her entangled relationship with her parents, Rhoades must have seemed to Stieglitz ripe for a Freudian cure. The implications of these conflicts were already evident as her friendship with Stieglitz began in 1911–12. She was already involved with Arthur Carles, whose paintings Stieglitz featured at 291 in January 1911. The affair had begun as a flirtation the preceding year at Steichen's villa, L'Oiseau bleu, where Rhoades had become close to Carles's wife, Mercedes, as well. When Carles revealed his affections for Rhoades, a distraught Mercedes went directly to Rhoades's mother, who then confronted Katharine. Rhoades vowed to stop seeing Carles at her studio, but, wounded again, she distanced herself even further from her mother, as well as from other close men friends.[37] Even though Rhoades felt bound to live with her mother until her mother's death in 1919, she erected an emotional barrier around herself, to her mother's dismay, and spent as much time as possible away from her—at her private studio, in Europe, or at Marion Beckett's Williamstown house. After a brief reconciliation with Mercedes, Carles continued to mourn the loss of Rhoades for several years, and in February 1914— to Mercedes's embarrassment—he hung a ghostly portrait of Rhoades, which he subtitled *In Memoriam* (Fig. 75), at the National Arts Club exhibition. Stieglitz would not have failed to notice Carles's romantic gesture of desire and mourning. This

75

Arthur B. Carles,
*Portrait of Katharine
Rhoades—In Memoriam,*
ca. 1914, oil on canvas,
$25\frac{1}{8} \times 24$ in.

allusion to an affair by a lover now spurned by the femme fatale could only have heightened Stieglitz's own fascination with Rhoades's hidden life. Rhoades, cool and reserved in public, was now revealing herself secretly to Stieglitz as warm and engaging but mysteriously troubled with ambivalence about herself.[38]

Over the course of 1914 Rhoades sought and welcomed Stieglitz's attention, especially his support for her painting and poetry, until the fall, when he began to ask her for "something More." He also tried to interest her in Ellis's writings. All summer long they had enjoyed an intense confidential correspondence. Rhoades was happy to indulge in what she called "Myself" letters, some of them eight pages or longer, expressively laid out in elongated purple script on lavender-bordered and monogrammed papers. In these outpourings she evaluated her development, usually in response to Stieglitz's probing of her feelings about her father and her friends.[39] Stieglitz and Rhoades were secretly practicing a form of "Freuding," then

a fashionable entertainment among Village intellectuals. Mabel Dodge, the doyenne of Village radicals, had even featured Freud's favorite American disciple and English translator, Dr. A. A. Brill, as the centerpiece of several of her salons, where Stieglitz had been a guest. Austrian by birth, Brill was Freud's choice as the leader of the American psychoanalytic movement. By 1918 he was the most prominent translator of Freud's writings into English and arguably the most famous psychoanalyst in New York City.[40] To be considered worthy of serious attention in this milieu, one had to parade before one's peers a deep self with all its scars. If advanced writing and art were generated in the unconscious, then poetry and painting failed or succeeded as self-confessions to the extent that the artist excavated and revealed the darkest, most passionate secrets.[41] Freud's examination of the psyche had redefined the neurotic individual, driven by early psychic wounds, as the potentially creative individual. Artistic process in this framework was now understood as a channeling of libidinal energies into cultural products. In modernist Manhattan, the work of art had to narrate the psyche's history, embedding the artist's rapture or despair. Beginning with Brigman's projection of her self into her nudes, Stieglitz's modernism defined itself through the latent romantic gesture of self-dramatization—a self-performance.

Freud set out his theory of the erotic and affective life in his *Three Essays on the Theory of Sexuality* (1905), which Brill in 1910 translated into English for a professional journal. This monograph of some one hundred pages must have been "the Freud book" that Rhoades had seen Stieglitz reading at 291 in September 1914 when she asked him about its content, while she was making her way through the more widely available *Interpretation of Dreams*.[42] At the same moment, Stieglitz was attempting to convince Rhoades to "give" more of herself to him as a means of becoming a "Woman" and maturing in her art. Stieglitz must have found Freud's explanation in *Three Essays* of how girls develop an adult sexuality, or resist it, a momentous illumination as Rhoades, through the following year, continued to refuse his demands that she grow up and "bare" herself, to him and in her painting.[43] Freud's third essay, "The Transformations of Puberty," discusses the sexual inhibitions that affect girls more strongly and earlier than they do boys and draws on Ellis's observations of women's sexual modesty, which Stieglitz had avidly read a

few years earlier. Freud described the mechanism by which women deny their sexuality as a modesty effect that stimulates the libido in men. A girl can become a woman and achieve a mature sexuality, Freud stated, only by transferring her erotogenic zone from the clitoris to the vagina in accepting a male lover. If a woman failed to do this, she was prone to hysteria. Freud further observed that if girls, when they later married, clung to their affection for their parents, thus preserving the libido's infantile fixation, they would "lack the capacity to give their husbands what is due to them; they make cold wives and remain sexually anaesthetic." In a passage that for Stieglitz must have recalled Rhoades's relation to her father and repudiation of sexuality (at least with him), Freud described such "girls" (that is, potential women) as driven, on the one hand, "to realize the ideal of asexual love in their lives and on the other hand to conceal their libido behind an affection which they can express without self-reproaches, by holding fast throughout their lives to their infantile fondness, revived at puberty, for their parents or brothers and sisters."[44]

In terms that engaged these theories Stieglitz argued with Rhoades about the necessity to resolve her arrested sexuality as a step toward self-realization. In their letters they euphemized this proposed sexual liaison as her "gift" to him, which, in turn, would enable her to obtain a more authentic voice in her art. The conceit of sexual "giving" as a form of psychotherapy to some extent evoked Freud's concern with the healthy or repressed life of the libido, but it also rested on Ellen Key's idea of sexuality as a gift that promotes a dynamic creativity. Stieglitz knew that Rhoades was a follower of Ellen Key, the marriage reformer who had been so important to Brigman's feminism. Key's influence over a whole contingent of sexologists was so great that Havelock Ellis called her a "prophet" of the new movement to liberalize marriage and "one of the chief moral forces of our time."[45] Key saw creativity and sexuality, inextricably locked together, as a liberating force. "A human being attains to new creative power" through a state of passion, she wrote, for "the artistic temperament often expresses itself in the demand for erotic renewal."[46] Such a love was "a great spiritual power, a form of genius comparable with any other creative force in the domain of culture." Sexual love was thus named as a "gift" of the lovers, not only to each other, but also to the "race," for it often

"translates itself into intellectual achievements."[47] Key was particularly concerned with the position of "soulful" women who were perhaps wary of this new morality of free love. She urged them to go forward enthusiastically into the approaching era "when sensuousness . . . regains its dignity." For "the power of giving erotic rapture" should not be "the monopoly" of men fixated on such pleasure. Rather, the new women needed to rediscover the traditional feminine "capacity for giving"—that is, "the old-fashioned gift of conceding the desires of the beloved with a happy smile, instead of insisting on their own."[48] So, in Stieglitz's pleading with Rhoades, the talk about "giving" evoked Key's language of love as well as Freud's analysis of female sexuality. With that one word, he reminded Rhoades of how personal creativity and vital sexuality were interdependent and intertwined.

Giving and Free Love

Village radicals employed a number of euphemisms for sex, such as Key's "gift," to speak of sexuality as spirituality in order to give permission to a fuller life of the body. Havelock Ellis, for example, popularized "the art of love" as an inherently class-specific conduct that was achieved only under the "highest conditions of civilization." Carpenter's euphemism for sex—a spiritual liberation that would lead to a higher consciousness, a higher type of individual, male or female—recalls Key's gift of love as intrinsic to the creativity of an elect. In various bohemian literary works, from Floyd Dell's *Love in Greenwich Village* to Margaret Sanger's feminist tracts on birth control, these euphemisms worked to rehabilitate the previously taboo arena of sexuality, specifically feminine sexuality. New York modernists did not rely exclusively on Freud as they battled traditions they found repressive. Before Freud's writings appeared in English, men and women in the Village were already acting out their sexual restlessness. Rather, Freud, Ellis, Key, and Carpenter gave bohemians a language that justified their behaviors. Moreover, the claim that free love was integral to civilization or higher consciousness permitted Village bohemia to distinguish itself as a subculture acutely opposed to middle-class materialist culture. This relation of opposition, played out in the arena of sexuality, al-

lowed cultural radicals to think of themselves as an elite, perhaps as compensation for their loneliness and isolation from their roots.[49]

But these euphemisms did not begin to hint at the inequality of men and women in "giving" or the price that women paid for their life in the radical subculture. For young women moving into the bohemia of the Village, a free-love relationship with a man more often than not entailed certain undesirable consequences, of which Rhoades was acutely aware. During their period of "Freuding," Stieglitz challenged Rhoades to "dare to see . . . [herself] straight." Responding in a long letter in early September 1914, she told him that she did dare to be a woman "who dares to become an artist" but that she was still "young and very chaste, fighting so desperately hard inside, for what is Necessity—that the outside assumes almost immobility." She tried to picture herself as Key's ideal woman, a lover of "all the things of the body which to me is a marvel of life— . . . [I] feel an intensity of demand and an urge of giving that is terrific—and which is continually misinterpreted." Although she had felt great joy, the pain and hurt of love were stronger—undoubtedly she was referring to the disastrous affair with Carles and the recent gossip about her and Steichen. She was "struggling toward the freedom which is the ideal," yet she was still subject to a "secretiveness of self and isolation which have been forced upon us." Urged by Stieglitz to change, she defended herself by critiquing social conditions that governed women's lives and interfered with her drive toward personal freedom: "Social conditions disgust all that is finest within us. They are so stupidly rotten, and experience has taught me to evade—unfortunately. Woman always has a great instinctive sense of protection and defensively she approaches the present. Why? Because she dares not belong wholly to the moment as it goes to her? And because society and her inheritance are forbidding?"

"The most universal power in me requires a breaking down of a thousand barriers in every direction, and a closer finer sense of values which can only come with a fuller comprehension of how to give—and yet I cannot give." Rhoades recognized that she was at a turning point and feared that if she did not make the transition to a full, adult life—a full life of the body—her creative potential would be blocked and wasted. But she was afraid to take that step toward a new kind of freedom. "Soon then, it may be that the moment has passed and that I shall not be able

to attain that creative state of spirit that my being says I must attain in order to give all that I know I have to give."[50]

Stieglitz questioned her reasoning and asked her to rethink the error of withholding herself. Rhoades responded that she yearned greatly to give,

> and never to regret having given. Do I feel that I have lost in not daring? I think it was not that the yearning was not intense enough. . . . But that the vision was as intense as the yearning, and the vision saw and decided—alone. Sometimes one gives more in not . . . daring, and surely if the yearning is intense enough, the only thing that can keep one from daring is the instinctive realization that one must *dare not to dare* in order to give. . . . Woman is brought up so horribly—to withhold her real self and to play the delightful hypocrite. . . . She grows afraid. Afraid of life, of her own demands, of the passion of living, of the desire to be free. Afraid, or at best having lost the knowledge of how to give.[51]

Rhoades's sense that women were conditioned by fear, which prevented them from moving out of bourgeois domesticity toward independence and freedom, resonates with Brigman's critique, also based on Ellen Key. So Rhoades articulated what she observed as the double bind of free love: on the one hand, she would not be able to mature and grow into her full creative potential until she learned to "give freely" of herself; on the other, she had already witnessed the disastrous price women pay for such freedom.

Bohemian women's enjoyment of a free, exploratory sexuality equal to that of bohemian men by and large took shape only in the realm of ideology. Rarely did women in actuality achieve the egalitarian status they so desired for themselves.[52] While the Village practice of romantic love might disrupt bourgeois codes, it stopped short of feminism's threat to restructure gender hierarchies. In aestheticizing the image of love, modernists evaded the issue of power relations between men and women that was essential to feminist arguments. If bohemian artists claimed a profeminism for their artistic and political ideals (in contrast to bourgeois antifeminism), their practices maintained a system of male producers fixated on female love objects. This traditional relationship was naturalized by sexology, a discourse regarded in the Village as absolute in its truth claims.[53] Rhoades there-

fore had reason to fear the lack of parity in bohemian love relationships. Although these feminist men supported women's public and professional advancement, a number of scholars concur with Lois Rudnick's assessment that "what they most often sought in their own personal relationships and celebrated in their fiction and poetry were women who were joyful and exciting companions, willing to subordinate home, community, and their own desires to men's needs." Thus "the men of Greenwich Village benefited far more than the women from the ideology of free love. Seeking a New Woman . . . , they wanted a lover who was always available to fulfill their sexual needs; a mother to provide them with the emotional security they lost when they abandoned their middle-class roots; and a muse to inspire them to world-transforming political and aesthetic feats."[54]

Rhoades's outpourings to Stieglitz, then, evince a familiar ambiguity: she pays lip service to the positive effects of giving in a love relationship and, at the same time, describes the extramarital sexual liaison as dangerous for women and refuses it for herself. Rhoades said that she was fighting for "Necessity," meaning the necessity that was her own core self. To consummate and transform her friendship with Stieglitz into a sexual union would exact a price: "One pays so heavily," she wrote him, "in getting one thing, one loses another. . . . And so one hurts, and one suffers."[55] But she also seemed to fear being overwhelmed by a stronger force, of losing herself in the act of giving. She pushed Stieglitz away as she had distanced herself from her mother. Rhoades's attraction to Stieglitz incorporated her feelings for both her parents: her desire for a nurturing, empowering father and her fear of the suffocating mother who, instead of freeing her into adult womanhood, bound her in the dependency of childhood to satisfy her own needs.

Woman-Child

Although Stieglitz belonged to the patriarchal generation against which the modernists defined themselves, he is something of an anomaly, for he succeeded in reinventing himself as a radical son. His first feminine partner of choice—Rhoades—was, however, a daughter too mindful of the costs, the disgrace their

liaison would bring to herself and her family. Until her mother's death in 1919, Rhoades remained largely subject to her mother's desires, although she was unable to fulfill those desires, or Stieglitz's, or her own completely. With the creative and intimate heterosexual couple as the new model for artists, writers, and politicos, Stieglitz obsessed over getting Rhoades to "bare herself before the world." His status as a modernist depended on his ability to convince her to transform herself. If she agreed to join him in such a partnership, he could see the completion of his own transformation as imminent, even though he went home at night to his conventional bourgeois home and stout hausfrau wife. Stieglitz hoped that his "Freuding" with Rhoades would lead her to reject her corrupt bourgeois façade. It would presumably all come crashing down when she had faced the secrets of her past with her controlling parents; her breakdown and transformation would then free her from her bondage to them to become Stieglitz's creative partner.[56]

Stieglitz took even more direct tactics: he told Rhoades that he dreamed of her becoming "Woman," clearly proposing what she would recognize, from their reading of Freud's book on dreams, as the fulfillment of his own dreams.[57] She was now a mature woman of twenty-eight, but he spoke to her of the need to prove herself as such in terms of the life of the body, and he wrote her letters—which she found to be "beautiful"—all about her potential becoming. Gratified, she acknowledged his points but then maneuvered to place on more comfortable ground the friendship she described as "remarkable . . . so right so natural, so free" that few would understand its purity.[58] The combat of words continued, as Stieglitz tried to shame her into more compliant and more productive modes of performance, moaning over the opportunities she was losing as she wasted her youth. Rhoades continued to affirm the possibilities still before her, but she also began to capitulate to his sense of her "lacks."[59]

Rhoades prided herself on her purity of vision and spontaneity and often called herself childlike, in the Romantic sense of the child as full of unselfconscious wonder and innocent delight in facing the world. As early as 1912 Stieglitz had begun referring to her affectionately as "the Kid." She responded by saying she wanted to be seven, standing in a field of grass with hot summer smells wafting all around her, or she felt like a five-year-old again on her mother's birthday in October 1914—

"Me all child." Rhoades insisted that although her youth had been painful she still preserved "the child in me." This stance of innocence functioned to deter Stieglitz's attempt to eroticize their relationship, but it also gained her his approval, for the rhetoric of childlike purity played to his model of the true artist as the antitype of bourgeois falsity and convention.

Rhoades accepted a term of praise Stieglitz had given her, that of a "wonder-child," agreeing that it fit her näiveté. But shortly after, he prodded his "wonder-child" to grow up into a woman-child. Rhoades immediately rejected his eroticizing as a corruption of her self-identity:

> You see, when I read about the wonder-child, I become rather interested too in "where does it come from." Of course it is not me. I'm quite sure of that; it is as though I were reading a letter you were writing someone else. . . . Perhaps a wonder-child . . . produced the feeling in you. Perhaps if I were a wonder-child I should have felt like doing the same thing. But, in our friendship that has not seemed to enter much. I think it has been something more intangible than touch. Perhaps more mental? Perhaps more spiritual? What do you think?[60]

Shortly afterward she backed away from his feminine ideal, telling him that she was "yet not big enough to understand the *Giving*—am too much the kid to be entirely the woman."[61]

The answer to Rhoades's question—where did this figure who was part-woman, part-child come from—is that Stieglitz adopted it from Carpenter's and Ellis's descriptions of woman's hidden psychic life. Stieglitz's fantasized woman-child personified an essential femininity in which sexuality was both manifest and secret. In *Love's Coming of Age* (1911), Carpenter had characterized woman as a great mute on the subject of sexuality, dominated by her "mother-feeling," which was the "great culmination of her life" and her "secret mission," yet unable to speak the sexual function on which her life was centered. Closer to a child and to a primitive, existing in a preverbal, intuitive state, woman served as the restorative center of man's life, his refuge, his primitive home.[62] Stieglitz's copy of Ellis's *Man and Woman* (1894), on which Carpenter relied heavily, still remains in O'Keeffe's Abiquiu Book Room. Ellis had also characterized woman as childlike, a being who

personified the instinctual moods of childhood. Woman's lack of distinction in the modern art world resulted, Ellis said, from her less intense sex drive—that is, her lack of desire: "The sexual sphere in women is more massive and extended than in men, but it is less energetic in its manifestations. In men the sexual instinct is a restless source of energy which overflows into all sorts of channels."[63] Ellis emphasized that woman's own sexuality is hidden from herself and that her male partner must educate her to it and bring her to its realization. He made clear that an active sexuality for women was only beneficial to other aspects of their development: "When their sexual emotions are touched, then at once they spring into life; they become alert, resourceful, courageous, indefatigable."[64] As Stieglitz appears here, picturing Rhoades as a woman-child and sending her copies of Ellis as an act of verbal foreplay, we can see him trying to initiate his role as a lover, to get Rhoades to realize her hidden, creative, womanly potential.

The Child, the Primitive, and the Modernist

Stieglitz's courting of Rhoades as a child and an erotic woman was not simply a seduction strategy. His search for a woman modernist who affirmed the sexologists' image of woman was fundamental to the artistic modernism of 291. Over the years 1912–16, when Stieglitz attempted to shape Rhoades according to his dream of the woman-child, he actually featured art created by children no fewer than four times at the 291 gallery. By late 1914, as we have seen, he began to identify the child's vision with feminine vision. Before that time, he used the figure of the child as a model for his male modernists, both European and American. The child was the first image Stieglitz adopted to invest his artists with the heroic form and dimensions of the Romantic tradition. In his conceit of the modernist as a child Stieglitz gave modernism's language of essential abstracted form the authority of a pure, unmediated vision of the world "as it is." The idea that the true artist saw the world with the eyes of a child was a commonplace throughout the nineteenth century. Kandinsky's art and writings, and his massive collections of children's drawings, resurrected the model for modernist artists.[65] More important to Stieg-

litz than children's drawings was the idea of the child's vision as a metaphor for the modernist's vision. Stieglitz employed the rhetorical figure of the modernist-as-child for different political effects as he tried to harness and direct the changing face of modernism in New York in the second decade of the twentieth century.[66]

Stieglitz's move to identify his modernists with the child originated in his friendship with the American painter Abraham Walkowitz. While in Paris in 1906–7 Walkowitz had become entranced with the art of Picasso, Cézanne, and Matisse, and he attributed the simplicity of their works to their childlike nature. He also credited himself with the ability to look "at the world through the eyes of a child."[67] The painters showcased at 291 before the children's exhibitions—for example, Matisse in 1908 and 1910—allowed Stieglitz to make the connection between modernism and juvenilia. American critics described Matisse's forthright hedonism, in his frolicking nudes, as erotically charged and primitive. The shock of a modernism that envisioned the human race returned to the state of innocent children was registered for viewers not only in Matisse's imagery but also in his spontaneous colored forms, which could be seen as imitations of a child's squiggling finger painting.[68] The work of Matisse was followed at the gallery by the art of Henri Rousseau, which was similarly derided in the press as the "crude dabblings of an untrained child."[69]

At this time Stieglitz was reading Kandinsky's essays, in which the child was held up as the repository of an imaginative vision that by its very nature saw into the essence of things. "There is an enormous unconscious power in the child that expresses itself . . . , and that raises his work to the level of adult's work, sometimes even higher," Kandinsky wrote in 1912. What Kandinsky called the "inner sound of the subject," or alternatively the essential, the necessary, or life itself, he saw as revealed automatically in the art of children.[70] For the *Blaue Reiter Almanac* Kandinsky and Franz Marc collected Russian folk art, Bavarian mirror paintings, children's drawings, Indonesian masks, medieval woodcuts, Inuit textiles, African wood sculptures, and Rousseau's paintings, as well as their own works and those of their cohorts. If the journal was intended to announce the new artistic millennium, the polyglot materials illustrating the text offered intuitional examples whose simplified language spoke to the producer's state of grace. Stieglitz's pur-

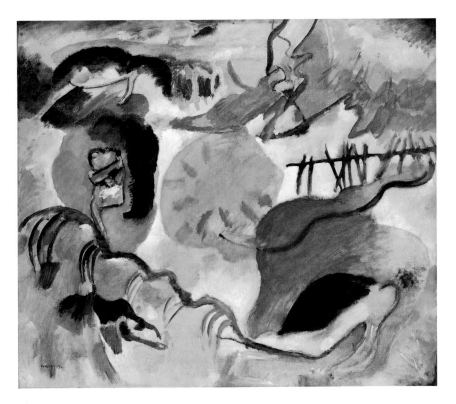

76

Wassily Kandinsky, *Garden of Love (Improvisation 27),* 1912,
oil on canvas, 47⅜ × 55¼ in.

chase of Kandinsky's painting *Garden of Love (Improvisation 27)* (Fig. 76), with its
scribblelike drawing and bright colors, seemingly smeared on, now meant that
there was at 291 a constant reminder of the arch-modernist as child.[71]

Bergson's philosophy also provided strong support for posing the child as the
model of creativity. Stieglitz's first children's art exhibition appeared between Berg-
son's lecture at Columbia University and the publication of extracts from Bergson's
writings in *Camera Work.* Certainly, Stieglitz was thinking of the child's overt intu-
itive capacity in relation to Bergson's call for an intuitive art that expands con-
sciousness and taps into the élan vital. Stieglitz developed Bergson's idea of the
evolved artist as intuitive and childlike into a vitalist program in which art offers a
therapeutic experience for body and soul, a release for adults from adult constraints

into a child's world of imagination and hedonistic pleasure.[72] Undoubtedly for Stieglitz, Matisse's appeal emanated from the promise, implicit in his sensuousness, of this therapy for the viewer.

Over the course of the four children's art exhibitions at 291, Stieglitz manipulated the trope of the child artist for the changing offensive and defensive purposes of his project. His first exhibition of children's art in April 1912 received more press coverage than any of the others (Fig. 77). Stieglitz framed his provocation to the establishment as a war of the free spirit against repression, speaking of the model of the child vision as a check against the diminution of artistic sight that resulted from the processes of education and observation over time. From Baudelaire to Monet and on to Gauguin, the vision of the child has been invoked as a metaphor for the authoritative purity of the modern artist whose images arise from intuition and feeling, in contrast to the academic artist's plodding deployment of conventionalized images and procedures. Stieglitz's statement to the press at his first exhibition of children's artwork set up this same opposition:

> It is only from children . . . that we can expect originality [in art] in these days. It is only from the little children [that] we can learn the point of view of the true child of nature, and that is art. The artist is an artist only in so far as he retains the childlike attitude. Beauty is constantly a surprise to him. The sky and the morning sunshine, the colors of a landscape or a woman's dress all delight him if he is a child at heart and should he live to be a thousand years old, if he's pure, he may keep it.[73]

By the time he mounted this theatrical exhibition, Manhattan's cultural radicals were already seizing upon the image of the child as a symbol of their cultural revolution.[74] The image of youth was their strongest weapon in their struggle to overturn the oppressive mores of the previous generation. Chief among the intellectuals defining this image of progressivism was Randolph Bourne, who announced this agenda in his essay "Youth" in the *Atlantic Monthly* and then followed it with a more extended treatment of the theme in *Youth and Life*, a book that Stieglitz had in his library. Bourne's conclusion to his essay can stand as the credo of the modernists: "The secret of life is then that this fine youthful spirit should never be lost. Out of the turbulence of youth should come this fine precipitate—a sane, strong,

77

Review of the First Children's Art Exhibition at 291 Galleries, "A Real Artist at Three,"
in *World Magazine*, May 12, 1912, newspaper clipping.

aggressive spirit of daring and doing. It must be a flexible, growing spirit, with a
hospitality to new ideas, and a keen insight into experience. To keep one's reac-
tions warm and true is to have found the secret of perpetual youth, and perpetual
youth is salvation."[75]

Bourne's essay was timely for Stieglitz. At the very moment it was published,
Hutchins Hapgood was employing the figure of the girl (as creative artist) spon-
taneously dancing her own nature, her own joy and inner law, to rebuke the me-
chanical, lifeless creator epitomized by the arch-academician Kenyon Cox. Relat-
ing this feminine figure to the modernist art of 291, Stieglitz reprinted Hapgood's
Globe editorial in *Camera Work* a few months later. For Hapgood, this was a contrast
of "direct opposites—death and life": the untutored beauty of the girl's dance, the

nudes of Matisse, and the "spiritual exhalation" of Rodin's drawings were played against the crushing of spirit in "conventional and mechanical instruction."[76] Hapgood's image of the girl-child as the embodiment of a new age was one that Stieglitz would grasp hold of in shaping his woman artist as woman-child.

Stieglitz's promotion of children's art similarly made the point that artists had to rediscover the child in themselves to produce an art that was vital, growing, and open to new ideas—ultimately, to social revolution.[77] In his first look at childhood creativity Stieglitz presented the child artist as genderless but also classless. Much of the art in this show was produced by a group of six-year-olds from a settlement house on the Lower East Side.[78] The picture of these lower-class children as standard-bearers of the liberated imagination was tremendously useful to Stieglitz as he positioned himself against the status quo as the leading anarchist of the New York art world.

Although Stieglitz won converts to his cause, as is evident in the critical response, some scoffed at such romantic theories and commented that much of the art on display was not exceptional children's work. At least two critics felt compelled to expose the strategic function of Stieglitz's model of child vision as innocent of convention by pointing out that one of the drawings exhibited—by Stieglitz's daughter, Kitty, executed when she was eleven—strongly resembled Max Weber's works, which Stieglitz had shown at 291. Kitty had studied drawing with Weber a short time before.[79]

Though his second exhibition of children's art at 291 (February–March 1914) was received with indifference, Stieglitz countered with another sensation eight months later that placed his gallery back in the newspapers. He commanded attention this time with an exhibition of West African sculptures from the collection of the Parisian Paul Guillaume, a show that had been arranged by the expatriate Mexican caricaturist Marius de Zayas, who was Stieglitz's close associate in these years (Fig. 78).[80] The point of this display was that modernist art had its formal roots in the primitive self and in primitive art, as well as in the gentler child self of the artist. The insight was hardly original, coming a decade after Matisse and Picasso had made their studies of African sculpture well known, but in New York it was an idea that would be replayed more than once over the next several

years.[81] In collaborating with Stieglitz on the 1914 show, de Zayas titled it "Statu-
ary in Wood by African Savages: The Root of Modern Art." He later published an
essay, "Modern Art in Connection with Negro Art," in which the African "Negro"
was caricatured as childlike and living in a world of fear. According to de Zayas,
this sculpture was teaching modernists how to express their subjectivity, "our
purely sensorial feelings in regard to form." But he characterized it as a barbarous
art that bypassed analysis and observation for the intense expression of the inner
life.[82]

Such traffic between the figures of the child and the primitive, a feature of nine-
teenth-century evolutionary discourses, circulated as the theory of recapitulation—
that ontology recapitulates phylogeny, or that the stages of individual human de-
velopment, from childhood to adulthood, recapitulate those of developing human
societies. In this racial and racist discourse popularized in Herbert Spencer's *Essays
on Education* (1861), the child was a primitive in the process of becoming a civilized
human being, just as primitive people represented the childhood of the human
race. Recapitulation theory was accepted by such psychologists as G. Stanley Hall,

79

Clara E. Sipprell, *Portrait of Max Weber with an African Congo Statuette,* ca. 1914–16, platinum print.

who in the late nineteenth century was a leader of the movement to study children. For Hall, the child was the key to the modern individual's "deep and strong cravings . . . to revive the ancestral experiences and occupations of the race."[83] The same discourse of the primitive circled around Stieglitz's first exhibition of children's art as one of his house critics, Sadakichi Hartmann, invoked its terms in comparing Native American baskets and blankets with the art of children.[84] In de Zayas's book *African Negro Art,* both the child and the primitive live in an unconscious world from which their art originates; it is modern man who must make a conscious effort to get back to the place of origins and find his essence.

These two figures, of the child and the primitive, were crucially intertwined in modernist discourse but also were distinguished from each other in the Stieglitz circle according to their gendered attributes. De Zayas's notion was that in African life terror and barbarism constituted the operative mode of psychic life that directly shaped the plastic forms of African sculpture. The primitive model allowed Stieglitz, Weber, de Zayas, and others in their circle to imagine for themselves a primitive alter ego or core self, hidden in the dark unconscious, at times mystically surfacing into the raw, chaotic flow of a life shaped wholly by the senses.[85]

In a photographic portrait dating from the period of the African sculpture exhibitions in New York, for example, Max Weber represents himself communing with a Congo sculpture, acknowledging just such a moment of self-identification. Weber here recognizes his deep self as a primitive psyche that is displaced and visualized in the sculpted object (Fig. 79). The criticism of Matisse's work in New York had also suggested how productive the coupling of the two terms *barbaric* and *innocent* could be in presenting hedonistic pleasure as a legitimate part of high art's mandate for transcendence. But for Stieglitz this discourse of the primitive served as a masculinizing counterdefensive against the potentially overfeminizing effects of defining the artist's essential nature in the terms of the softer, paradisiacal world of the child, especially the child as product and sign of bourgeois domesticity.[86]

Gendering the Child

Stieglitz's third exhibition of children's artwork, held in March and April 1915, makes clearer the shift in his thinking about the child as a model for the artist and about the gender of the child—a shift that followed his installation of African sculpture. This third children's exhibition was composed solely of drawings by boys from a public elementary school. And interestingly, their work was presented as manifesting some undesirable quality—a tainted vision. Stieglitz made this idea of contamination clear by selecting the work of boys that was produced, he said, "under the influence of a system." In the pamphlet he handed out in the gallery, Stieglitz pointedly contrasted the present travesty with the first two children's exhibitions, repeating that those earlier shows featured the "unguided work" of "unselfconscious" children—work that "disclosed, in a most illuminating manner, the invaluable quality of individual observation, and the equally valuable impulse towards individual expression."[87] The first and second children's exhibitions had included the works of untutored boys *and* girls, while Stieglitz represented the third exhibition as a display in which the [boy] child artist was not so much child as future patriarchal academician—the figure against whom the modernist had to construct himself. [88]

80

Abraham Walkowitz,
Improvisation of New York City,
ca. 1916, oil on canvas,
44 × 32¾ in.

The pernicious effect of schooling—any schooling—was delineated at 291 in the figure of the male child whose naturally intuitive vision had been perversely dulled. This distinction between the innate capacities and character of boys and girls might have been suggested by Charles Caffin, who in his review of the second children's exhibition at 291 tried to distinguish boys, especially after age ten, as more likely to be interested in observation and the technicalities of rendering than younger girls, who drew more from the imagination and more completely revealed the "child mind" in its quality of "pure imagination."[89] After the first children's exhibition in 1912 Stieglitz promoted the work of Walkowitz and Marin, both

artists whose drawings exhibited childlike qualities. Walkowitz, for example, rendered simplified, soft images of women, lovers, children, and dancing buildings (Fig. 80); similarly, Marin playfully transformed Manhattan's skyline into dynamically moving structures. In fact, in *Man and Woman*, Ellis had called attention to the frequent resemblance of "men of genius" to a child type. But by the time Paul Rosenfeld took over as official voice of the Stieglitz circle in the 1920s, Marin had been reconfigured by Rosenfeld and Stieglitz as an artist who through his masculine power and agency produced "orgasmic" and "explosive" works.[90] Following the 1915 exhibition of boys' art, Stieglitz split the model of the child as modernist into a primitive, virile, spontaneous self and an innocent, secretive, interiorized self. These were images he could manipulate at will, and later he would even combine them to suggest the subversive potential of his modernists.

The gendering of the child artist was completed in the next and final exhibition of children's art staged at 291. This exhibition was devoted entirely to the drawings of Stieglitz's ten-year-old niece, Georgia Engelhard (Figs. 81 and 82), whose impish character Stieglitz captured in 1920 in a portrait of her at age fourteen. To drive home the deviancy of the boys' art, created under a system, Engelhard was billed as "The Child Unguided—Untaught."[91] Ostensibly, this display was conceived to present the image of the true child once again. Charles Caffin made this point in his review of the show, contrasting the "steam-rolling of the individual to an average level in the methods of instruction" with Engelhard's "exceptional" and yet exemplary child vision, "free as the wind . . . [in] the play of the spirit" and at times reaching "a depth of emotional expression." This child's paintings called for a "reaffirmation of the miracle of instinct" and uncovered "the potentialities of human nature, could it be allowed in Bergson's happy phrase, to recreate self by self; to evolve out of the mystery of itself in a free and truly sane environment." But it is also striking that Engelhard's images, which supplied a model for adult modernists, were recommended via the tropes of femininity: "beautiful as need be," full of "spiritual suggestion," and "in communion with the grandeur of nature."[92] Stieglitz had kept the figure of the child alive for four and a half years at 291 by constantly reinventing it—from the ungendered, Romantic child, pure and innocent, to the contaminated masculine child—soon to be the adult male aca-

demician—and finally to the virginal girl-child of ten. After 1916 Stieglitz imprinted gender on his template of the artist as child: she was a "wonder-child" (Rhoades) or the "Great Child" (O'Keeffe).

Looking back over this project culminating in the girl-child as the model of "pure" artistic vision, we see Stieglitz making use of intersecting discourses of femininity and the primitive. The first discourse on the child he knew placed the child within the bourgeois domain of domesticity and feminized the figure of the child.[93] This route led to Gertrude Käsebier's kindergarten world and the definition of women as mothers or femmes fatales. The newer development of sexology led to Stieglitz's patriarchal modernism and private search for the woman artist

who would be a woman-child. The sexologists' legitimation of sexual desire as natural and healthy justified his desire for a woman-child who would revitalize his sexuality and thus his creativity. From Carpenter, he would have learned that woman was a mute on the subject of her extensive sexual life because, like the child and the primitive, she existed in a preverbal, intuitive state. From Ellis, he saw that woman was not only childlike but unable to realize her intellectual potential because she would not confront her sexual desire. According to Ellis, women rarely produced great art because they were homogeneous, like children, stable in character, and not individuated, while men were driven toward the extremes of idiocy or genius.[94]

83

Arnold Genthe, *Irma, Theresa, Anna, Lisa, Isadora, Erica, and Margot Duncan,*
ca. 1917, gelatin silver print, 5⅞ × 7½ in.

Evolutionists such as Herbert Spencer had used this distinction between ho-
mogeneity and heterogeneity to separate the primitive races from the civilized.[95]
Now it was employed to distinguish women from men by virtue of their likeness
to children. Both Bergson and Freud believed that the child could still be located
in the mature adult psyche—in fact, that child self must be apprehended there to
ensure psychic vitality. But Freud saw the child as sexualized and the sexual con-
flicts of childhood as the origins of the sexual conflicts of adulthood. Freud's child
was no longer an innocent, and neither was woman, whom Freud described in 1914
as a narcissist, resembling a cat as much as a criminal.[96] Freud's first American
popularizers tried to collapse the savagery of the primitive psyche into the child
psyche, a movement that some psychologists and neurologists strongly protested
as unnatural given the cherished belief in the child as innocent.[97]

For New York's intellectuals, however, a more acceptable image of the child, in

the form of the girl dancer, appeared on the New York stage in late 1914 and early 1915. The "Isadorables," once Duncan's child dancers, now ranging from thirteen to twenty years of age, performed in sold-out recitals, returning to the Metropolitan Opera House again in spring 1916 and fall 1917 (Fig. 83). They made an unforgettable impression on artists such as Robert Henri and Arnold Genthe who saw them, recalling the impact Duncan herself had had on Walkowitz and Weber when she had appeared a few years earlier in New York. They were "the loveliest children imaginable" to Sol Hurok.[98] Their lithe dancing bodies, both innocent and desirable, must have been for Stieglitz a frustrating reminder of his would-be woman-child—Rhoades, who continued to deny him access to the modernist paradise that this phantom figure promised.

Breakdown at 291

By October 1914, Stieglitz had pushed Rhoades to the breaking point: she told him that she wanted to stop "Freuding" with him. In early November 1914 she warned him to stop fantasizing about their relationship and insisted that their friendship was limited to a spiritual and intellectual affinity. To make Stieglitz see her point, she proposed that they burn their letters to acknowledge that their intimacy was at an end. A few weeks later, however, he again urged her to "concentrate" in her work, to "focus," to "crystallize," to invest more in her creative life *and* in her relationship with him, insisting that she could not become a woman until she realized a productive sexuality. To his request that she define their friendship, she wrote:

> The only two terms apparently, applied to a relationship between man and woman, not married to each other—are—friendship and a love affair. Neither seems to describe this—"friend" comes nearer. Whitman would say "camerado." . . . Companionship—perhaps that is how I like best to think of it and what comes nearest to that which I feel exists. I feel that it will be still more perfectly that than it is now. . . . What I feel most freely is a similar sensing of certain intangibilities and values and understanding of essentials—a desire to be frank even when not speaking.[99]

Clearly, she was trying to hang on to him as a mentor while she destroyed his hope of becoming her lover. Free-love affairs Rhoades damned as destructive and fleeting; the reality was that an affair consumed energy, life force, and emotion, leaving exhaustion and inertia in its wake. Instead, she wanted equilibrium, companionship, support, and trust from him.

This was not what Stieglitz wanted to hear. He pressured her more: Why could she not give to him as a woman, which was "the natural thing to do"? Rhoades again rejected the role of the woman-child: "Once in a while I feel as though your letters were not from you! It is a part of the same feeling I wrote about—that when you wrote to the wonder-child, it was not to me. And of course, it comes right down

to that, that the wonder-child is not I. If there is something in me of woman, that is possible, but I cannot be the wonder-child. It isn't in me to be it. And so, the question I ask yourself is—not being able to be the wonder-child, can I be the friend?"[100]

Six weeks later, in January 1915, Stieglitz hung an exhibition of her work along with that of her friend Marion Beckett at 291. Through visits to the studio the two shared on Thirty-first Street, he had closely followed their painterly development and over the preceding several months had been impressed with their progress.[101] It is clear, however, from their correspondence after the exhibition that neither Stieglitz nor Rhoades herself felt she had pushed far enough toward a personal form that would convey a sense of her inner self. From the autochrome slides that either Stieglitz or Steichen made of several of her paintings at this exhibition, her style at this point was comparable to that of Arthur Carles, whose post-Impressionist work Stieglitz had exhibited at 291 in 1912. Rhoades had worked alongside Carles in France, and some of her paintings in the 291 exhibition parallel Carles's example. In her *Self-Portrait* (Fig. 84), Rhoades's impassive, masklike face protects her from the viewer as she draws back, aloof, even arrogant. The hauteur of her face resembles that of Carles's death-in-life portrait of her as a cold, even ghostly presence (see Fig. 75). But Carles sees her as a dead spirit, while Rhoades fashions herself as a decorative surface that closes off the inner self from the world.

In her portrait of Carol Rhoades (Fig. 85), an image of her nine-year-old niece as a study in girlish innocence, she developed a fauvist manner, as in *Landscape (Williamstown)* (Fig. 86). These surfaces, with their tentative brushwork, however, failed to emit the charge, the "vital" movement that Stieglitz and his artists read as a sign of the artist's intuitive projection of the inner self. Her rudimentary fauvism, which in the Williamstown landscape achieves a more energetic composition, shows Rhoades experimenting with abstraction, like many of the young American painters—Hartley, O'Keeffe, Maurer, and others—whom Stieglitz would support in this period.[102] But Rhoades had not yet entirely relinquished the conventions of volume and modeling to find a more radical sense of pictorial structure that could be interpreted as the self in harmony with the rhythms of the world. Visual evidence of the artist's unconscious life was requisite to Stieglitz's

85

Katharine Nash Rhoades,
Portrait of Carol Rhoades,
ca. 1915, oil on canvas.

86

Katharine Nash Rhoades,
Landscape (Williamstown),
1915, oil on canvas.

definition of modernist art, according to Bergson's description of how the artist must work from an inner necessity, to display a synergy of personal and universal spirit. Such artists set free an inner music, Bergson wrote, "closer to man than his inmost feelings, being the living law." They "compel us to fall in with [those rhythms], like passers-by who join in a dance."[103] De Zayas restated this very point: the evolved artist would be marked by an "inner force" that was "awakened by stimulation of intellect and emotions." Marin's painting provided a prime example of this dynamic as Marin himself evoked it: "It is this 'moving of me' that I try to express, so that I may recall the spell I have been under and behold the expression of the different emotions which have been called into being."[104] In Rhoades's canvases, such as her *Nude* (Fig. 87), there was little of a unique or sustained rhythmic movement, although the Williamstown landscape with its strongly gesturing forms of trees strains at such an effect.

Her portraits approach Steichen's struggle in these same years to move away from the Whistlerian veiling toward modernist form. In his villa at Voulangis, where Rhoades and Carles had painted in 1912, Steichen too attempted to complete a group of large-scale decorative works for Ernst and Agnes Meyer (Fig. 88), using a process of fragmentation. While Steichen has somewhat fractured form into quasi-fauvist color planes, his imagery is still invested in the conventions of femininity—women as nature, the feminine body reverently aestheticized into art object—imposed on the figures of Rhoades, Beckett, and Meyer, who modeled for the panels. Steichen's failure resembles Rhoades's in that there is in these bodies no sense of the rhythmic movement that, in the Stieglitz circle, spoke of the artist's intuition of flow. He eventually abandoned painting altogether for photography.[105]

Because Rhoades was judged to be a young painter who still had time to develop, the press reacted generously and overall favorably. There were reservations about her marriage of strident color to a lingering volumetric approach to form, but reviewers praised her rendering of childhood naïveté and her landscapes for their "living" feel of air and light. Undoubtedly, the critic Charles Caffin had heard Stieglitz talk in front of the paintings in the gallery, for he too supported Rhoades as a qualified modernist—"pure, . . . lucid and clairvoyant"—who relied on her intuition, "psychically sensing her subject." Caffin emphasized the spiritual

87

Katharine Nash Rhoades,
Nude, ca. 1915, oil on
canvas.

88

Edward Steichen,
In Exaltation of Flowers:
Petunia, Caladium,
Budleya, ca. 1910–13,
oil on canvas.

expression of her Williamstown landscape, which Forbes Watson also liked for its "desired effect of ethereal freedom from the paintiness of paint."[106] Their close friend and colleague at 291 Agnes Ernst Meyer (Fig. 89), however, registered a sharp dissent—an opinion that pierced Stieglitz's public relations bubble. A philosophy major at Barnard, Meyer had been an enterprising reporter for the *New York Sun.* It was Meyer who had introduced Rhoades and Beckett to the 291 circle, and the three women formed an impressive contingent of Stieglitz's modernists—all were striking beauties. After marrying the investment banker Eugene Meyer, Agnes Meyer took up collecting modern art and collaborated with Stieglitz to promote it. In 1915 she, with de Zayas, opened the Modern Gallery in New York, attempting to supersede Stieglitz's 291.[107]

In her review for *Camera Work*, Meyer exposed Rhoades as being too inexperienced in life and too literary to achieve the painterly sensation of the heightened, transcendent moment she was striving for. Meyer insinuated that Rhoades's visual expression, which claimed such emotional terrain as her own, was false. Most likely, Meyer's comments referred here to Rhoades's sexual status in the new modernist exchange between aesthetic liberation and liberated sexuality. These personal implications were devastating to Rhoades, as well as to Stieglitz, who had clearly failed in his attempts to bring her to the essential modernist experience of the world that Rhoades alluded to in paint. Stieglitz's colleagues in the back room at 291 had debated whether her work merited exhibition there. Compared with the more complete and charged abstractions of Marin, Dove, Picasso, and Picabia recently displayed at 291, Rhoades's fauvism appeared hesitant and unremarkable. Rhoades thought Meyer's verdict reflected their analysis of her work—and their gossip about her personal life.[108]

Rhoades's response was to retreat from New York, deeply depressed, to her family's country house in Sharon, Connecticut, and to stay there for most of 1915. Even so, Stieglitz and Rhoades together managed to work on several volumes of the experimental Dada journal, *291*, along with Agnes Meyer, de Zayas, and Francis Picabia. In the issue for April 1915 Rhoades contributed an abstract drawing that engaged her defense of herself from Stieglitz's demands on her (Fig. 90). This drawing can be imagined to represent both the shape of a smoking gun and the head of a rooster trying to separate a spermatozoa at the bottom from an egg at the top. The drawing accompanied a feminist-themed issue in which the lead article, "Motherhood a Crime," told the story of an illegitimate birth that led to the suicide of the mother. In that context, of the tragedy of unwed motherhood, Rhoades's portrayal of the free-love affair as violence against women barely repressed her outrage against a corrupt social system in which women had to suffer for their sexual liberation.[109]

Stieglitz's disillusion with Rhoades came and went over the course of 1915–16. He refused to give up on her as a woman-child until it became clear, in 1917, that O'Keeffe was a better candidate, willing and ready to play the role. In his letters he continued to press her to grow up, torturing her—over the significance of her

90

Katharine Nash Rhoades,
Drawing, published in
291, no. 2, April 1915.

words and gestures—and himself to the point where Rhoades feared in July that he was having a breakdown. Rhoades too was at an impasse, not knowing how to balance the demands being made on her—to incorporate the worldliness of the woman with the purity of the child.[110] Responding to his complaints of his pain over her, Rhoades conveyed her exhaustion with the friendship and his pressures on her to perform: "I'm tired of being a woman and of not knowing how to be one." Rhoades finally acceded to his view of her, losing all sympathy for her own position. His letters made her hate herself and her "inner limitations." She knew she had a "problem inside" herself to solve that summer: "It's do or die . . . kill

91

Edward Steichen(?), *Picnic at Mt. Kisco, July 4, 1915,* 1915, gelatin silver print. (L. to r., clockwise): Agnes Meyer, Paul Haviland, Abraham Walkowitz, Marion Beckett, Francis Picabia, John Marin, Eugene Meyer Jr., Katharine Rhoades, J. B. Kerfoot, Emmy Stieglitz, Marius de Zayas, Alfred Stieglitz.

or cure." Trying to salvage the friendship and cool things down, Rhoades pleaded with Stieglitz not to be "so intensely personal" toward her, admitting that she needed him as a mentor who had taught her Bergson's lessons—"Life as Faith, Motion, Rhythm, and Song"—but telling him that his physical demands on her had become "terrific" on them both emotionally and could not be satisfied. Given that everyone at 291 was under a terrible strain exacerbated by the tension between the two of them and that his wife, Emmy, had complained to Rhoades on the phone that she knew she could be nothing to her husband, Rhoades determined to distance herself from Stieglitz by staying away from 291 over the summer and fall.[111]

When they saw one another again at a July Fourth picnic at the Meyers' Mt. Kisco estate (Fig. 91), Stieglitz, still suffering over her, directed his animosity toward Steichen, ostensibly over their disagreement about the conduct of the war. His feelings were further frustrated that fall by Rhoades's new friendship with Charles Lang Freer, the wealthy art collector and industrialist, whom Stieglitz sensed was a ri-

val to him as Rhoades's fatherly mentor.[112] Rhoades attempted to cure her own depression by spending more time with Freer in 1916 at his Detroit home, assisting him in cataloguing his vast Asian collections, and then in the Berkshires, where he planned to build his new country home. She now limited her contact with Stieglitz at the gallery and her correspondence with him.[113]

From 1914 to 1916 the language of dreams, self-revelation, and psychoanalysis permeated the heated environment in which Stieglitz and Rhoades argued in the same terms over their modernist partnership. The psychoanalytical frame for the work of art was also vital to Stieglitz's shaping of O'Keeffe as a modernist in 1916. As is well known, on New Year's Day 1916 Anita Pollitzer brought Georgia O'Keeffe's drawings into 291, and on May 23 Stieglitz opened a show of O'Keeffe's work along with radical drawings by two men, Réné Lafferty and Charles Duncan. Stieglitz characterized these works collectively as "psychopathic" for their attempt to uncover extreme and hidden states of mind. Lafferty had spent time in an asylum for the insane, and Duncan, Stieglitz feared, was on the brink of suicide. O'Keeffe's images, Stieglitz commented, "were of intense interest from a psycho-analytical point of view."[114] This groundbreaking exhibition followed from the changing trajectory of Stieglitz's modernism. The gallery had served to introduce modernism's liberated, erotic aesthetic, based on his reading of Kandinsky, Bergson, and Ellis. Now it proposed a Freudian variant, putting on display psyches in which eroticism, repressed and frustrated, was finally on the verge of collapsing into psychosis. At about the same time in the journal 291, Stieglitz played with a typeface he called "Psychotype, an art which consists in making the typographical characters participate in the expression of the thoughts and in the painting of the states of souls" (Fig. 92). He had also planned an issue of *Camera Work* to focus on the relationships between the art of children and the art of mental patients, since Freud's followers such as Brill believed that both demonstrated a direct link to the unconscious mind and held the key to the mysteries of human nature. The mental patients whose art was to be printed in *Camera Work* had been treated by Dr. Brill and had executed drawings as part of their therapy.[115] The assumption about these drawings was that the visual imagery, like a dream in psychoanalysis, functioned as a disguised symbol of trauma.

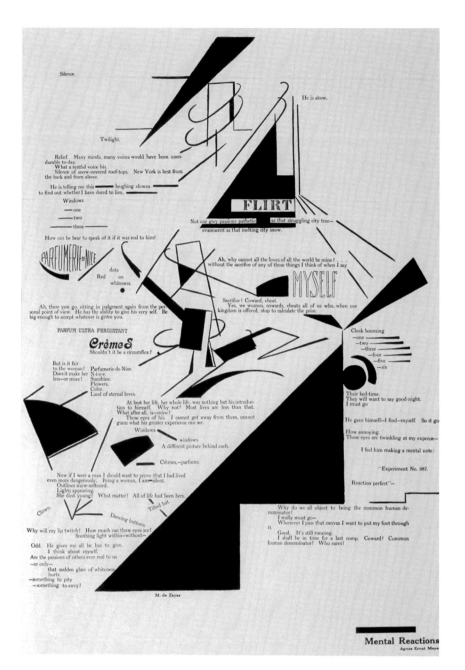

92

Marius de Zayas and Agnes Ernst Meyer, "Mental Reactions,"
published in *291*, no. 2, April 1915.

Psychopathic Modernism

Within two years of discovering the child as the image for the transcendent purity of his modernist enterprise, Stieglitz had engaged the figures of the primitive and the insane to keep his gallery alive, at a time when his colleagues Meyer and de Zayas had decided that the 291 gallery had served its purpose and required a reincarnation to cultivate a broader audience. Several times from 1912 on, Stieglitz himself considered shutting down 291 and *Camera Work*, reasoning that they had fulfilled their purpose, since modernist art was now ubiquitous in Manhattan. An issue of *Camera Work* (July 1914, published in January 1915), commemorating the 291 galleries from the various perspectives of Stieglitz's colleagues and friends, admitted as much, some implying that Stieglitz's moment was over. The establishment of several rival modernist galleries, among them Meyer's and de Zayas's in 1915, threatened Stieglitz's command of the field.[116] Through identifying his artists with the primitive, the insane, or the child, Stieglitz countered the threat by reinventing his modernist enterprise. Dramatizing his artists as these phantasmal figures enhanced their shock value and renewed his own radical opposition to academic and bourgeois materialism. Viewed as neurotic or insane, the strange affect of their abstractions gave new meaning to a modernist art based on "inner necessity"; with the bar for authenticity now raised to an extreme, Stieglitz intended to redefine the moral high ground of modernism.

In New York in 1916 the image of the idiot savant as a natural figure for the artist was not original to Stieglitz; like the figures of the child and the primitive, it had a place in the traditions of nineteenth-century Romanticism. At the end of the century the revival of interest in the art of insane persons was stimulated by the scrutiny that psychology brought to the terrain of the mental hospital. It was thought that if mental patients could not articulate their secrets in reasonable speech or confession, the tool psychoanalysis adopted, analysis of their drawings and scribbling could unlock the narratives buried in the unconscious. The German psychologist Fritz Mohr, for example, used the character of patients' drawings as a roadmap to the hidden topography of the patient's mind.[117] From roughly 1900 to 1915, a slew of exhibitions all over England and Europe featured the drawings of asylum in-

mates. One of the most important of these, in August 1913, sponsored by Beth-lem Hospital (London), came on the heels of the Armory Show only to reinforce the contemporary perception of modern art as similar to the art of the insane, in addition to that of primitives and children.[118]

The understanding of the unconscious as a place where a child self coexisted with an insane self had emerged in the critical response to Stieglitz's first exhibi-tion of children's art in 1912. Hartmann had written that all life springs from the unconscious and that all lower manifestations of nature subsist there. In this "sea of insanity," he had stated, we find also "the extreme of the fullest appreciation of existence, where man loses his identity . . . the great artist, like the madman who believes himself to be a king or Jesus Christ, [and] becomes one with the work he creates." The greatest artists, he had concluded, "remain simple as children but unconsciously in their art become identical with the object of their creation"—as madmen do.[119] The Stieglitz circle optimistically glossed this idea of the uncon-scious as a source of libidinal energy and spiritual knowledge.

A few months before Stieglitz introduced Engelhard, the ideal child artist, to modernist audiences in November–December 1916, his exhibition of O'Keeffe's drawings (Fig. 93), alongside those of Duncan and Lafferty, showcased these artists as an array of modernism's dramatis personae. Lafferty, recently released from a mental hospital, was represented by abstract images of a comet, a dragonfly, and a fountain. Duncan's drawings, like O'Keeffe's, were also complete abstractions. Writing about the "intense interest [of these works] from a psycho-analytical point of view,"[120] Stieglitz sensationalized what was already a collection of oddities: he eroticized O'Keeffe's work as unveiling a woman's hidden sexuality. Here the works of the marginalized, of outsiders, were submitted to the public as glimpses into aberrant psyches—the mental life of the insane and the secret sexuality of woman. As Stieglitz made out O'Keeffe's drawings, "'291' had never before seen woman express herself so frankly on paper."[121] Stieglitz's friend the critic Henry Tyrrell, reviewing this show for the *Christian Science Monitor*, immediately pegged O'Keeffe as the figure of the child in her work: she "looks within herself and draws with un-conscious naïveté what purports to be the innermost unfolding of a girl's being, like the germinating of a flower."[122] In Stieglitz's portrait of O'Keeffe two years

93
Georgia O'Keeffe,
Special No. 4, 1915,
charcoal on laid paper,
$24\frac{1}{2} \times 18\frac{1}{2}$ in.

later, he visualized Tyrrell's description, implying a sexual expressiveness in her drawing as he showed O'Keeffe giving birth to the image, which takes its life and grows directly from her body (Fig. 94). In his portrait of Duncan, Stieglitz similarly offered the weird identity he had constructed for him in the 1916 exhibition, as the strange effects lighting Duncan's head and torso from below make the artist seem to radiate a charged aura from within of a pool of darkness (Fig. 95).

This representation of the modernist as an extraordinary mind operating outside the boundaries of the normative psyche was echoed in the practices of Village radicals who re-created themselves as peasants, exotics, mystics—social types outside the bourgeois order they had left behind. Inspired by the writings of mystics such as Carpenter, Mme Blavatsky, and the Swami Vivekananda, fashionable

94

Alfred Stieglitz, *Georgia O'Keeffe,* 1918,
gelatin silver print, 9¹/₄ × 6¹/₁₆ in.

95
Alfred Stieglitz,
Charles Duncan,
1920, palladium print,
$9\frac{1}{8} \times 7\frac{1}{4}$ in.

bohemians put themselves on display as Orientals.[123] Robert Henri's portrait *Gertrude Vanderbilt Whitney,* for example, which finds this sculptor and heiress in harem pants lounging on a divan, recalls the erotic sinuosity of his *Ruth St. Denis in the Peacock Dance* (Figs. 96 and 97). Or consider Mabel Dodge (Fig. 98), dressed as an androgynous swami for one of her soirées.

In New York in 1916, letting it be known publicly that one was entering into psychoanalysis was inviting the stigma of sensationalism and the uncanny attached to this little-understood therapy. Mabel Dodge, for one, who visited Stieglitz's 291 gallery in this period, just as he occasionally frequented her salons, had herself psychoanalyzed by the famous Dr. Brill and then, in a series of newspaper articles,

96 (Left)
Robert Henri, *Gertrude Vanderbilt Whitney*, 1916, oil on canvas, 50 × 72 in.

97 (Below, left)
Robert Henri, *Ruth St. Denis in the Peacock Dance*, 1919, oil on canvas, 85 × 49 in.

98 (Below)
Unknown photographer, *Mabel Dodge, Dressed as a Swami*, ca. 1915, gelatin silver print.

confessed her liberated sexuality in a language that combined Freud with Bergson and theosophy.[124] This was, in fact, Dodge's second time around with psychoanalysis. She had undertaken her first adventure with a Jungian, Dr. Smith Ely Jelliffe, whom she abandoned for Brill's Freudian analysis. A chameleon of modernist traits, she remodeled herself constantly, from dowager empress of the Village intelligentsia, to mystic—a persona that displayed her rapport with another realm of consciousness—to primitive through her marriage to the Pueblo Indian Tony Luhan. By trumpeting her psychoanalysis, Dodge created an identity for herself as a person of substance and depth to compensate for the sense of inner emptiness that habitually depressed her.

As Stieglitz was preparing for the "psycho-analytical" adventure of the O'Keeffe, Duncan, and Lafferty exhibition, he suggested to Rhoades that she read Jung's *Psychology of the Unconscious* (1916). Most likely, Stieglitz had studied it in the interest of finding answers to the riddle of Rhoades's unwillingness to "bare herself" and "give" to him.[125] Stieglitz's own copy of this book contains many underlined passages in the introduction explaining Jung's theory of the libido. Particularly interesting to him were the passages on the origin of sexual dysfunction in the parental ties that remain inappropriately strong and constricting as a child reaches adulthood. For the libido to be freed, Stieglitz read, the childish tendencies of the adult must be relinquished.[126] For him these passages suggested Rhoades's investment in her father and her still fraught relations with her mother.

Earlier, in March 1915, Stieglitz had tried to break through the impasse with Rhoades by jolting her, publicly baring himself in three dreams he composed about her and then published in the first issue of their experimental *291*. Rhoades had told Stieglitz of her susceptibility to mystical dreams. Expressing her anxieties about her own future during the "Freuding" period of 1914, she had begun a painting to interpret her dream of a star falling into oblivion over a crystal island as a portent of her own fate.[127] But while both she and Stieglitz combed Freud's dream volume for insight into their own conflicts, their dreams, oddly enough, did not follow Freud's examples. In Freud's dreams, hermetic objects or persons stand in as displaced symbols or screens for childhood sexual trauma. Identifying the trauma and infantile wish behind each symbol solves the riddle. American popu-

larizers of psychoanalytic practice instead regarded the dream as an allegorical form that revealed the soul's "innermost secrets" and most often its "adulterous desire."[128] Stieglitz's dream suggesting his conflict with Rhoades played to the latter, American, sense of the dream. It also emulated another model, that of Olive Schreiner's in her small volume *Dreams* (1890), which went through at least nine editions by 1918.[129] A well-known South African feminist whose status was similar to Ellen Key's, Schreiner had been Havelock Ellis's lover and was esteemed in radical circles for her essays on the economic liberation of women. Stieglitz's dream-narratives recall Schreiner's "Three Dreams in a Desert" in their use of a first-person narrator who recounts the dreamer's struggle to gain freedom or fulfillment in relation to the love object. Schreiner's parables are meant to prophesy a new enlightened era or warn of the consequences should that enlightenment fail. Personalizing Schreiner's form to his own ends, Stieglitz's dreams set out a self-serving version of his erotic frustration with Rhoades; they warn of her possible end in spiritual death and creative sterility.[130] His fantasies dramatize his feelings of loss at his inability either to make Rhoades love him or to satisfy her needs, and they threaten his death and her madness. Clearly, Stieglitz was making himself an example to her of how to bare oneself to the world—the act he had urged upon her. Such dreams that bared the unconscious gave access to energies that could be transformed into art, and they hinted at the deep vision that defined the highly evolved artist as a member of New York's intellectual elite.

Enter O'Keeffe: A Woman, at Last

In linking the images by O'Keeffe, Lafferty, and Duncan to psychoanalysis, Stieglitz similarly marked his artists as radical modernists. He set their art before his public, not as weird or crazy, but as strange in the most enlightened way, abnormal because it was beyond normal: it was in touch with higher spheres of consciousness that only a few knew how to reach. In O'Keeffe's case, the interior life of woman unashamed was finally revealed for Stieglitz by means of a highly eroticized, abstract aesthetic, as he would write retrospectively in 1918. Stieglitz led a

stunned and silent Rhoades through this exhibition, and in a subsequent exchange of letters with her he reveled in his discovery of what he deemed a voice of feminine sexuality, thereby rebuffing her. Rhoades dismissed O'Keeffe's images as "trivial" and "superfluous," refusing to engage with Stieglitz's reading in them what she herself lacked and had always rejected from him.[131] In return, he goaded her, asking if she was busy painting—creating "babies all of your own making"—and claimed that he "knew in advance that you wouldn't like them [O'Keeffe's drawings]. And I understood your silence." But their purely personal nature—"so thoroughly feminine, so thoroughly frank, self-expressive"—staggered him. He wanted to live with them and show them, he told her, even though he felt it "a terrible responsibility" to expose something so private to public view. Probably, he was simply restating what Pollitzer herself had told him of O'Keeffe when he wrote to Rhoades, "I felt that the woman had made them for herself, that they were to be shown to nobody, except possibly to the friend of hers who betrayed the trust when she brought the drawings to me." Pollitzer later recorded that on his first look at O'Keeffe's drawings Stieglitz exclaimed, "Finally a woman on paper!"[132] His connection of O'Keeffe's feminine secrets—which he found so satisfyingly shocking—to the imagery of the insane Lafferty and the suicidal Duncan was Stieglitz's affront to the public—a gesture both voyeuristic and angry. "Trivial! Superfluous!" he mocked Rhoades. "What is trivial? What is superfluous? I have suffered tremendously while in the process of learning that what is the least trivial, the least superfluous, to me, seems most trivial, most superfluous, to everyone I know." Feeling his desires for public recognition and personal gratification frustrated or rejected by those closest to him at 291, especially de Zayas, Meyer, and Rhoades, Stieglitz lashed out at them through whatever means available to him.[133]

From this time, Rhoades increasingly involved herself in helping to shape Freer's collection of Asian art in Detroit. In Freer she found a father figure who would not trouble her with modernist sexual politics (Fig. 99). When she came to work as his secretary and assistant, he was too ill to regard an object of art as anything other than a means of sensuous therapy that ministers to body and soul. Their shared regard for his collection of Asian objects as a repository of aesthetic purity and spirit was the ground of their friendship.

Stieglitz and Rhoades continued to exchange letters even while he courted O'Keeffe in 1917. At the end of that year he wrote Rhoades that he had not changed his feelings about her.[134] They ceased writing in 1918, however, after Stieglitz's wife, Emmy, caught Rhoades on the street outside 291 and revealed the nature of his new relationship with O'Keeffe, pleading with Rhoades to intercede for her.[135] They resumed infrequent contact in 1919, the year in which both her mother and Freer died, but Rhoades could not bring herself to write O'Keeffe's name in her letters until 1921. Two years later, she purchased a still life painting, *Plums,* from O'Keeffe's 1923 exhibition at Anderson Galleries, although she indicated that she would have preferred the more mystical void of the "Doorway" painting in that exhibition, which O'Keeffe refused to sell and kept in her own collection for five decades after.[136] Remaining Stieglitz's and O'Keeffe's distant friend in the 1920s and 1930s, Rhoades continued to paint and write; she chose to live either alone or in all-female households with her friend Marion Beckett and Beckett's two adopted children and, later, with her niece Elizabeth Rhoades Reynolds.[137]

One later interchange between Rhoades and Stieglitz reveals a desire to come to terms with their changed circumstances in mutually supportive ways. In the late summer of 1923, Rhoades, among other guests, went to cheer an ailing Stieglitz at Lake George, at a time when O'Keeffe had fled the crowd at the compound to find herself again in the solitude of York Beach, Maine. At that time Stieglitz produced the first images in the series that would evolve into the *Songs of the Sky* (Fig. 100). These prototypes for the series he dedicated to Rhoades.[138] His "portrait" of her looks skyward, catching the swaying top of a tall shimmering birch tree in the wind. In the final image in the series of six, the tree is righted, straight, and come to rest after its swaying is over. When these works were exhibited in Stieglitz's Anderson Galleries show the following year, the reviewer for the *New York Times* related Stieglitz's understanding of these images as a narrative of Rhoades's potential to resolve the struggles of her life.[139] Several of Rhoades's own landscapes from this period (Fig. 101) raise the possibility that she produced them at Lake George that summer, in that they relate closely to several landscape photographs Stieglitz would compose at Lake George over the next few years. At the high point of their friendship in August 1914, Rhoades had connected their intellectual camaraderie—their "song"—with the transcendent vision of "sky space"—"crystal clear, greater and greater."[140] Many of her later works are cloudscapes that speak to this identity in the freedom of the disembodied and ethereal, an identity for which she found support in her study of Freer's Chinese art. As she put it in 1914 when for the first time she confronted Freer's Chinese paintings, she wanted something of what she had felt in her meditative absorption in them to enter her art: "the utter letting go of one's resistive self to become immersed in . . . life."[141]

Immersion in the silence of these Buddhist images had been a life-changing experience for Rhoades. The philosophy they projected to her—of losing the self as the ultimate act of enlightenment—relieved her from the demands that the maternal and paternal figures in her life had made on her to perform to their expectations—demands that she had no desire to fulfill. One can think of her drawing on this bodiless sensation of becoming "all sky-space" when she painted her sky images in the 1920s, especially in the large decorative series of murals she executed in a dining room in 1931 at the home of the New York financier Chester

100

Alfred Stieglitz, *Songs of the Sky,* 1924, gelatin silver print, 3⅝ × 4⅝ in.

Beach. Here the viewer's experience is one of wafting—upward—to the sky above the hills as the earth merges gradually in opalescent-colored planes of clouds illuminated by a hidden sun. The spiritual path Rhoades followed after Freer's death led her to retreat to a convent for several weeks each year during the 1930s and 1940s and to establish a library of religious texts.[142] This other way she chose for herself, then, lay outside and beyond the Freudian paradigm of sexuality as personal identity that ruled modernism in New York after 1910.

Once liberated from her parental figures, Rhoades made choices for herself that were in keeping with the mystical modernism found in the philosophies of William James and Bergson. With the advent of World War I, however, this mystical side of modernism lost its power to organize the imaginary life. The pessimism emanating from the European front and the popularization of Freud's model of the psyche as a dark, violent place made it impossible to maintain the optimism of a

101
Katharine Nash Rhoades, *Landscape at Lake George(?),* 1923(?), oil on canvas.

progressively evolving world consciousness as a viable modernist belief.[143] Agnes Meyer, for one, had agreed with Rhoades that modernism should be able to accommodate a different—quietist spiritual—sensibility in addition to the primitivist, ego-celebrating modernism Stieglitz was promoting. In 1914 she had urged Stieglitz to consider integrating Chinese art into an exhibition of modernist works to demonstrate what she thought were the related aesthetics of the two cultures.[144] O'Keeffe's aesthetic practices would demonstrate precisely that relation, as her principles were derived from the Japanese aesthetics of Arthur Wesley Dow and her constant study of Asian cultures. Her later solitary routines at Abiquiu were partly based on Asian practices of dress, diet, and immersion in nature. But Stieglitz's modernism, as we have seen, called on the mystical paradigm of the unconscious, as part of the universal flow of energy, to gloss and legitimate the life of the body. This use of the unconscious as mystical and erotic is especially apparent

in the narrative he made up for O'Keeffe's first abstractions of 1915–16. It was in the life of the body that Stieglitz's woman artist had to find her essential identity.

The Failure of Rhoades, the Success of O'Keeffe

At the turning point in their lives, 1915–16, both O'Keeffe and Rhoades were un-formed, artistically and personally, although both were mature women, aged twenty-eight and thirty respectively. The extent to which O'Keeffe had not solidified her artistic approach and was still experimenting when she sent her drawings to Stieglitz has become clear in the developmental history that the catalogue raisonné of her work reveals.[145] O'Keeffe was better schooled than Rhoades, however, in Stieglitz's imperative of formal experimentation. If in the classrooms of the older generation—for example, William Merritt Chase—O'Keeffe had gained nothing in finding a personal language of modernism, she had the good fortune to stum-ble on the method of the teacher who trained her in the principle of abstracting from nature: Arthur Wesley Dow. Rhoades had some rudimentary art instruction as an adolescent and afterward tried to develop a modernist idiom on her own. O'Keeffe, however, was more open and fluid, aesthetically and personally, than Rhoades, who was constricted by her family conflicts. Rhoades was ill prepared to perform the role of the independent woman artist before the public, as Stieg-litz insisted she must, and she asked him to release her from his high expecta-tions.[146] While Stieglitz intended to help free her from her past so that she could enter into a modernist partnership with him, Rhoades's desire for him as a father-mentor only led to her breakdown and the freezing of her personal and profes-sional development. Stieglitz would later make a public example of Rhoades as a failed woman-child. For all who would listen to him speak from the floor of the Anderson Galleries in the 1920s, Stieglitz used Rhoades's story of scarring and ar-rested development at the hands of her parents as a parable of womanly failure in contrast to O'Keeffe's successful self-transformation.[147]

The discrepancies between the two women's developments also have their roots in the economic conditions of their lives, as much as in aesthetic intelligence and

psychological formation. At one point Rhoades lamented that her money had prevented her progress—her lack of a sense of lack—and that only at the moment when she had no money and had to "work for her bread" would she "find time" to paint out of necessity. In leaving her a small fortune from his estate, Charles Freer made sure that for Rhoades such a day never arrived.[148] O'Keeffe, in contrast, was independent of her family after taking a teaching job in Amarillo, Texas, at age twenty-five. She was willing to submit for a time to the image of Stieglitz's natural woman and take on the role of woman-child in a way that Rhoades was not. As we will see in the following chapter, Stieglitz staged O'Keeffe's one-woman show in 1917—the final and culminating exhibition at 291—as woman's muted sexual body projected from the inside out. Although O'Keeffe allowed Stieglitz to interpolate this sexuality from her very first works he saw, she could never voice it literally herself, and she steadfastly refused this interpretation in various ways over the course of her career. In the scenario of modernism and its feminine paradigms that set out what it was possible to be as a woman, O'Keeffe played the role of Carpenter's preverbal woman, for complex reasons that I will explore in chapter 4. At first unable to explain the meanings of her abstractions, she later asked Mabel Dodge to do so for her from a woman's point of view, having found the mystifying criticisms that sprang from Stieglitz's erotic imaginings not simply inadequate but off the mark.[149]

Rhoades, in this scenario of the woman-child, was too articulate, too civilized, too bound by the cultural formations of her upper-class upbringing. Priding herself on her learning and her poetic voice, she could not inhabit the category of woman as an intuitive or a primitive. In 1915 she complained to Stieglitz that she could not find her interior: "I've looked all through myself and I'm not there! I'm all surface—I can't get at the underneath—can't find it." This lack of contact with a deep self she connected to her inability to paint out of an "inner urge or necessity." Rhoades wryly commented on her identity in the Freudian environment of modernist New York: "Most people would say she hasn't 'found herself.' Is floundering." And aiming at both herself and Stieglitz, she quipped, "That's the correct remark to make about chaste girls."[150] Here, she connects interiority, sexuality, and creativity, registering all of them as lacking in her. Stieglitz in his 1915

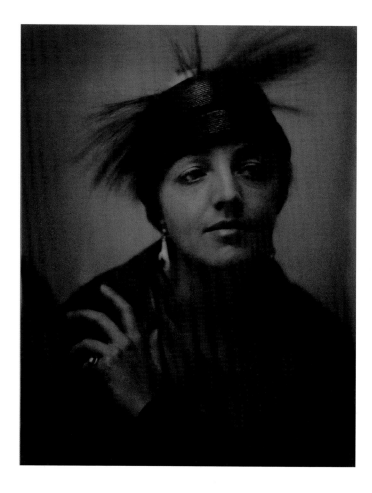

102

Alfred Stieglitz, *Katharine Nash Rhoades,* 1915, waxed platinum print, $9\frac{3}{4} \times 7\frac{11}{16}$ in.

portrait of her presents her as a worldly construction, built up in layers of feminine culture (Fig. 102). With arms folded around her, her body is self-enclosed, wrapped in a dark costume, her somber face crowned with that most absurd of feminine adornments—a hat with a frenzied contour that is reinforced by the fanning of her long fingers. Contrast this image with Stieglitz's portrait of O'Keeffe in a hat three years later (Fig. 103). Here the hat darkens an already severe face, and her animated hands are productive, as if conjuring her images behind her. In this view of Rhoades, there was no possibility of stripping her down—of ever reaching a "giving" female body beneath those layers. Both Rhoades's self-identity and Stieglitz's response to it speak of the powerful shaping force of language—

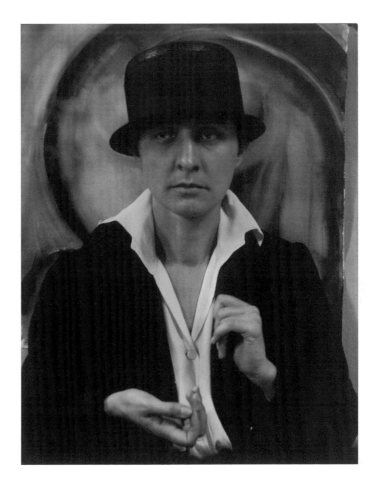

103

Alfred Stieglitz,

Georgia O'Keeffe, 1918,

platinum print, $9\frac{3}{8} \times 7\frac{7}{16}$ in.

of the sexologists' discourse of feminine sexuality, in this case the image of a negative femininity—the female body, frozen in a state of hysterical withholding from masculine heterosexual demands.

A caricature of Rhoades by Marius de Zayas (Fig. 104) at this same moment limns her as a blank, a mystery he cannot fathom, in contrast to the other women of the Stieglitz circle, whose characters are clearly related by their emblematic representations (Meyer's braininess; Colman Smith's mysticism) (Figs. 105 and 106). But Rhoades knew well her own limitations: hence, her vigorous defense of herself and her position in the spiritualized rhetoric of Bergsonian modernism. Her feminism also allowed her to defend, in social terms, her refusal to "give" of her

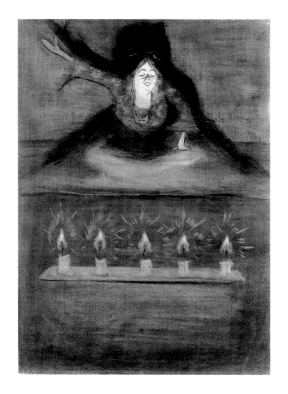

104

(Above, left) Marius de Zayas, *Katharine Nash Rhoades,* ca. 1915, charcoal on paper,
24 × 17¾ in.

105

(Above) Marius de Zayas, *Agnes Elizabeth Ernst Meyer,* ca. 1912–13, pastel over graphite on yellow paper, 23¹⁵⁄₁₆ × 15½ in.

106

(Left) Marius de Zayas, *Pamela Colman Smith,* ca. 1910, charcoal on paper,
24¼ × 18½ in.

sexuality to Stieglitz. We recall her rationale: "Woman is brought up so horribly—
to withhold her real self, and to play the delightful hypocrite—and there she will
find her success! And what happiness. She grows afraid. Afraid of life, of her own
demands, of the passion of living, of the desire to be free. Afraid, or at best hav-
ing lost the knowledge of how to give."[151] Like the radical women of the Village
who succumbed to the demands of their husbands to practice free love, Rhoades
realized that this ideology was a double-edged sword. On the one hand, they be-
lieved that inner growth issued from a more complete acceptance of their sexual
nature; on the other hand, the cost of living a life of free love was high. Mabel Dodge
and Neith Boyce, for example, were just two women among many in 1915 who, af-
ter experiencing free love in fleeting liaisons, disdained the pursuit of casual sex-
ual pleasure. For it was a central ethic of modernism in New York to act on the free
desire of the libido and then, as the only honest and truthful conduct, to confess
such dalliances openly to one's companion or spouse. Rhoades had seen enough
of these case histories (and had experienced one firsthand with Arthur Carles). She
confided to Stieglitz that she was horrified by the emotional destructiveness of free
sexuality without lasting commitment. What she wanted with all her friends, but
especially with him, she said, was equilibrium and lasting companionship on a
cooler plane, not a turgid love affair that was sure to end in psychic destruction,
not the heroic libidinal bohemianism on which Stieglitz's modernism began to
turn in 1915.[152]

It is also important to remember that Stieglitz at this time was a married man
with a child, that Rhoades knew Emmy Stieglitz socially, and that Stieglitz indi-
cated no willingness to leave his secure domestic arrangement. Looking at the broad
spectrum of New York intellectuals in this period, it is apparent that Village radi-
cals were able to embrace free love only by first cutting themselves loose from their
traditional social forms and community relations. Once they had done so, Christo-
pher Lasch observes, they made the intimacy of love affairs the new model of hu-
man relations—"a kind of religion . . . [that] had to supply the richness of the
larger social and public life which they rejected."[153] While Rhoades still had strong
ties to her family and to a social community in New York where she had grown up
and lived all her life, O'Keeffe was more or less adrift from such familial moorings

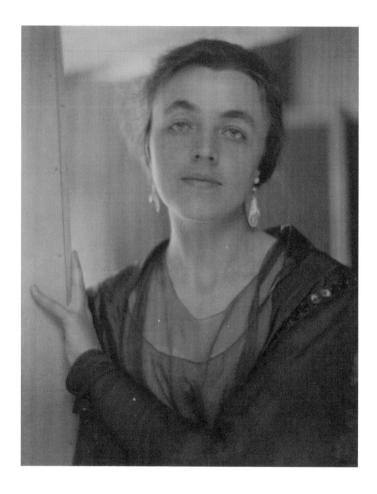

107

Alfred Stieglitz, *Katharine Nash Rhoades,* 1915, platinum print, 9¾ × 7⅝ in.

in the larger world; she was distant from her mother (who died in 1916) and estranged from her father (who died in 1919). O'Keeffe had fewer options than Rhoades, given the absence of economic support from her family. Rhoades's abstract drawing of a revolver, which had appeared in the feminist issue of *291* with the story of the unwanted pregnancy, had been her final answer to what she perceived as the destructive sexuality of free love. For her it was a smothering, a death of the self she was still struggling to know on its own terms, free of the domineering personalities that surrounded her. Rhoades's failure in the sexualized terms of Stieglitz's modernism is partly accountable for her symbolic negation of herself when she had much of her work destroyed just before her death in the 1960s.

If Rhoades had found a way to reconcile her child self with sexual desire, Stieglitz's life (and Rhoades's) would have been forever different. This alternative scenario with Rhoades is suggested in a second portrait of her that Stieglitz made in 1915—an image of her as his wish fulfillment. Here Rhoades hovers in a doorway as if she is about to pass through (Fig. 107). In this pose, she recalls Käsebier's girl-child standing on the threshold of womanhood in *Blessed Art Thou among Women* (Fig. 4). Now unwrapped from her dark costume, she appears soft, open, accessible, and accommodating. Had Rhoades actually been the dream woman that Stieglitz fashioned in this image, possibly there would be no story of Stieglitz and O'Keeffe, at least as we know it today. For when Stieglitz met O'Keeffe in 1916, her *Special* drawings were mere curiosities: she was gifted with technical skills but unformed, with no sure method or consistent thematics. Stieglitz rescued O'Keeffe at a point when, low in body and spirit and professionally isolated, she had recently contemplated other lines of flight—such as marriage—from her impasse. Had Stieglitz not brought her to New York and then mentored her art this way and that, it is difficult to say if or how O'Keeffe would have developed.[154] O'Keeffe herself suggested the open-endedness of her own story, acknowledging that her formation and recognition as a modernist artist had depended on her art coming together with an appropriate audience—a dovetail that only Stieglitz could have made possible.[155] There was no singular possible outcome to Stieglitz's search for his feminine phantom.

As it turned out, Rhoades offered Stieglitz a dress rehearsal for O'Keeffe. Through struggling to make Rhoades the voice of feminine sexuality, he invented the figure of the woman-child, the female partner required in the modernist theater of New York. Stieglitz later stated that his engagement with Rhoades made him "ready for O'Keeffe."[156] Rhoades's story is an important one in relation to O'Keeffe's because it allows us to discover the way in which the woman-child opened up the possibility of a feminine voice in modernism, even as the woman-child drew boundaries around that possibility.

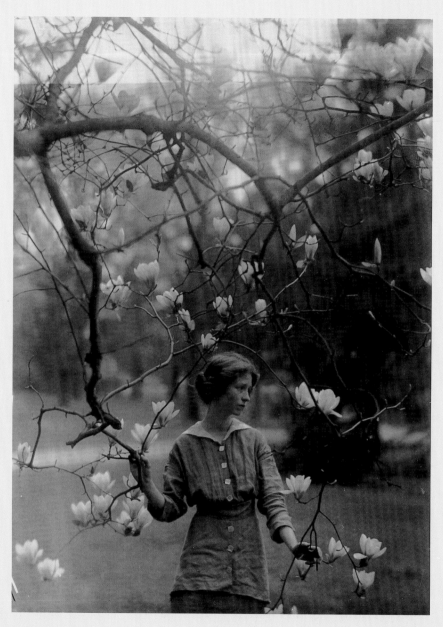

108

Arnold Genthe, *Edna St. Vincent Millay,* 1913, gelatin silver print(?)

The Burden and the Promise
of the Woman-Child
O'Keeffe in the 1920s

In the spring of 1917 Stieglitz presented O'Keeffe's drawings in a one-person show, giving the feminine voice the final statement in his modernist program. At the end of that same year, 1917, the feminine voice of literary modernism established its presence in New York when Edna St. Vincent Millay took up residence in the Village. She was already famous as the author of "Renascence," a poem that captured the mood of the youth movement underway in 1912 when it was first published. Stieglitz's colleague Mitchell Kennerley had recently reprinted her masterwork in a volume with several of her other poems. Arnold Genthe's photograph of Millay for the dust jacket (Fig. 108) was taken in the spring of 1913 at Kennerley's Mamaroneck, New York, estate, where she was frequently a guest. This image of the "girl-poet" standing amid a bower of flowering branches visualized her in a manner fitted to her future place in the youth movement. Millay's life in Village bohemia from 1917 to 1921 established her as a legend in New York modernism,[1] and her poetic voice mythologized the Village as a romance of free love. More than simply observing and eulogizing that life, her poetry celebrated the life—her life—of the free libido.

Millay lived her image in a very public manner, and her art embodied her life, as it was well known. These facts were instrumental to her transformation into an iconic feminine figure of modernism. As a petite, luminous beauty, she was cast by the press in the image of a woman-child. These lessons were not lost on Stieglitz. Kennerley was the American publisher of D. H. Lawrence's works, which at the end of World War I became Stieglitz's new ur-text for feminine sexuality, one he would enlist in developing a master narrative for O'Keeffe's artistry. Stieglitz

would make Kennerley's Anderson Galleries his own turf in the 1920s as the setting for his and O'Keeffe's exhibitions, which together composed the platform from which he established her image. Millay was the first to inhabit publicly the phantasmal figure of modernism's woman-child, whose work spoke the free life of the body. The woman-child was Stieglitz's creation but also at the same time a collective modernist fantasy. Had Millay not existed, Village radicals would have invented another feminine icon in some form, for they required this figure to clarify for themselves their own utopian desires.[2] In the modernist world of images, Stieglitz would follow suit in molding O'Keeffe, employing similar strategies to bring her to the same iconic status in the world of the visual arts. Each of these two women in her own field was to have no peers; each was the woman-child singular to her own audience. The child metaphor for the feminine was peculiar for both women, given their maturity in 1917: O'Keeffe was thirty years old, Millay, twenty-five. That metaphor provided the mechanism of collective fantasy that transformed them into icons; it responded serendipitously to the psychological conditions that allowed both women to accept the identity of the woman-child and to inhabit that role both privately and publicly.

The Language of the Woman-Child

It is important to consider how O'Keeffe, on her own, at first willingly took on the figure of the child in her identity until Stieglitz's subtext for her and her art fully emerged. O'Keeffe's acceptance of the "Great Child" identity was entangled with her desire to find a modernist visual vocabulary that would allow her inner self to speak, unprocessed through consciousness or intellect. These self-reflexive forms externalized her mood or feeling; moreover, they came to her mysteriously, as forms transferred directly from her unconscious mind to her page, she said, deploying Kandinsky's and Bergson's intuitional models for the artist familiar to her from *Camera Work*. More than anything, O'Keeffe told her friend Anita Pollitzer, she wanted to gain Stieglitz's approval, presumably by shaping herself and her art according to his prescriptions.[3] In late 1916, Stieglitz installed O'Keeffe's

works, along with those of Marin, Walkowitz, Macdonald-Wright, and Hartley, at 291 at the same time that he hung the watercolors of his niece Georgia Engelhard there. O'Keeffe's activities in 1917 following the show reveal the power of Engelhard the child artist as a model for her. The child model was doubly impressed on O'Keeffe in 1917 because she actually taught first- and second-grade children in Canyon in January of that year. Moreover, she had taught children from 1912 to 1914 in the Amarillo public schools. She now went on to explore the language of children's art (Fig. 109). In a watercolor of a house she adopted the very sign for a child's drawing, playfully aping the child's way of making an image, with its seemingly spontaneous quality, its rudimentary gestures and shapes, and its schematic disposition across the surface, almost to the point of symmetry.

Although O'Keeffe did not see the Engelhard exhibition, she would have read the reviews of it in *Camera Work*, which she followed closely, sometimes with Stieglitz's help as he sent her reviews of the shows at 291. O'Keeffe visited Stieglitz in late May 1917. During this visit Stieglitz rehung for her her recent show, which she had not been able to see. He was also closing 291 for good and sorting through the accumulated works there. Among these were Engelhard's watercolors from her exhibition (Fig. 110), which Stieglitz and Walkowitz, who had arranged the first children's exhibition, had preserved. After O'Keeffe returned to Texas, Stieglitz wrote her that 291 was in effect to be gutted because he could not "bear to think that its walls which held your drawings & the children's should be in charge of any one else but myself." It was as if he wished to prevent the defiling of a sacred space that had attained its purity through association with her drawings and those of the children.[4] Implied here too is their discussion of the special significance of her drawings in relation to the children's drawings—a twinning of her artistic identity with that of the child vision.

O'Keeffe experimented with the child vision during this formative period as she tested different styles.[5] She tried them on to see how easily they fit—and whether they would allow her a natural fluency of movement in projecting intuitive motifs, as signs for her moods, directly onto the blank surface. After sending Pollitzer her first set of charcoal abstractions, which Pollitzer, in February 1916, turned directly over to Stieglitz, O'Keeffe continued to experiment, producing works from ideas

109

Georgia O'Keeffe, *Yellow House,* 1917, watercolor on paper, 8⅞ × 11⅞ in.

110

Georgia Engelhard, *The Doll's Bungalow, Lake George,* 1916, watercolor on paper, 11¹⁵⁄₁₆ × 17⁵⁄₁₆ in.

that she termed "near insanity."[6] With this phrase she attempted to link her efforts to the advanced art that was thought to be drawn from the depths of the unconscious, just as Stieglitz would do in presenting her work with the "psychopathic" drawings of Duncan and Lafferty. So O'Keeffe's early language of abstraction was nurtured by the high modernist paintings and theories proliferating in and outward from New York. This experimentation in abstraction was also facilitated by her own immersion in the field of design, which had pioneered a method of simplifying and abstracting from nature. While teaching at Columbia College in South Carolina in the fall of 1915, O'Keeffe taught "four big classes in Design." At West Texas State Normal College during her first term in the fall of 1916, O'Keeffe taught design exclusively: beginning classes in the principles of design as well as the applications of design to costume, textiles, and interior decoration.[7] In fact, there is a considerable resonance between O'Keeffe's early spiraling drawings of forms that can be seen to fold in, or unfold, like fern fronds (Fig. 111) and the abstracted natural motifs of modern designers such as Christopher Dresser (Fig. 112) or Charles Leland.[8] The spiral, certainly, is ubiquitous in the culture of art nouveau and Arts and Crafts design—the matrix of design languages in which she was immersed in her classroom teaching.

These spirals appeared in some of her first charcoal drawings that attempt to project her interior states through an abstract calligraphy. The *Specials*, as she dubbed these experiments, were produced during a breakthrough period in 1915, when O'Keeffe was still in Columbia, South Carolina, and were offered to the public at her first 291 exhibition in 1916. She returned to the spiral throughout her career as a signature motif, a form she insisted was so deeply buried in her unconscious that she did not know where it came from or even that she constantly repeated it. In December 1915 she told Pollitzer that she was unsure what these and other abstract forms meant; and to both Pollitzer and Stieglitz she said she could not put their meaning into words. They just appeared in her head, O'Keeffe said, and using Kandinsky's synesthesia to describe them, she explained that she liked her "songs" because they embodied her unique way of feeling and seeing.[9] Even if she was unaware of the sources of her imagery, her immersion in advanced design sustained the process by which she produced her early abstractions.

O'Keeffe's appreciation of the costume designs of Léon Bakst during this period of her breakthrough is especially significant for her development of a highly personalized language of abstract motifs. In February 1916 O'Keeffe thanked Pollitzer profusely for sending her a folio of Bakst's costume designs: "I never enjoyed anything any more. . . . I looked at it all the spare time I had the day I got it—I had read a good deal about them—and never was so curious to see anything in my life— Were the costumes as great in reality as they are on paper?" And she continued, "Again I must say—it was great of you to send it to me. Dorothy [True] and I just pored over the Bakst book last year," indicating that she had studied his work earlier, during her first tenure at Columbia University's Teachers College (New York) in late 1914 or early 1915.[10]

112

Christopher Dresser, "Lines
Suggesting Power, Energy,
Force or Vigor," 1873.

Among the costumes in the folio O'Keeffe studied would have been Bakst's de-
signs (Figs. 113 and 114) for the infamous *Prelude à "L'après-midi d'un faune"* ballet
(1894), composed by Claude Debussy and performed by the Ballets Russes with
Nijinsky in the title role in Paris and London (1912), and those for the *Firebird* (Fig.
115), with music by Igor Stravinsky. Two recurring motifs in these costumes pre-
dominate in O'Keeffe's early abstractions of 1915–16 (Figs. 116 to 119), as well as
in the commercial illustrations she executed (e.g., Fig. 120) after her second
period of self-tutoring in Bakst's designs. One is a series of parallel lines that un-
dulate rhythmically along the tunic of the nymph (see Fig. 114); the other is the
spiral on the nymph's costume (again, Fig. 114) and the nymph's scarf that has en-
raptured the faun and entwines his body in a serpentine movement (Fig. 113). In

113
Léon Bakst,
Design for the Faun,
1912.

114
Léon Bakst,
Design for a Nymph,
1912.

115
Léon Bakst,
Design for the Firebird,
1909.

116
Georgia O'Keeffe, *No. 32–
Special,* 1915, pastel on
black paper, $14\frac{1}{2} \times 20$ in.

117

Georgia O'Keeffe,
*No. 20—From Music—
Special,* 1915, charcoal
on cream paper,
13½ × 11 in.

118

Georgia O'Keeffe,
Untitled, 1915,
charcoal on cream
paper, 24¼ × 18¾ in.

119

Georgia O'Keeffe,
No. 9 Special, 1915,
charcoal on cream
paper, 25 × 19 in.

120

Georgia O'Keeffe,
*The Frightened Horses
and the Inquisitive Fish,*
ca. 1916/1917.

THE FRIGHTENED HORSES AND THE INQUISITIVE FISH

the drawings O'Keeffe made while she was in South Carolina, *No. 20—From Music—Special* (Fig. 117) and *No. 9 Special* (see Fig. 119), her undulating lines have the effect of conveying a momentary frisson, whether that rippling feeling is pain (in the case of a headache in *No. 9*) or pleasure (on hearing music in *No. 20*). The spiral forms, in contrast, suggest her abstracting from forms in nature—for example, from plants (in *Untitled*, Fig. 118) or from water (in *No. 32—Special* and *No. 33—Special*; see Fig. 116). At times, as in *No. 32* or *Blue I*, her spirals and colors suggest the motifs and blues or oranges of the Firebird and the faun.[11] O'Keeffe found in Bakst a lexicon of abstract motifs through which she could externalize her moods and her experience of nature. During this period of studying Bakst and teaching design in Texas, her self-identification with the form of the spiral, which she used to speak her deepest feelings, appears regularly even in her cursive letter "I" (Fig. 121). Writing of her intent to make the drawings speak for her, she confided to Pollitzer, "I have been just trying to express myself—Words and I are not good friends at all. . . . I have to say it someway. . . . Ive [sic] been slaving on the violin—trying to make that talk—I wish I could tell you some of the things Ive wanted to say as I felt them."[12] After tutoring herself in Bakst, O'Keeffe was armed with an abstract language and fresh color that she thought would allow her to bypass words altogether and speak directly to the viewer's intuition.

O'Keeffe's claims for the musical source of her abstractions—her interdependent labors to make the violin and the blank page into instruments of her mental state—must also be taken seriously. When she began to produce the first *Specials*, she was explicit about their relation to the music of her mood, her experience of the world, to which she could only allude in the rhythms and softly gradated forms in charcoal.[13] As is well known, O'Keeffe's teachers Alon Bement and Arthur Wesley Dow encouraged her to listen to music while composing her drawings and to visualize music. O'Keeffe continued to call her abstractions from the Texas plains her "songs" and to practice composing them as a musical process through 1919 (Fig. 122). To some extent, her musical rhythms, constructed through somewhat parallel lines in motion, approached Marin's lines of force in his dancing forms.[14] This formal device also resembled Dresser's suggestion (Fig. 112) for isolating the essential movements of nature in terms of their energies, which Dresser envisioned

121 ▶

Georgia O'Keeffe, The letter
"I," from a letter to Anita Pollitzer,
dated September 1915.

122 ▼

Georgia O'Keeffe, *Series I–
From the Plains,* 1919, oil
on canvas, 27 × 23 in.

as alternately whirling and striking rays of light. O'Keeffe's idiom of musicality—her flowing movements that suggest the polyphonic lines of song as released and contained within a spiral—was highly personal to her and therefore effective as a translation of her feelings. These smooth, elongated curves undoubtedly led O'Keeffe as well as her contemporaries to think of her style as a feminine lyricism.

O'Keeffe had other sources for visualizing the energies of nature as song. In the May 1915 issue of Charlotte Perkins Gilman's journal the *Forerunner*, acquired by O'Keeffe in 1916 in Texas, she would have read a review of *Color Music* (1911), a book by Wallace Rinington of Queen's College, London, and in that same review a description of a new invention called a "Chromola," which translated musical notes into projected color effects across a screen of gauze curtains. The sound of a piano, the writer suggested, could be translated into "rippling showers, like the fall of rocket lights," while the organ might evoke "soft rushing waves, as of lit wind-driven clouds."[15] These suggestions are echoed in O'Keeffe's motifs of rhythmic wavy or jagged lines that can be read as cloud, rain, and wind, or as musical chord progressions and variations, in the early *Specials* and in later oil paintings such as *Series I—From the Plains* (see Fig. 122), *Music: Pink and Blue* (1918), and *Blue and Green Music* (1921).

Stieglitz's first presentation of O'Keeffe's work in 1916, as we have seen in chapter 3, framed her abstractions as disclosures of a woman's unconscious. Shortly thereafter, he similarly labeled Paul Strand's work "something from within" that was "pure" and "direct."[16] But he also embraced O'Keeffe's early abstractions as musical compositions, their musical language as evidence of her "pure" vision—an outward manifestation of the evolved condition of the person. According to the theories Stieglitz promoted at 291, such "plastic" (i.e., abstract) expressions displayed the artist's "inner force awakened by the stimulation of intellect and emotions by outside forces."[17] Having read and reread issues of *Camera Work* and *291* as well as Kandinsky's book, O'Keeffe emphasized in her letters to Stieglitz, as she had to Pollitzer, that the *Specials* projected her deepest feelings, which she could not verbally articulate. Hence she deliberately attached to her abstractions the 291 rhetoric that invested artistic creativity in the unconscious.[18] Stieglitz responded that the drawings were "living" because he could see her in them, but also "part

of myself." O'Keeffe grasped Stieglitz's notion of the artist's spirit as a musical voice visualized in the work of art. She told Strand a year later, for example, that she saw his inner musical self in his photographs: in his prints O'Keeffe heard his "sad songs," she said, "his wonderful music," just as she had recently sung him three songs in paint.[19]

So O'Keeffe's descriptions of her early works recognized them as musical, psycho-synesthetic abstractions. In their rhythmic movements and colors they offered visual equivalents of vocalese—songs of herself without words. Her inability or unwillingness to provide any interpretive clues other than the musical metaphor for her work, however, left the field open for others, especially Stieglitz. In 1916 O'Keeffe completely trusted him to guide her career and ceded control over her work to him. Confident of the symmetry of their friendship, she was emphatic on this point: "I wouldn't mind if you wrote me that you had torn them all up. . . . You understand—they are all as much yours as mine."[20] At the beginning of their relationship, then, O'Keeffe's attitude toward her artistic identity was paradoxical: she would assert her own image as a modernist, but she would do this by placing her career in Stieglitz's hands. O'Keeffe was no starry-eyed ingenue simply playing to a powerful man. In 1915–16 she had schooled herself in every aspect of New York modernism, studying its theories, languages, sexual politics, and personalities. Isolated in Charlottesville, Virginia, and then Columbia, South Carolina, she read *Camera Work* alongside Dell's *Women as World Builders* and the *Masses.* Pollitzer and O'Keeffe were curious about Katharine Rhoades after the publication of Rhoades's poetry in 291 in 1915, admiring her verse and envying her position in the Stieglitz fold. Who was Rhoades? O'Keeffe inquired of Pollitzer in Manhattan, who served there as her eyes and ears, and she confided how intrigued she was with Rhoades's ability to express herself in words.[21] O'Keeffe not only wanted to paint as a modernist—she wanted to *be* a modernist at the center of things. She had seen the unstoppable Stieglitz operating at 291 on several occasions, and she knew that he, more than any other, shaped the field of modern art in New York. Pollitzer had made O'Keeffe's wish come true, to have Stieglitz see and admire her work.

O'Keeffe and Stieglitz's tacit agreement on modernism's substance and style allowed him to take over her public identity, freely creating O'Keeffe, *the* woman

modernist. This agreement crystallized further when, in late May 1917, she visited him at 291 and they became better acquainted, beyond what had been accomplished in their correspondence. After looking at her work in the gallery and the art collection he had assembled over the years, and then making a trip to Coney Island with him and a few others, O'Keeffe returned to Texas, leaving Stieglitz astonished by her simplicity and directness. According to Pollitzer, "He talked on and on about her. Again and again I heard him say, 'She is innocent.'" Finally, following this visit, Stieglitz felt empowered to cast her in the image of the woman-child. Speaking directly to O'Keeffe in a letter of March 1918, he named her "The Great Child pouring out some more of her Woman self on paper—purely—truly—unspoiled."[22]

Over the year she spent in Texas from June 1917 until she went back to New York in June 1918, O'Keeffe, who had recently taught six- and seven-year-olds, now explored the child's mode of expression to see what it allowed her to do visually. It clearly necessitated a shift from the monochromatic range of the *Specials* to the affective primary colors characteristic of the child's palette. The array of representational watercolors she produced during this time represents a dramatic shift from her previous abstract mode, which had so pleased Stieglitz because it exposed the depths of her woman self.[23] On the train trip back to Canyon from New York in June 1917, she read a book called *Childhood* that Strand had given her. This gift suggests that Strand and O'Keeffe, and possibly Stieglitz as well, had been discussing a philosophy of child rearing and appropriate systems of education for children.[24]

At several points she took up the sign of the child's art—the house surrounded with trees. *Tree and Picket Fence* (Fig. 123), like *Yellow House* (Fig. 109), explores the primitivizing effects of a symmetrical, planar composition, in which a tree form is centered and flattened as an irregular mass between a house with doorway, behind, and a fence, in front. In *House with Tree—Green* (Fig. 124), objects are rendered as silhouetted masses, haloed in the moonlight. Their wavering contours give the illusion of childlike animation and unsteadiness in the gesture of the hand holding the brush. These effects are enhanced by the way in which O'Keeffe illuminates the forms' surfaces, using flickering points of light that she has imaginatively fabricated by leaving the white paper bare. The skill and control with which she

123
Georgia O'Keeffe,
Tree and Picket Fence, 1918,
watercolor on cream paper,
$17\frac{7}{8} \times 11\frac{7}{8}$ in.

124
Georgia O'Keeffe,
House with Tree—Green,
1918, watercolor and graphite
on cream paper, 19 x $13\frac{1}{8}$ in.

Georgia O'Keeffe,
Evening Star No. III, 1917,
watercolor on cream, smooth
wove paper, $8\frac{7}{8} \times 12$ in.

Georgia O'Keeffe,
*Light Coming on the Plains
No. 1,* 1917, watercolor on
beige, smooth wove paper,
newsprint, $11\frac{7}{8} \times 8\frac{7}{8}$ in.

executes such maneuvers, however, belie the naiveté and spontaneity implied in her process. With few exceptions, nearly all the watercolors O'Keeffe made in her child mode at this time were worked out as motifs explored in a series. Thus the design of the surface was both premeditated and refined in the movement from one work to the next so that O'Keeffe could create variations on a particular formal attack, to stretch each motif into a number of affective permutations.

"Why does she paint like a child?" an eight-year-old girl asked me, as I held up an illustration of O'Keeffe's *Evening Star No. III* (Fig. 125) while presenting O'Keeffe's work to my son Nicholas's elementary school class in Santa Fe. Without any prompting on my part, this girl had recognized her own gestures, the way O'Keeffe had mimicked the child's language of selective form and simplified movement. Moving away from such obvious children's motifs as houses and chickens, O'Keeffe internalized the child's schematizing system into a method suited to express her own childlike wonder as she faced the expansive Texas landscape alone on many a starlit night.[25] Her use of the spiral motif again in the *Evening Star* watercolors, as in the *Light Coming on the Plains* series from the same year (Fig. 126), is performed with a child's wavering unsteadiness of hand. The ordered, sequential movements of O'Keeffe's brush, recalling the child's drawing of a rainbow, are meant to approximate a direct translation of brilliant cosmic energies, rendered here as the rhythmic cadences of a song.[26] Her application of paint to the surface replicates the child's mastery of simplified, consolidated forms attained in the first school years, yet it preserves the sense of dynamism and motion characteristic of early childhood drawing.[27] The selection of this specific model of the child's vision contrasts with that of Kandinsky (see Fig. 76), who set his sights on the more chaotic aesthetic of the preschool child, at an age before the mastery of schematic forms. O'Keeffe preferred to simplify enough so that her work bears the sign of the child and, at the same time, to opt for an aesthetic of controlled form deploying Dow's Japanese method—already ingrained in her—of decoratively filling the space.

O'Keeffe's watercolors of 1917–18 in this child mode opened up a path to the essential devices of looking and composing that she would seize on when she returned to representation, after another interlude of abstraction, during her first

year of living with Stieglitz. After he generated Freudian interpretations for her abstractions, O'Keeffe, now working in oil at Lake George and Maine, revisited the representational strategies of the Texas watercolors. *Lake George with Crows* (Fig. 127) is a refined and simplified version of her 1917 watercolor *Canyon with Crows* (Fig. 128), a work O'Keeffe kept in her own collection until her death. Both images in turn recall their prototype, *The Doll's Bungalow, Lake George* (Fig. 110), a watercolor by the ten-year-old Georgia Engelhard exhibited at 291 in the same room where O'Keeffe's work had been hung in late 1916. As a member of the Stieglitz family in the 1920s, O'Keeffe adopted "Georgia Two" or "Georgia Minor," as the younger Georgia was called, as a painting partner in the summers at Lake George, thus keeping in her range of vision the child—the prescribed model of feminine creativity.[28] In her later works, Engelhard herself seemed to adopt the abstract, rhythmic manner as well as the modernist topos O'Keeffe had explored in the mid-1920s (Figs. 129 and 130). To be sure, the fluency of their interchange makes any primacy of vision of either problematic.

Like Rhoades, Engelhard served Stieglitz well in his search for the woman artist as woman-child. If the male artists of Stieglitz's group, such as Weber and Walkowitz, or even Marin, had earlier aspired to the innocence of the child, their move aimed to secure the authenticity of their vision, to establish a vision seemingly produced out of an essential, interior, primitivizing, natural self—in contrast to the sham self constructed from the worn-out, dead conventions of civilization. Within Stieglitz's critical circle in the 1920s, however, the rhetoric of innocence that created authority and value for the works of Dove, Hartley, and Marin became obsolete. Although Stieglitz privately at times still referred to his male modernists as his children, for them his critical machinery replaced the figure of the child with a rhetoric of masculine virility and feminine receptivity as the source of their creativity.[29] It would be O'Keeffe in the 1920s who was chosen to exemplify the modernist vision as the true, pure vision of the child. Hers was a special power of sight complicated and enriched by her womanly eroticism, a pure, natural sexuality opposed to bourgeois repression.[30]

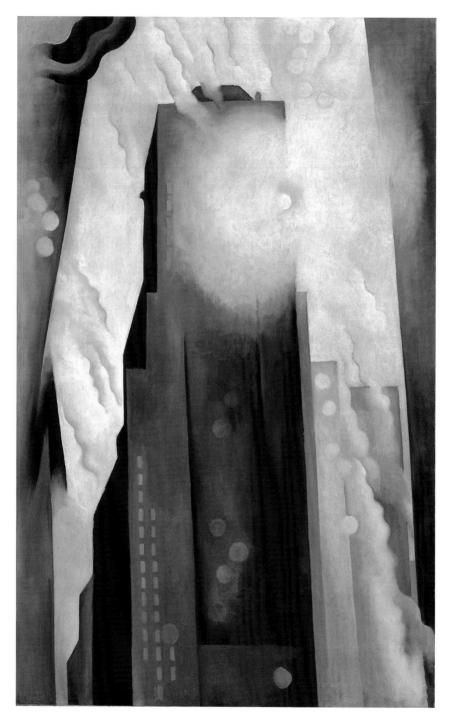

129

Georgia O'Keeffe, *The Shelton with Sunspots, N.Y.,* 1926, oil on canvas,
48½ × 30¼ in.

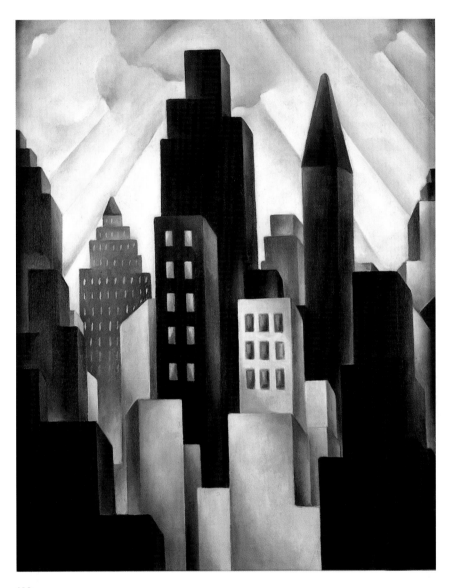

130

Georgia Engelhard, *New York Skyscrapers,* 1928, oil on canvas on board, 25⅝ × 22½ in.

Visualizing the Woman-Child

In 1919 Stieglitz penned "Woman in Art," his seminal statement on the feminine voice in art. Published only posthumously, it lays out his master narrative for the presentation of O'Keeffe as the woman-child. This was a narrative Stieglitz was also following in his contemporaneous photographic portrait of her (Fig. 131) and in the criticism he encouraged around the work she exhibited from 1917 through the 1920s. It is worth revisiting this essay to understand how the woman-child is at the center of his vision of O'Keeffe, the *woman* artist. He wrote: "Woman *feels* the World *differently* than Man feels it. The Woman receives the World through her Womb. That is the seat of her deepest feeling. Mind comes second." In the past, Stieglitz continued, woman had been relegated to childbearing as a "creative sphere. . . . With her the child was the Universe—the All." But now

> [the] Social Order is changing. The potential child brings about its equivalent in other forms. It may be in Color and Line—Form—Painting. A need. Woman finding an outlet—Herself. Her Vision of the World—intimately related to Man's—nearly identical—yet different. . . .
>
> In the past a few women may have attempted to express themselves in painting. . . . But somehow all the attempts I had seen, until O'Keeffe, were weak because the elemental force and vision back of them were never overpowering enough to throw off the Male Shackles. Woman was afraid. She had her secret. Man's Sphinx!!
>
> In O'Keeffe's work we have the Woman unafraid—the child—finally actually producing Art![31]

For Stieglitz woman's true self was definitively a child self, buried and veiled in obscurity at the site of her sexuality. Here he restated Ellis's description of woman as a being closer to a child than an adult man but dominated by her womb. It is important to note in this passage how Stieglitz has shifted the source of creativity away from the unconscious as a storehouse of motivating emotions—as O'Keeffe had explained her *Specials* to him—to the unconscious as the body. In Stieglitz's account it is this unconscious sexual life of the body that gives woman her identity, and it is because this creative life is hidden and must be searched out that it

131

Alfred Stieglitz,
Georgia O'Keeffe, 1918,
palladium print, $7\frac{1}{8} \times 9$ in.

attains its allure. Like Freud in his essay on feminine narcissism (1914), Stieglitz sees woman's sexuality as silenced by self-repression, inhibited by civilization, and powerful because she withholds it from man.[32] In this picture of woman, then, feminine sexuality is articulated not in terms of lack but in terms of plenitude. The secret, interior life of the woman-child fascinates in its potential to restore the blissful childhood paradise lost to man.

Stieglitz's yearning for this woman-child recalls the nineteenth-century literary tradition of the child as an emblem of the adult condition. From Goethe's Mignon at the beginning of the century, to Trilby at the end, the girl-child was called on to represent the deep past in the adult psyche. The feminine or feminized child who is wanted responds to the child self within the adult male artist or writer, personifying his creative interiority and making apparent his power and its source.[33] Stieglitz, in locating and developing O'Keeffe as woman-child, fabricated what he hoped was his mirror image. They were nearly twins: she was a reflection of his purer self, he declared at the time he was making this image of her.[34] We see Stieglitz here looking with envy across the divide of gender. Such was the pattern of

dislocated identity male modernists exhibited. Overwhelmed by their own lack, they cast a desiring gaze toward women, children, and primitives, whom they imagined as enjoying the rich inner life that modernity denied to men.[35]

We have already seen in chapter 3 how Stieglitz believed that O'Keeffe's self-narrative was available as a psychoanalytic self-representation that located the child in the woman and disclosed its essence as a pure, natural sexual energy. The story of Katharine Rhoades and her female predecessors in the life of 291 shows how Stieglitz had already formed his figure of the woman-child before meeting O'Keeffe in 1916. With O'Keeffe's appearance as the woman willing to assume the role of this fantasy figure in public, Stieglitz found his modernist partner and began with her a creative collaboration that would reestablish his modernism on even more sensational grounds. There can be no doubt that O'Keeffe's dramatization of the woman-child was a collaborative venture. But the terms of their partnership that bound her to him are complex.[36] Paul Strand's report on O'Keeffe to Stieglitz from Waring, Texas, in May 1918, predicted the conditions of their agreement. Stieglitz had dispatched Strand to fetch an ailing O'Keeffe to him in New York from her friend's Waring farm. Strand told Stieglitz that when he observed O'Keeffe at close range he saw that Stieglitz's initial perception of O'Keeffe as "a child and yet a woman" was correct. His language describing O'Keeffe bears a striking similarity to Rhoades's criticism of herself when Stieglitz pressed her to become the woman-child. Strand described O'Keeffe as "not clearly crystallized. . . . 'Georgia hasn't found herself yet.'"[37] Here was Rhoades's double, a beguilingly unformed woman of great potential but one who was cut loose from all familial ties and thus was a free agent to create her own life. Stieglitz responded that he was willing to make O'Keeffe his "responsibility."[38]

Stieglitz described himself and O'Keeffe in the first throes of their joy together "as children, 'either intensely sane or mad.'"[39] He wrote to Strand a few months after O'Keeffe went to New York, in 1918, that he and O'Keeffe responded to each another "more like kids than grown-ups."[40] This notion too of the modernist couple becoming children again in the bliss of free love was a standard conceit among Village bohemians. Stieglitz now assumed full status as a radical who had broken all domestic constraints to enter a paradise of love, art, and poverty. After they be-

came lovers in August 1918 and Stieglitz left his wife, he turned to his generous family for support of himself and O'Keeffe, often taking advantage of his brother's hospitality in housing and feeding them. Randolph Bourne had already set into place the image of the new guard (a generation younger than Stieglitz) as children perpetually seeking to renew their creativity to keep the modernist revolution alive. The paradigmatic couple of the Village, combining work and love, stayed youthful and artistically vital because of their childlike lack of sexual inhibitions. Louise Bryant, for example, wrote glowingly of her love relationship with John Reed that each was a "supplement" to the other: "Life is very lovely to us," she remarked, "we feel like children who will never grow up."[41]

Although the feminist men of the Village believed that the equality of women would free them as well, young feminist women used their partnerships with men as a way of achieving professional aspirations.[42] In like fashion, Stieglitz and O'Keeffe's partnership was formed to enhance both their personal and their professional lives. Stieglitz was certain that his discovery of this woman-child would restore his own potency, his own source of creativity. As he implies in "Woman in Art," the power of the unrepressed sexuality of the woman-child promises the power of male vitality. O'Keeffe, he believed, liberated his child self, showing him how to play, how to re-create himself.

Partnership with Stieglitz offered O'Keeffe a visible presence in modernist New York. It also required a trade-off, one that she was surely aware of: she would gain his protection (becoming his "responsibility") and obtain a career as an artist at the center of modernism while sacrificing her autonomy, at least for a time. In May 1918, as Strand was negotiating this new life for her and O'Keeffe was languishing, physically and emotionally, he and Stieglitz agreed that for O'Keeffe the change would mean the "death" of some things. "I think before she could go with you— there would be many things to be given up—very many. That is what you meant by death," Strand mused to Stieglitz. O'Keeffe had put it similarly to Strand when he had asked her, during their dalliance the preceding summer, why she would not commit to him (Strand) or to any one man. She responded that in marriage her freedom would come to an end: "As a woman it means willingness to give life— not only her life but other life—to give up life or give other life." In her letters to

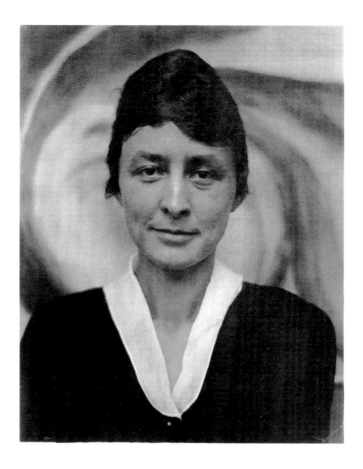

Strand from this period O'Keeffe frankly told him of her intention to defer the form-
ing of all ties so that she could continue her life of freedom in Texas, of nights
floating through space, as she portrayed herself, fueled by an elixir of flirting and
lovemaking without commitment. She said that she saw herself alone for years
to come. She may have thought she could maintain this freedom with Stieglitz as
well, for in September 1918, a few months after they had come together, Stieglitz
confided to Strand that O'Keeffe was leading him in a "merry dance," as she had
Strand.[43]

 Stieglitz's multifaceted portrait of O'Keeffe provides ample illustration of how
the modernist partnership worked to advance both personally and professionally,
with the art feeding off the life and the life lived to nurture the art. Although Stieg-

133
Alfred Stieglitz,
Arthur Dove, 1923,
gelatin silver print.

litz had photographed O'Keeffe in 1917, the project began in earnest after her ar-
rival in New York during the summer of 1918. More than any other vehicle, it was
this portrait of O'Keeffe that cast her as modernism's woman-child. In May 1917,
however, his first portraits of her (e.g., Fig. 132), standing before one of her ab-
stractions in the gallery, began rather tamely in picturing her as the female version
of his male modernist—for example, Arthur Dove (Fig. 133). Forging a public im-
age for the artists of 291 was a regular part of Stieglitz's photographic practice—
one that followed the pattern set when Käsebier undertook professional studio por-
traits of the Eight at the time of their debut as a Secessionist group in 1908.[44]
Wearing her hair pinned up and a dress appropriate to a schoolteacher, O'Keeffe's
identity emerges from her relation to her creation behind her. O'Keeffe and Dove

display the serious expressions of professional producers and in their rational demeanors elude the bourgeois suspicion of the modernist as deviant. Neither would be mistaken for the Village radical with flowing tie and hair or an eccentric peasant- or Cubist-inspired frock. O'Keeffe's prim white collar and sobriety align her with Stieglitz's own bourgeois identity. In photographic portraits by Brigman (1910), Steichen (1915), and others, he always appears in his workplace in proper business attire, with the loden cape from his student days abroad reserved for the street.

A year later, in the summer of 1918, after Stieglitz and O'Keeffe had just become lovers, he felt freer to compose her performing in order to expose her hidden self. With this sitting, Stieglitz fashioned a myth for the last but most important player in his modernist program. Able now to give full visual form to his woman-child,

Stieglitz possessed a formidable tool in making his arguments for the nature of feminine creativity in general, and her works in particular, by suggesting how woman was embodied in O'Keeffe's art. To visualize O'Keeffe as both an innocent child and a desiring woman, he adopted a poetics of whiteness that he had first explored in images of his daughter, Kitty, as a girl of six (see Fig. 21), which in turn reverberated with Käsebier's mothers and children. O'Keeffe displays herself to Stieglitz's camera in a white kimono, her long hair let down, recalling the informal style of girl children (Fig. 134), and so uncovers her private self to the viewer, who must stand in a relation of some intimacy to her. In these images of O'Keeffe as "white girl" Stieglitz plays on the eroticized narratives of Whistler's white girls. With her eyes half-closed and staring, her mouth somewhat open but mute as she awakens to her own sensual nature, O'Keeffe here recalls especially Whistler's first white girl, a figure often described as acting out her confusion at the sexual consummation that has transformed her from virgin to wife. This white and girlish O'Keeffe also reimagines the quintessential femme fatale of a decade earlier, the adolescent Evelyn Nesbit (see Fig. 28), whom Käsebier posed ingeniously for her camera. Boldly confronting the viewer with Nesbit's self-conscious sexuality, Käsebier makes a mockery of what should be Nesbit's purity. Though a well-known public figure in New York, Nesbit represented the guilty pleasure available to men of means. The sensation of the portrait was that it offered the secret so openly for public viewing. Captivated by this corrupted innocent, Stieglitz kept an alternate photograph of Nesbit in his private collection, and in 1906 he followed the trial of Nesbit's husband, Harry Thaw, for the murder of her lover, Stanford White, pasting up the newspaper accounts of her lurid escapades with White in a billboard format, as if for display.[45] In O'Keeffe's figure Stieglitz invokes both of these paradoxical constructions, the spiritual bride and the knowing virgin—a woman who simultaneously inhabits antithetical states of being. Here he reworks the traditional Judeo-Christian trope of marriage as a process of possessing the other and giving up the self, of marriage as a kind of death, so that his spiritual wedding to O'Keeffe transfigures both her and him. She comes to the viewer as white and pure—a redeemed newfound body as emblem of their transformation.

In 1918, as Stieglitz began to mold O'Keeffe's woman-child image in his photographs, the nudes of Anne Brigman were foremost in his mind. Early in that year, while he was still cleaning up the remains of 291, he wrote to Brigman that, looking with new eyes at her photographic nudes in his possession, he found them "a real pleasure" and was "showing them too to people" (see Fig. 58).[46] Directing O'Keeffe to stand in front of one of her abstract spirals (Fig. 135), Stieglitz seemed especially to be thinking of Brigman's liberated, universal woman. O'Keeffe, her long hair loosened over her bare shoulders, stretches her arms above her head to

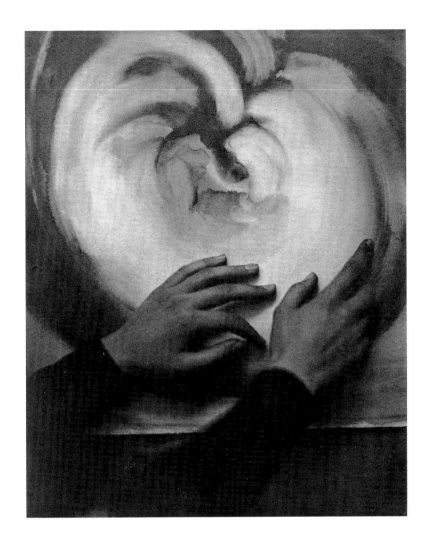

connect her fingers to the elongated lines spiraling rhythmically upward. Brigman's dancing nudes, choreographed to flow with the wild forms of nature that have given birth to her women, taught Stieglitz how to make O'Keeffe's body speak its hidden truths of sexuality. In earlier portraits of 1917 and 1918 O'Keeffe's hands, with their long curling fingers, were arranged against her images, as if to suggest that she conjured her images into existence (Fig. 136). But now O'Keeffe the Lover is directed to dance her maternal relation to her works. In extending the lines of her arms and fingers into the flow of the paper, Stieglitz envisions O'Keeffe's paint-

babies, as he thought of them, as emanating from deep within the unconscious body. From her dancing body a somnambulistic O'Keeffe is shown as transferring her musical rhythms to the white surface.[47]

O'Keeffe's reminiscences of the sessions for these photographs make clear that Stieglitz directed her, posing and arranging her body against her works, telling her how to move her hands and head and to "turn this way and that."[48] The image of Stieglitz commanding her has suggested comparisons with Pygmalion (in Stieglitz's creation of the woman-child) or Svengali (in Stieglitz's exercise of power over O'Keeffe), who hypnotized his woman-child, Trilby, so that she would perform her mysterious feminine nature.[49] Stieglitz encouraged such mythmaking; he was delighted, for example, with his friend Waldo Frank's claim for Stieglitz's personal magnetism, which asserted that Stieglitz got extraordinary photographs of his sitters because he "hypnotized" them.[50]

Mabel Dodge Luhan's essay on O'Keeffe's painting, written at O'Keeffe's request, sets down just such a picture of Stieglitz the "showman," manipulating his "somnolent" automaton-woman who speaks from her unconscious mind, making a sensational spectacle of herself to the public, to demonstrate his powers, his sexuality. "This woman's sex, Stieglitz, it becomes yours upon these canvases," Luhan wrote. "Sleeping, then, this woman is your thing. You are the showman, here, boasting of her faculty. More—you are the watchman standing with a club before the gate of her life, guarding and prolonging so long as you may endure, the unconsciousness within her."[51] But even in condemning Stieglitz's public production of O'Keeffe, and suggesting that he exploited her in his art, Luhan stays within the parameters of the eroticized discourse Stieglitz established to render O'Keeffe's creative process as that of a preverbal woman who mobilizes her artistic voice from the depths of her unconscious life.

Stieglitz's photographs of O'Keeffe in 1918, like his image of her in "Woman in Art" the following year, borrows from norms of bourgeois femininity to portray O'Keeffe's creative, "maternal" sexuality as natural. In the portrait of O'Keeffe standing against an ancient gnarled tree at Lake George, also from 1918 (Fig. 137), Stieglitz had her twist one hand uncomfortably around to press fingers, splayed out into fan shapes, against the craggy surface. Here Stieglitz recapitulates Brig-

137

Alfred Stieglitz,
Georgia O'Keeffe,
1918, gelatin silver
print, 9¼ × 7½ in.

man's conceit in *Soul of the Blasted Pine* (see Fig. 40) to establish the consonance of woman and nature, even if that association—grounded in the body—is as limiting as it is empowering, binding woman to an affective and aestheticized sphere of influence in human culture. Both the twisted motion of Brigman's nude and the gravity of O'Keeffe's face register the troubled dimension of this feminine dynamic. In the years to come Stieglitz would make O'Keeffe's pain a public aspect of her image as universal woman-child.

A year later, Stieglitz folded his representation of O'Keeffe as woman-child—with her essential childlike purity—into the profile of the savage to figure a transgressively erotic feminine creativity. In a unique palladium print (Fig. 138) O'Keeffe

is made to incorporate both light and darkness—that is, the Apollonian-Dionysian dichotomy in which the primitive is conventionally visualized in Western discourse. The darkness of O'Keeffe's body and face here is not simply keyed to this rhetoric; it also relates to Stieglitz's initial impression of O'Keeffe as exotic and strange, his sense that she had "some Indian blood."[52] Stieglitz imaginatively engaged Adolph de Meyer's photograph of a Ballets Russes dancer in a mask (Fig. 139), shaping O'Keeffe into a figure who might have stepped out of the Bakst costume designs she had admired. This de Meyer image was one that Stieglitz kept in his private collection. As in the photograph of the dancer, O'Keeffe's exposed torso—belly and breasts uncovered by the parted kimono—foregrounds her femininity. In de Meyer's photograph the mask distances the figure, precluding a relation-

ship of sameness; in effect, the mask is layered over the dancer as if to place her in a category apart from the viewer—that of woman. Stieglitz's remarkable image similarly estranges the female body, but her embrace of the phallic African spoon here also renders her as Stieglitz's twin. He related his sense of this identity to Dove during the first days with O'Keeffe in 1918: "O'Keeffe is truly magnificent. And a child at that. We are at least 90% alike—she a purer form of myself. The 10% difference is really perhaps a too liberal estimate—but the difference is really negligible."

 This summer of his rebirth, through his twinning with O'Keeffe, he spoke of as a period of "sane madness" in which "each moment is a happy eternity—sometimes—rarely— . . . of intensest pain," but also "intensely real."[53] The "sane

madness," infused with pain and pleasure that brought Stieglitz to life, he made the imaginary landscape of this photograph. O'Keeffe, her face severe, her hair pulled back, stares longingly, desiringly, at the African carving, which she holds up in profile so that it resembles a knife or a phallus, as if she is recognizing some part of herself in the fetish object. At the same time, she is made to pinch her breast. Her gesture dramatizes Havelock Ellis's observation that the sensation of pain is intrinsic to arousing strong emotions, especially fear, and is connected to the sexual impulse.[54] The phallic spoon that Stieglitz exhibited in his 1914 show of West African sculpture serves as his self-projection in this image. [55] He is the instrument of O'Keeffe's pain, but she also finds herself mirrored in this displaced Stieglitz. Rather than look away in fear, she gazes directly at the dreadful object, the secret truth of the self. The photograph functions in effect as a double portrait: it witnesses O'Keeffe and Stieglitz each finding the uncanny, the obverse sexuality of the other, in the self. Thus O'Keeffe the woman-child is represented as self-inventing and self-empowered from the core of her eroticized creativity; her artistic process is disclosed as a maternal, painful experience of giving birth to art, which is invested in a masculinized sublime of pain and truth as much as in modes of feminine mystery, beauty, and silence. In its multiplicity Stieglitz's photographic portrait asserts, however, that O'Keeffe is not to be contained within any dichotomies: light and dark, warm blood and purity, pain and pleasure. As a polymorphous figure, and especially as his double, she occupies both the masculine and the feminine positions.[56] The universality of her voice was to be central to the critical accounts he arranged for her work in the 1920s. As we will see, it described her as a mysterious new being transcending all these categories, and her art, as Stieglitz himself put it, as "the beginning of a new religion," while he portrayed himself as the prophet of that art.[57]

Two years later, Stieglitz produced a related image of O'Keeffe (Fig. 140), holding a figure sculpted by Matisse (which Stieglitz had shown at 291 in 1910). Matisse's figurine—based on his own study of African sculpture—now replaces the spoon as the sign of O'Keeffe's primitive identity. There are significant differences between the earlier image, however, and this later staging of a similar scenario. In this later print a sullen O'Keeffe, brow furrowed, looks away from the bronze statuette, which

she holds somewhat unwillingly, its presence a burden. Instead of exhibiting her nude body as the foundation of her identity, she is dressed in a plain, white tunic that sets up the dark and light dichotomy of the earlier image but without the shock and intensity of the earlier photograph's confessional drama.

By this time these modernist myths had been codified, and in the Village such self-mystifications were becoming tiresome even to the radicals. In about 1918–19, Sinclair Lewis's play *Hobohemia* allowed the Villagers to mock the dramatics of Stieglitz's modernism, as well as their own, by laughing at the extravagant claims for their art, their dress, and their obsession with sex, mysticism, psychoanalysis, socialism, free love, and the new and ephemeral in every cultural form. One moment in the play comments pointedly on Stieglitz's worship of the primitive as exposing the deep truth of the psyche: the eccentric artists and writers who are the main characters gather around a wooden sculpture that strongly resembles Matisse's Africanized statue to fawn over its "purity" and praise its rejection of degenerate capitalist modes of commodified representation (Fig. 141). Significantly, although O'Keeffe included the 1921 photograph in the "Key Set" of Stieglitz's prints that she assembled for the National Gallery of Art in 1946–49 and 1980, she omitted the primitivizing image of 1919, perhaps feeling that such theatrics were not simply passé but clearly over the top.[58]

In other images of O'Keeffe from 1919, Stieglitz fixed her as his perfect woman by reinventing the genre of the nude. He took O'Keeffe apart piece by piece in the photographs to adore and mystify her at the same time—giving the forms of hands, feet, neck, and torso an aura of perfection. Even as Brigman's nudes informed his prints of O'Keeffe's dancing body transmitting her song directly into her works, Stieglitz also must have been remembering Käsebier's experimental studies of expressive hands and feet, which he had seen in her studio in 1902. He described his new work to Brigman as "No tricks—No fuzzyism—No diffusion—No enlargements—Clean cut sharp heartfelt mentally digested bits of universality in the shape of Woman—head—torso—feet—hands—Even some trees too."[59] Despite Stieglitz's assertions of "no fuzzyism," many of his images of O'Keeffe's nude torso (Fig. 142) are highly aestheticized, distanced from the viewer. These effects, beloved by the Photo-Secessionists, were partly secured by the veiling inherent in

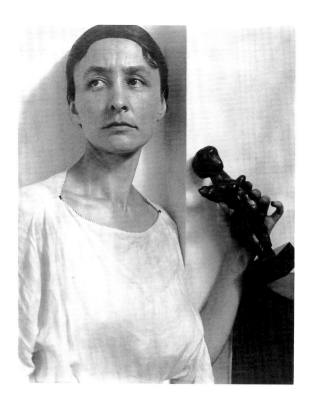

140
Alfred Stieglitz,
*Georgia O'Keeffe
with Matisse Sculpture,*
1921, palladium print,
$9\frac{1}{2} \times 7\frac{1}{2}$ in.

141
Unknown photographer, *Scene from Act I of Hobohemia,* 1919. Players (l. to r.): standing, Grace Morse,
Geoffrey Stein, Beatrice Prentice, Theodore Doucci; seated, Noel Tearle and Helen Westley.

his platinum and palladium papers, whose smooth, intermediate tones produce velvety, subtly gradated surfaces. Stieglitz went to even greater lengths in his nudes, however, to achieve the sense of a form floating weightless on a luminous surface. By using an umbrella to filter and diffuse the light in the studio room he produced a darkened body mass that generates a soft incandescent haloing all around it. Looking at this photograph, we recall his words on the body of the mother as "the place whence we came and where we desire when we are tired and unhappy to return, the womb of our mother, where we are quiet and without responsibility and protected. That is what men desire." It is Stieglitz the modernist child who gazes here at O'Keeffe's radiant torso as if to reclaim the mother's transcendent body.[60]

By personally possessing that maternal body, Stieglitz bridged the distance between the ideal and the lived experience. The nudes present his story of an inner void filled, the childhood paradise he had been seeking in his woman-child now regained.[61] For Stieglitz, O'Keeffe's full woman's body in the photographs represented this utopian state of being—the perfect immutable maternal object, which, through its distancing and veiling, supplied the fantasy of childhood. In O'Keeffe, the shape-shifter, his double, Stieglitz recognized a figure of desire who redeemed him from the purgatory of a deathlike bourgeois existence and restored him to the origins of self and creativity.

It is possible that O'Keeffe's own nude self-portraits of 1917 (Fig. 143) had suggested to Stieglitz the abstracting of her body into a shape to express the new freedom of the body in the life of sexuality.[62] There is a certain reciprocity between the formal presentation of O'Keeffe's shape as a dark blue simplified mass against a white ground and several of Stieglitz's nude portraits of her. But while her body was veiled in Stieglitz's images and staged as the body of universal woman, O'Keeffe's actual identity in the photographs was not hidden. Everyone knew to whom that body belonged, knew that she was a real, living woman, ambitious to be more than a body and to be a player in her own right in the field of modernism. Stieglitz had found his universal woman in one individual, and he made it known that her name was Georgia O'Keeffe. As is well known, Stieglitz exhibited the photographic portrait of O'Keeffe in two retrospective shows of his own work that he mounted at the Anderson Galleries in 1921 and 1923. Stieglitz's *Portrait* of O'Keeffe,

142

Alfred Stieglitz,
Georgia O'Keeffe–Torso,
1918, palladium print,
9³/₁₆ × 7³/₈ in.

143

Georgia O'Keeffe,
Nude Series, VIII, 1917,
watercolor on cream
paper, 18 × 13½ in.

exhibited at the Anderson Galleries in 1921, preceded the presentation of her work to the public at her first major exhibition in 1923.[63] Although Stieglitz's own statement "Woman in Art," written in 1919, illuminates his thinking about O'Keeffe to us now, that text was not published until after his death. Here, then, is the quintessential modernist relation of the artist to the work, in which her image was fixed in the consciousness of the intellectual elite even before her work was fully known to the public.

Significantly, Stieglitz all but ceased producing these nude portraits of O'Keeffe after 1919. After their 1921 exhibition they were virtually unseen until 1978, when O'Keeffe chose several for a Stieglitz retrospective at the Metropolitan Museum of Art. Following the nudes, the portraits in the 1920s show O'Keeffe most often swathed in dark clothing, often divested of the signs of her femininity, her hair hidden under a hat, her face often registering sadness, pain, or melancholy (Fig. 144). But running counter to these new images of a severe O'Keeffe, Stieglitz continued throughout the decade to push the eroticizing, Freudian frame for O'Keeffe and her work that had made her into a sensational, even notorious, figure at his 1921 exhibition. Possibly Stieglitz had simply exhausted his inventiveness in photographing O'Keeffe as a nude and changed his tactics.[64] There is also a strong probability that O'Keeffe responded less than enthusiastically to being photographed as a nude once she realized the consequences for her critical reception. Instead, O'Keeffe attempted to control her own image by portraying herself as disciplined, sober, and ascetic. By refusing to let Stieglitz exhibit the nudes again, O'Keeffe herself was complicit in his darkening of her image. This strategy was similar to the public relations efforts of Edna St. Vincent Millay, who in the 1920s reformed herself from the "It" girl of the Village into a serious professional poet who dressed in tailored suits.[65]

The effect of reverting to an image of O'Keeffe as a dark lady was that Stieglitz confounded the sensational public figure he had just manufactured. His new approach denied the erotic life that the nude photographs and the critical writing declared for her paintings. So Stieglitz first bared O'Keeffe to the world and then, after 1921, veiled her. He alone possessed access to the secret life of the woman-child. This last maneuver of refashioning her in a nearly unrecognizable, unfem-

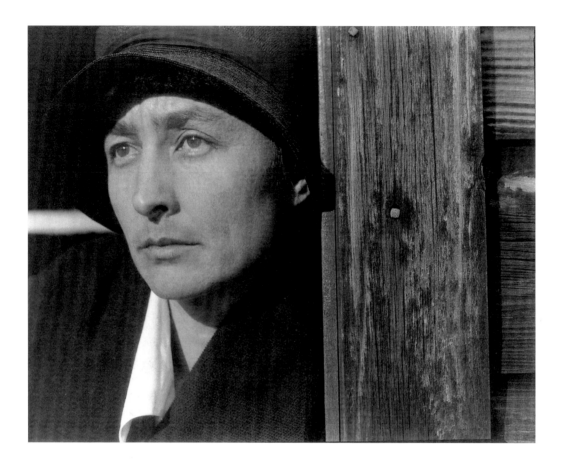

inine form would continue, through the 1920s and after, to mystify O'Keeffe and to encourage erotic interpretations of her work.

Thereafter, when Stieglitz chose to photograph the female nude, for the most part he substituted others, as O'Keeffe professed illness and opted out. He turned to O'Keeffe's youthful friends Rebecca Strand and Frances O'Brien or "Georgia Minor," his now fourteen-year-old niece, Georgia Engelhard (Fig. 145). In a caricature of the woman-child as an adolescent Eve, Stieglitz posed the bright shape of Engelhard's body against the dark plane of a shed, balancing the angles of knees, shoulders, elbows, and buttocks. These self-conscious manipulations recall not only Brigman's nude *Finis* (see Fig. 51) but also O'Keeffe's earlier calligraphic rendering of her own body in blue watercolor strokes against a planar background.

144
Alfred Stieglitz,
Georgia O'Keeffe:
A Portrait, 1922,
palladium print,
7⁷/₁₆ × 9⁷/₁₆ in.

145 ▷
Alfred Stieglitz,
Georgia Engelhard,
1920, palladium print,
9¹/₈ × 7³/₈ in.

The junior woman-child here folds her body over, oblivious to the viewer, as an exemplary display of feminine narcissism. In posing Engelhard clutching Eve's apples of secret knowledge to herself, Stieglitz once again gave form to his obsession with woman's sexuality, but now with a humor foreign to the images of O'Keeffe.

The criticism of O'Keeffe's work in the 1920s took its primary cues from Stieglitz's photographs of her. Paul Rosenfeld's writings served as Stieglitz's second vehicle in creating a popular image of O'Keeffe as a fantasy figure. Rosenfeld's article on O'Keeffe, "American Painting," published in the *Dial* in 1921, following the first major exhibition of her *Portrait,* was a collaborative work, completely informed by Stieglitz's talk. Rosenfeld revised his basic text on O'Keeffe twice, once

for *Vanity Fair* (1922) and a second time for his book *Port of New York* (1924), rewriting the O'Keeffe chapter under Stieglitz's direction at Lake George in the summer of 1923. Rebecca Strand, who witnessed the collaboration of the two men and typed the manuscript, aptly observed that "the article [contained] much that Stieglitz has found out about her [O'Keeffe] and much about her as a person that derives from his photographs rather than directly from her paintings."[66]

Rosenfeld translated O'Keeffe's paintings into a language inspired by D. H. Lawrence's sagas of modern sexuality. Stieglitz, Rosenfeld, and others of their circle had been poring over Lawrence's novels *The Rainbow* and *Women in Love* since 1915, shortly after they began to be published in the United States. Rosenfeld identified Lawrence's lovers with Stieglitz and O'Keeffe. In 1920 he gave them a copy of Lawrence's poem "Look! We Have Come Through!" (1919), his inscription implying that the story was also Stieglitz and O'Keeffe's.[67]

Lawrence's belief in human sexuality as mystically tied to nature can be traced in part to his admiration for Edward Carpenter's views.[68] Reading Lawrence, Stieglitz was in effect returning to his own roots in Carpenter. But where Carpenter had treated modern woman's sexuality only in the most cursory manner, Lawrence now vividly uncovered that hidden life. It was Lawrence's sense of nature pulsing and throbbing with an energy both mystical and sexual that Rosenfeld reinvested in O'Keeffe's paintings. The movements Rosenfeld imagined as characterizing her surfaces he variously phrased as thrusting, counterthrusting, fiery, piercing, throbbing, trembling, unfurling, singing, and undulating. In Lawrence's vision of a fecund natural world, he found a vocabulary and an imagery that suited Stieglitz's notion of how O'Keeffe's forms and colors parsed the world of feminine sexuality—writing passages often bordering on purple prose:

> Rigid, hard-edged forms traverse her canvases like swords through cringing flesh. Great rectangular menhirs plow through veil-like textures; lie stone-like in the midst of diaphanous color. Sharp lines, hard as though they had been ruled, divide swimming hue from hue. . . . But, intertwined with these naked spires thrusting upward like Alp-pinnacles, there lie strangest, unfurling, blossom-delicate forms. Shapes as tender and sensitive as trembling lips make slowly, ecstatically to unfold before the eye. Lines as sinuous and softly breathed as Lydian tunes for the chromatic flute climb tendril-like. It is as though one had been given to see the mysterious parting movement of petals under the rays of sudden fierce heat; or the scarcely perceptible twist of a leaf in a breath of air; or the tremulous throbbing of a diminutive bird-breast.[69]

As he shaped his fantastic account of O'Keeffe's painted world, Rosenfeld had before him four paintings, borrowed or purchased from O'Keeffe: an apple composition, a canna flower study (similar to the one in Fig. 146), a "musical blue mountain," and an abstraction from 1919 (probably the same painting as that in Fig. 147).[70]

But Rosenfeld, of course, took as much from Stieglitz—his photographs, his talk—as from Lawrence. His writing approaches Stieglitz's mystifying in the portrait of the woman-child: it turns on an impossible construction in which contrary elements synergize to compose a creature wondrous and never-before-seen. For

147
Georgia O'Keeffe,
Series I, No. 7,
1919, oil on canvas,
20 × 16 in.

Rosenfeld, O'Keeffe's feminine vision—as produced by her unconscious mind—
offers a revelatory experience that breaks upon the viewer in the dizzying pyro-
technics of color forms across her surfaces. In its intensity the vision approaches
Lawrence's "insight into the facts of life." O'Keeffe's psyche, as Rosenfeld repre-
sents it, produces a whirling panoramic vision that ceaselessly astonishes the viewer
with its raw newness, the mysteries it discovers in the natural world. O'Keeffe's
visual maneuvers, in the end, mirror, so as to uncover, her own secret life. "She
feels in . . . [natural forms] the secret life. She feels in them the thing that is the
same with something within herself." As in the flower form of the red canna, at
the center of her structures there is often something mysterious, veiled, or glow-
ing, which Rosenfeld designates as the secret of her being. He verbally manufac-
tures an effect of astonishment for O'Keeffe's nature dramas by describing her im-

ages in contrasting terms (passion and purity, ecstasy and pain, whiteness and flame, power and delicacy) and by imagining her abstract forms as acting out masculine and feminine roles in the dramatizing of a woman's sexuality. O'Keeffe's art is thus endowed with a power founded in life's paradoxical essence; her art can never be understood logically but can be appreciated only as an experience of the sublime: "The greatest extremes lie close in her burning vision one upon the other; far upon near, hot upon cold, bitter upon sweet; two halves of truth." In short, her art encompasses the entire range of sensuous and spiritual experience: the "mysterious cycles of birth and reproduction and death expressed through the terms of a woman's body."[71]

The Woman-Child and O'Keeffe's Ambivalence

According to Rosenfeld, then, O'Keeffe's body and, pointedly, her sex were in her paintings:

> Essence of very womanhood permeates her pictures. . . . It is always as though the quality of the forms of a woman's body, the essence of the grand white surfaces had been approached to the eye, and the elusive scent of unbound hair. Yet, it is female, this art, only as is the person of a woman when dense, quivering, endless life is felt through her body; when long tresses exhale the aromatic warmth of unknown primaeval submarine forests, and the dawn and the planets glint in the spaces between cheeks and brows. It speaks to one ever as do those high moments when the very stuff of external nature in mountain-sides and full-breasted clouds, in blue expanse of roving water and rolling treetops, seems enveloped, as by a membrane, by the mysterious brooding principle of woman's being.[72]

O'Keeffe's response to the first of Rosenfeld's essays was "fury," a term she used over the next several years to express her deep anger at the interpretations of her work that were based on Rosenfeld's writings. Taking up Stieglitz's tropes for the woman-child as "whiteness," an image of "white radiance," Rosenfeld pictured her as "a girl," an "innocent one," whose art spoke through her womb: "She feels

clearly where she is woman most; because she decides in life as though her consciousness were seated beneath her heart where the race begins." Recalling Stieglitz's portraits of O'Keeffe as strangely bewildered at times or pinching her breast, he wrote of her creativity as born of the ecstasy of pain, extending Stieglitz's metaphor of her body giving birth to her images. Rosenfeld argued that O'Keeffe's art, as a product of the unconscious body, augured a new, higher state of being and that she exemplified the natural intuitive creativity of the child. These refrains provided critics through the end of the 1920s with what would become the mythology of O'Keeffe and her art.[73]

The fact that O'Keeffe privately anguished over this presentation of her work in the framework of this myth raises questions about her cooperation with Stieglitz and his critics. A close examination of the conditions under which the *Portrait* of O'Keeffe was made casts doubt on whether it can legitimately be termed a "collaboration." Over the years O'Keeffe admitted to friends that her relationship to Stieglitz was not that of an equal. As is well known, Stieglitz was a domineering personality. O'Keeffe put it this way: "There was such a power when he spoke—people seemed to believe what he said, even when they knew it wasn't their truth. He molded his hearer. They were often speechless. If they crossed him in any way, his power to destroy was as destructive as his power to build—the extremes went together. I have experienced both and survived, but I think I only crossed him when I had to—to survive."[74]

In posing for the early photographs in the *Portrait*, O'Keeffe without reservation gave herself to Stieglitz, just as she entrusted him with the caretaking and presentation of her art at her first 291 exhibition in 1916. She had told Stieglitz then that she considered her drawings rightfully his as much as hers, even to the point where he could do with them whatever he wished. This total unquestioning deference to Stieglitz's judgment was characteristic for O'Keeffe in her relation to men with whom she was infatuated.[75] That she understood her own vulnerability is made clear in her statement to Strand in 1917 that being emotionally involved with a man made her "feel like a sort of slave" when she really wanted to be "gloriously free" to develop a "mastery" of herself.[76] In 1918–19, when Stieglitz made the nudes, O'Keeffe was recovering from the mental and physical exhaustion pre-

cipitated by her conflict with the administration and other teachers at West Texas State Normal over her position on the war. Her mother was dead, and she was estranged from her father; she had no family to support her financially or emotionally. In Stieglitz, O'Keeffe found a supportive father who, in offering to bring her to New York to take care of her, promised an end to her troubles; moreover, as the patriarch of artistic modernism, he gave her the opportunity to achieve the things she wanted most in life—to paint, but also to be recognized in the field of modernism, and ultimately to be "on top."[77]

During the 1920s she asserted herself with Stieglitz either by turning inward, staging emotional scenes, or running away from him and the family compound at Lake George. When O'Keeffe battled with Stieglitz to have a child in 1922–23, she lost. According to Stieglitz, her paintings would have to serve as her "children." In modernist circles, where the ability of artists to create depended on their release from responsibility and their own childlike freedom, there was no place for real children, although from a distance those of others were often admired.[78] In the exhibitions that put O'Keeffe on the map of modernism in the early 1920s, Stieglitz presented her paintings not as her work alone but as work she produced in association with him.[79] Forthrightly admitting his nurturing guidance of her, and her public image, she told Blanche Matthias in the 1920s that she felt "like a little plant that . . . [Stieglitz] has watered and weeded and dug around."[80]

There is no question that O'Keeffe greatly admired Stieglitz as an artist and trusted him to orchestrate her career. Stieglitz's statement to Paul Strand in 1918, that "whenever she looks at the proofs [of the *Portrait*]," O'Keeffe "falls in love with herself—or rather her Selves," suggests how the photographs offered her the ability to think of herself in a way that supported her wish to be a beautiful woman as well as an important figure in modern art.[81] She was enraged, however, by the repercussions she personally had to bear from the notoriety he brought her. Stieglitz's great-niece, Sue Davidson Lowe, for example, recounts the sensational 1921 exhibition of Stieglitz's portrait of O'Keeffe as "profoundly upsetting [to O'Keeffe], one whose pain she would relive . . . with each of her own annual shows after 1923." With each exhibition she had to endure the "voyeurism of the press" and the "ordeal of exposure."[82]

From 1921 through the early 1930s O'Keeffe was plagued with illness and a series of breakdowns, as she and Stieglitz lived in a delicate balance, a constant state of tension.[83] In the early days of their partnership, when Stieglitz had imagined them as children at play, he told friends that he was approaching a "state of Nirvana" and that O'Keeffe was truly contented, feeling as she had when she was "happiest as a kid."[84] The turning point in what proved to be a fragile relationship occurred in 1923–24: it was the year of their marriage, of his daughter Kitty's depressive illness and institutionalization, and of O'Keeffe's first breaking point in their partnership. Rebecca Strand witnessed O'Keeffe's unhappiness with Stieglitz in the summers of 1923 and 1924 and related to her husband that O'Keeffe was "beside herself." Stieglitz was "at the root of it. . . . Inside the house [is] so much suffering between two people who really care so much for one another that they hurt one another." O'Keeffe had been "pushed pretty far and is pretty ragged, spiritually."[85] In September 1923 Rebecca Strand had reported, regarding O'Keeffe's abrupt departure from the Stieglitz family compound at Lake George, that "Stieglitz wants his own way of living and his passion for trying to make other people see it in the face of their own inherent qualities really gets things into such a state of pressure that you sometimes feel as though you were suffocating."[86]

At Stieglitz and O'Keeffe's joint 1924 exhibition, he showed a new portrait of Rhoades, which expressed his continued pining for her. Composed the preceding summer during Rhoades's visit to him at Lake George, this serial portrait consisted of sky and tree images, from which his *Songs of the Sky* project directly followed. Stieglitz continued to regret his missed opportunities with Rhoades, bringing her up several times during interviews in the early 1940s when Nancy Newhall attempted to record his recollections of his life. He told Newhall that "if he had been a real man, which, he said, he wasn't—if he had been six feet tall, all strength and sinew, he would have carried Rhoades off to some mountaintop, built them a little house, given her children, and let her paint." But instead, he had "never touched her: held her hand once for perhaps five seconds."[87]

Although O'Keeffe chose to continue the partnership, she made small spaces for herself, periodically escaping from New York and from personal and professional pressures. Her unspoken pact with Stieglitz—her trade-off of her own in-

dependence for his investment in her, his managing of her career and mentoring of her creativity—amounted to his control over the rhythm of their life together as well as the presentation of her work and her identity. O'Keeffe later reflected, "He was the leader or he didn't play. It was his game and we all played along or left the game."[88] In their first five years together (1918–22), O'Keeffe did not realize what the cost of playing his game would be; instead, she allowed him to craft his *Portrait* of her in a "heat and excitement" that seemed "clear and bright and wonderful."[89] O'Keeffe well knew that her viability in modernism would depend on the success of her and Stieglitz as creative partners. To their public, their working partnership was the "reciprocal sexual performance of the heterosexual couple,"[90] as Marcia Brennan has termed it, and at that time her image depended on this perceived reciprocity—on her very dependence on him—as well as her willingness to allow it to exist in the public realm.

As O'Keeffe endured recurring illnesses in the 1920s, anticipating critical scrutiny at each new exhibition of her work, she suffered in silence much of the time, hoping the unwanted erotic talk would die away. But Barbara Lynes has shown that O'Keeffe took some measures to refashion her identity as a committed and trained professional to counter the picture of Stieglitz's naïf whose paintings emanated spontaneously from a brush attached to her body. O'Keeffe in fact wrote short essays for her exhibition pamphlets to redirect the interpretation of her works and granted interviews, presenting herself as she wanted to be seen. By 1929, O'Keeffe had succeeded in tempering her image as a woman obsessed with her own sexuality with a greater sense of her hardworking professionalism.[91] Finally, after Stieglitz's death, as O'Keeffe removed herself entirely to New Mexico, she engineered an image that radically countered Stieglitz's woman-child and placed her painting in a less gendered framework. Ultimately, for herself, she erased from her life both Stieglitz and the myth he had generated about her creativity.[92] Stieglitz in effect admitted O'Keeffe's hatred for his eroticizing of her work when he told Nancy Newhall in 1942 that he feared O'Keeffe, after his death, would destroy his nude images of her and her early abstract works on which this eroticized image had been constructed.[93]

O'Keeffe came to terms with this body of work, however, by rejecting any rela-

tion between Stieglitz's photographs of her and her personal identity. She maintained that her paintings had nothing to do with Stieglitz or with the Freudian interpretations—his insistence that her work revealed her unconscious drives. Away from Stieglitz during her first summer in New Mexico, in 1929, O'Keeffe told Rebecca Strand that she "resents tremendously the way most of the people around Stieglitz swallow whole whatever he says, particularly about her. She knows his mechanism very well and knows when a mechanism is at work . . . , and she feels that others don't penetrate this but accept everything en bloc."[94] By 1978, when she stated that she could not recognize herself in his eroticized woman-child images of 1918–19, she had dissociated the photographs from herself and read them as Stieglitz's mirror reflection of himself, not of her.[95]

O'Keeffe despised the characterization of her images as works painted with her body—from her womb. That, she emphasized, was purely Stieglitz's fantasy. But, interestingly enough, she accepted the intuitive child part of Stieglitz's woman-child figure as her alter ego. She responded warmly to Matthias's description of her in 1926 as an "intuitive woman" who possessed the "candor of a child" and told Waldo Frank that she was an intuitive type.[96] That a child figure was at the center of her self-identity, instrumental to her own imaginative space and creative process, is important to the story of her remarkable capacity to reinvent her visual language and to control her iconic status as the feminine voice of modernism.

The Dreamspace of the Child

Stieglitz's *Portrait* of O'Keeffe, after 1921, exposed her darkness and suffering. The ascetic now veiled the child in the only image of O'Keeffe the woman and artist that was available to the public. O'Keeffe's will regarding her own identity was also asserted in this new darkness as she tried to modulate her image into that of a serious professional. At the same time, she felt a constant pressure to produce so that Stieglitz could mount the annual shows of her latest work, beginning in 1923. Her impossible task was to speak in the mythic voice of the feminine but in a new way every year, so as to create the effect of discovery and surprise in her exhibitions. Ex-

hausted by these demands by the end of the decade, she admitted the difficulty of meeting them. O'Keeffe believed that her art incorporated something of herself, her femininity, but her idea of how she might be articulating this feminine essence did not agree with Stieglitz's definition of her femininity as her sexuality. Her constant reinventions of her painterly vocabulary from 1923 to 1933 provided the requisite shock, the novelty of feminine vision, but her restlessness also represents her quiet efforts to subvert the critical reading of eroticized scenarios into her forms.[97] In these formal shifts we can see O'Keeffe attempting to remove any nuance of sexual performance from her identity as the woman-child of modernism. What is left of the figure, we might ask, once Stieglitz's Freudian approach to O'Keeffe as a woman artist is discarded? By O'Keeffe's own account, her ability to enter a private dreamspace at her core where she retained a secret child self nurtured her creative process, enabling her to speak her inner self in her own language.

The visual modes O'Keeffe developed in the mid-1920s relate her sense of her art as feminine without eroticism. After 1923 O'Keeffe returned to representational forms, abandoning her earlier abstractions that had permitted critics to supply an erotic story for her work.[98] She found new tropes for her femininity in her sensuous response to forms and effects in nature. While all her modes of composition engage a process of abstraction, some have the scope of the landscape panorama, some invoke the preciosity of the miniature, and still others show her looking up at forms above her or down at them on the ground below.

As is well known, O'Keeffe's methods were founded on Arthur Wesley Dow's lessons in *Composition* (1899; Figs. 148 and 150). O'Keeffe knew Dow's text by heart, from her student days with Dow's lieutenant Alon Bemont and "Pa Dow" himself, and from teaching Dow's method to her design students in Texas. Dow's design process emphasizes the framing of a motif—its placement on the surface and its relation to the whole space—and the study of *notan*, or the relation between light and dark tonalities. O'Keeffe's work over the course of the 1920s shows her exploring the possibilities of framing as visualized in Dow's plates. Based on the lessons of the Japanese print, Dow's illustrations taught the Photo-Secessionists as well as O'Keeffe's generation of modernists how to pull out the frame vertically or horizontally and arrange the motif on the surface for surprisingly intimate effects.

N° 47

148
Arthur Wesley Dow,
*Schemes of Dark
and Light in Two
Values Using Boats
and Houses,* 1899.

His small sketches of trees or flowers, laid out in serial fashion, shifted the viewing position of the observer, clearly demonstrating variables of proximity and distance, moving in on and out from the object, to capture different rhythmic movements of the form or to control the intensity of experience. Using this system since 1916, O'Keeffe developed her motifs, often serially, to explore a range of expressive possibilities as she manipulated the color and form of each motif. The adjustment of the pictorial frame to delimit the artist's vision mimics the framing action of the camera lens, opening out or closing in on the object or repositioning the object within the space of the frame (see Fig. 148).[99] O'Keeffe realized how to make this visual mobility yield dynamic surfaces where the edges and interior lines of forms move dramatically, with a velocity, in rhythmic relation to one another. As Frances O'Brien, her student in the 1920s, observed, O'Keeffe was a restless per-

149
Georgia O'Keeffe, *Little House,* 1921/1922, oil on canvas, 18¼ × 10 in.

fectionist in her work: "She was always searching, experimenting, trying new methods and colors and pigments. Nothing satisfied her." She was also secretive, said O'Brien, and at this time allowed no one to watch her paint except O'Brien.[100]

At times O'Keeffe returned to the child vision she had explored in 1917, flattening space and tipping up the ground toward the surface (Fig. 149) to produce the effect of a fresh, intuitive way of seeing the world, although her design is obviously reminiscent of Dow's plates (Fig. 150). In her abstracted landscapes and floral forms, as well as pure abstractions, the musical mode of the late 1910s became her intuitive method of composing. O'Brien noted that O'Keeffe's method focused on filling a blank space decoratively with abstracted shapes. She first saw the blank space in her mind and then filled it with shapes that became familiar to her over time. Sometimes she would make postage stamp–size preparatory drawings for

150

Arthur Wesley Dow, *Schemes of Dark and Light in Two Values Using Flowers of Different Shapes,* 1899.

her oils that laid out the forms across the white surface. Her sense of asymmetrical balance, acquired from Dow's Japanese aesthetic, had become an ingrained resource for her design sense, so that it functioned for her like automatic writing, an automatic way of organizing and playing with form on surface. While she returned again and again to certain arrangements of the surface, she also employed highly personal motifs—shapes that she saw in her head—and certain modes of focus to produce magnified and simplified shapes, or close studies of complexity.[101] Her numerous statements, made over decades, that she thought in colored form rather than words, illuminate the nature of her creativity. We know that she had difficulty expressing her feelings in words, so that Stieglitz characterized her as "not a talker or a questioner." Perhaps we can see a serendipity at work in the meeting of Stieglitz, the designer of the woman artist as child, and O'Keeffe as a woman who actually possessed the child's proclivity toward visual expression of thought. According to Howard Gardner's scheme of artistic development, O'Keeffe's insistence on her art as her natural intuitive form of speech suggests the latent prelinguistic phase usually manifested in the right-brained dominance of very young chil-

dren at a time when their visual and spatial senses (right brain) still outweigh the linguistic ability of the left brain.[102] In some crucial way, O'Keeffe might have actually preserved the artistically talented young child's ease of movement between brain hemispheres and between linguistic and visual intelligences.

Other psychic resources from her childhood were also at work in her ability to produce the sensation of surprise in her paintings. The tendency to pull the gaze in toward the form to produce the private world of the miniature or to pull out the frame, expanding it, to capture the sense of the self alone in the macrocosm can be traced to times when O'Keeffe played by herself in nature, crystallizing what was to become her essential creative vision. Although O'Keeffe projected herself as a hardworking professional artist, rooted in disciplined studio practice, she thought of her process privately as a recovery of and escape into her child self, so that her experimentation was for her like playing. She spoke to Mitchell Kennerley of how her creative moments released her into an interior world: "I see my little world— as something that I am in—something that I play in—it is inevitable to me." This dreamspace released her from the pressures of the Stieglitz compound, with its bourgeois rituals and congested rooms, which she found oppressive.[103]

O'Keeffe had to have silence in order to find her inner voice speaking to her; in her account of her intuitive process of working, she had to locate again the imaginative world she inhabited as a child in Sun Prairie, Wisconsin, where she first formed the habit of playing and sketching freely as she wandered alone through the woods behind the family home. As a small child one summer she had experienced the formative moment of her creative practice when she made a dollhouse for herself, partly from natural objects. She moved this miniature structure to different sites on her parents' farm, reshaping the landscape around the toy house to create a complete fantasy world. For the mature O'Keeffe, entering the world of the miniature—seeing her "little world"—was the essential creative mechanism allowing her to translate her internal vision into colored shapes and lines. Replicated in the form of the miniature, the world can be ordered, aestheticized, and controlled at will, even if one feels oneself a captive in the larger world. This wandering through the landscape and playing in nature provided a refuge from her overbearing, strict mother, with whom she strongly disagreed. Growing "more and

more satisfied to live within herself" in silence, she withdrew from the grown-up world to make a world entirely her own.[104] O'Keeffe as an adult could reenter this space, releasing herself into the remembered sensation of solitude and freedom that she associated with her childhood experience in Wisconsin. This private ritual of exploring nature would serve her well in South Carolina, Texas, and New Mexico, and especially at Lake George in the 1920s.

O'Keeffe, in her key compositional modes in the 1920s, returned to the dream-space of her child self, exploiting it for startling effects, picturing what she, Stieglitz's wonder-child, could see. In the Stieglitz-Rosenfeld criticism, the revelation of nature's mysteries by a woman who is at her center a child—that is, nature revealing itself—justified the pronouncements about the singularity of her vision. In that mythic origin of her art she privately believed the vision of herself producing her art in an intuitive act of play, and she kept quiet about her way of designing her canvases from preparatory sketches. Her own process resembled a game of discovering the new, in the sense of recalling the child's freely moving body and imagination. This mobility resonates in the enormous variety of her compositions from the 1920s: her canvases show her at times looking up the sky and trees, at others moving down to the ground, and often turning herself from side to side as if spinning around. These novel spatial experiences produced effects that must have seemed bizarre for contemporary audiences in the way they subvert the viewer's expectation of a steady, level gaze out toward the landscape, with a horizontality conforming to the contours of earth, sky, and bodies of water at the horizon.

Although O'Keeffe's abstractions and abstracted landscapes of the 1920s both originated in her experience in nature, their strangeness proceeds as much from her visual dynamism as from her extreme simplification. In these works, form is approached as movement, active, alive, and undulating in rhyming and rolling lines. Her practice of abstracting from nature can be seen in the series from Palo Duro Canyon of 1916–17, in which O'Keeffe simplified and compressed a few definitive landscape forms, the small rounded shrubs and the zigzagging cliffs, until she arrived at a stripped-down balance of these two elements (Fig. 151). Framing the expansion of sky, water, and earth in parallel rolling lines, this approach allowed her to render Lake George as a panorama of sheer energies (Fig. 152). The formal con-

151

Georgia O'Keeffe,
No. 13 Special,
1916/1917,
charcoal on cream
paper, 24$\frac{1}{2}$ × 18$\frac{3}{4}$ in.

gruity of her abstractions and abstracted landscapes can be seen by turning one of these abstractions (Fig. 153) ninety degrees so that it rests on its side.

This consonance of O'Keeffe's abstraction and representation underlines her dependence on the same formal process: a layering of long, undulating lines in parallel motion to compose an event on the canvas, the undulation propelled by the modulation of color and tone along the line. While O'Keeffe thought of herself as a colorist first and foremost, her artistry in producing musical effects on the surface hinges on the edges of things, their contours, and the rhythmic movement of line. From 1919 on, her orchestration of rippling lines, in emulation of the fugal counterpoint of her favorite composer, J. S. Bach, recurs as the compelling

visual structure of her musical abstractions, landscapes, and floral and plant stud-ies.[105] O'Keeffe now systematized the wavering child's hand with which she had applied watercolor strokes to the page in 1917 into an edge animating the exterior world, playing with forms in nature, making them her own. It is significant that O'Keeffe did not engage this mode when she turned to manufactured objects or urban structures, preferring instead to limn their contours through the method of

◄ **152**

Georgia O'Keeffe,
*Red, Yellow and
Black Streak,* 1924,
oil on canvas,
$39^{3}/_{8} \times 31$ in.

153 ►

Georgia O'Keeffe,
*Grey Line with
Lavender and Yellow,*
1923/1924, oil on
canvas, 48×30 in.

precisionist streamlining. Rather, it was in the multiple rippling edges of natural forms, moving horizontally or vertically across the surface, that she now projected her personal voice. By the end of the 1920s, she had increased and accelerated her edges into a myriad of fluttering floral movements, eventually exhausting the lyrical line as a language of her femininity.

At times O'Keeffe combined lateral undulations with a centered form. She

154 ▲

Georgia O'Keeffe,
*Pool in the Woods,
Lake George,* 1922,
pastel on paper
24 × 18 in.

◄ 155

Georgia O'Keeffe,
Pond in the Woods,
1922, pastel on paper,
24 × 18 in.

organized *Pool in the Woods, Lake George* (Fig. 154), for example, around a vortex or a nebula that generates its energies outward from the center across the surface in rhythmic lines. Edges and lines on her surfaces, whether evoking a still-life form or the surge of wind, water, or earth, she conceived in terms of velocity—movement—that was always unpredictable. As O'Brien noted, the edge that moves with certain velocity became instrumental to O'Keeffe in the 1920s. In a related pastel, *Pond in the Woods* (Fig. 155), O'Keeffe tightens her focus so that we now see only the eye at the center, the nebula of water that spirals mystically around successive radiating rings of color vibrations. *Pink Moon and Blue Lines*, which was titled *The Ocean and the Pink Moon* at O'Keeffe's 1924 exhibition, is composed similarly to *Pool in the Woods* but on a vertical axis, so that the parallel rhythmic lines climb up the sides of the space to spiral over in greeting to the centered moon. These undulating lines here and elsewhere in her imagery signify her sense of watery movement she had learned from the wave motif of the nymph's costume in Bakst's drawings for "*L'après-midi d'une faune.*"

The abstract spirals of 1915 that O'Keeffe continually reinvented as her interior voice, her inexplicable feelings, she now recognized everywhere in nature. As late as *Grey Blue and Black—Pink Circle* (Fig. 156), the form appears to signal her affinity to the magic of a kachina doll. This identity is suggested in her placement of the viewer to look directly into the center of the spiraling vortex of color. The whirling color and the dancing rhythm of the projectile, bobbing up and down, relates our own dizzy sense of the swirling movement. This relation of the viewer's body to the enlarged rhythmic forces of space on the surface of her works is crucial to the experience of these works. In the swirling and spiraling, in the restless flow of movement across the surface, the viewer's eye is captured and the viewer's body engulfed in the flow. By magnifying the forms on the surface, the hypnotic, repetitive movements overwhelm and in effect force the viewer into the trancelike rhythms of the dance at hand. We do not simply witness the drama; we feel swept into it, in a way that Brigman's miniaturized nature dramas fail to engage us.

The mysteries O'Keeffe found in the small and in the cosmic she also relates through the same process of magnification. Her treatment of the miniature in nature makes us feel as if we have been suddenly reduced to the scale of a Lilliputian

156

Georgia O'Keeffe, *Grey Blue and Black–Pink Circle,* 1929,
oil on canvas, 36 × 48 in.

world. Exploding the proportions of the form and focusing in on its parts to isolate the abstract beauty of its movements allow O'Keeffe to tell of a silent world and its pure music. Whether that motif is the humble, unassuming skunk cabbage (Fig. 157) or the blatant lusciousness of a pink tulip (Fig. 158), O'Keeffe forces our faces down to the level of the object, often just as she has encountered it on the ground, to confront its undulating rhythms, eerie haloings, or spiraling and vector-like movements of color. Often this magnification of the microcosmic engages us in a game of seeking out what is hidden or only partly apparent to the eye. All of O'Keeffe's flower paintings render the microcosm of the flower world as a macrocosm, making the convex lens of the eye an instrument of magnification. In these compositions, the flowers open out, letting us glimpse the source of life at the center. Often, in compositional complexity—in the multiplying parts in her studies of leaves and seaweed—O'Keeffe finds in this microscopic and therefore

157 ▲

Georgia O'Keeffe,
Skunk Cabbage, 1922,
oil on canvas, 18 × 14 in.

158 ▷

Georgia O'Keeffe,
Pink Tulip, 1925, oil on
canvas, $31\frac{3}{4}$ × 12 in.

159
Georgia O'Keeffe,
Seaweed, 1927, oil
on canvas, 9 × 7 in.

secret world a chaos she seems to relish discovering. This tiny sampling of sea-weed (Fig. 159), a mere 9 by 7 inches, presents a multiplicity that defies compre-hension. A closer look, we feel, would not bring this fairy world into better focus but only continue to make apparent a bewildering number of parts unseen from a more distant view. The enlarged forms of *Flower Abstraction* (Fig. 160), a canvas four feet high, dissolve into a series of rhythms, the flower pushed so close that the eye cannot comprehend it as a separate, remote thing. Instead, we see only a part of it, which, in filling our entire frame of vision, enfolds our whole being. The numerous parts of the flower now become gigantic, their amplitude on the surface defined by their contours. We follow the edges of stems, leaves, and petals,

160

Georgia O'Keeffe, *Flower Abstraction,* 1924, oil on canvas, 48 × 30 in.

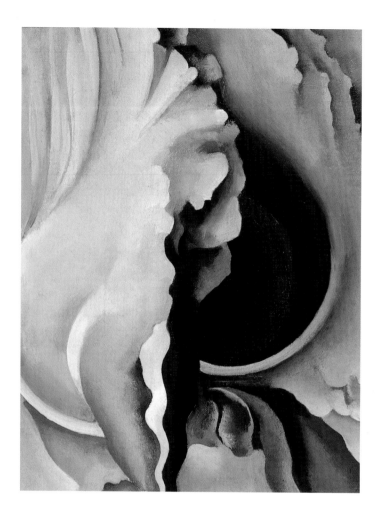

161
Georgia O'Keeffe,
The Black Iris, 1926,
oil on canvas, 9 × 7 in.

successively pulling back in smooth, then frilled, and finally fluttering movements, as the eye tracks the forms upward from the bottom of the frame. The center of the flower remains hidden and veiled by the multitude of translucent membranes that block it from our sight.

In the iris compositions from 1926 to 1927 (Fig. 161), O'Keeffe similarly veiled the center with diaphanous petals that ripple into a frisson at their edges, permitting half-glimpses of the flower's core, partly revealed, partly concealed in darkness. It was precisely this type of construction, built around the act of veiling, that allowed critics like Rosenfeld (earlier, in the abstractions) to assert that O'Keeffe's

images dramatically uncovered the mystery of feminine sexuality or that led McBride to call O'Keeffe in 1927 a "priestess of mystery," or Louis Kalonyme to write in 1928 that O'Keeffe's vision cut through civilization's mask of femininity to unveil the true, natural feminine essence.[106] The structuring of her forms replicates the experience of seeing through an outer shell into a deep place of glowing life forms. From the first mystical flower forms of 1919 to the later jack-in-the-pulpit images of the early 1930s, she employed this same floral anatomy as the structure of feminine mystery. She insinuated the importance of interiority to the practice of her painting, including her floral imagery, when she wrote of her vision as a private space, as her "little world—as something that I am in—something that I play in—it is inevitable to me."[107] It is likely that her game of hide-and-seek on the canvas corresponded to her own need to escape into a psychological free zone, protected from the outside world. But the sense of interiority, of a space within that reverberates with indescribable sensations, opened up this imagery to Freudian interpretations of hidden feminine sexuality—that in her work we look into a private space, the body's inner space, crossing a boundary in art previously untraversed. From the first spiraling forms of the 1915 charcoals to the abstractions and florals of the 1920s, this narrative described O'Keeffe's core self as a taboo image, a bodily interior space that could be visualized only in terms of metaphorical abstractions.[108]

While O'Keeffe remained acutely aware of the sexualized framework that Stieglitz's critics generated for her art and did not welcome it, she believed in the essential femininity of her art. She surely exploited the floral composition as a sign of her femininity, for these paintings became her signature works by 1929. Throughout the 1920s she explored several approaches to still-life objects: trompe l'oeil, enlarged forms of leaves and flowers, such as morning glories and poppies; simplified tabletop compositions of fruit on a plate or eggs in a dish; yin-yang oppositions of natural forms such as skunk cabbages; and vertical, thrusting images of heavy phallic calla lilies. There was also the series of New York skyscrapers, received—recently and contemporaneously—as a gender-bending project expressing O'Keeffe's self-empowerment.[109] In 1927 especially her surfaces exploded with swirling roses, poppies, petunias with huge flaring skirts, and the frilli-

162
Georgia O'Keeffe,
White Rose with
Larkspur No. II,
1927, oil on canvas,
40 × 30 in.

est of sweet peas. The penultimate composition in which these floral forms flutter their delicate membranes in the viewer's face, suggesting that they waft their fragrance in the same direction, came in two images of a large white rose, accompanied by a spray of diaphanous blue larkspur (Fig. 162).

If O'Keeffe did not herself wear the conventional frilly costumes and florid cosmetics considered feminine in these years, it is clear that in her works she was quite willing to engage the conventions for femininity. The repetition of floral forms on the walls of her annual exhibition in 1928 elicited the appropriate response from

the critics: Kalonyme, for example, called her display a "woman's art," "innocent . . . of all aesthetic categories of masculine approach in painting." No wonder the critic McBride would joke the following year that respectable old ladies from Iowa were traveling to New York to commune with O'Keeffe's works at the Intimate Gallery.[110] O'Keeffe in these works had availed herself of a recognizably feminine mode that modernist women writers were also employing at that moment. Like her, these writers self-consciously constructed a feminine voice out of an aesthetic of intricacy, craft, and preciosity and suggestions of a confined and silent space.[111] If O'Keeffe reasoned that she could obscure herself in the concreteness of the still-life subject, critics nonetheless found her buried in the delicate surfaces and intricate rhythmic movements of her image, the paradigm of a true, natural femininity.

By the end of the 1920s the game of hide-and-seek had become tiresome to her. O'Keeffe faced considerable difficulties in maintaining her production level and, even more problematic, the inventiveness that had so stunned Stieglitz in 1916–19. He and O'Keeffe continued to provide the public with the annual shock of the self-renewing woman-child. The yearly performance her exhibitions required drained her as she generated for each show enough canvases that satisfied her and then submitted herself to the hateful circus of interviews. The speculative essays continued to read bared sexuality in her canvases. From year to year in the 1920s, however, she repeated herself in her modes of experiencing nature and the resulting forms in her paintings. One can understand why at the end of the decade she needed to get herself away from Manhattan and Lake George into a new environment if she were going to be able to "evolve" in her work, as required by Stieglitz's vitalist doctrine of the creative mind's perpetual youth. By 1927–28, when, following a period of hospitalizations and recovery, O'Keeffe was burned out, she told Stieglitz of her need to get back to the West—to "'her' America"—a proposal he rejected, unwilling that either of them venture out of modernist New York.[112] To Ettie Stettheimer, O'Keeffe wrote in 1929, "I knew I must get back to some of my own ways or quit—it was mostly all dead for me." A few months earlier O'Keeffe had complained to Rebecca Strand that Stieglitz's steady pressure on her to produce was making it difficult for her to go on.[113] In 1929 two critics noted signs in her work that she had stopped growing, hinting also that she would soon occupy the title of Old Master,

163
Georgia O'Keeffe,
Gerald's Tree I,
1937, oil on canvas,
40 × 30⅛ in.

a category antithetical to modernism. And in 1930 O'Keeffe again commented on
the difficulty of reinventing the wonder of the essential feminine voice in visual
form.[114]

O'Keeffe, on her first getaway with Rebecca Strand to New Mexico in 1929,
underwent a transformation. Before Strand's eyes, she grew from the seemingly
"frail" child Stieglitz had projected to a woman as "tough as a hickory root . . .
[now] finding what she knew she needed."[115] Although O'Keeffe did return to Stieg-
litz from this excursion to the Southwest, as she would nearly every year thereafter
until his death, the permanent change in her was represented in the shifting of her

work into an imaginary panorama of heat, dryness, scarcity, pain, sublime immensity and darkness, and sometimes mystical hallucination. This landscape automatically disabled the Freudian scenario of the woman-child that had circulated around her renderings of the lush, green paradisiacal forms and colors she found at Lake George. The time she spent in New Mexico distancing herself from Stieglitz's critical machinery even gave her the strength to taunt the critics in her self-consciously eroticized jack-in-the-pulpits, begun the year after her return to New York from Taos.[116] O'Keeffe recovered her freedom to do as she wished and to reinvent herself in her work. From New Mexico she wrote to Seligmann, "I feel like myself again and I like it."[117] She was not, in 1929, the same woman she had been in 1919. It is not too much to state that her exhaustion and despair at the required annual performances of her paintings were also linked to her own maturation, to her physical aging and emotional growth. Plunging herself into the desert world of northern New Mexico, O'Keeffe transformed her imagery and her identity in modernism; she would less and less often reprise the distinctive feminine lyricism that had characterized her nature studies and abstractions of the 1920s. O'Keeffe found now that modes of disjunction, irony, and the surreal fit her, and she developed surprising juxtapositions of static objects or landscape formations invoking acute experiences of body and mind. Occasionally, her desiccated tree forms—for example, in *Gerald's Tree I* (Fig. 163), with their twisting movements with limbs lifted, pleading toward the sky—recall Anne Brigman's evocation of suffering in *The Dying Cedar* and *Soul of the Blasted Pine*—photographs that O'Keeffe certainly knew from the days in 1918 when Stieglitz was studying them as he prepared to photograph her. Like Brigman in the High Sierra, O'Keeffe in the New Mexico desert traced a history of struggle in solitary trees and rocks that suggests a pathos appropriate to stories of human striving and endurance, a theme particularly reverberant of her own experience.

In July 1931, shortly after O'Keeffe's return to Lake George from New Mexico, Edna St. Vincent Millay drove to the Stieglitz compound, a few hours away from her farm at Austerlitz, New York. The two feminine icons of New York's modernism

finally faced one another, undoubtedly with great curiosity. They were distantly acquainted through Mitchell Kennerley, who had been Millay's publisher and the owner of Anderson Galleries, where Stieglitz had staged his and O'Keeffe's exhibitions during the previous decade. A petite, flaming-haired beauty, Millay had long since abandoned her amorous life in the Village and had settled down, more or less, at her country estate, where under the watchful eye of her husband she could turn all her energies to the composition of her verse. The meeting of the two women was edgy. Little was spoken as the poet and painter shyly admired one another. Later, O'Keeffe attempted, in a letter to Millay, to explain her bewildered and awed behavior. In Millay, a luminous "wonder child"[118] of a woman, O'Keeffe seemed to recognize herself.

O'Keeffe wrote that she found Millay to be like a tiny hummingbird she had once wished to catch hold of for a few moments but whose fluttering evanescence forbade capture. "You were like the hummingbird to me," O'Keeffe told Millay, perhaps enraptured by the myth as much as the person of Millay, as modernism's great lyric girl-poet. "It is a very sweet memory to me—And I am rather inclined to feel that you and I know the best part of one another without spending much time together—It is not that I fear the knowing—It is that I am at this moment willing to let you be what you are to me—it is beautiful and pure and very intensely alive—."[119] In her imagining of Millay as bird, it was the freedom to fly away at will that O'Keeffe coveted—in fact, she recognized the necessity of flight to the bird's essence. She ended her letter with the hope that they would come together again someday when both were sure of their absolute freedom. Her tone was intense and private, as if she were revealing herself to herself in a diary. O'Keeffe's response to Millay suggests a fashioning of Millay as a soul mate—a woman artist and a free individual. Her words from New Mexico resonate with this moment, that feeling like herself again, O'Keeffe would again pursue a "mastery" of herself, as she put it, and the voice she had known in South Carolina and Texas so many years ago.

Notes

Introduction

Epigraph is taken from Herbert J. Seligmann, *Alfred Stieglitz Talking: Notes on Some of His Conversations, 1925–1931* (New Haven: Yale University Library, 1966), 61–62.

1. Treatments of Stieglitz and his modernism that portray or elucidate his modernist program and O'Keeffe's pivotal role in it include Paul Rosenfeld, *Port of New York: Essays on Fourteen American Moderns* (New York: Harcourt, Brace, 1924; reprint, with introduction by Sherman Paul, Urbana: University of Illinois Press, 1961); Seligmann, *Alfred Stieglitz Talking*; Sue Davison Lowe, *Stieglitz: A Memoir/Biography* (New York: Farrar, Straus and Giroux, 1983); Anne Middleton Wagner, *Three Artists (Three Women): Modernism and the Art of Hesse, Krasner, and O'Keeffe* (Berkeley and Los Angeles: University of California Press, 1993); Richard Whelan, *Alfred Stieglitz: A Biography* (Boston: Little, Brown, 1995); Barbara Buhler Lynes, *O'Keeffe, Stieglitz, and the Critics, 1916–1929* (Chicago: University of Chicago Press, 1991); Marcia Brennan, *Painting Gender, Constructing Theory: The Alfred Stieglitz Circle and American Formalist Aesthetics* (Cambridge: MIT Press, 2001); Wanda Corn, *The Great American Thing: Modern Art and National Identity, 1915–1935* (Berkeley and Los Angeles: University of California Press, 1999); and Sarah Greenough et al., *Modern Art and America: Alfred Stieglitz and His New York Galleries* (Washington, DC: National Gallery of Art, 2001).

2. Heinz Ickstadt, "Liberated Women, Reconstructed Men, and 'Wandering' Texts," *Amerikastudien/American Studies* 43 (1998): 593–600.

3. Ibid., 599–600.

4. The modernist landscape was composed of bifurcated domains—nature and culture, country and city, work and domesticity—in which the first terms assumed a masculine dimension and the second a feminine. On the feminine as a premodern home and a space outside modernity but intrinsic to the textual matrix of modernism, see Rita Felski, *The Gender of Modernity* (Cambridge, MA: Harvard University Press, 1995), 35–60.

5. Sinclair Lewis, "Hobohemia: A Farce-Comedy in Three Acts," typed MS, ca. 1918, New York Public Library Collections. This play was produced Feb. 8, 1925, at the Greenwich Village Theater. Stieglitz maintained his domestic arrangement with his wife, Emmy, until she threw him out in 1918; then he took refuge with O'Keeffe in his brother's household and at his family's Lake George compound.

6. Casey Nelson Blake, *Beloved Community: The Cultural Criticism of Randolph Bourne, Van Wyck Brooks, Waldo Frank, and Lewis Mumford* (Chapel Hill: University of North Carolina Press, 1990), 25–45, comments on these cultural radicals' longing for the maternal. Susan Stewart, *On Longing: Narratives of the Miniature, the Gigantic, the Souvenir, the Collection* (Asheville, NC: Duke University Press, 1993), 23, offers a rich commentary on the paradox of modernist longing, describing nostalgia as a desire for "the erasure of the gap between nature and culture, and hence a return to the utopia of biology and symbol united within the walled city of the maternal." This utopia, she continues, is a space "where lived and mediated experience are one, where authenticity and transcendence are both present and everywhere."

7. Brennan, *Painting Gender.* Whelan, *Alfred Stieglitz,* 15–16, comments on Stieglitz's desire for a twin and his preoccupation with self-exploration as the psychological source of his photography.

8. Nina Miller, *Making Love Modern: The Intimate Public Worlds of New York's Literary Women* (New York: Oxford University Press, 1999), 5, cites Raymond Williams's similar point about the Bloomsbury modernists' constituting a fraction of the ruling class: "They were at once against its dominant ideas and values and still willingly, in all immediate ways, part of it." See Raymond Williams, *Problems in Materialism and Culture* (London: Verso, 1980), 152–63.

9. See Henri Bergson, "What Is the Object of Art? (from *Laughter*)," *Camera Work* 37 (Jan. 1912): 22–36; and Havelock Ellis, *The Dance of Life* (New York: Houghton, Mifflin, 1923); Stieglitz's and O'Keeffe's copy of Ellis's book is in O'Keeffe's Abiquiu Book Room.

10. Thanks to Michael Leja for his suggestions on Rhoades's disruption of Stieglitz's modernism. On Stieglitz's obsession with his "dark lady," see Whelan, *Alfred Stieglitz,* 16–17, and Dorothy Norman, *Alfred Stieglitz: An American Seer* (New York: Random House, 1973), 15–16.

11. Miller, *Making Love Modern,* 8–9; Felski, *Gender of Modernity,* 13.

12. Warren Sussman, "'Personality' and the Making of Twentieth-Century Culture," in *New Directions in American Intellectual History,* ed. John Higham and Paul K. Conkin (Baltimore: Johns Hopkins University Press, 1977), 212–26; Marcia Brennan, in *Painting Gender,* articulates the process through which Stieglitz's critics narrated

the works of his modernists as transcendent, embodied sexualities; Alfred Stieglitz to Georgia O'Keeffe, June 1916, quoted in Anita Pollitzer, *A Woman on Paper: Georgia O'Keeffe* (New York: Simon and Schuster, 1988), 139–40.

13. Corn, "Introduction: Spiritual America," in *Great American Thing*, 3–40, treats portrait photography and literary portraiture as the strategies of group promotion in the field of American modernism.

14. Lowe, *Stieglitz*, 49, writes that O'Keeffe alone escaped the limits that Stieglitz imposed on his women friends when he held them up to his fantasy of femininity. When we attend to O'Keeffe's own testimony on this issue, presented here in chapter 4, it is clear that she too felt intensely pressured by Stieglitz's imposition of this fantasy.

15. Lynes, *O'Keeffe, Stieglitz*; Wagner, *Three Artists*; Brennan, *Painting Gender*; Sarah Greenough, *Alfred Stieglitz: The Key Set; The Alfred Stieglitz Collection of Photographs*, vol. 1, 1886–1922 (Washington, DC: National Gallery of Art; New York: Abrams, 2002), xxxvi–xxxvii.

16. See Seligmann, *Alfred Stieglitz Talking*, 61–62; Stewart, *On Longing*, 23; and Mario Jacoby, *The Longing for Paradise: Psychological Perspectives on an Archetype*, trans. Myron B. Gubitz (Boston: Sigo Press, 1985), 10–13.

The Photo-Secession

1. Ann Douglas, *Terrible Honesty: Mongrel Manhattan in the 1920s* (New York: Farrar, Straus and Giroux, 1995), 217–53.

2. "Interview with Sam Lifshey," folder F25, in "Mina Turner's Biographical Notes on Gertrude Käsebier from Interviews," Gertrude Käsebier Papers, MS collection no. 149, University of Delaware Library.

3. On the organizational and political history of the camera clubs, see William Innes Homer, *Alfred Stieglitz and the Photo-Secession* (Boston: New York Graphic Society, 1975); Richard Whelan, *Alfred Stieglitz: A Biography* (New York: Little, Brown, 1995), 137–206; Beaumont Newhall, *The History of Photography from 1839 to the Present* (New York: Museum of Modern Art, 1982), 153, 156, 158; and Ulrich F. Keller, "The Myth of Art Photography: A Sociological Analysis," *History of Photography* 8 (Oct.–Dec. 1984): 249–75.

4. Christian A. Peterson, *After the Photo-Secession: American Pictorial Photography, 1910–1955* (New York: Norton; Minneapolis: Minneapolis Institute of Arts, 1997), 15–16.

5. Geraldine Wojno Kiefer, "The Leitmotifs of *Camera Notes, 1897–1902*," *History of Photography* 14 (Oct.–Dec. 1990): 350–51.

6. See Alfred Stieglitz, "The Platinotype up to Date," *American Amateur Photographer* 4 (1892): 495, and "Some Remarks on Lantern Slides, a Method of Developing: Partial and Local Toning," *Camera Notes* 1 (Oct. 1897): 33–34, both cited in Kiefer, "Leitmotifs of *Camera Notes*," 351.

7. See Joseph Shiffman, "The Alienation of the Artist: Alfred Stieglitz," *American Quarterly* 3 (1951): 250; William Innes Homer, *Alfred Stieglitz and the American Avant-Garde* (Boston: New York Graphic Society, 1977). Kiefer, "Leitmotifs of *Camera Notes*," 349–59, cites other contributing sources for the Symbolist philosophy and style of the New York pictorialists in the 1890s, among them the writings of Henri Bergson and George Bernard Shaw. In addition to these, the critics of *Camera Work* often linked Stéphane Mallarmé's poetry and the art of Rodin and Camille Corot with the aesthetics of veiling and mystery.

8. Sadakichi Hartmann, "The Technique of Mystery and Blurred Effects," *Camera Work* 7 (July 1904): 24–26. Maeterlinck's letter on photography is printed in *Camera Work* special suppl. (1906): n.p. For similar invocations of Maeterlinck, see also Sadakichi Hartmann, "Dawn-Flowers (To Maurice Maeterlinck)," *Camera Work* 2 (Apr. 1903): 29; Sidney Allan [Hartmann], "Roaming in Thought (After Reading Maeterlinck's Letter)," *Camera Work* 4 (Oct. 1903): 21–24; Charles H. Caffin, "The Art of Eduard J. Steichen," *Camera Work* 30 (Apr. 1910): 33–36; Benjamin de Casseres, "Art: Life's Prismatic Glass," *Camera Work* 32 (Oct. 1910): 33–34, and "Modernity and the Decadence," *Camera Work* 37 (Jan. 1912): 17–19.

9. Caffin, "Art of Eduard J. Steichen," 34.

10. On the importance of Whistler's exhibitions in the 1880s and 1890s, see Kathleen Pyne, *Art and the Higher Life: Painting and Evolutionary Thought in Late Nineteenth-Century America* (Austin: University of Texas Press, 1996), chap. 3; Nicolai Cikovsky Jr. with Charles Brock, "Whistler and America," in *James McNeill Whistler*, ed. Richard Dorment and Margaret F. MacDonald (New York: Abrams, 1995), 29–38; and Linda Merrill et al., *After Whistler: The Artist and His Influence on American Painting* (Atlanta: High Museum of Art, 2003; distributed by Yale University Press). Joel Smith, *Edward Steichen: The Early Years* (Princeton: Princeton University Press, 1999), 23 and 26, cites Whistler's nudes and nocturnes as visual paradigms for Steichen.

11. For references to James McNeil Whistler, see "Index of Selected Names and Subjects," in Jonathan Green, ed., *Camera Work: A Critical Anthology* (New York: Aperture, 1973), 360. On imagining Whistler working with a camera, see Allan,

"Roaming in Thought," 24. Arthur Wesley Dow, *Composition: A Series of Exercises in Art Structure for the Use of Students and Teachers* (Garden City, NY: Country Life Press; New York: Doubleday, Doran, 1899). On the influence of Dow in the 1890s and the importance of Japanese art to his design system, see Frederick C. Moffatt, *Arthur Wesley Dow (1857–1922)* (Washington, DC: Smithsonian Institution Press, 1977), and Nancy E. Green, *Arthur Wesley Dow and American Arts and Crafts* (New York: American Federation of Arts; Abrams, 2000).

12. On Whistler's significance as a codifier of elite taste, see Pyne, *Art and the Higher Life,* chap. 3, especially 125–34.

13. For Whistler's spiritualist practices and those of the generation after him, and for Swinburne's verses articulating hidden, feminine desire in this painting, see Pyne, *Art and the Higher Life,* 94–100 and chap. 4, "Aesthetic Strategies in the 'Age of Pain': Thomas Dewing and the Art of Life." For the Protestant reformation of feminine typology, see Nancy F. Cott, "Passionlessness: An Interpretation of Victorian Sexual Ideology, 1790–1850," *Signs* 4 (Winter 1978): 234–35; Ruth H. Bloch, "Untangling the Roots of Modern Sex Roles: A Survey of Four Centuries of Change," *Signs* 4 (Winter 1978): 237–52; Maurice Bloch and Jean H. Bloch, "Women and the Dialectics of Nature in Eighteenth-Century French Thought," in *Nature, Culture and Gender,* ed. Carol P. MacCormack and Marilyn Strathern (Cambridge: Cambridge University Press, 1980), 33–40; Ludmilla Jordanova, "Natural Facts: An Historical Perspective on Science and Sexuality," in *Sexual Visions: Images of Gender in Science and Medicine between the Eighteenth and Twentieth Centuries* (Madison: University of Wisconsin Press, 1989); Jeffrey Weeks, *Sex, Politics and Society: The Regulation of Sexuality since 1800* (London: Longman, 1981), chap. 2; Leonore Davidoff and Catherine Hall, *Family Fortunes: Men and Women of the English Middle Class, 1780–1850* (Chicago: University of Chicago Press, 1987); and Mary Poovey, *Uneven Developments: The Ideological Work of Gender in Mid-Victorian England* (Chicago: University of Chicago Press, 1988), esp. chap. 1.

14. On the reception of Whistler's aesthetic as feminized in the writings of English and American critics, see Pyne, *Art and the Higher Life,* 114, 160–61, 183–200.

15. Sadakichi Hartmann, "On the Elongation of Form," *Camera Work* 10 (Apr. 1905): 34–35.

16. Hartmann, "Technique of Mystery," 26.

17. Margaret Whitford, "Pre-oedipal," in *Feminism and Psychoanalysis: A Critical Dictionary,* ed. Elizabeth Wright (Oxford: Blackwell, 1992), 345–49.

18. Julia Kristeva, "From One Identity to an Other" and "Motherhood According to Giovanni Bellini," in *Desire in Language: A Semiotic Approach to Literature and Art,* ed.

Leon S. Roudiez, trans. Thomas Gora, Alice Jardine, and Leon S. Roudiez (New York: Columbia University Press, 1980), 124–47 and 237–70.

19. Rita Felski, *The Gender of Modernity* (Cambridge, MA: Harvard University Press, 1995), 38–40, 45–46.

20. Susan Stewart, *On Longing: Narratives of the Miniature, the Gigantic, the Souvenir, the Collection* (Baltimore: Johns Hopkins University Press, 1984), 23.

21. De Casseres, "Art," 34.

22. On Käsebier's fame before 1902, see, for example, Sadakichi Hartmann, "Gertrude Käsebier," *Photographic Times* (May 1900): 195–99; Charles H. Caffin, "Mrs. Käsebier and the Artistic-Commercial Portrait," *Everybody's Magazine* 4 (May 1901): 480–95; and Frances Benjamin Johnston, "The Foremost Women Photographers of America: The Work of Mrs. Gertrude Käsebier," *Ladies' Home Journal* 18 (May 1901): 1. Barbara L. Michaels, *Gertrude Käsebier: The Photographer and Her Photographs* (New York: Abrams, 1992), 88, 173 n. 8, and *Gertrude Käsebier: Her Photographic Career, 1894–1929* (Ann Arbor, MI: University Microfilms, 1985), 100–102, establish that the claims of Stieglitz's desire to award the first number of *Camera Work* to F. Holland Day are based on a misunderstanding of the correspondence between Stieglitz and Day. Steichen recounted the politics of the first issue of *Camera Work* in "Interview with Col. Edward J. Steichen," folder F24, in "Mina Turner's Biographical Notes on Gertrude Käsebier from Interviews," Gertrude Käsebier Papers, MS collection no. 149, University of Delaware Library.

23. Keller, "Myth of Art Photography," 249–75.

24. Alfred Stieglitz, "Our Illustrations," *Camera Notes* 3 (July 1899): 24.

25. Michaels, *Gertrude Käsebier: The Photographer*, 67 and 87.

26. Carroll Smith-Rosenberg, *Disorderly Conduct: Visions of Gender in Victorian America* (New York: Knopf, 1985), 245.

27. Michaels, *Gertrude Käsebier: The Photographer*, 13, details Käsebier's childhood. After the move to Brooklyn, Käsebier's father made a living as a mineral processor and refiner, while her mother supplemented their income by taking in boarders.

28. Smith-Rosenberg, *Disorderly Conduct*, 53–76 and 245–57; on 281, she cites statistics that suggest how from 1889 to 1908 a majority of college-educated women were refusing to marry and electing graduate school. See also Nancy Sahli, "Loving Relationships among Women," in *Major Problems in American Women's History*, ed. Mary Beth Norton (Lexington, MA: Heath, 1989), 243–48.

29. Michaels, *Gertrude Käsebier: The Photographer*, 14 and 17.

30. Eileen Boris, *Art and Labor: Ruskin, Morris, and the Craftsman Ideal in America* (Philadelphia: Temple University Press, 1986), 95, 100.

31. On the progressive belief in reforming the social environment through aesthetics and the education of children, see Pyne, *Art and the Higher Life*, 38–47. Michaels, *Gertrude Käsebier: The Photographer*, 17, comments on the pervasive Froebelian culture at Pratt.

32. Rosemary O'Day, "Women and Education in Nineteenth-Century England," in *Women, Scholarship and Criticism: Gender and Knowledge c. 1790–1900*, ed. Joan Bellamy, Anne Laurence, and Gill Perry (Manchester: Manchester University Press, 2000), 96–100, addresses Froebel's impact on England; for the Froebelian culture of Pratt, see Elizabeth Harrison, "Spiritual Motherhood," *Pratt Institute Monthly* 4 (Nov. 1895): 76–79, and "The Growth of the Kindergarten Movement," *Pratt Institute Monthly* 4 (Nov. 1895): 61–75. The quotation is from "Spiritual Motherhood," 77.

33. C. Jane Gover, *The Positive Image: Women Photographers in Turn of the Century America* (Albany: State University of New York Press, 1988), 10, 29–33, 69.

34. Ibid., 34–35; Lily Norton, "Department of Commerce: Business Principles for Women," *Pratt Institute Monthly* 2 (Apr. 1894): 261.

35. Gover, *Positive Image*, 22–23, 78–82; F. Holland Day, "Art and the Camera," *Camera Notes* 1 (Oct. 1897): 22.

36. At the Philadelphia exhibition she had the maximum number of works accepted, the same number, in fact, as Stieglitz, who was a juror there; see Michaels, *Gertrude Käsebier: The Photographer*, 18–28, 48–49.

37. Sarah Kofman, *On Freud and Women*, discusses Freud's dyad of feminine narcissism and maternity; maternity, which involves a libidinal investment outside the self, is the only correct and moral feminine identity in the framework of Freud's bourgeois social structure.

38. Michaels, *Gertrude Käsebier: The Photographer*, 49, 51, identifies this image as a painting by the English Arts and Crafts artist Selwyn Image; the picture was hanging in the home of Agnes Rand Lee, the model for the picture.

39. Giles Edgerton [Mary Fanton Roberts], "Photography as an Emotional Art," *Craftsman* 12 (Apr. 1907): 92, also terms the image "a picture of great beauty and peace achieved in a chance moment as a 'study in white.'"

40. Michaels, *Gertrude Käsebier: The Photographer*, 51, suggests that Käsebier imagines a "Lamentation scene" here; Edgerton, "Photography," 92, refers to the woman in this photograph as the "ghost of radiant motherhood." Michaels, *Gertrude Käsebier: Her Photographic Career*, 244–49, 268–70, discusses the themes of motherhood and childhood independence and recounts the story of the Lee family.

41. Crane's essay, "The Progress of Taste in Dress in Relation to Art Education," was

published in *Aglaia* (1894) and reprinted in Walter Crane, *Ideals in Art* (London: George Bell and Sons, 1905). See Isobel Spencer, *Walter Crane* (London: Studio Vista, 1975), 168.

42. The most thorough description of Käsebier's printing methods and materials is in Debra Hess Norris, "Appendix III: Käsebier's Printing Methods," in *A Pictorial Heritage: The Photographs of Gertrude Käsebier* by William Innes Homer (Newark: Delaware Art Museum, 1979), 33–35.

43. *The Manger* and *Blessed Art Thou* were published in *Camera Notes* in July 1900 and in *Camera Work* in the first issue of 1903. *Adoration* appeared in *Camera Notes* in July 1899, and *The Picture-Book* followed in *Camera Work* in 1905.

44. For the etchings in drypoint, some with color and aquatint, shown in New York in 1895, see Adelyn Dohme Breeskin, *Mary Cassatt: A Catalogue Raisonné of the Graphic Work* (Washington, DC: Smithsonian Institution Press, 1979), nos. 127–159. *Peasant Mother and Child*, ca. 1894, is no. 159, which was in the 1895 New York exhibition; see also nos. 128, 134, 136, 139, 142–149, 150, and 156, in which the heads and bodies of the two figures merge and/or the child stands on the mother's lap.

45. Child R. Bayley, "Things Photographic in the United States of America: Mrs. Käsebier," *Photography* 15 (Jan. 17, 1903): 63.

46. See Arthur Wesley Dow, "Mrs. Gertrude Käsebier's Portrait Photographs," *Camera Notes* 3 (July 1899): 22–23; Caffin, "Mrs. Käsebier"; Eva Lawrence Watson, "Gertrude Käsebier," *American Amateur Photographer* 12 (May 1900): 219–20; and Johnston, "Foremost Women Photographers," 1.

47. Joseph T. Keiley, "Mrs. Käsebier's Prints," *Camera Notes* 3 (July 1899): 34; Charles H. Caffin, "Mrs. Käsebier's Work: An Appreciation," *Camera Work* 1 (Jan. 1903): 17–19; Spencer B. Hord [Chippendale], "Gertrude Käsebier, Maker of Photographs," *Bulletin of Photography*, June 8, 1910, 363–67, and "The Pictures in This Number," *Camera Work* 1 (Jan. 1903): 63; R. A. Cram, "Mrs. Käsebier's Work," *Photo-Era* 4 (May 1900): 131–36, and "Gertrude Käsebier at the Photo-Secession," *Photo-Era* 16 (Mar. 1906): 215.

48. Stieglitz, "Our Illustrations," 24; Sadakichi Hartmann, "Portrait Painting and Portrait Photography," *Camera Notes* 3 (July 1899): 13–19; Caffin, "Mrs. Käsebier's Work"; and Joseph T. Keiley, "Gertrude Käsebier," *Photography*, Mar. 19, 1904, 223–27, 237.

49. For an example of the reframing of Rodin as an innocent, see Agnes Ernst Meyer, "Some Recollections of Rodin," *Camera Work* 34–35 (Apr.–July 1911): 15–18. Michaels, *Gertrude Käsebier: The Photographer*, 107, compares the Rodin portrait and *Blessed Art Thou* as white-on-white compositions.

50. Michaels, *Gertrude Käsebier: The Photographer*, 96.

51. See "Persons Who Interest Us," *Harper's Bazaar*, April 14, 1900, 330, and Zitkala-Sa, *American Indian Stories* (Washington, DC: Hayworth, 1921).

52. On the Indian series, see Michaels, *Gertrude Käsebier: The Photographer*, 29–44; Elizabeth West Hutchinson, "Progressive Primitivism: Race, Gender, and Turn-of-the-Century American Art" (PhD diss., Stanford University, 1998), chap. 3, "The Indians in Käsebier's Studio: Race and Gender and the Modern Artist"; "Some Indian Portraits," *Everybody's Magazine* 4 (Jan. 1901): 2–24; and Rayna Green, "Gertrude Käsebier's 'Indian' Photographs: More Than Meets the Eye," *History of Photography* 24 (Spring 2000): 58–60.

53. On the verso of *The Bat*, in the Stieglitz collection at the Metropolitan Museum of Art, is written in Stieglitz's hand: "White claims that he and Mrs. K. did this together. / That it was his idea. That Mrs. White is the model: / Photographed on Mrs. K's visit to Newark, Ohio / A.S." See Weston J. Naef, *The Collection of Alfred Stieglitz: Fifty Pioneers of Modern Photography* (New York: Metropolitan Museum of Art; Viking Press, 1979), 391, no. 356. The image resembles an earlier White nude that had been published in *Camera Notes* in 1901; see *Camera Notes* 5 (Oct. 1901): 117.

54. In 1905 Stieglitz included *The Bat* in an exhibition of the Photo-Secession at the Little Galleries, and in 1910 at the Albright Art Gallery; it was also exhibited in Leeds (1902), Hamburg (1903), and Dresden (1904); see Naef, *Collection of Alfred Stieglitz*, 391, no. 356.

55. Stieglitz affixed to a posterboard an enormous sheet from a newspaper report of the trial, illustrated with Käsebier's portrait of Nesbit; see the Stieglitz Scrapbooks, Alfred Stieglitz Papers, Yale Collection of American Literature, Beinecke Rare Book and Manuscript Library, Yale University (hereafter YCAL).

56. Frank Crowninshield, "An Elegante of Another Era," in *Appreciations of Rita de Acosta Lydig*, exhibition catalog, Museum of Costume Art, International Building, Rockefeller Center, New York (Mar. 12, 1940), n.p.; quoted in Michaels, *Gertrude Käsebier: The Photographer*, 114.

57. Michaels, *Gertrude Käsebier: The Photographer*, 97.

58. Candace Wheeler, "Art Education for Women," *Outlook* 55 (Jan. 2, 1897): 81–87; Boris, *Art and Labor*, 124–26, has documented this same economic development among the women of Arts and Crafts guilds in the Northeast.

59. Keller, "Myth of Art Photography," 249–75.

60. See ibid. For examples of Stieglitz's indifference to certain photographers' economic plight and to responsible business practices, see Eva Watson-Schutze's

letters to Stieglitz, Alfred Stieglitz Papers, YCAL MS 85, box 43, folder 1036, Nov. 1904 through May 1905, in which she angrily asks for an accounting of the money owed her for photographs sold.

61. On Rose O'Neill, see Michaels, *Gertrude Käsebier: The Photographer*, 118.

62. See the descriptions of Käsebier provided by her studio assistants and her grand-daughter (Mina Turner) in interviews with Sam Lifshey, Mrs. Henry Clifton, [Adele Miller], and Harriet Hibbard, folders F25, F26, and F27 in "Mina Turner's Biographical Notes on Gertrude Käsebier from Interviews," and "Mina Turner's Proposed Outline of a Biography of Gertrude Käsebier," folder F29, in the Gertrude Käsebier Papers, MS collection no. 149, University of Delaware Library.

63. For biographical treatments of Smith, see Melinda Boyd Parsons, "Pamela Colman Smith," in Dictionary of Women Artists, ed. Delia Gaze (Chicago: Fitzroy Dearborn, 1997), 2:1289–92; and Stuart Kaplan, "Pamela Colman Smith: The Rider-Waite Tarot Artist," in *The Encyclopedia of Tarot*, ed. Stuart Kaplan (Stanford, CA: U.S. Game Systems, 1990), 3:1–45; see also Melinda Boyd Parsons, *To All Believers: The Art of Pamela Colman Smith* (Wilmington: Delaware Art Museum, 1975); and Mary K. Greer, *Women of the Golden Dawn: Rebels and Priestesses* (Rochester, VT: Park Street Press, 1995). A January 3, 2006, e-mail from Melinda Parsons to the author clarified Smith's chronology further.

64. Kaplan, "Pamela Colman Smith," 1–9. Smith published "Two Negro Stories from Jamaica," Journal of American Folklore 35 (Oct.–Dec. 1896): 278, and illustrated *Annancy Stories* (New York, 1899), a group of twenty-two folktales that she also transcribed. On the Golden Dawn, see Parsons, "Pamela Colman Smith"; Kaplan, "Pamela Coleman Smith"; and Greer, *Women of the Golden Dawn*.

65. Contemporary writers noted Smith's sources in Crane and compared her visionary qualities to Blake's; see M. Irwin Macdonald, "The Fairy Faith and Pictured Music of Pamela Colman Smith," Craftsman 23 (1912): 20–34; Kaplan also comments that Smith and her father amassed a large collection of Japanese prints while she was at Pratt. Parsons, "Pamela Colman Smith," 1290–91, relates her style to Dow's teaching at Pratt and mentions Smith's later collaboration with Crane.

66. Smith later described the origin of this process of sketching, dating from around 1900, to an interviewer; see the Hon. Mrs. Forbes-Sempill and Pamela Colman Smith, "Music Made Visible," Illustrated London News 170 (Feb. 1927): 258–60. See letters to Stieglitz dated November 8, 1907, and February 21, 1908, and "List of Drawings and Prices" in "Correspondence with Pamela Colman Smith, 1907–1909," Alfred Stieglitz Papers, YCAL MS 85, box 45, folder 1076.

67. Pamela Colman Smith, "Music Pictures," holograph MS, Alfred Stieglitz Papers, YCAL MS 85, box 45, folder 1076.

68. Arthur Ransome, *Bohemia in London* (New York: Dodd, Mead, 1907), 56–65; Dorothy Norman, "Writings and Conversations of Alfred Stieglitz," *Twice a Year: A Semi-Annual Journal of Literature, the Arts, and Civil Liberties*, no. 1 (Fall/Winter 1938): 82; Greer, *Women of the Golden Dawn*, 406. Smith's earlier Pre-Raphaelite style is also recorded in a portrait by Alphaeus Cole (1906) that is based on an earlier sketch (1903). The portrait is illustrated in Parsons, *To All Believers*, n.p.

69. James Huneker, *New York Sun*, Jan. 15, 1907, reprinted in "The Editors' Page," *Camera Work* 18 (Apr. 1907): 37–38.

70. Benjamin de Casseres, "Pamela Colman Smith," *Camera Work* 27 (July 1909): 18–20.

71. Macdonald, "Fairy Faith," 22, 27, 32. Kaplan, "Pamela Colman Smith," relates that in about 1899 Terry named Smith "Pixie" (5); he quotes John Butler Yeats, father of W. B. Yeats, who met her in England in 1899 and was mystified by her appearance as to her origins and age (8); and he comments on how her strange appearance possibly prevented her from achieving economic success in the art market (40). For another invocation of the child figure to signify the presence of artistic greatness and explicate the logic of Smith's work, see Macdonald, "Fairy Faith," 27. For illustrations of Smith's miniature theater sets, see I. C. Haskell, "The Decorative Work of Miss Pamela Colman Smith," *Pratt Institute Monthly* 6 (Dec. 1897): 65–67, and Gardner Teall, "Cleverness, Art, and an Artist," *Brush and Pencil* 6 (1900): 135–41.

72. Robert Demachy, "Mme. Käsebier et son oeuvre," *La Revue de Photographie* (July 15, 1906): 292, describes the woman in this image as "déjà vacillante sous l'étourdissement proche."

73. Demachy, "Mme. Käsebier," 293–94, comments that in Käsebier, "nous la comprenons mystique, presque voyante, accomplissant les gestes de son art avec la conviction et le respect d'un sacerdoce"; "Je sais reconnaître les fiancés, je me sens en communion avec la mère dans l'adoration de son enfant, je devine le passé du vieillard et l'ambition du jeune homme, je comprends le muet regard, quêteur d'indulgence, de la femme laide"; and "La fatigue de celui-ci est égale à la mienne et que c'est là le facteur psychologique qui communiquera la vie au portrait et vous fera pour ainsi dire *lire entre les lignes*."

74. Ibid., 295: "Mme. Käsebier a raison quand elle affirme que pour créer une image vivante il faut qu'il y ait dans l'air, au moment de sa conception, émission de vibrations émotionnelles."

75. "Interview with Mrs. Henry Clifton [Adele Miller]," folder F27, in "Mina Turner's Biographical Notes on Gertrude Käsebier from Interviews," Gertrude Käsebier Papers, MS collection no. 149, University of Delaware Library.

76. Sarah Greenough, "Alfred Stieglitz, Rebellious Midwife to a Thousand Ideas," in Sarah Greenough et al., *Modern Art and America: Alfred Stieglitz and His New York Galleries* (Washington, DC: National Gallery of Art, 2001), 22–53. The essays on Steichen, Rodin, Matisse, and Picasso following Greenough's in the same volume make clear the importance of the female nude in the modernism with which Stieglitz identified 291 in these years. For a complete inventory of the articles and illustrations published in *Camera Work* and the exhibitions mounted at 291, see Sue Davidson Lowe, *Stieglitz: A Memoir/Biography* (New York: Farrar, Straus and Giroux, 1983), Appendices I and II, 423–37.

77. Greer, *Women of the Golden Dawn*, 409.

78. Joseph T. Keiley, "The Buffalo Exhibition," *Camera Work* 33 (Jan. 1911): 27, used Stieglitz's work as a direct rebuke to Käsebier, citing Stieglitz's "masterly technique," a sensitiveness that was "symphonic and aggressive, but . . . sure of touch and fertile of fancy."

79. Caffin's attack parodied an article praising Käsebier as a great artist who operated out of feminine experience, intuition, and sympathy with the sitter. See Giles Edgerton [Mary Fanton Roberts], "Photography as an Emotional Art," 80–93; and for Caffin's parodic response, Charles H. Caffin, "Emotional Art (after Reading the 'Craftsman,' April, 1907)," *Camera Work* 20 (Oct. 1907): 32–34. On Stieglitz's complaints against the Photo-Secession, see, for example, Lowe, *Stieglitz*, 132–33; Edward Abrahams, *The Lyrical Left: Randolph Bourne, Alfred Stieglitz, and the Origins of Cultural Radicalism in America* (Charlottesville: University of Virginia Press, 1986), 1–20; Whelan, *Alfred Stieglitz*, 217–25, 288–92; and Michaels, *Gertrude Käsebier: The Photographer*, 120–29, 136–38.

80. Michaels, *Gertrude Käsebier: The Photographer*, 127–38, 156, details how Käsebier went on with her portrait photography until shortly before her death; Peterson, *After the Photo-Secession*, 16–17.

The Speaking Body and the Feminine Voice

1. Weston J. Naef, *The Collection of Alfred Stieglitz: Fifty Pioneers of Modern Photography* (New York: Metropolitan Museum of Art; Viking Press, 1975), especially chap. 5, "Newcomers to the Circle." On Coburn, see William Innes Homer, *Alfred Stieglitz and the Photo-Secession* (Boston: Little, Brown, 1983), 101–10.

2. Anne Brigman, "Awareness," *Design for Arts in Education* 38 (June 1936): 17–18. For biographical treatments of Brigman, see Therese Thau Heyman, *Anne Brigman: Pictorial Photographer/Pagan/Member of the Photo-Secession* (Oakland, CA: Oakland Museum, 1974), 1; and Susan Ehrens, *A Poetic Vision: The Photographs of Anne Brigman* (Santa Barbara, CA: Santa Barbara Museum of Art, 1995), 19.

3. Anne Brigman, foreword to *"Songs of a Pagan"* (unpublished), dated July 30, 1939, p. 1, Alfred Stieglitz Papers, Yale Collection of American Literature MS 85, box 8, folder 173, Beinecke Rare Book and Manuscript Library (hereafter YCAL).

4. Brigman, foreword, 1; and Heyman, *Anne Brigman*, 2.

5. Ehrens, *Poetic Vision*, 20; for newspaper reports on Brigman's theatrical activities, see the following articles in the *San Francisco Call*: "To Present Two Original Plays," Mar. 4, 1908, which details her part in Charles Keeler's "Will o' the Wisp"; "Photo Men Ask Woman to Exhibit," Mar. 6, 1908, which comments on her "marked histrionic talent"; and "Wins Gold Medal for Lens Studies," Nov. 11, 1909, which reports on her recent interpretive reading of *Enoch Arden*, to the accompaniment of a pianist. For another example of a similar utopian project at the artists' colony of Cornish, New Hampshire, see Kathleen Pyne, *Art and the Higher Life: Painting and Evolutionary Thought in Late Nineteenth-Century America* (Austin: University of Texas Press, 1996), chap. 4.

6. Anne Brigman to Alfred Stieglitz, Jan. 9, 1903, Alfred Stieglitz Papers, YCAL. (Hereafter I use the correspondents' initials, AB and AS, in citations of their letters.) Michael G. Wilson, "Northern California: The Heart of the Storm," in *Pictorialism in California: Photographs 1900–1940* (Malibu, CA: J. Paul Getty Museum and Henry E. Huntington Library and Art Gallery, 1994), 1–22, discusses the relationship between the California and New York camera clubs and notes that although several California photographers had some nominal, brief connection with the Photo-Secession, Stieglitz elevated Brigman alone to the rank of fellow (in 1906) and gave her his full support.

7. AS to AB, June 24, 1914, Alfred Stieglitz Papers, YCAL.

8. AB to AS, Feb. 17, 1904, Alfred Stieglitz Papers, YCAL.

9. Brigman, "Awareness," 17.

10. AB to AS, undated, probably end of Sept. or early Oct. 1906; the date 1905, suggested by the Beinecke, is unlikely, since Brigman placed her first trip to the High Sierra in 1906, soon after the earthquake; see Brigman, foreword, 1.

11. Brigman, "Awareness," 18, and foreword, 1–2.

12. Brigman, foreword, 1–2.

13. Maurice Maeterlinck, "On Women," excerpted from *The Treasure of the Humble* (New York: Dodd, Mead, 1897), in *The Woman Question by Ellen Key, Dickinson, and Others,*

comp. and ed. T. R. Smith (New York: Boni and Liveright, 1918), 165–72. Steichen, who photographed Maeterlinck in these years, also persuaded the poet to write an essay endorsing the medium of photography as the art of the future; it was published in *Camera Work* 2 (Apr. 1903) as a supplement to that issue, which was devoted to the work of Steichen. See Joel Smith, *Edward Steichen: The Early Years* (Princeton: Princeton University Press; New York: Metropolitan Museum of Art, 1999), 16–17, 26 n. 42, on Steichen's reverence for Maeterlinck's writings.

14. Just as he identified with Maeterlinck's worship of feminine mystery, Steichen found a language of feminine muteness he relished in Whistler's intimate nudes executed in oil, pastel, and watercolor. See Smith, *Edward Steichen*, 23 and 26.

15. Sarah Greenough, "Alfred Stieglitz, Rebellious Midwife to a Thousand Ideas," in Sarah Greenough et al., *Modern Art and America: Alfred Stieglitz and His New York Galleries* (Washington, DC: National Gallery of Art; Boston: Bulfinch Press, 2000), 31, comments on the prevalence of the modernist nude at 291 from 1908 to 1912.

16. On the exhibition of Rodin's drawings in Europe and at 291, see Anne McCauley, "Auguste Rodin, 1908 and 1910: 'The Eternal Feminine,'" in Greenough et al., *Modern Art and America*, 71–81.

17. In the gallery notes for Rodin's first 291 exhibition in 1908, Stieglitz's only reason to publish Arthur Symons's essay on Rodin's drawings would have been to magnify the public's shock, for Symons's prose brings Rodin's nudes to life as a rapacious feminine sexuality in motion—woman, the animal, in the mystery of her flesh, a "monstrous" and "devastating machine," registering a "spawning entanglement of animal life." See "Rodin Drawings at the Photo-Secession Galleries," *Camera Work* 22 (Apr. 1908): 35–40, which reprints Symons's essay from Arthur Symons, *Studies in Seven Arts* (New York: Dutton, 1906), 19, as well as reviews by J. N. Laurvik from the *New York Times*, Charles de Kay from the *New York Evening Post*, and W. B. McCormick from the *New York Press*, who either followed Symons's lead or dismissed the drawings as merely technical studies, not for public display.

18. The practice of veiling, which denies corporeality, only to establish the body as an eroticized object, exemplifies Stieglitz's strategy, endorsed through the critical machinery of *Camera Work*, to defend Rodin's "pagan ecstasy" as the essential creative spirit behind all forms of high art. See Benjamin de Casseres, "Rodin and the Eternality of the Pagan Soul," *Camera Work* 34–35 (Apr.–July 1911): 13–14, defends Rodin and Matisse, claiming that they are descendants of Phidias and Leonardo and belong in the league of such pioneering geniuses as Whitman, Wagner, and Richard Strauss. In the same 1911 issue of *Camera Work*, Agnes Meyer similarly tries to reconfigure Rodin's scandalous image as a sensualist into the sympathetic picture

of a sweet child and an antimaterialist who seeks the spiritual side of things, or alternatively, a martyr at the hands of the Academy; Agnes Ernst Meyer, "Some Recollections of Rodin," *Camera Work* 34–35 (Apr.–July 1911): 15–19.

19. Hutchins Hapgood, *A Victorian in the Modern World* (New York: Harcourt, Brace, 1939), 152; Lois Rudnick, "The New Woman," in *1915: The Cultural Moment, the New Politics, the New Woman, the New Psychology, the New Art, and the New Theatre in America*, ed. Adele Heller and Lois Rudnick (New Brunswick, NJ: Rutgers University Press, 1991), 69–78, cites Hapgood and treats this paradigm of female sexuality as primary to modernism in Manhattan. On this issue, see also Michael S. Kimmel, "The Contemporary 'Crisis' of Masculinity in Historical Perspective," in *The Making of Masculinities*, ed. Harry Brod (Boston: Allen and Unwin, 1989), 121–53.

20. "Works of Nature and Works of Art, Blended in the California Camera Studies of Anne Brigman," *Vanity Fair* 6 (June 1916): 50–52; the author of the article, possibly the editor Frank Crowninshield, presents a perspective on Brigman that could have been gained only from Stieglitz, who lent the magazine the prints of Brigman's photographs for publication.

21. AB to AS, Feb. 19, 1907, Alfred Stieglitz Papers, YCAL.

22. J. Nilsen Laurvik, "Mrs. Annie W. Brigman—A Comment," *Camera Work* 25 (Jan. 1909): 47. On Stieglitz's statement that Brigman was one of the few photographers who counted, an assessment he made after his association with the Photo-Secessionists had essentially ended, see "Works of Nature," 51, where Stieglitz is the unidentified source of the statement there; and AB to AS, Jan. 18, 1914, and AS to AB, June 24, 1914, Alfred Stieglitz Papers, YCAL. Brigman's work was featured in nos. 25, 38, and 44 of *Camera Work.*

23. J. Nilsen Laurvik, "International Photography at the National Arts Club, New York," *Camera Work* 26 (Apr. 1909): 39 and 41. Brigman later commented that she seemed to have "inherited Mrs. Kasebier's halo!" See AB to AS, July 16, 1914, Alfred Stieglitz Papers, YCAL.

24. Joseph T. Keiley, "The Buffalo Exhibition," *Camera Work* 33 (Jan. 1911): 27, praised Brigman for transcending the individual self to find something larger in nature reminiscent of Ovid and Shakespeare.

25. On the Spencerian narrative of evolution as represented in the painted female figure of the 1890s, see Pyne, *Art and the Higher Life*, especially chap. 4; and Martha Banta, *Imaging American Women: Ideas and Ideals in Cultural History* (New York: Columbia University Press, 1987).

26. See Carroll Smith-Rosenberg, *Disorderly Conduct: Visions of Gender in Victorian America* (New York: Knopf, 1985), 261 and 268, on the way in which female sexuality was deployed as a metaphor for political vision.

27. The generational differences between women (as mothers and daughters, or first- and second-generation "new women") who refused men's sexual hegemony or embraced and used it for their own advancement are described by Smith-Rosenberg, *Disorderly Conduct*, 245–96; Ann Douglas, *Terrible Honesty: Mongrel Manhattan in the 1920s* (New York: Farrar, Straus and Giroux, 1995), 7 and 217–53; and Christine Stansell, *American Moderns: Bohemian New York and the Creation of a New Century* (New York: Metropolitan Books, 2001), 247–52.

28. Richard Whelan, *Alfred Stieglitz: A Biography* (New York: Little, Brown, 1995), 264; and Sue Davison Lowe, *Stieglitz: A Memoir/Biography* (New York: Farrar, Straus and Giroux, 1983), 78–79. Benita Eisler, *O'Keeffe and Stieglitz: An American Romance* (New York: Doubleday, 1991), 191, suggests that the ninety thousand photographs of actresses that Stieglitz had collected as a student in Germany of "actresses" were erotic and pornographic. Greenough, "Alfred Stieglitz," and McCauley, "Auguste Rodin," also briefly comment on Stieglitz's interest in the writings of the sexologists and Freud at the end of the first decade of the twentieth century. It is moreover evident from Stieglitz's correspondence and the Stieglitz and O'Keeffe library, contained in the Book Room of O'Keeffe's Abiquiu house and the library at Ghost Ranch, that Stieglitz in his lifetime owned at least three complete sets of Ellis's *Studies* and numerous other works by Ellis.

29. On the conservative politics of the sexologists, see Smith-Rosenberg, *Disorderly Conduct*, 268–80. Havelock Ellis, *Studies in the Psychology of Sex*, vol. 3, *Analysis of the Sexual Impulse, Love and Pain, the Sexual Impulse in Women* (F. A. Davis, 1927), 253.

30. Marcia Brennan, *Painting Gender, Constructing Theory: The Alfred Stieglitz Circle and American Formalist Aesthetics* (Cambridge: MIT Press, 2001), 105, 301 n. 34, cites Stieglitz's letter to Ellis's American publisher, F. A. Davis of Philadelphia, dated Oct. 17, 1911.

31. AB to AS, Mar. 27, 1906; Feb. 19, 1907; Mar. 3, 1907; Mar. 7, 1909; Nov. 1, 1909, Alfred Stieglitz Papers, YCAL.

32. On Steichen's response to the Armory Show, see Penelope Niven, *Steichen: A Biography* (New York: Clarkson Potter, 1997), 374–76, who cites Steichen's letter to Stieglitz, late Mar. 1913, Alfred Stieglitz Papers, YCAL. For a brief time after this, Steichen experimented with a semi-Cubist idiom but then abandoned it and painting altogether.

33. AB to AS, Apr. 11, 1910, Alfred Stieglitz Papers, YCAL.

34. AB to AS, Mar. 21, 1911, and Apr. 26, 1911, Alfred Stieglitz Papers, YCAL, described the conflict brewing within the Stieglitz circle as Brigman had experienced it the preceding summer, White's unhappiness and rude treatment of her, and the mood of "survival of the fittest in Clarence White's classes or the survival of the fighter."

35. AB to AS, Mar. 21, 1911, Alfred Stieglitz Papers, YCAL.

36. AB to AS, Apr. 26, 1911, and Nov. 22, 1911, Alfred Stieglitz Papers, YCAL.

37. See AB to AS, July 24, 1912, and Mar. 21, 1913, Alfred Stieglitz Papers, YCAL. Edward Carpenter, *The Drama of Love and Death: A Study of Human Evolution and Transfiguration* (London: George Allen, 1912), 24–47.

38. See AB to AS, Mar. 21, 1913, Alfred Stieglitz Papers, YCAL.

39. "Works of Nature," 51.

40. See Laurvik, "Mrs. Annie W. Brigman," 47, "International Photography," 41, and "The Exhibition at the Albright Gallery: Some Facts, Figures, and Notes," *Camera Work* 33 (Jan. 1911): 65. See also "Works of Nature," 51.

41. See Frank Kermode, *The Romantic Image* (New York: Macmillan, 1957), 50–79, who discusses the Symbolist writers' use of the dancer's body as a metaphor for the ideal work of art. Mike Weaver, "Alfred Stieglitz and Ernest Bloch: Art and Hypnosis," *History of Photography* 20 (Winter 1996): 293–303, relates the performances of such "magnetized" (hypnotized) dancers as Mme Magdeleine G to Stieglitz's interest in the life of the unconscious. Émile Magnin of the École de Magnétisme in Paris practiced a mesmeric influence on his female subject that he termed "*magnetism.*"

42. Elizabeth Francis, "From Event to Monument: Modernism, Feminism, and Isadora Duncan," *American Studies* 35 (Spring 1994): 25–45.

43. Fredrika Blair, *Isadora: Portrait of the Artist as a Woman* (New York: McGraw-Hill, 1986); and Lillian Loewenthal, *The Search for Isadora: The Legend and Legacy of Isadora Duncan* (Pennington, NJ: Princeton Book Company; Dance Horizons Book, 1993).

44. John Sloan, quoted in Loewenthal, *Search for Isadora*, 10.

45. Francis, "From Event to Monument," 30. Duncan's study of Greek Tanagra figurines and Botticelli's *Primavera* contributed to her idea of dance as natural movement. On the modernist typology of the feminine as a premodern space in the texts of sociologists and anthropologists, see Rita Felski, *The Gender of Modernity* (Cambridge, MA: Harvard University Press, 1995), 35–60.

46. See Duncan's lecture on dance, "The Dance of the Future," given in Berlin in 1903, later published as a pamphlet and then reprinted in Isadora Duncan, *The Art of the Dance*, ed. Sheldon Cheney (New York: Theatre Arts, 1928), 54–64; excerpted in Blair, *Isadora*, 67–68.

47. Loewenthal, *Search for Isadora*, 6–14; on Walkowitz's drawings of Duncan, see Kent Smith, *Abraham Walkowitz: Figuration, 1895–1945* (Long Beach, CA: Long Beach Museum of Art, 1982), 15–17; Abraham Walkowitz, *Isadora Duncan in Her Dances* (Girard, KS: Halbeman-Julius Publications, 1945).

48. Charles H. Caffin, "Henri Matisse and Isadora Duncan," *Camera Work* 25 (Jan. 1909): 19–20. Blair, *Isadora*, 42–49, 107, 117–18, 182–93, relates that in Moscow and St. Petersburg a few years earlier, critics treated Duncan's dance similarly, as visual music, her body registering a purity and incorporeality, or a "spiritual corporeality"—a state as spiritual as sound.

49. Francis, "From Event to Monument," 34.

50. Niven, *Steichen*, 316–18. Duncan later, in the early 1920s, invited Steichen to photograph her and her dancers in Greece.

51. Caffin, "Henri Matisse," 17–20; on Stieglitz's continuing consciousness of Duncan's contribution to modern art, see Lowe, *Stieglitz*, 131.

52. Bennard B. Perlman, *The Lives, Loves, and Art of Arthur B. Davies* (Albany: State University of New York Press, 1998), 172–73, 226, 233.

53. Francis, "From Event to Monument," 33, cites Duncan's 1903 lecture, "The Dance of the Future," in Duncan, *Art of the Dance*, 62–63.

54. Francis, "From Event to Monument," 43–44 n. 11, refers to the autobiographies of Duncan, Mabel Dodge Luhan, Joseph Freeman, Floyd Dell, and Margaret Anderson.

55. AB to AS, Feb. 17, 1904, Alfred Stieglitz Papers, YCAL.

56. Of these early works, *Mother* is illustrated in Fayette J. Clute, "The Western Workers in the United States," *Photograms of the Year* (London: Iliffe and Sons, 1904), 166, and may well be a composition she sent to Stieglitz she called *The Madonna of the Peach Tree*. *The Little Virgin* is illustrated in Emily J. Hamilton, "Some Symbolic Nature Studies from the Camera of Annie W. Brigman," *Craftsman* 12 (Sept. 1907): 662.

57. She continued: "The few figures I have used through the years of the mountain series were slim, hearty, unaffected women of early maturity, living a hardy out-of-door life in high boots and jeans, toughened to wind and sun . . . cooking for weeks over a camp-fire with wood from the forest around us . . . and carrying water from the icy lake at our feet . . . bearing and forbearing to the utmost. . . . The orthodox Judgment Day will have no more wan and weary looking faces rise from their graves to face the pale beauty of early dawn, than I, exhausted and numb and grimy with granite sand, have seen, as my companions in misery lifted on unsteady elbows, to stare with heavy, half-seeing eyes, into the wonder of distances far below and away to the rim of the world . . . gray . . . cold . . . silent . . . with a great star pulsing a melody above the coming day." See Brigman, foreword, 2.

58. Ibid., 3.

59. In 1908, for example, she had written, "Though I use Sierra trees and crags and thunderstorms, they, the negatives, are not records of the topography of that country; they might be anywhere in the wild world. They hold, in pictorial form, stories of the deep emotions and struggles or joys of the human soul." See Annie W. Brigman, "Just a Word," *Camera Craft* 15 (Mar. 1908): 88. Hamilton, "Some Symbolic Nature Studies," 660, similarly interpreted Brigman's nudes as conveying "a vivid understanding of the emotional possibilities of life . . . all that . . . [Brigman] had learned in living. . . . The human figure is used to aid her in making clear all that she feels and sees in nature."

60. AB to AS, Nov. 22 [1911]; June 18, 1912; July 24, 1912; and Dec. 21, 1912, Alfred Stieglitz Papers, YCAL.

61. "Fear Retards Woman, Avers Mrs. Brigman," *San Francisco Call*, June 8, 1913.

62. "Works of Nature," 50–52.

63. AB to AS, Nov. 22 [1911], Alfred Stieglitz Papers, YCAL.

64. Ellen Key, *Love and Marriage*, trans. Arthur G. Chater (New York: G. P. Putnam; Knickerbocker Press, 1911).

65. Floyd Dell, *Women as World Builders: Studies in Modern Feminism* (Chicago: Forbes, 1913; reprint, Westport, CT: Hyperion Press, 1976), 76–89.

66. Anne Brigman, "The Glory of the Open," *Camera Craft* 33 (Apr. 1926): 155–63. The passage quoted from an author whom Brigman cited as "S.B." stated of her photographs that "her art, and anything she pictures becomes her own by right of the infusion of her soul. Things live which were elsewise inanimate. Rocks and trees become her emotions. So too, figures become part of [her] landscape." The Whitman passage she quoted was from "Song of the Open Road" ("Afoot and light-hearted I take to the open road"). Brigman quoted a number of lines from two poems in Carpenter's *Towards Democracy* (London: George Allen and Unwin, 1883): "The Secret of Time and Satan" and "As the Greeks Dreamed." From the latter poem the following lines seem to evoke her sense of the human body's rhyming with nature: "How the human body bathed in the sheen and wet, steeped in sun and air, / Moving near and nude among the elements / Matches somehow and interprets the whole of nature. / How from shoulder to foot of mountain and man / alike the lines of grace run on."

67. Susan Stewart, *On Longing: Narratives of the Gigantic, the Miniature, and the Souvenir* (Ashville, NC: Duke University Press, 1993), 73–74, evokes the experience of the gigantic in nature.

68. See ibid., 74 and 104–16, on the miniature.

69. Ibid., 124.

70. Reviewing her work in the Jan. 1909 issue of *Camera Work*, the *British Journal of Photography* characterized Brigman's pictures as "vamped up"; see "New Books," *British Journal of Photography*, Apr. 16, 1909, 311. Regarding Brigman's self-taught technique, Hamilton, "Some Symbolic Nature Studies," 664, comments that Brigman "has had big problems to conquer."

71. For Brigman's and Stieglitz's rebuttals to the charge of "monkeying," see Brigman, "Just a Word," 87; and Alfred Stieglitz, "Our Illustrations," *Camera Work* 25 (Jan. 1909): 48.

72. AB to AS, Sept. 10, 1907, Alfred Stieglitz Papers, YCAL. At an earlier point Brigman told Stieglitz, "I don't care whether a print is straight or curved or on the bias—so long as it has a soul and is worthwhile"; see AB to AS, undated letter, probably late Sept. or early Oct. 1906, Alfred Stieglitz Papers, YCAL. I disagree here with the Beinecke's dating of the letter to 1905.

73. AB to AS, Mar. 27, 1907. On Feb. 19, 1907, Brigman discusses her problems with platinum, royal bromide, gum bichromate, and ozobrome; on Mar. 3, 1907, she asserts that she wants to make platinum prints but needs tutoring; on Mar. 7, 1909, she defends her use of ozobrome again; on Jan. 18, 1914, Alfred Stieglitz Papers, YCAL, she quotes Stieglitz's comments on her work back to him. Brigman recalls Stieglitz's assessment of her prints as "Rotten—but worth while" in "What 291 Means to Me," *Camera Work* 47 (Jan. 1915): 17–20. AS to AB, June 24, 1914, Alfred Stieglitz Papers, YCAL, asserts Brigman's position in Stieglitz's pantheon of photographers. In AS to AB, June 19, 1941, Alfred Stieglitz Papers, YCAL, Stieglitz continued to maintain that "not many of the shining lights in the photography of today really count as you do" and told Brigman that her prints in *Camera Work* represented "a landmark."

74. See the Brigman–Stieglitz correspondence, Alfred Stieglitz Papers, YCAL, particularly from 1914 to 1918.

75. On Brigman's anger over titles changed when her photographs were published under Stieglitz's management of the process, see AB to AS, Mar. 23, 1904, and Mar. 3, 1907, Alfred Stieglitz Papers, YCAL.

76. AB to AS, Apr. 24, 1907; Nov. 20, 1907, Alfred Stieglitz Papers, YCAL.

77. See, for example, AB to AS, May 24, 1908, and Jan. 18, 1914, Alfred Stieglitz Papers, YCAL.

78. Brigman also produced several book illustrations using fantastic figures of mer-women and other creatures ascending toward the heavens to suggest a theosophist evolution of a higher consciousness. For illustrations of these works, see Ehrens, *Poetic Vision*, 34, and Brigman's negatives of these illustrations at the George Eastman House.

79.	See *Imogen! Imogen Cunningham Photographs, 1910–1973* (Seattle: Henry Art Gallery; University of Washington Press, 1974); *Louise Dahl-Wolfe: A Photographer's Scrapbook* (New York: St. Martin's/Marek, 1984), 2–5; both cited also in Judith Fryer Davidov, *Women's Camera Work: Self/Body/Other in American Visual Culture* (Durham, NC: Duke University Press, 1999), 323–30, who offers a different interpretation of Brigman's photographs. Dassonville's photograph of Oliver was reproduced as the frontispiece of *Camera Craft* 46 (Nov. 1939).

80.	See AB to AS, Mar. 21, 1913, Alfred Stieglitz Papers, YCAL, for Brigman's reaction to Duchamp's *Nude Descending a Staircase*, as well as Hartley's and Marin's modernism.

81.	AB to AS, Jan. 18, 1914; and AS to AB, Oct. 29, 1915, Alfred Stieglitz Papers, YCAL.

82.	For historical accounts that differentiate first- from second-generation feminism, see Christopher Lasch, *The New Radicalism in America (1889–1963): The Intellectual as a Social Type* (New York: Knopf, 1967), 46–55; Smith-Rosenberg, *Disorderly Conduct*, 245–56, 281–89; and Douglas, *Terrible Honesty*, 239–49.

83.	AS to AB, undated, probably early 1918, Alfred Stieglitz Papers, YCAL, since Stieglitz thanks Brigman for her Christmas card and states that he is writing eight years after her 1910 trip to visit 291.

84.	AS to AB, Dec. 24, 1919, Alfred Stieglitz Papers, YCAL.

The Feminine Voice and the Woman-Child

1.	Hutchins Hapgood, *A Victorian in the Modern World* (New York: Harcourt, Brace, 1939), 152.

2.	I thank Professor Thomas Schlereth of the Department of American Studies at Notre Dame for identifying the flowers in this photograph as amaranthus or "love lies bleeding."

3.	Wassily Kandinsky, "Extracts from *The Spiritual in Art*," *Camera Work* 39 (July 1912): 34–35; Henri Bergson, "An Extract from Bergson (from *Creative Evolution*)," *Camera Work* 36 (Oct. 1911): 20–21; and "What Is the Object of Art? (from *Laughter*)," *Camera Work* 37 (Jan. 1912): 22–36.

4.	Kandinsky's volume did not appear in English translation until 1914. Stieglitz used either the translation Hartley had secured or the original, Wassily Kandinsky, *Über das Geistige in der Kunst, insbesondere in der Malerei* (Munich: R. Piper, 1911); the first English-language version was *The Art of Spiritual Harmony*, trans. Michael T. H. Sadler (1914; reprint, New York: Dover Publications, 1977); Alfred Stieglitz (hereafter AS) to Wassily Kandinsky, May 26, 1913, Alfred Stieglitz Papers, Yale Col-

lection of American Literature, Beinecke Rare Book and Manuscript Library, Yale University (hereafter YCAL).

5. Henry May, *The End of American Innocence: A Study of the First Years of Our Own Time, 1912–1917* (Chicago: Quadrangle Paperbacks, 1964), 228.

6. Tom Quirk, *Bergson and American Culture: The Worlds of Willa Cather and Wallace Stevens* (Chapel Hill: University of North Carolina Press, 1990), 42–45, 47, 50, 53, 65–67, observes that in Bergson's writing spirit "is always ascending, seeking to perpetuate its past in the future," while matter "is always descending, content to remain what it is and to drag spirit down with it. The burden of necessity is that spirit must always express and organize itself in matter and conform to physical law, but evolution is creative in that spirit asserts its rights in and through matter, always seeking simpler, more efficient means to express itself." May, *End of American Innocence*; Bergson, "What Is the Object?" 23–24.

7. Nathan G. Hale Jr., *Freud and the Americans: The Beginning of Psychoanalysis in the United States, 1876–1917* (New York: Oxford University Press, 1995), 3–13, 430–31. Freud's 1909 lectures at Clark were published in the *American Journal of Psychology* 21 (1910): 181–218. Although I am aware that Freud's ideas changed during his life, I am seeking here a glimpse of how New York modernists (e.g., Stieglitz) would have understood and appropriated Freud's writings circa 1914–15.

8. Hale, *Freud and the Americans*, 241–43. Since the initial publication of Hale's research on the American reception of Freud, other scholars have supported and elaborated on his findings; see, for example, Robert C. Fuller, *Americans and the Unconscious* (New York: Oxford University Press, 1986).

9. Havelock Ellis, *Studies in the Psychology of Sex*, 6 vols. (Philadelphia: F. A. Davis, 1906); Hale, *Freud and the Americans*, 259–67 (the quotation on Ellis is from 262); Jeffrey Weeks, "Havelock Ellis and the Politics of Sex Reform," in *Socialism and the New Life: The Personal and Sexual Politics of Edward Carpenter and Havelock Ellis*, ed. Sheila Rowbotham and Jeffrey Weeks (London: Pluto Press, 1977), 180–81.

10. Weeks, "Havelock Ellis," 166.

11. The set of Ellis's *Studies* that remains at O'Keeffe's Abiquiu Book Room comprises volumes from several different editions (1906, 1911, 1913, 1927), making it likely that Stieglitz gave away some volumes, as he did to Katharine Rhoades, and later acquired replacements. Another set of Ellis's *Studies* exists in the Ghost Ranch Library, Georgia O'Keeffe Museum Research Center. Marcia Brennan, *Painting Gender, Constructing Theory: The Alfred Stieglitz Circle and American Formalist Aesthetics* (Cambridge: MIT Press, 2001), 104–5, 301 n. 34, cites Stieglitz's letter of Oct. 17, 1911, Alfred Stieglitz Papers, YCAL, to Ellis's publisher, F. A. Davis, in Philadelphia.

12. Hale, *Freud and the Americans*, 259–66; Weeks, "Havelock Ellis," 166–67.

13. Hale, *Freud and the Americans*, 265–66, 431, quotes Ellis on Freud, from Havelock Ellis, "The Psychoanalysts," *Dial* 46 (Sept. 7, 1916): 54.

14. Edward Carpenter, *Love's Coming of Age* (New York: Boni and Liveright; Mitchell Kennerley, 1911). Sheila Rowbotham, "Edward Carpenter: Prophet of the New Life," in Rowbotham and Weeks, *Socialism*, 100–101, quotes Carpenter, *Towards Democracy* (London: George Allen and Unwin, 1883), 18 and 31.

15. The correspondence of Stieglitz and Mitchell Kennerley, 1911–41, Alfred Stieglitz Papers, YCAL, notes the exchange of their publications.

16. See Carpenter, *Love's Coming of Age*, 120–40; Rowbotham, "Edward Carpenter," 107–22.

17. See Brennan, *Painting Gender*.

18. Linda Dalrymple Henderson, "Mysticism as the 'Tie That Binds': The Case of Edward Carpenter and Modernism," *Art Journal* 46 (Spring 1987): 29–37.

19. That Duchamp's legacy prevailed in the later twentieth century supported Clement Greenberg's complaint that Stieglitz privileged Kandinsky's mysticism over Picasso's intellectual analysis and thus adopted the "wrong" road of modernism. Greenberg dismissed the modernism of the Stieglitz circle as a distortion of European modernism—"a formless vapor of messianic emotion, esotericism, and carried-away, irresponsible rhetoric having scarcely any relation to the art in question." Clement Greenberg, "L'art américain au XXe siècle," *Temps Modernes*, Aug.–Sept. 1946, 343, quoted in Michael Leja, "Modernism's Subjects in the United States," *Art Journal* 55 (Summer 1996): 71, 72 n. 19. On Stieglitz's love of Whitman, see Celeste Connor, *Democratic Visions: Art and Theory of the Stieglitz Circle, 1924–1934* (Berkeley and Los Angeles: University of California Press, 2001), in addition to Brennan, *Painting Gender*, and Barbara Buhler Lynes, *O'Keeffe, Stieglitz, and the Critics, 1916–1929* (Chicago: University of Chicago Press, 1991).

20. Christopher Lasch, *The New Radicalism in America, 1889–1963: The Intellectual as a Social Type* (New York: Knopf, 1965), 108–9.

21. Lasch, *New Radicalism*, 56–62; Christine Stansell, *American Moderns: Bohemian New York and the Creation of a New Century* (New York: Metropolitan Books, 2000), chaps. 7 and 8, describes numerous examples of such creative partnerships in the Village during this period.

22. Nina Miller, *Making Love Modern: The Intimate Public Worlds of New York's Literary Women* (New York: Oxford University Press, 1999), 8–9; Rita Felski, *The Gender of Modernity* (Cambridge, MA: Harvard University Press, 1995), 3; Elaine Showalter, *Sister's Choice: Tradition and Change in American Women's Writing* (Oxford: Clarendon Press, 1991), 108–10.

23. Carol Robinson (Rhoades's great-niece), interviews by the author: Oct. 17, 1998, July 11, 1999, and Oct. 18, 1999. See also H. Nichols B. Clark, "Katharine Nash Rhoades (1885–1965)," in *Avant-Garde Painting and Sculpture in America, 1910–1925*, ed. William Innes Homer (Wilmington: Delaware Art Museum, 1975), 118–19. Rhoades's letters to Stieglitz are preserved in the Alfred Stieglitz Papers, YCAL.

24. Katharine Nash Rhoades (hereafter KNR) to AS, Oct. 4, 1914, Alfred Stieglitz Papers, YCAL, recalls that her first time at 291 was "when Steichen took my photograph, when they were living there and then later I turned to the right at the elevator and went in to see some photographs, some of yours and some of Steichen's." This must refer to the first exhibition of the Photo-Secession at 291, Nov. 24, 1905–Jan. 5, 1906, the only time Stieglitz's and Steichen's prints were on the walls together during the time the Steichens were in residence. Steichen and his family left for France in October 1906. Rhoades's letters to Stieglitz after her return from France begin in early February 1911. Letter from KNR to Mrs. Arthur B. Carles, from the SS *Adriatic*, Jan. 1, 1911, Arthur B. Carles Papers, Archives of American Art, Smithsonian Institution (hereafter Carles Papers, AAA), restricted roll no. 4270, lent by Dr. Perry Ottenberg, dates Rhoades's return to the United States. She presumably sailed with the sculptor Malvina Hoffman, arriving in Naples in March 1910; see Hoffman, *Yesterday Is Tomorrow: A Personal History* (New York: Crown, 1965), 95–96. On Rhoades, Beckett, and Carles at Steichen's Voulangis cottage, see Penelope Niven, *Steichen: A Biography* (New York: Clarkson Potter, 1997), 355–57; on Carles, see Barbara Ann Boese Wolanin, *The Orchestration of Color: The Paintings of Arthur B. Carles* (New York: Hollis Taggart Galleries, 2000).

25. KNR to AS, Feb. 15, [1911], Alfred Stieglitz Papers, YCAL, indicates that Rhoades's mother had recently purchased a Carles painting from Stieglitz. The Carles exhibition at 291 took place Jan. 17, 1912–Feb. 3, 1912.

26. See Bergson, "An Extract from Bergson," 20–21, and "What Is the Object?" 22–26. In the latter excerpt, Bergson addresses the drama as an ideal form that characteristically employs electrified moments when "inner tensions" between the mask of life and inner states explode, "laying bare a secret portion of ourselves, . . . the tragic element in our character." The dramatist put before the audience the greater reality of deep-seated memories, a "life-history of a soul, a living tissue of feelings and events—something . . . which has once happened and can never be repeated."

27. KNR to AS, undated [1911?], Apr. 11 [1911], July [1911?], and Dec. 23 [1911], Alfred Stieglitz Papers, YCAL.

28. KNR to AS, Aug. 27, 1914, Alfred Stieglitz Papers, YCAL.

29. KNR to AS, Aug. 5, 1914, Alfred Stieglitz Papers, YCAL.

30. KNR to AS, Sept. 21, 1914, Alfred Stieglitz Papers, YCAL.

31. Paul Rosenfeld, *Port of New York: Essays on Fourteen American Moderns* (New York: Harcourt, Brace, 1924), 259. Richard Whelan, *Alfred Stieglitz: A Biography* (Boston: Little, Brown, 1995), 264, also comments on the cultlike behavior of the Stieglitz circle. For an example of this mode of address as a commonplace among acolytes at 291, see Miss Clifford Williams, "Appreciation," *Camera Work* 44 (Oct. 1913): 44. Possibly Stieglitz was trying to make Rhoades jealous by flirting with and publishing this admirer, whose writing is nearly identical to Rhoades's in its use of Bergson's language; see KNR to AS, Dec. 5, 1914, Alfred Stieglitz Papers, YCAL.

32. KNR to AS, Sept. 21, 1914, Alfred Stieglitz Papers, YCAL, responds to a letter to AS by de Zayas, sent to her by AS, in which de Zayas exalted Stieglitz as a Whitmanesque figure for whom the sun will shine; for Rhoades's transcendental moments in nature, see, for example, KNR to AS, Oct. 1 and Oct. 9–11, 1914, Alfred Stieglitz Papers, YCAL. Rosenfeld wrote much of *Port of New York* at Stieglitz's Lake George retreat, where Stieglitz read and edited the chapters on himself and O'Keeffe; see Rebecca Strand to Paul Strand, Sept. 20 and 21, 1923, Center for Creative Photography, University of Arizona, Tucson. Brennan, *Painting Gender*, 29–34, recounts Whitman's place in the Stieglitz circle and the comparisons Stieglitz's admirers made between him and Whitman.

33. Stieglitz made clear that the revolutionary goal of modernist art was the transformation of life; see Agnes Ernst, "The New School of the Camera," *New York Morning Sun*, Apr. 26, 1908.

34. See KNR's letters to AS as follows (all at Alfred Stieglitz Papers, YCAL): on Kandinsky and other pamphlets, Sept. 11, 14, and 21, 1914; on Nietzsche, Mar. 3, 1915; on Moore, Aug. 30, 1916; on Rolland, Sept. 27, 1916; on Ellis, Oct. 7 and 9, 1914, and Jan. 11, 1915; and on Freud, July 23, 1913, Sept. 30, 1914, Oct. 1, 3, 4, and 9–11, 1914. For Stieglitz's probing about her father and their dream analysis, see KNR to AS, Aug. 25, 1913, Aug. 27, 1914, Sept. 21, 22, and 24, 1914, and Oct. 9–11, and 15, 1914. For her adulation of his "Vision" and great gifts, see the letters of Aug. 27, 1914, and Sept. 21, 1914.

35. KNR to AS, Oct. 1, 1914, and Apr. 3, [1912]. Twelve of Matisse's sculptures were shown at 291 from Mar. 14 to Apr. 6, 1912.

36. Carol Robinson, interview by author, Oct. 17, 1998.

37. Rhoades's friendship with Mercedes and Arthur Carles is documented in the Carles Papers, AAA, restricted roll no. 4270. On the breakup of the romance of

Rhoades and Carles, which had been conducted both in the presence of Mercedes and secretly in Rhoades's Manhattan studio, see especially letters from KNR to Arthur Carles (hereafter AC), Nov. 9, 1912, and Jan. 10, 1913; Elizabeth Nash Rhoades to AC, Nov. 14, 1912; Mercedes Carles to AC, Nov. 13, 1914. The Carleses divorced in 1926.

38. KNR to AS, Oct. 9–11, 1914, describes Rhoades's troubled relationship with her mother, her hurtful silences that her mother could not understand: "I am worlds distant where she wants to feel the touch of my livingness near her and I don't come back when I know that. I can't. My being wouldn't be worlds distant if it didn't have to be! How can I bring myself back." Mercedes responded sarcastically to Carles's portrait of Rhoades in a letter to AC, Feb. 6, 1914, Carles Papers, AAA, restricted roll no. 4270. Rhoades and her mother continued what must have been for Rhoades a guilt-ridden friendship with Mercedes.

39. See, for example, KNR to AS, Sept. 2 and 7, 1914, and most of her letters that follow until January 1915 (all Alfred Stieglitz Papers, YCAL).

40. Hale, *Freud and the Americans*, 389–96, treats Brill's career and notes that between 1908 and 1917 Brill was responsible for making Freud available in English translation.

41. On the centrality of Freud to the cultural practices of New York modernists, see Ann Douglas, *Terrible Honesty: Mongrel Manhattan in the 1920s* (New York: Farrar, Straus and Giroux, 1995), 53–58 and 123–25.

42. Sigmund Freud, *Three Essays on the Theory of Sexuality*, trans. A. A. Brill, Monograph Series No. 7 (New York: Journal of Nervous and Mental Diseases Publishing Co., 1910). This book of essays was later translated and edited by James Strachey (New York: Avon; Discus Books, 1962); also cited in Brennan, *Painting Gender*, 104. In the editor's note, ix–xv, Strachey gives the history of the book's publication. KNR to AS, Sept. 21, 1914, Alfred Stieglitz Papers, YCAL, inquired, "Was the Freud book interesting that you had, that day at 291?" Clearly, this was a reference not to *The Interpretation of Dreams*, which they had long been discussing, but to a different volume of Freud.

43. Rhoades recapitulated and responded to Stieglitz's demands on her to "give" more personally and in her art, in letters dated Sept. 2, 7, and 21, 1914, Oct. 25, 1914, Nov. 1 and 29, 1914, Dec. 5, 1914, Mar. 15, 1915, Apr. 23, 1915, and Aug. 19, 1915.

44. Freud, *Three Essays*, 121–24, 130–31. See n. 11, above, for Stieglitz's interest in reading Ellis on women's modesty. Sandra Gilbert and Susan Gubar, *No Man's Land: The Place of the Woman Writer in the Twentieth Century*, vol. 1, *The War of the Words* (New Haven: Yale University Press, 1988), 168–71, explain that Freud's theory of

women's sexual frigidity implied an image of the woman poet or artist as a frigid—that is, dysfunctional—producer.

45. KNR to AS, Aug. 21 [1912]. Havelock Ellis, introduction to Ellen Key, *Love and Marriage*, trans. Arthur G. Chater (New York: Putnam; Knickerbocker Press, 1911), xvi.

46. Key, *Love and Marriage*, 34, 38.

47. Ibid., 38–39, 46–48.

48. Ibid., 80–81, 86–87.

49. Nina Miller, "The Bonds of Free Love: Constructing the Female Bohemian Self," *Genders* 11 (Fall 1991): 38–40; Ellis, *Studies*, vol. 6 (see also vol. 3); Carpenter, *Love's Coming of Age*, 141–55; Key, *Love and Marriage*, 30, 34, 46; Douglas, *Terrible Honesty*, 146; Lasch, *New Radicalism*, 101–9.

50. KNR to AS, Sept. 2, 1914, Alfred Stieglitz Papers, YCAL. For Rhoades's distraught response to gossip about her and Steichen, see KNR to AS, June 27, 1914, Alfred Stieglitz Papers, YCAL; and KNR to Agnes Meyer, Aug. 27, 1914, Agnes and Eugene Meyer Papers, Library of Congress.

51. KNR to AS, Sept. 7, 1914, Alfred Stieglitz Papers, YCAL. A week later Rhoades answered Stieglitz's continuing pleas with "Yes, there is a big 'Yes' in daring not to dare, . . . and I think you will agree that only in giving as I gave was I able to be myself and so give purely"; KNR to AS, Sept. 14, 1914, Alfred Stieglitz Papers, YCAL.

52. Miller, "Bonds of Free Love"; Christina Simmons, "Modern Sexuality and the Myth of Victorian Repression," in *Passion and Power: Sexuality in History*, ed. Kathy Peiss and Christina Simmons (Philadelphia: Temple University Press, 1989), 157–77; and Ellen Kay Trimberger, "Feminism, Men, and Modern Love: Greenwich Village, 1900–1925," in *Powers of Desire: The Politics of Sexuality*, ed. Ann Snitow, Christine Stansell, and Sharon Thompson (New York: Monthly Review Press, 1983), 131–52.

53. Miller, "Bonds of Free Love," 42–57, clarifies how this evasion worked in commenting on the gender relationships in the Village that colored the bohemians' dichotomy of artistic idealism and bourgeois materialism: "On the one hand, feminism, as an ostensibly positive value, belonged to art and the Village, while antifeminism fell to the reactionary mainstream. On the other hand, bohemian individualism implicitly took as its subject the romantic artist, a paradigm of experience effectively and traditionally male in its privileging of transcendence over materiality." Simmons, "Modern Sexuality," 157–77, makes an argument similar to Miller's in that she sees "the myth of Victorian repression," as spelled out by Michel Foucault, as strategically useful in permitting women a greater lat-

itude of sexuality, yet as leaving intact a modified male cultural dominance, rather than ending gender disparity and producing a true egalitarian reform of gender relations, as it promised to do.

54. See Lois Rudnick, "The New Woman," and Ellen Kay Trimberger, "The New Woman and the New Sexuality: Conflict and Contradiction in the Writings and Lives of Mabel Dodge and Neith Boyce," both in 1915, the Cultural Moment: The New Politics, the New Woman, the New Psychology, the New Art and the New Theatre in America, ed. Adele Heller and Lois Rudnick (New Brunswick, NJ: Rutgers University Press, 1991), 69–81, 98–115. Douglas, Terrible Honesty, 247, and Carroll Smith-Rosenberg, Disorderly Conduct: Visions of Gender in Victorian America (New York: Knopf, 1985), 283–93, however, remind us that if modernism re-entrenched patriarchy on new terms, this patriarchal modernism could have been secured only in collaboration with modernist daughters, for the daughters themselves rejected the older economic feminism for the promise of power that awaited them in sexual liberation.

55. KNR to AS, Sept. 2, 1914, Dec. 5, 1914, Alfred Stieglitz Papers, YCAL.

56. KNR to AS, Sept. 21, 1914, Alfred Stieglitz Papers, YCAL. See Douglas, Terrible Honesty, 33–40, on the moderns' seeking horror as the truth of life—"what cannot be borne"—and the credo of "terrible honesty" it necessitated. In this practice, Douglas sees Freud as the moderns' patron saint, who sought out patients' lies as if they were criminals.

57. Rhoades replied, "I am glad that I am not unhappy in . . . [your] Dream, to have become Woman, for I am so very glad to be—becoming one—all the time"; KNR to AS, Sept. 24, 1914, Alfred Stieglitz Papers, YCAL.

58. "There's no use trying to fool myself into thinking that one may live on Intangibilities—the Inner self is full of richness and power, but we are human and the necessity for—we called it Proofs the other day—still exists"; KNR to AS, Oct. 1, 1914, Alfred Stieglitz Papers, YCAL.

59. KNR to AS, Oct. 27 and 29, 1914, Alfred Stieglitz Papers, YCAL.

60. See KNR to AC, early Feb. 1912, Carles Papers, AAA, in which Rhoades states that Stieglitz told her mother he was thinking of going to Philadelphia to see Carles and of taking "the kid (me) with him"; KNR to AS, Mar. [1912?], Sept. 7 and 14, 1914, Oct. 9, 9–11, and 25, 1914, Alfred Stieglitz Papers, YCAL.

61. KNR to AS, Dec. 5, 1914, Alfred Stieglitz Papers, YCAL.

62. Carpenter, Love's Coming of Age, 43–44; on 46–47, he invokes Michelet (as quoted in Ellis's Man and Woman): "To every man, . . . the woman whom he loves is as the Earth was to her legendary son; he has but to fall down and kiss her breast and he is strong again."

63. Havelock Ellis, *Man and Woman: A Study of Human Secondary Sexual Characteristics* (London: A. & C. Black, 1894); on women as childlike, 52, 185–86, 387, 385; on the lack of great women artists, 318; on the sexual sphere as "massive" in women but "restless" in men, 326–27.

64. Ellis, *Studies*, vol. 3, especially "The Sexual Impulse in Women."

65. Jonathan Fineberg, *The Innocent Eye: Children's Art and the Modern Artist* (Princeton: Princeton University Press, 1997).

66. Compared to Kandinsky, who amassed great numbers of children's drawings for his own use, Stieglitz seems relatively uninterested in children's drawings themselves, based on the small group of these (some of which are Kitty's) preserved in his papers at Yale University. Quite probably, Stieglitz returned most of the children's drawings shown at 291 to their teachers. Clearly, Kandinsky's precedent of collecting children's drawings, modeling his own work on their randomness and spontaneity, and publishing these works laid the groundwork for Stieglitz's interest in children's art. Abraham Walkowitz saved a few works of Stieglitz's last child artist, Georgia Engelhard, for posterity when Stieglitz closed his gallery 291. The New York dealer Virginia Zabriskie acquired, through Walkowitz's estate, several of Engelhard's watercolors from her 1916 exhibition at 291. At least three of Engelhard's drawings are also in the Stieglitz papers at Yale.

67. William Innes Homer, *Alfred Stieglitz and the American Avant-Garde* (Boston: New York Graphic Society, 1977), 146; Whelan, *Alfred Stieglitz*, 304; "Some Remarkable Work by Very Young Artists," *Evening Sun*, Apr. 27, 1912, Scrapbook No. 1, Alfred Stieglitz Papers, YCAL.

68. See, for example, Charles H. Caffin, "Henri Matisse and Isadora Duncan," *Camera Work* 25 (1909): 17–20; and Sadakichi Hartmann, "Once More Matisse," *Camera Work* 39 (1912): 22–33. The Matisse exhibitions at 291 are discussed by Homer, *Alfred Stieglitz*, 58–61, who notes that the 1910 exhibition contained drawings and reproductions of Matisse's oil paintings, such as the *Joie de vivre* (1905–6); John O'Brian, *Ruthless Hedonism: The American Reception of Matisse* (Chicago: University of Chicago Press, 1999), chap. 1; Marcia Brennan, "Corporeal Disenchantment or Aesthetic Allure? Henri Matisse's Early Critical Reception in New York," *Analecta Husserliana* 65 (2000): 243–58; and Anne McCauley, "Matisse," in Sarah Greenough et al., *Modern Art and America: Alfred Stieglitz and His New York Galleries* (Washington, DC: National Gallery of Art, 2001).

69. Henry Tyrrell, in the *Evening World*, quoted in *Max Weber: Retrospective Exhibition* (New York: Whitney Museum of American Art; Minneapolis: Walker Art Center, 1949), 22.

70. Wassily Kandinsky, "On the Question of Form," *Blaue Reiter Almanac* (1912); reprinted (1974) in *The Blaue Reiter Almanac*, ed. Wassily Kandinsky and Franz Marc, introd. Klaus Lankheit (new documentary ed.; New York: Da Capo, 1989), 174–76.

71. Although the child's imagination is only briefly mentioned in a footnote in Kandinsky's *Concerning the Spiritual in Art*, Stieglitz was familiar with the *Almanac*, which contained Kandinsky's "On the Question of Form." AS to Wassily Kandinsky, May 26, 1913, Alfred Stieglitz Papers, YCAL. Stieglitz wrote that he had known Kandinsky's books (plural) for years and was trying to arrange an exhibition of Kandinsky's work at 291.

72. Henri Bergson, *Creative Evolution*, trans. Arthur Mitchell (1911; Lanham, MD: University Press of America, 1983), 176–77, discusses the artist's attempt to "regain" the intuitive or sympathetic thread that binds life together, "breaking down, by an effort of intuition, the barrier that space puts up between him and his model." This "aesthetic intuition" was gained not simply through a leap of space, from self to world, but also, following Bergson's logic of becoming, through a leap back through time, to the child self at the core of adult consciousness; see 312–13, where Bergson invokes the evolutionary discourse of recapitulation theory to warn that as "the child becomes the man" the conscious self is attained but the intuitional self is lost; the intuitive capacity is that which the artist must "regain," as on 177.

73. "The Future Futurists: Things Artistic Revealed to Babes That Are Hid from the Wise and Prudent," *New York Daily Tribune*, Mar. 31, 1912, pt. 5, p. 4; Scrapbook no. 1, Alfred Stieglitz Papers, YCAL.

74. Lasch, *New Radicalism*, 83–90.

75. Randolph S. Bourne, "Youth," *Atlantic Monthly* 109 (Apr. 1912): 433–41; reprinted in Bourne, *Youth and Life* (Boston: Houghton, Mifflin, 1913). Stieglitz and O'Keeffe's copy of Bourne's book is in the Ghost Ranch Library at the Georgia O'Keeffe Museum Research Center.

76. Hutchins Hapgood, "In Memoriam," *Camera Work* 39, suppl. (July 1912): n.p.

77. Stieglitz's polemic also anticipated John Dewey's slightly later dictum that "adults must become as little children"; if children possessed an innate sense of God, then artists needed to continually discover that sense within them by proceeding intuitively, listening to their inner selves, just as children should be allowed to develop naturally, to express their innate talents and character. See John Dewey, *Democracy and Education: An Introduction to the Philosophy of Education* (New York: Macmillan, 1916), 50–51, for his concept of education as growth and unfolding of the child's inner nature and capacities; cited in Lasch, *New Radicalism*, 88–89.

78. Homer, *Alfred Stieglitz*, 146; and Whelan, *Alfred Stieglitz*, 304, note that the loan of the drawings was arranged by Walkowitz, who himself had been raised in that neighborhood and was connected with anarchist circles there. On this point, see "The Future Futurists," *New York Daily Tribune*. Gail Levin, *Edward Hopper: An Intimate Biography* (New York: Knopf, 1995), 154, reports that the students were from a class taught by Jo Nivison, Edward Hopper's future wife.

79. "A Real Artist at Three," *World Magazine*, May 12, 1912, 10. Another critic also noted the derivation of Kitty's drawing from Weber's; see the exhibition review by Mr. Harrington in the *New York Herald*, reproduced in *Camera Work* 39 (July 1912): 48. Whelan, *Alfred Stieglitz*, 273, reports that Weber gave Kitty drawing lessons during July and August 1910, when he visited the Stieglitz family vacationing in Deal Beach, New Jersey. The writer of "A Real Artist at Three" considers Stieglitz's claims for the purity and innocence of the child's vision by examining the resemblance of Kitty's drawings to Weber's.

80. On de Zayas and his role in Stieglitz's 291 gallery, see Douglas Hyland, *Marius de Zayas: Conjurer of Souls* (Lawrence, KS: Spencer Museum of Art, 1981), especially 30–45.

81. At the Modern Gallery, a few blocks away from 291, Stieglitz's associates de Zayas and Agnes Meyer exhibited Picabia's work alongside African sculptures in October and November 1915 and again in January 1916.

82. De Zayas's essay, "Modern Art in Connection with Negro Art," was published in *Camera Work* 48 (Oct. 1916): 7. In it de Zayas wrote, "Negro art, product of the 'Land of Fright' created by a mentality full of fear, and completely devoid of faculties of observation and analysis, is the pure expression of the emotions of a slave race—victims of nature—who see the outer world only under its most intensely expressive aspect and not under its natural one"; Marius de Zayas, *African Negro Art: Its Influence on Modern Art* (New York: Modern Gallery, 1916), 41. See Hyland, *Marius de Zayas*, 45 and 63 n. 118. See also Helen M. Shannon, "African Art, 1914: The Root of Modern Art," in Greenough et al., *Modern Art and America*, 168–83.

83. For recapitulation theory as the basis of the evolutionary theory of social development, see George W. Stocking Jr., *Race, Culture, and Evolution: Essays in the History of Anthropology* (Chicago: University of Chicago Press, 1982); and John Cleverley and D. C. Phillips, *Visions of Childhood: Influential Models from Locke to Spock* (New York: Teachers College Press, 1986), chap. 4, "The Child and the Species"; G. Stanley Hall, "Childhood and Adolescence," in *Health, Growth, and Heredity*, ed. Charles Strickland and Charles Burgess (New York: Teachers College Press, 1965), 103, quoted in Cleverley and Phillips, *Visions of Childhood*, 51.

84. Sadakichi Hartmann, "The Exhibition of Children's Drawings," *Camera Work* 39 (July 1912): 46. Lasch, *New Radicalism*, 88–89, however, points out that progressives such as John Dewey had no use for recapitulation, believing instead that education could reform the mistaken habits of the past into a more promising future. See Dewey, *Democracy and Education*, 84–85: "The business of education is rather to liberate the young from reviving and retraversing the past than to lead them to a recapitulation of it." Henry McBride, reviewing the second children's art show at 291 in the *New York Sun*, stated as well that those artists engaged with primitive art would also be interested in this children's exhibition; reprinted in *Camera Work* 45 (Jan. 1914): 24.

85. De Zayas, "Modern Art," 7. On primitivism and modernism, see William Rubin and Kirk Varnedoe, *Primitivism in Twentieth-Century Art*, 2 vols. (New York: Museum of Modern Art, 1984); Gail Levin, "'Primitivism' in American Art: Some Literary Parallels of the 1910s and 1920s," *Arts Magazine* 59 (Nov. 1984): 101–5; Sally Price, *Primitive Art in Civilized Places* (Chicago: University of Chicago Press, 1989); Marianna Torgovnick, *Gone Primitive: Savage Intellects, Modern Lives* (Chicago: University of Chicago Press, 1990), 9; Susan Hiller, ed., *The Myth of Primitivism: Perspectives on Art* (London: Routledge, 1991); Michael Leja, *Reframing Abstract Expressionism: Subjectivity and Painting in the 1940s* (New Haven: Yale University Press, 1993), chap. 2, esp. 49–68. Whitney Chadwick, "Fetishizing Fashion/Fetishizing Culture: Man Ray's *Noire et blanche*," *Oxford Art Journal* 18 (1995): 6, 16 nn. 16 and 19, comments on the critical reception of Stieglitz's 1914 African sculpture exhibition.

86. Lisa Tickner, "Men's Work? Masculinity and Modernism," *Differences* 4 (Fall 1992): 1–37, suggests a similar reaction formation in English modernism. On the nineteenth-century child as feminized and the sign of domesticity, see Philippe Ariès, *Centuries of Childhood: A Social History of Family Life*, trans. Robert Baldick (New York: Vintage Books, 1962), 58–59. Hugh Cunningham, *Children and Childhood in Western Society since 1500* (London: Longman, 1995), 75, comments on the feminization of the Romantic child in the popular imagination. Anne Higonnet, *Pictures of Innocence: The History and Crisis of Ideal Childhood* (London: Thames and Hudson, 1998), 9, 27–28, 39, 45, 47, addresses this gendering of the child specifically through the commercialization of the visual imagery of the child in nineteenth-century English and American culture, stating that "the image of the child was less relegated to a feminine audience than actively claimed through identification by a feminine audience" (43) and that "the boy's struggle to shed the Blue Boy look was . . . his struggle to leave the feminine domestic domain of childhood and enter the world of grown-up masculinity" (47).

87. Stieglitz meant to stigmatize the boys' work with the statement that their drawings were produced "under the influence of a system." He warned the viewer to approach this body of work with caution. In the exhibition's didactic materials, Stieglitz allowed the boys' teachers to present a statement defending their system; they argued that their method constituted a rejection of the traditional pedagogical methods employed in schools. The pamphlet produced for the third children's art exhibition at 291, "Third Exhibition of Children's Drawings at the Little Gallery of the Photo-Secession," 291 Fifth Avenue, New York, Mar. 27 to Apr. 17, 1915, Alfred Stieglitz Papers, YCAL, was reprinted in *Camera Work* 48 (Oct. 1916): 9. The boys' teachers were identified as Dr. Joseph Cohen and Miss Eda L. Puckhaber.

88. Stieglitz had written of the second children's exhibition that "all the drawings shown were by children who had received no guidance in the use of brush or pencil. All manifested the delightful imaginative and fanciful qualities which are the child's kingdom, and which unfortunately are, by degrees, submerged as the child's evolution develops more fully the faculty of observation"; see *Camera Work* 45 (Jan. 1914): 18.

Stieglitz had underscored this point earlier in reprinting in *Camera Work* a review of the earlier children's exhibitions that had found the contrast between the works of Stieglitz's untutored children and those children instructed by teachers to be "a startling and sad commentary upon our art education." Walter Storey, review for *Arts and Crafts Magazine* (Oct. 1912), reprinted in *Camera Work* 45 (Jan. 1914): 25. John Dewey similarly promoted education as a growth of the powers within, encouraged by a nurturing environment; this was the correct educational model, according to Dewey, rather than an imposition of conventions and rules from without; see *Democracy and Education*, 79–81.

89. Charles H. Caffin, review in the *New York American*, reprinted in *Camera Work* 45 (Jan. 1914): 23–24.

90. Ellis, *Man and Woman*, 391. Whelan, *Alfred Stieglitz*, 313, remarks that in 1913 Marin had been Stieglitz's ideal childlike artist, who displayed the child's mode of play in his art. See Brennan, *Painting Gender*, 142–52, on Rosenfeld's masculinist framing of Marin.

91. The exhibition announcement, contained in a bound volume in folder 2396, box 117, Alfred Stieglitz Papers, YCAL, was reprinted in its entirety in *Camera Work* 49–50 (June 1917): 33. Three of Engelhard's drawings were featured in *Women of the Stieglitz Circle*, exhibition catalog (Santa Fe, NM: Owings-Dewey Fine Art, 1998), with an essay by Suzan Campbell, n.p.

92. Charles H. Caffin, review in the *New York American*, reprinted in *Camera Work* 49–50 (June 1917): 34.

93. See n. 86 above.

94. Ellis, *Man and Woman*, 318, 326–27, 358, 366.

95. See Kathleen Pyne, *Art and the Higher Life: Painting and Evolutionary Thought in Late Nineteenth-Century America* (Austin: University of Texas Press, 1996), chap. 1.

96. Sigmund Freud, "On Narcissism: An Introduction" (1914), in *The Standard Edition of the Complete Psychological Works of Sigmund Freud*, vol. 14 (1914–16), ed. and trans. James Strachey (London: Hogarth Press and Institute of Psycho-Analysis, 1957), 73–104; see also Sarah Kofman, *The Enigma of Woman: Women in Freud's Writings*, trans. Catherine Porter (Ithaca: Cornell University Press, 1985), 39–71.

97. Hale, *Freud and the Americans*, 298–99, 408.

98. Fredrika Blair, *Isadora: Portrait of the Artist as a Woman* (New York: McGraw and Hill, 1986), 45–49 and 67–69.

99. KNR to AS, Nov. 1, 6, 15, and 26, 1914, Alfred Stieglitz Papers, YCAL.

100. Rhoades argued against consummating their relationship: "Would it still be so pure, so spiritual? You say yes. Theoretically that should be so, but I say no. And you say it is the test of its purity, that if it is really pure it will remain always. But you are speculating on what would be true in an ideal world—and you are living in a rotten one—and so, of what value, a test of purity in a rotten world?" KNR to AS, Dec. 5, 1914, Alfred Stieglitz Papers, YCAL.

101. Letter from AS to Steichen, May 9, 1914, Alfred Stieglitz Papers, YCAL, relates Stieglitz's visit to the studio Rhoades and Beckett shared and his favorable impression of their works there. Unfortunately, Rhoades destroyed several of her works featured at this exhibition shortly before she died.

102. For the range of artists who passed through a phase of fauvist experimentation, see William H. Gerdts, "The American Fauves: 1907–1918," in *The Color of Modernism: The American Fauves* (New York: Hollis Taggart Galleries, 1997), 5–136.

103. Bergson, "What Is the Object?" 23–24.

104. Marius de Zayas and Paul B. Haviland, "The Study of the Modern Evolution of Plastic Expression" (New York: 291, 1913), 14, 21, also quotes John Marin's statements.

105. On Steichen's decorative project for the Meyers, see Niven, *Steichen*, 376–78.

106. In *Camera Work* 48 (Oct. 1916): 18–21, Stieglitz reprinted several positive reviews of Rhoades and Beckett's exhibition, among them Arthur Hoeber in the *New York Globe*, Elizabeth Luther Carey in the *New York Times*, Forbes Watson in the *New York Evening Post*, Charles H. Caffin in the *New York American*, Robert J. Cole in the *New York Evening Sun*, and Henry Tyrrell in the *Christian Science Monitor*.

107. See Agnes Meyer, *Out of These Roots: The Autobiography of an American Woman* (Boston: Little, Brown, 1953), 105, who calls Rhoades and Beckett "two of the most beautiful young women that ever walked this earth." The three women were at times called the "three graces" of 291. Meyer named one of her daughters, Katharine Meyer Graham, after Rhoades. They maintained a distant friendship after the death of their mutual friend Charles Freer, while Meyer's relations with Stieglitz became hostile after the opening of her gallery in 1915, and then distant as well. Meyer had interviewed Stieglitz for the *Sun* in 1908 and had been a huge supporter of his modernism and a financial backer after her marriage.

108. Although Meyer's review of the Rhoades-Beckett exhibition was not published until 1916, it was written immediately following the exhibition at 291, and Stieglitz consulted Rhoades about whether he should print it. See Agnes Meyer, review in *Camera Work* 48 (Oct. 1916): 8–9. KNR to AS, Feb. 18, 1915, Alfred Stieglitz Papers, YCAL, on her response to Meyer's review, the negative influence of Steichen and Eugene Meyer on Agnes Meyer's opinion of Rhoades's painting, and the backroom gossip about her and Stieglitz. These tensions were compounded by Meyer and de Zayas's plans to found a new gallery, the Modern Gallery, in a bid to usurp Stieglitz's mission and extend it into a wider social arena.

109. "Motherhood a Crime," and "Drawing by Katharine Rhoades," *291*, no. 2 (Apr. 1915), n.p.; and Clark, "Katharine Nash Rhoades," 118. Rhoades's contributions to 291 are briefly discussed in Willard Bohn, "Visualizing Women in 291," in *Women in Dada: Essays on Sex, Gender, and Identity*, ed. Naomi Sawelson-Gorse (Cambridge: MIT Press, 1998), 240–61; and Dickran Tashjian, "Authentic Spirit of Change: The Poetry of New York Dada," in *Making Mischief: Dada Invades New York*, ed. Francis M. Naumann (New York: Whitney Museum of American Art, 1996), 268–69. Bohn's interpretation of Rhoades's poem "I Walked into a Moment of Greatness" (which she published in the May 1915 issue of 291) as an evocation of her erotic experience of art is entirely at odds with my reading of the archival evidence.

110. To his complaints in March that he was "losing his grip," she had replied sarcastically that she had lost her grip years ago as an adolescent and had "never had time to go back to the undeveloped me and educate it properly in the 'ways of the world.'" The "Kid" was afraid to grow up. Although she knew the importance of doing what he urged her to do, if she did what he wanted, something in her would be lost—the truthfulness of the Kid; if she grew up, something essential to the child in her would die. See KNR to AS, Mar. [1915]; and Mar. 23–24, 1915, Alfred Stieglitz Papers, YCAL.

111. KNR to AS [Apr. 1915] spoke of "kill or cure" this summer; on Apr. 23, 1915, she despaired of "not knowing how to be a woman" and continued: "I wish I were a seagull. I think I could make more of a success at it. . . . What would you have thought if I'd poked holes in all my canvases the other day? I wish I had the courage to do it. They seem like barnacles clinging on to me, I'd like to get free of them. . . . I've always longed to destroy things that are over—the actual physical things"; on Apr. 15, 1915, she refused Stieglitz's love but reaffirmed the value of the friendship and her need for him, communicated her own suicidal state over the past month, and conveyed Emmy's lament; all Alfred Stieglitz Papers, YCAL.

112. KNR to AS, July 10, 1915, Aug. 6–7, 1915, Alfred Stieglitz Papers, YCAL.

113. Rhoades was with Freer in Detroit in April 1916 and at the Berkshire Inn, in Great Barrington, from June through late August 1916; KNR to AS, Apr. 23, 1916, June 19, 1916, July 2, 1916, Aug. 11, 1916, Alfred Stieglitz Papers, YCAL. There was some speculation as to the nature of Rhoades's friendship with Freer; see Mercedes Carles to AC, Apr. 8, 1916, Carles Papers, AAA.

114. AS to KNR, May 31, 1916, Alfred Stieglitz Papers, YCAL, calls the work of the three artists "psycho-pathic"; for his comments on the "psycho-analytical" content of O'Keeffe's drawings, see Editor's Notes [Stieglitz], "Georgia O'Keeffe— C. Duncan—Réné Lafferty," *Camera Work* 48 (Oct. 1916): 12. The works of O'Keeffe, Duncan, and Lafferty were on display at 291 from May 23 to July 5, 1916.

115. The planned children's issue is mentioned in *Camera Work* 46 (Apr. 1914): 52; Sue Davidson Lowe, *Stieglitz: A Memoir/Biography* (New York: Farrar, Straus and Giroux, 1983), 204, reports that this issue would connect children's art with that of the insane. Unfortunately, the issue would remain unfinished and unpublished. For the note on "Psychotype," see "'291': A New Publication," *Camera Work* 48 (Oct. 1916): 62.

116. For Stieglitz's thoughts on shutting down 291 and *Camera Work*, and the rivals to his operations, see, for example, Lowe, *Stieglitz*, 197–200, 205–6; and Whelan, *Alfred Stieglitz*, 312, 325–27, 331–34, 351–54. A letter of July 1915, Meyer Papers, Library of Congress, records Meyer and de Zayas's sense of Stieglitz's exhaustion and the need to reincarnate his project in a form with a more broad–based social support.

117. John M. MacGregor, *The Discovery of the Art of the Insane* (Princeton: Princeton University Press, 1989), discusses the Romantic naturalization of the child, the primitive, and the insane and the new support the study of psychology brought to this tradition at the end of the nineteenth century; see especially 69, 75, 93–97, 180–82, 190–93.

118. "Art and Insanity in the Light of an Exhibition of Pictures by Lunatics," *Current Opinion* 55 (1913): 340, stated of the Bethlem exhibition that the "pictures might prove a fruitful, unexplored line of study and a good index of the patient's state, . . . [since] drawing is a mode of expression in which the individuality of the person is well marked." MacGregor, *Discovery*, 161–66, treats the exhibitions of drawings by mental patients held in London and Paris in the early years of the century, especially the Bethlem exhibition of 1913, and quotes the comment in the *Times*, Aug. 14, 1913, that the exhibition offered an opportunity to glimpse the human mind "unfettered by normal inhibitions."

119. Hartmann, "Exhibition of Children's Drawings," 46.

120. Editor's Notes [Stieglitz], "Georgia O'Keeffe," 12.

121. Ibid.

122. "Henry Tyrrell in the *Christian Science Monitor* (Boston)," review reprinted in *Camera Work* 48 (Oct. 1916): 60–61.

123. Henderson, "Mysticism."

124. Dodge's newspaper columns were syndicated in the Hearst newspapers, Aug. 1917–Feb. 1918. Mabel Dodge Luhan, *Movers and Shakers* (1936; reprint, Albuquerque: University of New Mexico Press, 1985), 505–12; Lois Rudnick, *Mabel Dodge Luhan: New Woman, New Worlds* (Albuquerque: University of New Mexico Press, 1984), 139–41; Sanford Gifford, "The American Reception of Psychoanalysis, 1908–1922," in Heller and Rudnick, 1915, especially 134–36.

125. Carl G. Jung, *The Psychology of the Unconscious: A Study of the Transformations and Symbolisms of the Libido, a Contribution to the History of the Evolution of Thought*, trans. and introd. Beatrice M. Hinkle (New York: Moffat, Yard, 1916). KNR to AS, Apr. 23, 1916, Alfred Stieglitz Papers, YCAL, reports that Rhoades has "found Jung's book," which "looks most interesting."

126. Stieglitz's own copy of this volume is in the Book Room of Georgia O'Keeffe's Abiquiu home. I refer here to the underlined passages in that volume on pages xxxi–xxxiii.

127. KNR to AS, Oct. 15 and 25, 1914, Alfred Stieglitz Papers, YCAL.

128. Hale, *Freud and the Americans*, 409–10.

129. Olive Schreiner, *Dreams* (New York: Robert K. Haas, 1890). Most of Schreiner's dream compositions in this volume are punctuated by or end in the phrase "I awoke," as does each of Stieglitz's three dream stories.

130. Alfred Stieglitz, "One Hour's Sleep: Three Dreams," 291, Mar. 1915.

131. Stieglitz's 1918 essay "Woman in Art" details his idea of how O'Keeffe's art originates from the erotically charged feminine core of her being; it was published

only posthumously in Dorothy Norman, *Alfred Stieglitz: An American Seer* (New York: Random House, 1973), 19–21. For the disagreement between Rhoades and Stieglitz over O'Keeffe's drawings at the 291 exhibition, see KNR to AS, May 30, 1916; and AS to KNR, May 31, 1916, Alfred Stieglitz Papers, YCAL.

132. Anita Pollitzer, *Lovingly, Georgia: The Complete Correspondence of Georgia O'Keeffe and Anita Pollitzer* (New York: Simon and Schuster, 1990), 115. The remark "Finally a woman on paper!" is a later addendum on the letter from Pollitzer to O'Keeffe, dated Jan. 1, 1916, Alfred Stieglitz Papers, YCAL.

133. In "'291' and the Modern Gallery," *Camera Work* 48 (Oct. 1916): 63–64, Stieglitz made public his dispute with de Zayas and Meyer over the relation between his 291 gallery and their affiliated Modern Gallery, announcing the split between them in a brusque and perfunctory manner that must have been embarrassing to de Zayas.

134. Rhoades recapitulates Stieglitz's confession of his feelings for her in her letter; see KNR to AS, Dec. 21, 1917, Alfred Stieglitz Papers, YCAL.

135. See AS to KNR [late 1918], letter in pencil on rough paper, Alfred Stieglitz Papers, YCAL.

136. KNR to Georgia O'Keeffe, Feb. 1923, Georgia O'Keeffe Papers, YCAL. See Barbara Buhler Lynes, *Georgia O'Keeffe: Catalogue Raisonné*, vol. 1 (New Haven: Yale University Press; Washington, DC: National Gallery of Art; Santa Fe, NM: Georgia O'Keeffe Foundation, 1999), no. 330, for *Plums*, ca. 1920, and no. 295, *59th Street Studio*, 1919, for the canvas Rhoades called "the Doorway," which O'Keeffe sold in 1974.

137. In 1935 Rhoades had an exhibition of her work in a gallery called Delphic Studios on Fifth Avenue, and she established a private library of world religions at about the same time. See an exhibition checklist from her Delphic Studios exhibition of Mar. 11–24, 1935; and the pamphlet Rhoades sent Stieglitz, "The Library, 175 East 71st Street, New York City, Books on the Christian Religion; History, Philosophy, Theology, Liturgy, Worship, Biographies, Etc." (Jan. 1939), which describes Rhoades's Library of St. Bede, now housed at the University of the South; both in the Alfred Stieglitz Papers, YCAL.

138. Whelan, *Alfred Stieglitz*, 451, comments on Rhoades's presence at Lake George and on Stieglitz's "portrait" of her as part of the *Songs of the Sky*. Sarah Greenough, *Alfred Stieglitz: The Key Set; The Alfred Stieglitz Collection of Photographs*, vol. 1, 1886–1922 (Washington, DC: National Gallery of Art; New York: Abrams, 2002), 521–24, nos. 876–81, illustrates the *Portrait—K. N. R., Nos. 1–6* (1923), emphasizing that these six prints are not part of the *Songs of the Sky* but were preliminary to the execution of the series.

139. Undoubtedly, the reviewer listened to Stieglitz's talk in the gallery; "Art: Exhibitions of the Week; 'Spiritual America' Print," *New York Times*, Mar. 9, 1924, relates that "'Songs of the Sky and Trees' [*sic*] is a portrait of a friend of this artist scientist and philosopher, expressed through sky and tree, a tree that dances and sparkles in the first plates becoming in the last print a thing of dignity and completeness. He has let imagination work out two future possibilities—a happy and an unhappy ending, as it were."

140. KNR to AS, Sept. 21, 1914, Alfred Stieglitz Papers, YCAL; Katharine N. Rhoades, "There Is Always a 'More'—a Greater Vision—a Greater Realization," *Camera Work* 47 (July 1914): 55–57.

141. KNR to AS, Oct. 17(?), 1914, and Oct. 20 and 21, 1914, Alfred Stieglitz Papers, YCAL.

142. Carol Robinson, interview by author, July 11, 1999. While Rhoades's letters to Stieglitz, particularly in the early 1920s, suggest theosophical leanings, Rhoades herself was later an active member of Trinity Church, New York, and retreated annually in the 1940s to the Episcopal convent St. Margaret's outside Boston for meditation and prayer. With reference to the Library of St. Bede, which she established in 1937, see the pamphlet, "The Library," Alfred Stieglitz Papers, YCAL; also "The Library of St. Bede Added to University's Services," *Sewanee News*, Mar. 1968, 4–5.

143. Douglas, *Terrible Honesty*, 132–42, 180.

144. Agnes Meyer to AS, July 5, 1914, Alfred Stieglitz Papers, YCAL, mentioned Cézanne and Picasso, in particular, as good candidates for such an exhibition.

145. Lynes, *Georgia O'Keeffe*, vol. 1.

146. See for example, KNR to AS, Aug. 5, 1915, Alfred Stieglitz Papers, YCAL.

147. Herbert J. Seligmann, *Alfred Stieglitz Talking: Notes on Some of His Conversations, 1925–1931* (New Haven: Yale University Library, 1966), 88–89.

148. KNR to AS, Aug. 9, 1915, Alfred Stieglitz Papers, YCAL. While Freer was alive, Rhoades was never remunerated with money for her services to him and his collection. In his will, however, he bequeathed her one thousand shares of capital stock in Parke, Davis and Company; his home at Great Barrington, Massachusetts; and many books and Asian objects from his collections. He also stipulated that the collections and educational mission of the Freer Gallery of Art be developed in consultation with Rhoades, and he named her one of three people (in addition to Agnes Meyer and Mrs. H. O. Havemeyer) whose approval of new acquisitions for the gallery was required. See "Last Will and Testament of Charles L. Freer," dated May 13, 1918, Charles Lang Freer Papers, Freer Gallery of Art Archives.

149. Barbara Buhler Lynes, "Georgia O'Keeffe and Feminism: A Problem of Position,"

in *The Expanding Discourse*, ed. Norma Broude and Mary D. Garrard (New York: Harper Collins, 1992), 437–50; Lynes, *O'Keeffe, Stieglitz*.

150. KNR to AS, Aug. 9, 1915, Alfred Stieglitz Papers, YCAL. Rhoades continues in a vein of self-loathing, "But perhaps she found herself and didn't like what she found—and in her grumbling lost the whole d __ thing! Scatterbrained! And somewhat of a fake, because she seems to fool her friends with thinking she's got poise—and is quite a fine sort of woman."

151. KNR to AS, Sept. 7, 1914, Alfred Stieglitz Papers, YCAL.

152. KNR to AS, Nov. 5 and Dec. 5, 1914, Alfred Stieglitz Papers, YCAL. Rudnick, *Mabel Dodge Luhan*, 89–91, 104–5, discusses the disillusionment of women radicals such as Dodge, Boyce, and others with the ideology of free love.

153. Lasch, *New Radicalism*, 101–9.

154. O'Keeffe had dabbled in commercial illustration in 1916–17 and had considered that career path, but her correspondence with Paul Strand (CCP, University of Arizona) in 1917 also reveals her discouragement and temptation to marry in that year.

155. Perry Miller Adato, *Georgia O'Keeffe*, WNET/New York, 1977. O'Keeffe told Adato that she could have been "much better as a painter and nobody would have noticed it" and that she was "luckier than others" and especially lucky that she was "in touch with her times." As Barbara Lynes has pointed out to me, it is significant that O'Keeffe in this statement erases Stieglitz as the causal factor in her success. Lynes shows that this erasure was O'Keeffe's strategic rewriting of her career after Stieglitz's death in 1946; see Barbara Buhler Lynes, "O'Keeffe's O'Keeffes: The Artist's Collection," in Barbara Buhler Lynes with Russell Bowman, *O'Keeffe's O'Keeffes: The Artist's Collection* (New York: Thames and Hudson, 2001), 29–70.

156. See Nancy Newhall interview with Stieglitz, in her "Notes for a Biography of Alfred Stieglitz," MS in the Beaumont and Nancy Newhall Papers, Special Collections and Visual Resources in the Getty Research Institute for the History of Art and the Humanities, entry for Mar. 13, 1942, 28.

The Burden and the Promise

1. Nancy Milford, *Savage Beauty: The Life of Edna St. Vincent Millay* (New York: Random House, 2001); Nina Miller, *Making Love Modern: The Intimate Public Worlds of New York's Literary Women* (New York: Oxford University Press, 1999), chap. 1, "Edna St. Vincent Millay," 16–40.

2. Stieglitz and Kennerley had exchanged publications from 1912 on. Milford, *Sav-*

age Beauty, 331–33, establishes Millay's identity in the press as that of a child. See also Miller, *Making Love Modern*, 18.

3. Barbara Buhler Lynes, "1916 and 1917: My Own Tune," in Sarah Greenough et al., *Modern Art and America: Alfred Stieglitz and His New York Galleries* (Washington, DC: National Gallery of Art; Boston: Bulfinch Press, 2000), 261–69, notes O'Keeffe's self-conscious production of work that could be related to the modernism Stieglitz was showcasing.

4. O'Keeffe had her first formal meeting with Stieglitz at 291 in May 1916 at the time of her show with Duncan and Lafferty. For the Engelhard drawings that Walkowitz preserved, see *Abraham Walkowitz and Alfred Stieglitz: The "291" Years—1912–17* (New York: Zabriskie Gallery, 1976). Alfred Stieglitz (hereafter AS) to Georgia O'Keeffe (hereafter GOK), May 31, 1917, excerpted in Sarah Greenough and Juan Hamilton, *Alfred Stieglitz: Photographs and Writings* (Washington, DC: National Gallery of Art, 1983), 202.

5. For O'Keeffe's study of different design systems, see Charles Eldredge, *Georgia O'Keeffe: American and Modern* (New Haven: Yale University Press, 1993); Sarah Whitaker Peters, *Becoming O'Keeffe: The Early Years* (New York: Abbeville Press, 2001); and Elizabeth Turner, *Georgia O'Keeffe: The Poetry of Things* (Washington, DC: Phillips Collection; New Haven: Yale University Press, 1999).

6. GOK to AS, Feb. 1, 1916, from Columbia, SC. In reference to making her drawings "talk," O'Keeffe states that some of her ideas "may be near insanity." In GOK to AP, Feb. 9, 1916, Columbia, SC, O'Keeffe states that she doubted the "soundness" of her "mentality" during the time she made the drawings and asks Pollitzer if in the expression of the drawings she is "completely mad"; in Jack Cowart, Juan Hamilton, and Sarah Greenough, *Georgia O'Keeffe: Art and Letters* (Washington, DC: National Gallery of Art; Boston: New York Graphic Society Books, 1987), 150–51.

7. GOK to Anita Pollitzer (hereafter AP), Oct. 1915, and Sept. 18, 1916, Alfred Stieglitz /Georgia O'Keeffe Papers, Yale Collection of American Literature, Beinecke Rare Book and Manuscript Library, Yale University (hereafter YCAL).

8. See Christopher Dresser, *Principles of Decorative Design* (London: Cassell, Petter and Galpin, 1873); Charles G. Leland, *Drawing and Designing* (Chicago: Rand McNally, 1889).

9. See Georgia O'Keeffe, *Some Memories of Drawings*, ed. Doris Bry (Albuquerque: University of New Mexico Press, 1988), n.p., on her sense that the charcoals projected "things in my head . . . shapes and ideas so familiar to me" and on the spiral shape as a recurring image for her but one she never remembered from previous work.

GOK to AP, Dec. 1915 and Dec. 13, 1915, and GOK to AS, Feb. 1, 1916, all in Anita Pollitzer, *A Woman on Paper: Georgia O'Keeffe* (New York: Simon and Schuster, 1988), 39–40, 123–24. To Paul Strand, O'Keeffe also revealed her distrust of words to assign meaning to feelings, especially those embodied in images; GOK to Strand (hereafter PS), June 25, 1917, Center for Creative Photography, University of Arizona, Tuscon (hereafter CCP).

10. GOK to AP, Feb. 9, 1916, in Cowart et al., *Georgia O'Keeffe*, 151.

11. Barbara Buhler Lynes, *Georgia O'Keeffe: Catalogue Raisonné* (New Haven: Yale University Press; Washington, DC: National Gallery of Art; Santa Fe, NM: Georgia O'Keeffe Foundation, 1999), 1:57, connects O'Keeffe's account to Pollitzer of dangling her feet in a pool of water with *No. 32—Special* and *Special No. 33*; Lynes, "1916 and 1917," 263, relates several of the 1915 pastels to O'Keeffe's fascination with water; see GOK to AP, Oct. 1915, in Pollitzer, *Lovingly, Georgia: The Complete Correspondence of Georgia O'Keeffe and Anita Pollitzer*, ed. Clive Giboire (New York: Simon and Schuster, 1990), 48.

12. GOK to AP, Feb. 1, 1916, in Cowart et al., *Georgia O'Keeffe*, 150.

13. GOK to AP, December 1915, in Pollitzer, *Woman on Paper*, 39.

14. See GOK to AP, Feb. 21, 1916, in Cowart et al., *Georgia O'Keeffe*, 152, for O'Keeffe's enthusiasm for Marin and her study of his works reproduced in *Camera Work* 39 (July 1912).

15. Unsigned review of *Color Music* (1911), by Professor Wallace Rinington, *Forerunner* 6 (May 1915): 140. O'Keeffe's volume of this journal at the Abiquiu Book Room is inscribed inside the front cover, "Georgia O'Keeffe / October 19, 1916."

16. Alfred Stieglitz, "Our Illustrations," *Camera Work* 49–50 (June 1917): 3.

17. Marius de Zayas and Paul Haviland, *The Study of the Modern Evolution of Plastic Expression* (New York: 291, 1913), 12–21.

18. GOK to AP, Aug. 25, 1915, in Pollitzer, *Woman on Paper*, 12–13; GOK to AP, Sept. 1915, Georgia O'Keeffe Papers, YCAL, states that "Kandinsky is reading much better this time than last time," indicating that O'Keeffe was reading Kandinsky for the second time.

19. AS to GOK, June 1916, in Pollitzer, *Woman on Paper*, 139–40; GOK to PS, June 12 and 25, 1917, CCP.

20. GOK to AS, July 27, 1916, in Cowart et al., *Georgia O'Keeffe*, 153–54.

21. On O'Keeffe's and Pollitzer's interest in Rhoades, see AP to GOK, July 26, 1915, GOK to AP, September 1915, in Pollitzer, *Lovingly, Georgia*, 8 and 25. Pollitzer's and O'Keeffe's intense immersion in Stieglitz's publications, as well as journals and books by Greenwich Village radicals, is also detailed in their correspondence for 1915–16, as reprinted in Pollitzer, *Lovingly, Georgia*.

22.	In GOK to AP, June 20, 1917, O'Keeffe reported on her experience at 291 and the trip to Coney Island with Stieglitz, Paul Strand, and a man named Gaisman who had invented the Auto-Strop Razor and the Autograph Camera; in Cowart et al., *Georgia O'Keeffe*, 162–63; Pollitzer, *Woman on Paper*, 164; AS to GOK, Mar. 31, 1918, in Pollitzer, *Woman on Paper*, 159.

23.	Herbert J. Seligmann, *Alfred Stieglitz Talking: Notes on Some of His Conversations, 1925–1931* (New Haven: Yale University Press, 1966), 117, records Stieglitz as recalling that he was initially opposed to her shift from black and white to color.

24.	GOK to AP, Jan. 17, 1917, and GOK to PS, June 3, 1917, in Cowart et al., *Georgia O'Keeffe*, 159–61. The book Strand had given O'Keeffe was probably either a volume on child rearing and child psychology, *Childhood*, by Mrs. Theodore W. Birney, with an introduction by G. Stanley Hall (New York: Frederick A. Stokes, 1905), or a treatise on the representation of the child in English literature, *Childhood*, by Alice Meynell (New York: Fellowship Books, 1913). Theories of children's education would continue to occupy the Stieglitz circle into the 1920s; as evidence, see the chapter Paul Rosenfeld devoted to Margaret Naumburg, a progressive educator and student of Maria Montessori, in Paul Rosenfeld, *Port of New York: Essays on Fourteen American Moderns* (New York: Harcourt, Brace, 1924), 117–34. Naumburg ran a class for young children in the Henry Street settlement in 1913–14 and shortly afterward established her own school, the Walden School, on West Sixty-eighth Street. She married Waldo Frank, a Stieglitz circle intimate, and in 1921 exhibited the artworks of her students at the Bourgeois Gallery, New York, that Rosenfeld again viewed as examples of what Stieglitz had earlier framed as the "natural," pure vision of the child. I thank Marcia Brennan for the reference to Naumburg.

25.	GOK to AP, Sept. 11 and 18, 1916, confides this practice, in Cowart et al., *Georgia O'Keeffe*, 156–57. For her watercolor of a chicken in the child mode, see Lynes, *Georgia O'Keeffe: Catalogue Raisonné*, vol. 1, no. 175.

26.	See GOK to PS, Sept. 12, 1917, CCP, for O'Keeffe's experience of the plains as a song.

27.	On the development of children's drawing practices, see Howard Gardner, *Artful Scribbles: The Significance of Children's Drawings* (New York: Basic Books, 1980), especially 137–49.

28.	Sue Davidson Lowe, *Stieglitz: A Memoir/Biography* (New York: Farrar, Straus and Giroux, 1983), 230.

29.	See Marcia Brennan, *Painting Gender, Constructing Theory: The Alfred Stieglitz Circle and American Formalist Aesthetics* (Cambridge: MIT Press, 2001), chaps. 4–6; Seligmann, *Alfred Stieglitz Talking*, 16, notes for Jan. 22, 1926, records Stieglitz stating that Marin, Dove, and O'Keeffe possessed a "simplicity" that bespoke their "childlikeness"; and 66, on Mar. 2, 1926, calling Marin's watercolors "innocent, like a child."

30. Barbara Buhler Lynes, *O'Keeffe, Stieglitz, and the Critics, 1916–1929* (Chicago: University of Chicago Press, 1991); and Brennan, *Painting Gender.*

31. Alfred Stieglitz, "Woman in Art," in Dorothy Norman, *Alfred Stieglitz: An American Seer* (New York: Aperture, 1973), 136–38.

32. Havelock Ellis, *Studies in the Psychology of Sex*, vol. 3, *Analysis of the Sexual Impulse, Love and Pain, The Sexual Impulse in Women* (Philadelphia: F. A. Davis, 1927), 253, states that "in a certain sense, their [women's] brains are in their wombs. . . . [T]hey may appear to be passing through life always in a rather inert or dreamy state; but, when their sexual emotions are touched, then at once they spring into life; they become alert, resourceful, courageous, indefatigable." Havelock Ellis, *Man and Woman: A Study of Human Secondary Sexual Characters* (London: Walter Scott; New York: Scribner's, 1894), 387, describes women as nearer to children than adult men. Sigmund Freud, "On Narcissism: An Introduction," (1914), in *The Standard Edition of the Complete Psychological Works of Sigmund Freud*, ed. and trans. James Strachey, vol. 14, 1914–1916 (London: Hogarth Press and Institute of Psycho-Analysis), 73–104.

33. Carol Steedman, *Strange Dislocations: Childhood and the Idea of Human Interiority, 1780–1930* (Cambridge, MA: Harvard University Press, 1995), 10–12, 18, 28–29, 41.

34. AS to GOK, Mar. 31, 1918, reprinted in Pollitzer, *Woman on Paper*, 159; See also text, above, at note 22. See also AS to PS, May 27, 1918, CCP, on O'Keeffe as the "Great Child" and AS to Arthur Dove [July 1918], Alfred Stieglitz Papers, YCAL, on O'Keeffe as a "purer form of myself." Richard Whelan, *Alfred Stieglitz: A Biography* (Boston: Little, Brown, 1995), 404, cites all the sources given here.

35. Christopher Lasch, *The New Radicalism in America, 1889–1963: The Intellectual as a Social Type* (New York: Knopf, 1963), 59–63.

36. Anne Middleton Wagner, *Three Artists (Three Women): Modernism and the Art of Hesse, Krasner, and O'Keeffe* (Berkeley: University of California Press, 1993), frames Stieglitz's photographic portrait of O'Keeffe, the primary vehicle through which he created her public image and the narrative for her works, as a benign collaboration. As will become apparent in this chapter, my examination of the primary sources has led me to agree with the differing conclusions presented by Lynes, *O'Keeffe, Stieglitz*, and Sarah Greenough, *Alfred Stieglitz: The Key Set; The Alfred Stieglitz Collection of Photographs, 1886–1922* (Washington, DC: National Gallery of Art; New York: Abrams, 2002), 1:xxxvi– xxxvii.

37. PS to AS, May 18, 1918, CCP; Strand actually reports what O'Keeffe's friend, Leah Harris, who owned the Waring ranch, had told him in confidence.

38. AS to PS, Apr. 27, 1919, CCP.

39. Lowe, *Stieglitz*, 217, quotes AS to Arthur Dove, Aug. 15, 1918, Alfred Stieglitz Papers, YCAL.

40. AS to PS, Nov. 17, 1918, CCP.

41. Lowe, *Stieglitz*, 216–27, recounts that the couple lived first at Elizabeth Davidson's Fifty-ninth Street studio (which Stieglitz's brother, Lee, paid for); moved in 1920 to Lee's house, where they lived for the next four years; and "were fed frequently "at Lee's or his sister, Agnes Engelhard's house." Louise Bryant to Sara Bard Field, June 16, 1916, quoted in Christine Stansell, *American Moderns: Bohemian New York and the Creation of a New Century* (New York: Metropolitan Books, 2000), 253.

42. On professional/love partnerships in modernist New York circles in this period, see Stansell, *American Moderns*, 225–27, 249–58. On 249, Stansell cites Stieglitz and O'Keeffe's partnership as one in a long list of bohemian couples—primarily writers and politicos—who combined love and work.

43. PS to AS, May 18, 1918, CCP; AS to PS, Sept. 10, 1918, CCP; and GOK to PS, June 25, Aug. 16, and Sept. 12, 1917, CCP.

44. On Käsebier's portraits of the Eight as promotional material for publication in newspapers on the eve of their inaugural exhibition, see Barbara L. Michaels, *Gertrude Käsebier: The Photographer and Her Photographs* (New York: Abrams, 1992), 117.

45. This posterboard with clippings is still in the Alfred Stieglitz Papers, YCAL. For the erotic dimension of Whistler's "white girls," the reception of Whistler's *Symphony in White, No. 1: The White Girl* (1862, National Gallery of Art), and the muteness of the figure, see Kathleen Pyne, *Art and the Higher Life: Painting and Evolutionary Thought in Late Nineteenth-Century America* (Austin: University of Texas Press, 1996), chap. 3.

46. AS to Anne Brigman, undated letter [early 1918], Alfred Stieglitz Papers, YCAL, written while Stieglitz was working in the attic room above the old gallery, sorting through the works of art and publications he had collected there.

47. Stieglitz referred to the painting procedures of both Rhoades and O'Keeffe as one of making children; see AS to Katharine Nash Rhoades, May 31, 1916, Alfred Stieglitz Papers, YCAL, in which Stieglitz refers to Rhoades's paintings as "babies." Seligmann, *Alfred Stieglitz Talking*, 73, 134–35, records Stieglitz in 1926 referring to O'Keeffe's paintings as her children; on 78, Stieglitz reports O'Keeffe's postpartum depression after her first painting was "taken away" from her. On O'Keeffe as performing in the tradition of somnabulistic dancers, see Mike Weaver, "Alfred Stieglitz and Ernest Bloch: Art and Hypnosis," *History of Photography* 20 (Winter 1996): 293–303.

48. Georgia O'Keeffe, introduction to *Georgia O'Keeffe: A Portrait by Alfred Stieglitz* (New York: Metropolitan Museum of Art; Viking Press, 1978), n.p.

49. For the Pygmalion comparison, see Whelan, *Alfred Stieglitz*, 484–85; for Svengali, see Weaver, "Alfred Stieglitz and Ernest Bloch," 293–94.

50. Frank was appropriating for Stieglitz's myth a remark often made about Käsebier's relation to her sitters. See Alfred Stieglitz, "How I Came to Photograph Clouds," *Amateur Photographer and Photography* 56 (Sept. 19, 1923), reprinted in Greenough and Hamilton, *Alfred Stieglitz*, 206–8.

51. Mabel Dodge Luhan, "The Art of Georgia O'Keeffe," undated MS (1926– 27?), Mabel Dodge Luhan Papers, YCAL, MSS 196, 1–4. O'Keeffe's letter to Luhan, 1925(?), Georgia O'Keeffe Papers, YCAL, asks Luhan to write about her art from a woman's perspective.

52. Seligmann, *Alfred Stieglitz Talking*, 67, reports Stieglitz's story of his first impression of O'Keeffe's face, circa 1908, from a portrait head by Eugene Speicher that had been entered in a painting contest judged by Stieglitz's father.

53. AS to Arthur Dove, July and August 1918, Alfred Stieglitz Papers, YCAL.

54. Havelock Ellis, "Love and Pain," in *Studies*, vol. 3, especially 184–88. Marius de Zayas, *African Negro Art: Its Influence on Modern Art* (New York: Modern Gallery, 1916), 14, explores the notion of African sculptures as fetish objects that embody both instinctual drives and a spirit force that speaks to the primitive living in a world of terror.

55. Helen Shannon, "African Art, 1914: The Root of Modern Art," in Greenough et al., *Modern Art and America*, 175, fig. 45, identifies the spoon as the work of Guro or Bete people, Ivory Coast, nineteenth or early twentieth century.

56. Wagner offers a reading of O'Keeffe's art that approaches Stieglitz's projected identity for O'Keeffe in this portrait project: in *Three Artists* she imagines how O'Keeffe's art can be apprehended as the projected sensibility of a being who can claim a universal position, one that speaks for both masculinity and femininity.

57. Seligmann, *Alfred Stieglitz Talking*, 41, quotes Stieglitz on O'Keeffe's painting as a "new religion" and on 108 recounts Stieglitz's narrative of his own recognition as a messenger of that religion.

58. See Sinclair Lewis, "Hobohemia: A Farce-Comedy in Three Acts," typed MS, ca. 1918, New York Public Library Collections. The play was produced Feb. 8, 1925, at the Greenwich Village Theater. George Cram Cook and Susan Glaspell wrote another play in this same genre in 1920 for the Provincetown Players. Titled *Suppressed Desires*, it mocked the Villagers' obsessions with Freud, the practice of "psyching," and sex. See George Cram Cook and Frank Shay, eds., *The Provincetown Plays* (Cincinnati, OH: Stewart Kidd, 1921). O'Keeffe kept the 1919 palladium print in her collection until she sold it to Vivian Horan. On the 1921 photo-

graph, see Greenough, *Alfred Stieglitz*, 402, no. 609, *Georgia O'Keeffe with Matisse Sculpture*, palladium print. On the Matisse bronze, *La Vie (Torso with Head)*, 1906, in the Stieglitz collection at the Metropolitan Museum of Art, see John Cauman, "Henri Matisse, 1908, 1910, and 1912: New Evidence of Life," in Greenough et al., *Modern Art and America*, 93, fig. 33.

59. Barbara Michaels, "Rediscovering Gertrude Käsebier," *Image* 19 (June 1976): 31, notes that Stieglitz visited Käsebier's studio in 1902 at the time Käsebier was pursuing her experimental work with hands and feet and showing it to visitors. AS to Anne Brigman, Dec. 24, 1919, Alfred Stieglitz Papers, YCAL.

60. AS to Herbert Seligmann, February 22, 1926, quoted in *Alfred Stieglitz Talking*, 61–62. Nancy Armstrong, "Modernism's Iconophobia and What It Did to Gender," *Modernism/Modernity* 5, no. 2 (1998): 47–75, offers a different interpretation of Stieglitz's nudes of O'Keeffe and other nudes of photographers' lovers in relation to the syntaxes of pornography and modern literature.

61. Susan Stewart, *On Longing: Narratives of the Miniature, the Gigantic, the Souvenir, the Collection* (Durham, NC: Duke University Press, 1993), 116–17, 125, explains this identification of the subject with the child and the mother as part of the process by which the subject is created: "In the play of identity and difference out of which the subject 'appears' at any given point, the relation between childhood and the present . . . constitutes an imaginary at either end: for the child, the mother as object of desire; for the adult, the image of the past, the dual relation before it was lost, the pure body-within-the-body, which is only approximated in reproduction." The adult's desire for this lost state of childhood manifests itself in the form of a "pure object," which "will remain complete at a distance."

62. Lynes, *Georgia O'Keeffe: Catalogue Raisonné*, 1:106, no. 176, confirms that according to the Stieglitz-O'Keeffe correspondence these watercolor nudes were self-portraits.

63. Stieglitz also exhibited two less provocative portraits of O'Keeffe—one of her hands and one of her head—in March 1919 at the Young Women's Hebrew Association, New York, that went relatively unnoticed by critics.

64. Greenough, *Alfred Stieglitz*, xxxvii, lvi n. 144, suggests that most of the nudes were made in the first three years O'Keeffe was with Stieglitz, 1918–20, and that by 1920 Stieglitz had run out of new ways to photograph her; Greenough also states that the "Key Set" contains all but two nudes of O'Keeffe; in that set, nos. 676 (1921), 677 (1921), and 827 (1922) were probably the last nudes Stieglitz made of O'Keeffe until the seven torsos of 1931, nos. 1438–44. Lynes, *O'Keeffe, Stieglitz*, 131–33, observes that O'Keeffe's appearance in Stieglitz's photographs of the

1920s ran counter to the narrative frame Stieglitz and the critics gave to her paintings and that this sensuous O'Keeffe portrayed in the criticism was no longer available to the public except in an imaginary way.

65. Lynes, conversation with the author, July 12, 2003. On Millay's attempt to change her public image, see Daniel Mark Epstein, *What Lips My Lips Have Kissed: The Loves and Love Poems of Edna St. Vincent Millay* (New York: Holt, 2001), 135, who cites a portrait of herself that Millay commissioned from the photographer Berenice Abbott in which she presents herself in a tailored suit.

66. Rebecca Strand (hereafter RS) to PS, Sept. 20 and 21, 1923, CCP. See Paul Rosenfeld, "American Painting," *Dial* 71 (Dec. 1921): 649–70, reprinted in Lynes, *O'Keeffe, Stieglitz,* 171–74; "The Paintings of Georgia O'Keeffe," *Vanity Fair* (Oct. 1922): 56, 112, 114; and *Port of New York,* 198–210.

67. Seligmann, *Alfred Stieglitz Talking,* 13, states that Stieglitz was still buying first editions of Lawrence's works at auction in 1926. In 1913 Mitchell Kennerley published Lawrence's *Sons and Lovers* and *Love Poems and Others.* Stieglitz's volumes of *The Rainbow* and *Women in Love* in the Abiquiu Book Room were published in 1915 and 1920 respectively. Rosenfeld's inscription in his gift volume of Lawrence's poems reads, "To Georgia O'Keefe [sic] / and Alfred Stieglitz— / To whom this book belongs / Paul Rosenfeld / June 1920." Lynes, *O'Keeffe, Stieglitz,* 46–50, also comments on the collaborative nature of Rosenfeld's writing and its investment in Lawrence's language and details Marsden Hartley's and Paul Strand's contributions to propagating Stieglitz's Freudian interpretations of O'Keeffe's work; see also Brennan, *Painting Gender,* 100–105, and Bonnie Grad, "Georgia O'Keeffe's Lawrencean Vision," *Archives of American Art Journal* 38 (2000): 2–19.

68. Sheila Rowbotham, "Edward Carpenter: Prophet of the New Life," in *Socialism and the New Life: The Personal and Sexual Politics of Edward Carpenter and Havelock Ellis,* ed. Sheila Rowbotham and Jeffrey Weeks (London: Pluto Press, 1977).

69. See Paul Rosenfeld, "Georgia O'Keeffe," in *Port of New York,* 202.

70. RS to AS, Aug. 7, 1922, Alfred Stieglitz Papers, YCAL, described four of the O'Keeffe paintings hanging in the bedroom of Rosenfeld's house at Westport, Connecticut, where she was vacationing. Three of them were probably those reproduced in "Paintings of Georgia O'Keeffe," 56: *Apple Family I* (1922, private collection, Santa Fe); *Tree and Mountain near Lake George* (ca. 1921, destroyed by O'Keeffe); and *Series I, No. 7* (1919; see Fig. 147), which Strand mistakenly called one of the "black spot" works. For these three paintings, see Lynes, *Georgia O'Keeffe: Catalogue Raisonné,* vol. 1, nos. 279 and 316, and vol. 2, appendix 2, no. 31.

71. Rosenfeld, "Georgia O'Keeffe," 199; "Paintings of Georgia O'Keeffe," 117.

72. Rosenfeld, "Paintings of Georgia O'Keeffe," 56, 112, 114.

73. On O'Keeffe's "fury," see GOK to Mitchell Kennerley, fall 1922, and GOK to Sherwood Anderson, Sept. 1923, cited in Lynes, *O'Keeffe, Stieglitz*, 58 and 70, also reprinted in Cowart et al., *Georgia O'Keeffe*, 170–71, 174. On his conceit of O'Keeffe as a "Whiteness," see AS to Sherwood Anderson, June 22, 1923, Alfred Stieglitz Papers, YCAL. Seligmann, *Alfred Stieglitz Talking*, 64, records Stieglitz in 1926 as still visualizing O'Keeffe as whiteness. Paul Rosenfeld, "American Painting," reprinted in Lynes, *O'Keeffe, Stieglitz*, 171–74. Lynes also recapitulates the eroticized thematics Stieglitz continued to generate in the criticism of O'Keeffe's work; see especially Lewis Mumford, "O'Keefe [*sic*] and Matisse," *New Republic* 50 (Mar. 2, 1927): 41–42, reprinted in Lynes, *O'Keeffe, Stieglitz*, 264–66; Louis Kalonyme, "Georgia O'Keeffe: A Woman in Painting," *Creative Art* 2 (Jan. 1928): xxxiv–xl, reprinted in Lynes, *O'Keeffe, Stieglitz*, 278–82; and Blanche Matthias, "Georgia O'Keeffe and the Intimate Gallery: Stieglitz Showing Seven Americans," *Chicago Evening Post Magazine of the Art World*, Mar. 2, 1926, 1, 14, reprinted in Lynes, *O'Keeffe, Stieglitz*, 246–50; Matthias foregrounds the image of O'Keeffe as the intuitive child, though she divests that image of its usual eroticism. Brennan, *Painting Gender*, 121, refers to the process of Rosenfeld's criticism as the embodiment of O'Keeffe in her images and describes how O'Keeffe's oscillating response to this criticism makes clear her predicament in going against Stieglitz.

74. O'Keeffe, introduction to *Georgia O'Keeffe: A Portrait by Alfred Stieglitz*.

75. GOK to AS, July 27, 1916, in Cowart et al., *Georgia O'Keeffe*, 154.

76. GOK to PS, Sept. 12, 1917, CCP.

77. O'Keeffe told Pollitzer that she would like to have Stieglitz's approval more than anyone's; GOK to AP, Oct. 11, 1915, Georgia O'Keeffe Papers, YCAL. She had also sought "Pa" Dow's approval of her work after her second exhibition in 1917; see Arthur W. Dow to GOK, Apr. 24, 1917, and GOK to AP, Sept. 18, 1916, both in Georgia O'Keeffe Papers, YCAL. O'Keeffe calls Dow "Pa Dow" in Cowart et al., *Georgia O'Keeffe*, 157– 58. O'Keeffe confided her competitive drive and her need to be "on top" to Carol Merrill; see C. S. Merrill, *O'Keeffe: Days in a Life* (Albuquerque, NM: La Alameda Press, 1995), 14. In "Notes on an Interview with Frances O'Brien," typescript of an interview by Nancy Wall, taped Mar. 29, 1986–May 2, 1987, file #OB2300, Library, Georgia O'Keeffe Museum Research Center, on 59 and 80, O'Brien quotes Stieglitz on O'Keeffe's drive toward fame and comments on her competitiveness with her four sisters. O'Brien was on intimate terms with Stieglitz and O'Keeffe; for periods of time she stayed at their homes in New York City and at Lake George and later at Abiquiu.

78. AS to PS, Nov. 10, 1918, CCP, called O'Keeffe "not a talker—nor a questioner." O'Keeffe explained to Carol Merrill that she customarily responded with silence to things printed about her that she felt were untrue, in hopes that they would eventually go away; see Merrill, *O'Keeffe*, 63. On O'Keeffe's battle with Stieglitz to have a child, see Lowe, *Stieglitz*, 247. Stieglitz states that O'Keeffe gives birth to her children in art in his 1919 essay "Woman in Art"; Seligmann, *Alfred Stieglitz Talking*, 73, 134–35, records Stieglitz in 1926 as still referring to O'Keeffe's works as her children.

79. See the exhibition catalogs for O'Keeffe's shows of 1923, 1924, and 1925 at the Anderson Galleries, all of which were titled to reflect his presentation of her work: "Alfred Stieglitz Presents the Paintings of Georgia O'Keeffe."

80. GOK to Blanche Matthias, Mar. 1926, in Cowart et al., *Georgia O'Keeffe*, 183.

81. Lowe, *Stieglitz*, 260, comments on O'Keeffe's feeling of safety with and dependence on Stieglitz; Lynes, *O'Keeffe, Stieglitz*, 56, remarks on the impact of the *Portrait* on O'Keeffe's self-image. In AS to PS, Nov. 17, 1918, CCP, Stieglitz added to the statement about O'Keeffe's selves, "There are very many." Merrill, *O'Keeffe*, 65, reports that O'Keeffe, in March 1977, told her that Stieglitz's photographic *Portrait* made her see her face differently, as long instead of round.

82. Lowe, *Stieglitz*, 242.

83. See, for example, AS to Sherwood Anderson, Sept. 5, 1924, and to Herbert Seligmann, June 19, 1928, Alfred Stieglitz Papers, YCAL, for Stieglitz's complaint that O'Keeffe lets "so many meaningless things upset her." In AS to Paul Rosenfeld, Nov. 20, 1923, Alfred Stieglitz Papers, YCAL, Stieglitz once again invoked the child metaphor for himself and O'Keeffe, this time referring to their helplessness at organizing their lives.

84. AS to Waldo Frank, Nov. 26, 1920, Alfred Stieglitz Papers, YCAL, and AS to PS, Oct. 9, 1920, CCP.

85. RS to PS, Aug. 8 and 10, 1924, CCP.

86. RS to PS, Sept. 27 and 28, 1923, CCP; Strand continues, "Well, it's all terrible. . . . Rosenfeld felt he couldn't work here. Said he had never been in such a hell, but he'll get used to it. It's good for him to see that everything isn't quite so romantic and rosy as it seems."

87. Seligmann, *Alfred Stieglitz Talking*, 70–71, records Stieglitz's story of one of Rhoades's uncles visiting the 1924 exhibition of Stieglitz and O'Keeffe at Anderson Galleries. Telling this incident from the distance of two years later, in 1926, Stieglitz capitalized on the opportunity to lament Rhoades's failure to develop, in contrast to O'Keeffe's triumph. Nancy Newhall, "Notes for a Biography of Alfred

Stieglitz," Beaumont and Nancy Newhall Papers, Special Collections and Visual Resources, Getty Research Institute for the History of Art and the Humanities, 28.

88. Georgia O'Keeffe, "Stieglitz: His Pictures Collected Him," *New York Times Magazine*, Dec. 11, 1949, 24.

89. Lynes, *O'Keeffe, Stieglitz*, 159; O'Keeffe, introduction to *Georgia O'Keeffe: A Portrait by Alfred Stieglitz*, n.p.

90. Marcia Brennan to the author, Dec. 11, 1999.

91. Lynes, *O'Keeffe, Stieglitz*. Merrill, *O'Keeffe*, 63, reported O'Keeffe's comments, in Mar. 1977, on the strategy of silence as a response to writing about her work with which she disagreed: "I have found that when something is written which is untrue, it is best not to comment because that only draws attention to it. Otherwise it disappears and fewer people notice it."

92. Barbara Buhler Lynes, "O'Keeffe's O'Keeffe's," seminar presentation, Georgia O'Keeffe Museum Research Center, Sept. 25, 2001; see also Barbara Buhler Lynes, "O'Keeffe's O'Keeffes: The Artist's Collection," in *O'Keeffe's O'Keeffes: The Artist's Collection* (New York: Thames and Hudson, 2001), 29–70.

93. Newhall, "Notes," entry for Feb. 18, 1942, 23. In the early 1960s, when the Beinecke Library at Yale University was soliciting manuscripts for its growing Stieglitz Archives, O'Keeffe, concerned to guard both her privacy and the romantic myth of her partnership with Stieglitz, asked Rebecca Strand (then James) not to give the library "anything that had to do with . . . struggle" between her and Stieglitz. Rebecca Strand James to GOK, Sept. 6, 1963, Georgia O'Keeffe Papers, YCAL. James did not heed her friend's plea.

94. RS to PS, June 19, 1929, CCP.

95. O'Keeffe told Pollitzer that the *Portrait* "had nothing to do with me personally," in Pollitzer, *Woman on Paper*, 168. O'Keeffe, introduction to *Georgia O'Keeffe: A Portrait by Alfred Stieglitz*, n.p. Greenough, in *Alfred Stieglitz*, 1:xxxviii, confronts the forced nature of the collaboration, quoting O'Keeffe's statements to Perry Miller Adato and others that the nudes of the *Portrait* were made according to his desire, not hers.

96. Matthias, "Georgia O'Keeffe," reprinted in Lynes, *O'Keeffe, Stieglitz*, 247. O'Keeffe's approval of Matthias's review as "one of the best things that have been done on me" is recorded in GOK to Matthias, Mar. 1926, Georgia O'Keeffe Papers, YCAL, reprinted in Cowart et al., *O'Keeffe*, 183; GOK to Waldo Frank, summer 1926, Georgia O'Keeffe Papers, YCAL, reprinted in Cowart et al., *O'Keeffe*, 184.

97. Lynes, *O'Keeffe, Stieglitz*, on 61, 73, 97, and 159, remarks on O'Keeffe's efforts to change the direction of her work from abstraction to representation after she re-

alized, in 1923, the impact of Stieglitz's eroticized narrative of her art. On 158, Lynes quotes O'Keeffe's ruminations to Michael Gold, a reporter for the *New Masses*, on the difficulty of producing a distinctly feminine art, a form of "painting that is all of a woman, as well as all of me"; originally printed in Gladys Oaks, "Radical Writer and Woman Artist Clash on Propaganda and Its Uses," *New York World*, Mar. 16, 1930, Women's section, 1, 3.

98. Barbara Buhler Lynes, *Georgia O'Keeffe* (New York: Rizzoli, 1993), n.p., notes that after 1923, even when O'Keeffe worked in an abstract mode, the natural forms inspiring the abstractions are more readily identifiable than in her earlier work; and Barbara Buhler Lynes, "The Language of Criticism: Its Effect on Georgia O'Keeffe's Art in the 1920s," in *From the Faraway Nearby: Georgia O'Keeffe as Icon*, ed. Christopher Merrill and Ellen Bradbury (Reading, MA: Addison-Wesley, 1992), 43–54.

99. Peters, *Becoming O'Keeffe*, credits O'Keeffe's formation in Dow's system and explores the photographic vision of O'Keeffe's paintings as a direct dialogue in which she engaged with Stieglitz and several of the Photo-Secessionists. I see Dow's system of composition as one that presented an inherently similar framing system to that of the mobile photographic lens. Thus O'Keeffe and the Photo-Secessionists were already working on the principles of the same system, even before O'Keeffe became aware of their photography and hence the attractiveness—even comfortableness—of their work for her.

100. See "Notes on an Interview with Frances O'Brien," typescript, 26 and 54.

101. Ibid., 20 and 105. O'Keeffe also related to Perry Miller Adato that she first saw shapes in her head and was often unaware of the sources of these shapes or that she was repeating shapes from her earlier works; in Adato's film, *Georgia O'Keeffe*, WNET/New York, 1977.

102. Gardner, *Artful Scribbles*, 150–51.

103. See, for example, the interviews of O'Keeffe in 1927 by Dorothy Adlow and Frances O'Brien, both reprinted in Lynes, *O'Keeffe, Stieglitz*, 268–72. GOK to Mitchell Kennerley, Jan. 20, 1929, no. 41 in Cowart et al., *Georgia O'Keeffe*, 187. In the same letter O'Keeffe speaks of her painting *Red Barn, Wisconsin*, 1928, as projecting the "healthy part of me . . . my childhood," which clearly stands in her mind as a golden period of freedom that she can recapture only fleetingly at Lake George, where everyone and everything seems to conspire against her achieving a creative state. In her letter to Waldo Frank, summer 1926, no. 37 in Cowart et al., *Georgia O'Keeffe*, 184, O'Keeffe speaks of her thought process as intuitive and of her inability to know how she arrives at certain ideas. Decades after her summers at the Lake George compound, O'Keeffe was still lashing out at Stieglitz for

what she viewed as his suffocating regulation of her life there; Georgia O'Keeffe, interview by Charlotte Willard, 1960, tape recording, Georgia O'Keeffe Museum Research Center; and Adato's film, *Georgia O'Keeffe*.

104. Presumably, O'Keeffe recounted these episodes of the dollhouse and her conflict with her mother to Anita Pollitzer, who recapitulated them in *Woman on Paper*, 60–61. In her narrative of her childhood, O'Keeffe emphasized her solitude in nature as her essential condition for happiness.

105. According to O'Brien, O'Keeffe often spent her evenings reclining on a sofa, listening to Bach; and at Lake George in the 1920s O'Keeffe labored to perfect the edges of things; see "Notes on an Interview with Frances O'Brien," 5 and 18.

106. Kalonyme, "Georgia O'Keeffe," xxxiv–xl, and Henry McBride, "Paintings by Georgia O'Keefe [sic]: Decorative Art That Is Also Occult at the Intimate Gallery," *New York Sun*, Feb. 9, 1929, 7, both reprinted in Lynes, *O'Keeffe, Stieglitz*, 278–82 and 295–96.

107. GOK to Mitchell Kennerley, Jan. 20, 1929, Georgia O'Keeffe Papers, YCAL, reprinted in Cowart et al., *Georgia O'Keeffe*, 187.

108. On the problem of visualizing the body's interior spaces and its erotogenic zones, see Stewart, *On Longing*, 104. Anna C. Chave, "O'Keeffe and the Masculine Gaze," *Art in America* 78 (Jan. 1990): 114–25, 177, continues this critical tradition in articulating O'Keeffe's abstractions and flowers as representations of her "experience of her own body" and as metaphors for her "experience of space and penetrability"—that is, as projections of O'Keeffe's desire.

109. See Vivian Green Fryd, "Georgia O'Keeffe's *Radiator Building*: Gender, Sexuality, Modernism, and Urban Imagery," *Winterthur Portfolio* 35, no. 4 (2000): 269–89.

110. Kalonyme, "Georgia O'Keeffe," xxxiv–xl, and McBride, "Paintings by Georgia O'Keefe," 7, both reprinted in Lynes, *O'Keeffe, Stieglitz*, 278–82 and 295–96.

111. Elaine Showalter, *Sister's Choice: Tradition and Change in American Women's Writing* (Oxford: Clarendon Press, 1991), 110–11.

112. AS to Herbert Seligmann, June 28, 1928, Alfred Stieglitz Papers, YCAL.

113. GOK to Ettie Stettheimer, Aug. 24, 1929, Georgia O'Keeffe Papers, YCAL, also reprinted in Cowart et al., *Georgia O'Keeffe*, 195; for Strand's testimony on this point, see n. 115 below.

114. O'Keeffe complained to Lilian Sabine, "It is much more difficult to go on now than it was before. Every year I have to carry the thing I do further so that people are surprised again." See Sabine, "Record Price for Living Artist: Canvases of Georgia O'Keeffe Were Kept in Storage for Three Years until Market Was Right for Them,"

Brooklyn Sunday Eagle Magazine, May 27, 1928, 11, Edward Alden Jewell, "Georgia O'Keeffe," *New York Times*, Feb. 10, 1929, sec. 9, 12, and Murdock Pemberton, "Mostly American," *Creative Art* 4 (Mar. 1929): l–li, all reprinted in Lynes, *O'Keeffe, Stieglitz*, 288–91, 296–97, and 298–99; see also Gladys Oaks, "Radical Writer," cited in Lynes, *O'Keeffe, Stieglitz*, 158, for O'Keeffe's comment on her continual search for new forms of purely feminine expression.

115. RS to PS, May 4, 1929, CCP. Strand remarked to her husband that O'Keeffe appeared greatly regenerated immediately after their arrival in Taos and that now O'Keeffe could work at her own pace: "Stieglitz's tempo is certainly too fast for her and is bad for her, when she can't keep up." In a letter of May 5, 1929, CCP, Rebecca reflected to Paul on how Stieglitz would disapprove of O'Keeffe's and Strand's leisurely days and on O'Keeffe's state of exhaustion: "I am sure Stieglitz would feel Georgia is frittering away a lot of time, but she really needs this letdown." RS to AS, May 14, 1929, Alfred Stieglitz Papers, YCAL, describes O'Keeffe's transformation to an irate Stieglitz.

116. In a conversation with the author (Oct. 10, 2000), Sue Davidson Lowe stated that O'Keeffe was playing with the critics in her conception of the jacks; Lowe cited as evidence a letter in her possession from Georgia Engelhard who reported on O'Keeffe's thinking as O'Keeffe was beginning the series.

117. For her statement to Seligmann, see Adato's film *Georgia O'Keeffe*.

118. Milford, in *Savage Beauty*, relates that in 1912 Millay's admirer and friend the poet Arthur Davison Ficke addressed Millay as a "wonder-child," preceding Stieglitz's address of Rhoades and then O'Keeffe as a "wonder-child" by a few years (80).

119. On Millay's perceived childlike persona and her image in the press as a "lovely, fragile child," see Milford, *Savage Beauty*, esp. 331–33; on 340–41, Milford quotes O'Keeffe's undated letter to Millay.

Index

Page numbers in italics refer to figures.

Bryant, Louise, 217

Buddhism, 107, 179

Buffalo, International Exhibition of Pictorial Photography, 28, 60, 85–86

Caffin, Charles, 6, 10, 32, 33, 90, 152, 161, 284n48

Camera clubs, 4, 19, 20, 21

Camera Notes: and Aestheticism, 5; and Japanese art, 8; and Käsebier's work, 23, 28, 29, 32; and Keiley's writing, 32; and pictorialism, 8; Stieglitz as editor of, 4, 5, 8, 23, 28, 29; and Whistler's work, 8

Camera Work: and Arts and Crafts movement, 67; and Bergson's writing, 118–19, 126–27, 145, 192; and Boughton's work, 86; and Brigman's work, 67, 68, 73, 76–77, 86, 105; and Caffin's writing, 32, 33, 60, 90; and de Casseres's writing, 15, 280n18; and Demachy's work, 69; and Hapgood's writing, 147; and Hartmann's writing, 6, 11; and Kandinsky's writing, 118, 192; and Käsebier's work, 3, 16, 23, 28, 37, 38, 40, 60; and Keiley's writing, 60; and Laurvik's writing, 76; and Maeterlinck, 5–6, 53, 280n13; and Matisse's work, 79; and Meyer's writing, 164, 280n18; and Photo-Secession, 32; and "psychopathic" art, 167; and Rodin's work, 75, 79, 280n18; and Pamela Colman Smith's work, 53; and Steichen's work, 73; Stieglitz as editor of, 3, 5, 8, 16, 23, 28, 32, 37, 38, 40, 43, 60, 76, 105, 117, 123, 126–27, 145, 147, 167, 272n22; and Symbolism, 5–6, 270n7; and Whistler's work, 5–6, 8

Capitalism, 121, 122, 229

Carles, Arthur, 126, 133–34, 134, 138, 159, 161, 187, 291–92nn37–38

Carpenter, Edward, xxxii, 64, 81, 84, 100, 121–22, 129, 137, 142, 155, 171, 183, 237, 285n66

Cassatt, Mary, 21, 29, 29, 30

Catholicism, 59

Cézanne, Paul, 59, 75, 76, 126, 144

Chase, William Merritt, 4

Childhood: and Bergson's writing, 156; and Bourne's writing, 146–47; and Brigman's identity, 67; and Cézanne's work, 144; and Dewey's writing, 296n77; and domestic sphere, 154, 298n86; and female sexuality, 61, 155; and femininity, 15, 41, 61, 123, 142–43, 153–56, 210, 298n86; and Freud's writing, 156; and gender, 298n86; and intuition, 145, 146, 152, 155, 193, 240, 244, 247, 296n77; and Käsebier's identity, 47; and Käsebier's work, 2, 4, 15, 18, 20–22, 27, 35, 37, 38, 41, 189; and Marin's work, 299n90, 309n29; and Millay's identity, 266, 320nn118–19; and modernism, xxxviii–xxxix, 143–44, 153, 169, 170, 216–17, 241; and nostalgia, 14, 15; and O'Keeffe's identity, xxxviii, 193, 211, 216, 244; and primitivism, 148–50, 153–56; and production of art, 143–46; and Rhoades's identity, 141–42, 189; and Rhoades's work, 125; and Rodin's work, 76; and Romanticism, 141, 143, 298n86; and self, xxxix, 153, 170; and Pamela Colman Smith's identity, 47, 55, 61; and Pamela Colman Smith's work, 55; and Steichen's work, 15; and Stieglitz's cultural agenda, 67, 123, 125, 167, 211, 309n29; and Stieglitz's identity, 113, 217, 231; and unconscious, 170; and Walkowitz's work, 144, 211; and whiteness, 31, 61; and White's work, 15. *See also* Woman-child

Children's art, 143, 145–48, 151–54, 167, 170, 193, 206, 209, 210, 295n66, 298n84, 299nn87–88, 309n24; and children's dance, 147, 156–57; and creativity, xxxix, 145, 148, 210, 211, 240, 296n77; and Gardner's theory of development, 248–49; and Kandinsky's work, 143, 144–45, 295n66; and Matisse's work, 144, 146; and O'Keeffe's work, xxxviii, 193, 206, 209, 210, 240, 244, 247–50, 252, 309n29; and Rousseau's work, 144; and Stieglitz, 143–48; 151–54

Chinese art, 179, 181

Class, social, 148

Coburn, Alvin Langdon, 5, 33, 63, 78, 86

Columbia University, 8, 118, 127, 145, 196

Commercial activity: of artists, 9, 42, 43, 47, 60; of women, 20, 42, 43, 47, 60. *See also* Anticommercialism

Commercial photography, 42, 43, 44, 60

Cordoba, Mercedes de, 126, 133, 291–92nn37–38

Core self, 92, 122, 123, 140, 150, 261. *See also* Inner self

Costumery: and Bakst's designs, 196–97, 202; and Duncan's dance, 89, 117; and Käsebier's identity, 46–47, 78; and Käsebier's work, 27, 35, 39–40, 45–46; and Rhoades's identity, 117, 184

Cox, Kenyon, 147

Crane, Walter, 27, 51, 276n65

Creativity: of Brigman, 93; and childhood, xxxix, 145, 148, 210, 211, 240, 296n77; and female sexuality, xxxviii, 217, 228; and femininity, 1, 210, 221, 225; of Käsebier, 1, 21; and masculine sexuality, 211; and maternity, xxxiv, 21; and modernism, xxxvi, 64, 217; of O'Keeffe, xxxviii, xxxix, 221, 225, 228, 240, 243, 248; and sexual drive, xxxviii, 80, 136–37, 155; of Pamela Colman Smith, 55; of Stieglitz, 155, 217, 231; and unconscious, 64, 118, 123, 204, 214

Cunningham, Imogen, 108, 109

Dada, 164

Dahl-Wolfe, Louise, 108

Dance: and Brigman's work, xxxiv, xxxv, 64, 87, 89, 99, 102, 223; and childhood, 147, 156–57; and Duncan, xxxiv, 87, 89–90, 99, 283n45, 284n48; and female body, 64; and modernism, 87, 91–92; and Nijinsky, 197; and Photo-Secession, 87; and self, xxxiv, 87; and Stieglitz's cultural agenda, xxxiv, 80, 90–91; and Stieglitz's portrait of O'Keeffe, xxxiv, 223–24

"Dark lady," Stieglitz's obsession with, xxxv–xxxvi

Darkness: and Brigman's work, 73, 104, 106–8; and Hartmann's writing, 14; and Käsebier's work, 26, 27, 38; and Pamela Colman Smith's work, 58, 59; and Steichen's work, 35, 73; and Stieglitz's portraits of O'Keeffe, 233–34; and Whistler's work, 6

Dassonville, William, 108, 109

Daughterhood, 3, 31, 78, 85

Davies, Arthur B., 91, 91, 132

Day, F. Holland, 20, 30, 33, 272n22

Debussy, Claude, 197

De Casseres, Benjamin, 14, 15, 53, 55, 75–76

Dell, Floyd, 81, 99, 137, 205

Delphic Studios (New York), 304n137

Demachy, Robert, 56, 57, 58, 69, 70, 72, 93

Dematerialization, 11, 16, 34, 39, 56, 77

Depth psychology, xxxix, 5, 14, 131

Design: and Bakst's work, xxxv, 196–97, 202; and O'Keeffe's work, 195–97, 202, 245, 248; and Pamela Colman Smith's work, 48

Desire: and free love, 187; and nostalgia, xxxix; and O'Keeffe's work, 319n108; and Pamela Colman Smith's work, 51; and Symbolism, 59

Desire, female: and production of art, 155; and sexology, 82, 155; and Whistler's work, 10

Desire, male: and de Cassere's writing, 15; and production of art, 15; and Rhoades's identity, 117

Dewey, John, 296n77, 298n84, 299n88

Dewing, Thomas W., 11, 12, 13

De Zayas, Marius, 59, 83, 84, 148–50, 161, 164, 166, 168, 169, 185, 186, 291n32, 297nn81–82, 301n108, 304n133, 312n54

Disembodiment: and femininity, 1, 10; and Käsebier's work, 15, 16, 56, 78; and Rhoades's work, 179; and Whistler's work, 1, 11

Dodge (Luhan), Mabel, 135, 173, 174, 175, 183, 187, 224

Domestic sphere: and Brigman's identity, 110, 111; and Brigman's work, 63; and childhood, 154, 298n86; and femininity, xxix, xxxi, 41; and Käsebier's work, 2, 41, 43, 58; and middle class, 63; and women's autonomy, 18

Dove, Arthur, 122, 123, 164, 211, 219, 219–20, 227, 309n29

Dow, Arthur Wesley, 4, 8, 27, 32, 43, 47, 51, 181, 182, 245, 246, 247, 248, 276n65, 315n77, 318n99

Dreams: and Freud's writing, xxxv, 52, 119, 132, 141, 175; and Davies's work, 92; and Maeterlinck's writing, 5; and Rhoades-Stieglitz friendship, xxxv, 132, 141, 167, 175–76; and Schreiner's writing, 176, 303n129; and Seeley's work, 11; and Pamela Colman Smith's work, 52, 58; and Whistler's work, 6

Dresser, Christopher, 187, 195

Duchamp, Marcel, 110, 122, 289n19

Duncan, Charles, 167, 170, 171, 173, 175, 177, 195

Duncan, Isadora, xxxiv, 78, 88, 89–90, 92, 99, 117, 157, 283n45, 284n48

Eastman, Max, 81

Education: of children, 149, 151–52, 206, 309n24; of women, 17, 18–19, 272n28

Ellis, Havelock, xxxii, xxxiv, 64, 81–82, 119–21, 122, 132, 135, 136, 137, 142–43, 153, 155, 167, 176, 228, 282n28, 288n11, 310n32

Engelhard, Georgia, 153, 154, 170, 193, 194, 210–11, 213, 234, 235, 295n66

Equality, women's, 17, 19, 20, 33, 97, 138, 139, 294n53

Eroticism: and Freud's writing, 135; and Käsebier's work, 39; and Key's writing, 136–37; and modernism, xxix, 81, 82, 108, 110, 125, 167; and O'Keeffe's identity, xxxi, xxxviii, 211, 221; and O'Keeffe's work, xxxvii, 170, 176, 181, 183, 245, 318n97; and Rodin's drawings, 75–76; and Pamela Colman Smith's work, 51; and Steichen's work, 75; and Stieglitz's cultural agenda, xxix, xxxi, xxxv, 81, 82, 84, 108, 110, 181, 183, 280n18; and Stieglitz's portraits of O'Keeffe, 221, 224, 225, 228, 233, 234, 243, 244; and Whistler's work, 221

Eugene, Frank, 5

Evolution: and Bergson's writing, 118, 119, 296n72; and Brigman's work, 92, 107, 286n78; and Carpenter's writing, 84, 121; and female identity, 78; and Hartmann's writing, 11; and Key's writing, 99; and Spencer's writing, 149, 156; and spiritualism, 48, 181; and utopianism, 122

Family relations: and female separatism, 18; of Käsebier, 3, 18, 42, 47; and Käsebier's work, 20; of O'Keeffe, 183, 187–88, 241, 249; of Rhoades, 132–33, 140–41

Fauvism, 159, 161, 164

Femininity: and Brigman's identity, 110; and Brigman's work, 102, 106, 108, 225; and childhood, 15, 41, 61, 123, 142–43, 153–56, 210, 298n86; and disembodiment, 1, 10; and domestic sphere, xxix, xxxi, 41; and Duncan's dance, 90; and Freud's writing, 156, 215; and intuition, 19, 32, 56, 66, 142, 155, 183, 278n79; and Käsebier's work, xxxiii, xxxiv, 1–3, 15–17, 27, 32–34, 37, 38, 41, 46, 58, 60, 61, 68; and middle class, 33, 44; and modernism, xxix–xxxv, 61, 216, 267n4; and O'Keeffe's identity, 61, 90, 224–26; and O'Keeffe's work, 244, 245, 253, 261–65, 320n114; and Photo-Secession, 15–17; and pictorialism, 3, 15; and primitivism, 142, 154–55, 183; and production of art, 33; and progressive values, 16, 18, 27, 41, 68; and self, xxix, xxxi, 60, 106, 108, 123; and Pamela Colman Smith's identity, 61; and Steichen's work, 161; and Stieglitz's cultural agenda, xxxii, 3, 15–17, 61, 90, 123, 153, 154, 211; and Stieglitz's portraits of O'Keeffe, 224–26, 233; and unconscious, 14; and veiling, 1; and Whistler's work, 23, 280n14; and white girl, 10, 15; and whiteness, 23, 38, 46, 61

Feminism: and Brigman's work, 64, 81, 98, 99, 101, 104, 105, 110, 111, 115, 136; and Carpenter's writing, 121; and gender hierarchy, 139; and Käsebier's identity, 18; and Key's writing, 99, 136, 176; and Rhoades's identity, 185;

Mysticism: and Bergson's writing, 118, 119, 121; and Carpenter's writing, 122; and Dodge's identity, 173, 175; and Ellis's writing, 120; and feminine voice, 56, 58; and Kandinsky's writing, 119, 121, 289n19; and Käsebier's identity, 58, 61; and Käsebier's work, 56; and D. H. Lawrence's writing, 237; and modernism, 180, 181; and modernist self-fashioning, 171; and O'Keeffe's work, 178, 181, 261; and Rhoades's work, 179–81; and self, 119, 122; and Pamela Colman Smith's identity, 48, 52, 61, 185; and Pamela Colman Smith's work, xxxiv, 58; and Stieglitz's cultural agenda, 181; and unconscious, 119, 181

Narcissism, 15, 23, 156, 215, 235, 273n37
National Arts Club (New York), 77, 133
National Gallery of Art (Washington, D.C.), 229
Native American culture, 35, 37–38, 150
Nature: and Brigman's work, 64, 66, 71–72, 77, 85, 86, 93, 99–101, 106, 109, 225, 265, 281n24; and Davies's work, 92; and Duncan's dance, 89; and Käsebier's work, 35, 37, 38, 56; and D. H. Lawrence's writing, 237; and O'Keeffe's work, 202, 204, 209, 238, 239, 245, 250, 252–53, 255, 265, 318n98; and Rhoades's identity, 116; and Pamela Colman Smith's work, 48, 51, 53; Stieglitz's experience of, 111; and Stieglitz's work, 109
Naumburg, Margaret, 309n24
Negatives, photographic: and Brigman's work, 69; and Demachy's work, 69; and Käsebier's work, 23–24, 30, 39, 58; and Steichen's work, 117; and Stieglitz's cultural agenda, 5
Nesbit, Evelyn, 39–40, 40, 221
Neurosis, xxxvii, 119, 135, 169
Newhall, Nancy, 242
New York: Brigman's art received in, 82–83, 105; Brigman's extended stay in, 80–81, 82–83, 123; Duncan's dance received in, 87, 89, 90–92, 157; Käsebier's portraiture in, 39, 42,

60; Rodin's art received in, 75; Pamela Colman Smith as resident of, 47–48; Pamela Colman Smith's art received in, 52–53, 58; Whistler's work received in, 6, 8. *See also* Greenwich Village
Nietzsche, Friedrich, 132
Nijinsky, Vaslav, 197
Nostalgia, xxxix, 14–15, 231, 268n6
Nude, female: and Brigman's work, xxxiv, 63, 64, 66, 68, 69, 72, 76, 84–87, 89, 92, 98, 100–103, 105, 108, 109, 111, 222, 223, 225, 229, 234; and Dahl-Wolfe's work, 108; and dance, 89, 91, 92; and Davies's work, 91; and Demachy's work, 69, 72; and Käsebier's work, 39, 58, 72; and male nude in Imogen Cunningham's work, 108; and Matisse's work, xxxiv, 77, 79, 84, 144, 148; and O'Keeffe's work, 231; and Photo-Secession, 69, 72; and Rhoades's work, 161; and Rodin's work, xxxiv, 77, 79, 84, 280n17; and Pamela Colman Smith's work, 59; and Steichen's work, 73, 75; and Stieglitz's cultural agenda, 16, 59, 75–76, 80, 84, 98, 111, 117, 222, 223, 278n76; and Stieglitz's work, 229, 231, 233–35, 243, 313–14n64, 317n95; and Whistler's work, 280n14

O'Brien, Frances, 234, 246–47, 255, 315n77
Occultism, 9, 48, 56, 66, 107. *See also* Spiritualism
Oceanic imagery, 11
O'Keeffe, Georgia: childhood of, xxxvii, xxxviii, 249–50, 318n103, 319n104; compared to Rhoades, xxxvi, 116, 117, 182–84, 187–88, 316n87; family relations of, 183, 187–88, 241, 249; illnesses of, 234, 240–41, 242, 243, 263; Millay's relations with, 265–66; Frances O'Brien's relations with, 246–47, 315n77; Pollitzer's relations with, 167, 177, 192, 193, 195, 196, 202, 203, 205, 308n21; as reader of *Camera Work*, 192, 193, 204; as reader of 291 journal, 204, 205; as resident of New Mexico, 243, 244, 250, 264–65, 266, 320n115; as resi-

dent of South Carolina, 195, 203, 205, 250, 266; as resident of Texas, xxxviii, 183, 193, 195, 202, 206, 216, 218, 241, 245, 250, 266; as resident of Virginia, 205; as resident of Wisconsin, 249–50; and stays at Lake George, 210, 224, 241, 242, 250, 263, 265, 318n103, 319n105; Stieglitz as lover of, 216–17, 220; Stieglitz as mentor of, 189; Stieglitz as twin of, 215, 227; Stieglitz's cohabitation with, 210, 311n41; Stieglitz's correspondence with, 204, 206; Stieglitz's courtship of, 178, 218; Stieglitz's economic dependence on, 42; Stieglitz's initial contact with, 205–6, 307n4; Stieglitz's marriage to, 242; Stieglitz's partnership with, xxvii, xxxvii, 216–17, 218, 240–44; Paul Strand's relations with, 205, 206, 216, 217–18, 240, 309n24; Rebecca Strand's relations with, 234, 242, 263, 264; as student of Bement, 202, 245; as student of Dow, 182, 202, 245, 315n77, 318n99; teaching experience of, xxxviii, 183, 193, 195, 202, 241, 245; vacations in Maine, 179, 210

O'Keeffe, Georgia, Stieglitz's portraits of: polymorphousness of, 228; and primitivism, 226, 228, 229; as white girl, 221

O'Keeffe, Georgia, identity of: and childhood, xxxviii, 193, 211, 216, 244; and eroticism, xxxi, xxxviii, 211, 221, 243; and female body, 113; and female sexuality, 3, 4, 16, 55, 60, 61, 113, 216, 223, 224, 243; and femininity, 90, 224–26; and intuition, xxxviii, 244, 315n73, 318n103; and Käsebier's work, 3; and masculinity, 228; and modernism, xxvii, xxix, 113, 117, 122, 167, 205–6, 211, 216, 217, 219, 231, 233, 241, 243, 245, 265; O'Keeffe's control of representations of, xxix, xxxviii, 233, 243, 306n155; and professionalism, xxxviii, 243, 244, 249; and Rhoades's identity, 116, 117, 205; and Rosenfeld's writing, 236; and Stieglitz's cultural agenda, 3, xxvii, xxix, xxxi–xxxix, 3, 4, 16, 55, 60, 61, 90, 108, 113, 117, 167, 182, 183, 192, 205–6, 214–29,

231, 233–34, 240–44, 263, 310n36; and Stieglitz's photographic works, xxviii, xxx, xxxiv, 112, 121, 170–71, 172, 184, 185, 214, 215, 218, 218–29, 220, 222, 225, 226, 231, 233–35, 240, 310n36, 313–14n64, 317n95; and unconscious, 113; and whiteness, 221, 239, 315n73; as woman-child, xxxi, xxxii, xxxiii, xxxvi–xxxix, 4, 55, 61, 113, 117, 192, 214–17, 219–22, 225, 228, 237, 239, 243–45, 263, 265

O'Keeffe, Georgia, works of: and abstraction, xxxv, 159, 170, 176, 183, 193, 195–97, 202, 204, 206, 209–10, 222, 237, 239, 245, 247, 250–52, 255–56, 258, 260–61, 265, 317n97, 318n98, 319n108; and automatism, 248; and Bakst's work, xxxv, 196–97, 202, 255; and Bergson's writing, 192; and Brigman's work, 265; catalogue raisonné of, 182; and childhood, xxxviii, 193, 206, 209, 210, 240, 244, 247–50, 252, 309n29; critical reception of, 170, 235–40, 250, 260–61, 263, 315n73; and design, xxxv, 195–97, 202, 245, 248; Dodge's response to, 183, 224; and Dow's work, 245, 247, 248; and Dresser's work, 195, 202; and Engelhard's work, 193, 210–11; and eroticism, xxxvii, 170, 176, 181, 183, 245, 318n97; exhibitions of, 167, 175, 178, 183, 191, 192–93, 195, 210, 233, 240, 241, 242, 244, 262–63, 266, 316nn79,87; and female body, 183, 239, 240, 319n108; and female nude, 231; and female sexuality, 170, 177, 183, 239, 245, 261; and feminine voice, xxxv, 191, 244, 263, 264; and femininity, 244, 245, 253, 261–65, 318n97, 320n114; and floral imagery, 237–38, 247, 252–53, 256, 258, 260–62, 319n108; and framing, 245–46, 318n99; Freudian interpretation of, 210, 215, 244, 245, 261, 314n67; and intuition, xxxvi, 193, 202, 240, 247–50, 318n103; and Japanese art, 181, 245, 248; and Kandinsky's work, 192, 195, 204, 209; and D. H. Lawrence's writing, 191, 236–38; and Leland's work, 195; and Marin's work, 202; and the miniature, 245, 249, 255; and

O'Keeffe, Georgia, works of (continued)
modernism, xxxvii, 65, 170, 176, 183, 195,
205, 210, 241, 243, 263, 265; and music,
202, 204–5, 224, 237, 247, 251–52, 256; and
mystery, 261; and mysticism, 178, 181, 261;
and nature, 202, 204, 209, 238, 239, 245,
250, 252–53, 255, 265, 318n98; and Photo-
Secession, 318n99; and primitivism, 206;
and "psychopathic" art, 167, 170, 177, 195,
307n6; and representation, 209–10, 245, 251,
317n97; Rhoades's response to, 177, 178; and
Rosenfeld's writing, 235–40, 250, 260; and
self, 192, 206, 261; and spirals, xxxv, 195,
197, 204, 209, 222, 223, 255, 256, 261, 307n9;
and Stieglitz's cultural agenda, xxxvii, 159,
170, 176–77, 182, 183, 189, 191, 192, 204–5,
210, 240–45, 250, 261, 263, 265, 309n29,
318n97; and Strand's work, 204–5; and
sublime, 239; and synesthesia, 195, 204, 205;
and unconscious, 192, 195, 204, 214, 224,
238, 240, 244; and veiling, 260; by title: The
Black Iris, 260, 260; Blue and Green Music, 204;
Canyon with Crows, 210, 211; "Doorway" paint-
ing, 178; Evening Star series, 208, 209; Flower
Abstraction, 258, 259; The Frightened Horses and
the Inquisitive Fish, 201; Gerald's Tree I, 264, 265;
Grey Blue and Black—Pink Circle, 255, 256; Grey
Line with Lavender and Yellow, 251, 253; House
with Tree—Green, 206, 207; Lake George with
Crows, 210, 210; Light Coming on the Plains
series, 208, 209; Little House, 149, 149; Music:
Pink and Blue, 204; Nude Series, VIII, 231, 232;
Pink Moon and Blue Lines (The Ocean and the Pink
Moon), 255; Pink Tulip, 256, 257; Plums, 178;
Pond in the Woods, 254, 255; Pool in the Woods,
Lake George, 254, 255; Red, Yellow, and Black
Streak, 250, 252; Red Barn, Wisconsin, 318n103;
Red Canna, 236, 237, 238; Seaweed, 258, 258;
Series I, No. 7, 237, 238; Series I–From the Plains,
203, 204; The Shelton with Sunspots, N.Y., 212;
Skunk Cabbage, 256, 257; Specials, 170, 171, 189,
195, 196, 199–201, 202, 204, 206, 214, 250,
251; Tree and Picket Fence, 206, 207; Untitled,
200, 202; White Rose with Larkspur No. II, 262,
262; Yellow House, 194, 206
Oliver, Don, 108–9, 109
O'Neill, Rose, 45–46, 46
Orientalism, 173

Patriarchy, 18, 110, 111, 140, 154, 294n54
Philadelphia: Photographic Society of, 21;
salons in, 4, 23
Photographic techniques, 4, 5, 8, 27, 63, 82,
104–5, 229, 231, 286n73
Photography as high art, 8, 14, 33, 79–80
Photo-Secession: and anticommercialism, 43;
and Boughton's work, 86; and Brigman's
work, 63, 67, 69, 76, 77, 82, 93, 104–6, 108,
110; and Coburn's work, 63, 78; and com-
mercialism, 60; and Demachy's work, 56;
and Dow's work, 8, 43, 245; and Duncan's
dance, 87; and female body, 87; and female
nude, 69, 72; and female psyche, 87; and
femininity, 15–17; and Käsebier's identity,
15, 60; and Käsebier's work, 9, 15–17, 28, 32,
39, 47, 56, 59–60, 77, 78, 106; and maternal-
ity, xxxiii, 77–78; and O'Keeffe's work,
318n99; and retrospective exhibition in
Buffalo, 28, 60, 85–86; Steichen's concep-
tualization of, 5; and Stieglitz's cultural
agenda, xxxiii, 5, 15–17, 28, 39, 43, 59–60,
77–78, 82, 105, 108, 110, 117; and Stieglitz's
work, 9; and Symbolism, 106; and veiling, 5;
and Whistler's work, 4–6, 8–11, 43, 78, 82;
and white girl, 9, 10, 31, 93; and White's
work, 9, 78
Picabia, Francis, 164, 166, 297n81
Picasso, Pablo, 59, 82, 144, 164, 289n19
Pictorialism: and anticommercialism, 42–43;
and Coburn's work, 1, 15, 33; and Day's
work, 20, 33; and Dow's work, 8; and femi-
ninity, 3, 15; and Käsebier's work, 1, 3, 15,
16, 20, 24, 27; and middle class, 1; and pro-
gressive values, 1; and Steichen's work, 1, 15,
33; and Stieglitz's cultural agenda, 3, 4, 5, 8,
15–17, 33, 42–43, 47, 58; and Whistler's work,

8, 24; and white girl, 15; and White's work, 1, 15, 33

Pictorial Photographers of America, 60

Platinum printing, 5, 27, 37, 38, 82, 104, 229, 286n73

Pollitzer, Anita, 167, 177, 192, 193, 195, 196, 202, 203, 205, 206, 308n21

Portraiture: and Beckett's work, 123; and Brigman's work, 67, 93, 220; as commercial practice, 42; as feminine practice, 19, 32; and Henri's work, 173; and Käsebier's work, xxxvii, 17, 20–21, 27–30, 32, 34–35, 37, 39–40, 42, 45, 53, 56–57, 219, 221; and Rhoades's work, 159; and Steichen's work, 115–17, 220; and Stieglitz's work, xxxvii, 30, 31, 121, 170–71, 179, 189, 214, 218–29, 231, 233–35, 240, 242

Post-Impressionism, 126, 159

Pratt Art Institute: Dow as teacher at, 8, 27, 47, 51, 276n65; Froebel's pedagogy at, 19; Käsebier as student at, 8, 18, 20, 27; Pamela Colman Smith as student at, 47, 51; women's education at, 18–19

Preoedipal relations, 11, 14

Preverbal condition, 14, 142, 155, 183, 224

Primitivism: and Apollonian-Dionysian dichotomy, 226; and Brigman's identity, 67, 85, 109, 111; and Brigman's work, 85; and childhood, 148–50, 153–56; and Duncan's dance, 90; and female sexuality, 155; and femininity, 142, 154–55, 183; and Käsebier's work, 35, 37; and Matisse's work, 90; and modernism, 148–50, 153, 169, 170, 181, 216; and O'Keeffe's identity, 226, 228; and O'Keeffe's work, 206; and self, 150–51, 153; and Pamela Colman Smith's identity, 47, 61; and Spencer's writing, 149, 156; and Stieglitz's cultural agenda, 148–50, 154, 169, 229; and Stieglitz's portraits of O'Keeffe, 226, 228, 229

Progressive values, 1, 15, 16, 18, 26, 27, 41, 58, 68, 119

Protestantism, 10

Psyche: and Brigman's work, 64, 85, 106; and childhood, 156; and Freud's writing, 156, 180; and Hartmann's writing, 11; and modernism, xxxvii, 85, 111, 171; and Photo-Secession, 87; and primitivism, 156; and Pamela Colman Smith's work, 52; and Steichen's work, 73; and Swinburne's collaboration with Whistler, 10

Psychoanalysis, 11, 14, 85, 119, 135, 167, 169, 170, 173, 175–76, 216. See also Depth psychology; Freud

Puritanism, 1, 120, 122, 127

Reed, John, 217

Repression, 78, 92, 119, 146, 167, 211, 215, 293n53

Revolution, 118, 129, 146, 148, 217

Rhoades, Katharine Nash: compared to O'Keeffe, xxxvi, 116, 117, 182–84, 187–88, 316n87; and correspondence with Stieglitz, 125–26, 127, 129–32, 134, 157–59, 164–65, 167, 177, 178–79; European experiences of, 123, 125, 126; family relations of, 132–33, 140–41, 182, 187, 292n38; father figure sought by, 126, 133, 177, 182; identity of, xxxv–xxxvi, 115–117, 124, 126, 131, 132–33, 141–43, 157, 182, 183–85, 187, 188–89, 211, 216; and interest in Bergson's philosophy, 126–28, 131, 185; and interest in Freudian theory, xxxv, 131–38, 141, 157, 175, 180; and interest in Key's writing, 136, 138, 139; and involvement with 291 journal, 164, 175, 188, 209, 301n109; personal finances of, 183; poetry by, 129, 205, 301n109; portraits of, 114, 115–17, 116, 123, 124, 126, 128, 133, 134, 183–85, 184, 186, 188, 189, 242, 290n24; and relations with Marion Beckett, 125, 126, 178; and relations with Carles, 126, 133–34, 138, 187, 291–92nn37–38; and relations with Freer, 166–67, 177, 179, 180, 183, 301n107, 305n148; and relations with Agnes Meyer, 301n107; and relations with Steichen, 126, 138, 290n24; and relations with Stieglitz,

117; and O'Keeffe's identity, 3, 4, 16, 55, 60, 61, 113, 216, 223, 224, 243; and O'Keeffe's work, 170, 177, 183, 239, 245, 261; and primitivism, 155; and production of art, 143; and Protestantism, 10; and Rhoades's identity, 184–85, 187, 188–89; and Rodin's work, 75, 82; and sexology, 64, 81, 120–22, 125, 142–43, 155, 185; and Pamela Colman Smith's work, 51, 59; and Steichen's work, 75; and Stieglitz's cultural agenda, xxxii, 60, 61, 63, 64, 81–82, 85, 108, 110, 111, 113, 117, 122–23, 135–36, 170, 176, 191, 215, 216; and Stieglitz's work, 223, 224, 235; and Symbolism, 59; and Symons's writing, 280n17; and Whistler's work, 10; and white girl, 9–10; and whiteness, 61

Sexuality, male: and modernism, 79, 81, 123; and production of art, 143, 155; and Stieglitz's cultural agenda, 79, 81, 123

Shaw, George Bernard, 270n7

Sloan, John, 89

Smith, Pamela Colman: birth of, 47; commercial activity of, 48; and conversion to Catholicism, 59; and correspondence with Stieglitz, 51, 52, 59; death of, 59; education of, 47, 51; identity of, 47, 52–53, 55, 58–59, 61, 66, 131, 277n71; portraits of, 52–53, 54, 55, 185, 186; and relations with Käsebier, 47; as resident of England, 47, 59; as resident of Jamaica, 47, 48; as resident of New York, 47–48; spiritualist activity of, 48

Smith, Pamela Colman, works of: and antimodernism, 51; and art nouveau, 51; and automatism, 52; and Blake's work, 51, 53; and childhood, 55; and Walter Crane's work, 51, 276n65; critical reception of, 53, 55; and de Casseres's writing, 53, 55; and dreams, 52, 58; and eroticism, 51; exhibitions of, 47, 48, 53, 63; and female body, 51; and female nude, 59; and female sexuality, 51, 59; and Greenaway's work, 51; and Käsebier's work, 58; marketing of, 58; and modernism, xxxiv, 47, 52, 58–59; and modernity, 58; and music, 51, 52; and mysticism, xxxiv, 58; and nature,

48, 51, 53; and self, 47; and spiritualism, 48, 51, 53; and Stieglitz's cultural agenda, xxxiv, 47, 51, 52–53, 58–59, 61, 63; and Symbolism, 52, 59; and Tarot, 48; and theatrical design, 48; and unconscious, 51, 52; and Whistler's work, 51; by title: *Beethoven Sonata No. 11–Self-Portrait*, 48, 49, 51; *The Blue Cat (Schumann's "Carnivale")*, 50, 51; *Sea Creatures*, 50, 51; *Sketch for a Glass*, 48, 49

Socialism, 121, 122, 229

Spencer, Herbert, 149, 156

Spiritualism, 9, 10, 14, 17, 48, 51, 53, 55–56, 78, 107, 109, 110, 118, 122, 171, 181, 185, 286n78

Steichen, Edward J.: and Brigman's work, 72; Isadora Duncan's relations with, 90; and eroticism, 75; and fauvism, 161; and female body, 161; and female nude, 73, 75; and Käsebier's work, 34–35; and Maeterlinck's work, 5, 6, 280nn13–14; marketing of work by, 43; and modernism, 82–83; and murals, 117, 161; and pictorialism, 1, 4–5, 15, 33; and portraiture, 114, 115–17, 116, 126, 220; as resident of France, 82, 90, 115, 126, 161; Rhoades's relations with, 126, 138, 290n24; and Rhoades's work, 161; Rodin's relations with, 75; and Stieglitz's cultural agenda, 4–5, 16, 43, 77, 90; and Symbolism, 6; and Whistler's work, 6, 280n14; and white girl, 15; works by: *Agnes Ernst (Meyer)*, 163; *Dawn Flowers*, 72; *Gertrude Käsebier*, 2; *Katharine Nash Rhoades* (same title for different works), 114, 115–17, 116, 126, 290n24; *Moonlight: The Pond*, 7; *Nude with Cat*, 73; *Picnic at Mt. Kisco*, 166

Stettheimer, Ettie, 263

Stieglitz, Alfred: birth of, 1; Brigman's personal relations with, 67–68, 80–81, 82–84, 99, 104–5, 222; daughter of, xxxix, 29, 31, 60, 148, 221, 242, 297n79; first marriage of, 29, 42, 60, 64, 111, 133, 141, 166, 178, 187, 217, 268n5; identity of, xxvii, xxxii, 1, 43, 113, 215–17, 231; Käsebier's personal relations with, 42, 43, 59, 60, 313n59; Agnes Meyer's personal relations with, 301n107;

Tarot, 48

The Ten, 10

Terry, Ellen, 48

Theater, 47, 48, 55, 67, 189

Theosophy, 107, 118, 122, 175, 286n78, 305n142

True, Dorothy, 196

291 galleries: African art exhibited at, 148–51; Beckett's work exhibited at, 159, 301n108; Brigman's visit to, 82–83, 104–5, 115, 123; Carles's work exhibited at, 126, 159; Cézanne's work exhibited at, 75, 82; children's art at, 146, 148, 151, 153, 193, 295n66, 298n84; Dodge's visits to, 173; Dove's work exhibited at, 164; Engelhard's work exhibited at, 153, 193, 210, 295n66; Hartley's work exhibited at, 193; Kandinsky's work exhibited at, 145; Käsebier's work exhibited at, 60; Macdonald-Wright's work exhibited at, 193; Marin's work exhibited at, 164, 193; Matisse's work exhibited at, 75, 77, 82, 144; O'Keeffe's work exhibited at, 167, 170, 183, 193, 195, 210, 240; Picabia's work exhibited at, 164; Picasso's work exhibited at, 82, 164; "psychopathic" art exhibited at, 167; Rhoades's visits to, 123, 125, 126, 132, 166; Rhoades's work exhibited at, 159, 164, 301n108; Rodin's work exhibited at, 75, 77, 82, 280n17; Pamela Colman Smith's work exhibited at, 47, 48, 52–53, 58, 63; and Stieglitz's cultural agenda, 17, 43, 58–60, 75, 76, 77, 82, 109, 117, 121, 122, 123, 130, 144, 146, 148, 151, 153, 169, 193, 219, 304n133; Walkowitz's work exhibited at, 193

291 journal, 164, 167, 168, 175, 204, 205, 301n109

Tyrrell, Henry, 170–71

Unconscious: and Bergson's writing, 118; and childhood, 170; and creativity, 64, 118, 123, 204, 214; and female sexuality, 64, 85, 113; and femininity, 14; and Freud's writing, 119; and Hartmann's writing, 14, 170; and Jung's writing, 175; and Kandinsky's writing, 118, 144; and modernism, xxix, 85, 119, 167; and mysticism, 181; and O'Keeffe's identity, 113; and O'Keeffe's work, 192, 195, 204, 214, 224, 238, 240, 244; and production of art, 64, 135; and psychopathology, 167, 169; and sexology, 64, 123; and Pamela Colman Smith's work, 51, 52; and spiritualism, 14; and Stieglitz's cultural agenda, xxxv, 85, 113, 123, 159, 167, 181, 214, 244; and Stieglitz's portrait of O'Keeffe, 224; and Symbolism, 6. See also Subconscious

Utopianism, xxxviii, xxxix, 3, 4, 81, 122, 192, 231, 268n6

Vanity Fair, 84, 98, 236, 281n20

Veiling: and femininity, 1; and Käsebier's work, 15, 77; and Maeterlinck's writings, 5; and maternality, 1; and O'Keeffe's work, 260; and Photo-Secession, 5; and Stieglitz's cultural agenda, 5, 15, 280n18; and Stieglitz's portraits of O'Keeffe, 229, 231, 233; and Symbolism, 1, 5, 270n7; and Whistler's work, 1, 5, 6, 8, 10, 82

Village. See Greenwich Village

Vitalism, 118, 126, 145, 263

Vivekananda, Swami, 122, 171

Voice, feminine: and Brigman's work, xxxv, 64, 65, 77, 93, 110, 112; and Käsebier's work, xxxv, 37, 56, 58; and Millay's work, 191; as mystical, 56, 58; and O'Keeffe's work, xxxv, 191, 244, 263, 264; and Pamela Colman Smith's work, xxxv, 58; as speaking body, 64, 93; and Swinburne's collaboration with Whistler, 10; and writings by women, 191, 263

Voice, modernist, 111–12, 263

Walkowitz, Abraham, 88, 89–90, 123, 144, 152, 152–53, 157, 166, 193, 211, 296n66, 297n78

Watson-Schütze, Eva, 5, 16, 32

Weber, Max, 59, 84, 123, 148, 150, 150–51, 157, 211, 297n79

Wheeler, Candace, 42

Whistler, James McNeill: and abstraction, 9; and Aestheticism, 4; and Caffin's writing, 6, 32; and Coburn's work, 63; compared to Maeterlinck, 6; and costumery, 27; and disembodiment, 1, 11; and dreams, 6; and eroticism, 82, 221; exhibitions of work by, 6, 8; and female nude, 280n14; and female sexuality, 10; and femininity, 23, 280n14; and Japanese art, 8, 43; and Käsebier's work, 22–23, 27; and maternality, 22–23; and Photo-Secession, 4–6, 8–11, 43, 78, 82; and pictorialism, 8, 24; and Pamela Colman Smith's work, 51; and spiritualism, 10, 17, 78; and Stieglitz's cultural agenda, 8; and sublimation, 82; Swinburne's collaboration with, 10; and Symbolism, 1, 5, 8; and veiling, 1, 5, 6, 8, 10, 82; and white girl, 9–10, 221; works by: *Nocturne: Grey and Silver*, 7; *Symphony in White, No. 2: The Little White Girl*, 9, 9–10

White, Clarence: as head of Pictorial Photographers of America, 60; marketing of work by, 43; and Photo-Secession, 9, 78; and pictorialism, 1, 15, 33; and relations with Käsebier, 27–28, 38–39, 60; and Stieglitz's cultural agenda, 4, 43, 83; as teacher of photography, 83; and white girl, 9, 15

White girl: and feminine voice, 10; and Käsebier's work, 9, 15, 23, 31, 37, 39, 56; and Photo-Secession, 9, 10, 31, 93; and pictorialism, 15; and Stieglitz's work, 9, 31, 221; and Swinburne's work, 10; and Whistler's work, 9–10, 221

Whiteness: and childhood, 31, 61; and female sexuality, 61; and femininity, 23, 38, 46, 61; and Käsebier's work, 18, 21, 22, 23, 24, 27, 28, 29, 30, 31, 34, 37, 38, 46; and maternality, 21, 22–23, 27, 28, 29; and O'Keeffe's identity, 221, 239, 315n73; and Seeley's work, 11

Whitman, Walt, xxxii, 100, 122, 129, 130, 280n18, 285n66

Whitney, Gertrude Vanderbilt, 91

Woman-child: and Engelhard's identity, 211, 234–35; and Millay's identity, 191–92; and O'Keeffe's identity, xxxi, xxxii, xxxiii, xxxvi–xxxix, 4, 55, 61, 113, 117, 192, 206, 214–17, 219–22, 225, 228, 239, 243–45, 263, 265; and Rhoades's identity, xxxv, 117, 124, 126, 142–43, 157–59, 182, 183, 189, 211, 216; and Stieglitz's cultural agenda, xxxi, xxxii–xxxiii, xxxv–xxxix, 4, 55, 61, 84, 117, 124, 126, 142–43, 148, 154–55, 157–59, 189, 191–92, 206, 211, 214–17, 219–22, 225, 228, 234, 237, 248, 263

"Woman in Art," Stieglitz's statement on, xxxii, xxxiii, 1, 18, 214, 217, 224, 233, 303n31, 316n78

Women: and camera clubs, 19, 20, 21; commercial activity by, 20, 42, 43, 48; education of, 17, 18–19, 272n28; equality of, 17, 19, 20, 33, 97, 138, 139, 294n53; masculinization of, 44; middle-class, 17–18, 42, 44, 81, 98, 115, 121, 125; and modernism, 76, 92, 115, 123, 124; photography as craft for, 19; professional, 16, 17, 133, 217; self-expression of, xxix, xxxi, 60, 123; social position of, 1, 16–18, 76, 92, 97, 107, 110, 111, 125, 138. *See also* Body, female; Desire, female; Femininity; Sexuality, female

World War I, 59, 109, 166, 180, 241

Wunderlich, Rudolf, 6

Yeats, William Butler, 48, 53, 277n71

Zitkala-Sa (Gertrude Simmons Bonnin), 36, 37, 38

Designer:	Sandy Drooker
Text:	10/17 Quadraat
Display:	Akzidenz Grotesk BE
Compositor:	Integrated Composition Systems, Inc.
Indexer:	Andrew Joron
Printer and binder:	Friesens Corporation